MASTERING DIVERSITY

MANAGING FOR SUCCESS UNDER ADA & OTHER ANTI-DISCRIMINATION LAWS

JAMES WALSH

MERRITT PUBLISHING, A DIVISION OF THE MERRITT COMPANY

SANTA MONICA, CALIFORNIA

Mastering Diversity
Managing for success under ADA and other anti-discrimination laws

First Edition, 1995
Copyright © 1995 by Merritt Publishing, a
division of the Merritt Company

Merritt Publishing
1661 Ninth Street
Santa Monica, California 90406

For a list of other publications or for more information, please call (800) 638-7597.
In Alaska and Hawaii, please call (310) 450-7234.

Library of Congress Catalogue Card Number: 95-073598

Walsh, James
Mastering Diversity
Managing you workforce under ADA and other anti-discrimination laws
Includes index.
Pages: 474

ISBN: 1-56343-102-5
Printed in the United States of America.

Acknowledgments

Writing this book has been a reportorial challenge. The subject matter—especially the Americans with Disabilities Act and affirmative action standards—has been changing almost daily since the project began. Conventional wisdom about what these changes mean has also shifted dramatically.

I've been lucky to have a strong staff at Merritt Publishing to help me make sense of the chaos. We've developed a system that works well in researching and analyzing complicated statute and case studies. Luisa Beltran, Pat Sheppard, Tracy Lovik and Ericka Weeks have made the breadth and depth of research in this book possible. Jan King has helped shape it into a coherent argument. Ginger McKelvey has made sure it's gotten into print quickly and cleanly. Mimi Tennant and Cynthia Chaillie have made sure what's gotten into print makes some kind of sense. I thank them all.

I also thank James Bovard, Robert Lattimer and Fred Lynch for reading early versions of this book and offering their thoughts.

Finally, if a bit sentimentally, I thank my father—also James Walsh. He knows the federal legal system intimately. He's helped me in various large and small ways to think about its problems without getting distracted by trivial points.

Mastering Diversity is the fourth title in Merritt Publishing's "Taking Control" series, which seeks to help employers and business owners deal with the host of extraordinary risks facing the modern business enterprise.

Upcoming titles will cover workplace safety, business insurance, employee compensation and other topics. To keep these projects—and the series as a whole—well focused, the editors at Merritt Publishing welcome feedback from readers.

James Walsh

MASTERING DIVERSITY
TABLE OF CONTENTS

INTRODUCTION:

DIVERSITY AS A VIRTUE

The blessing and the curse of workplace diversity is that it is a virtuous idea. Long before anti-discrimination laws took effect, enlightened business people sought a balance of race, gender and background in the workplace because it was the right thing to do—and because it strengthened a company's collective experience.

Of course, others didn't see things this way. Because they could, bigotted employers discriminated against employees or potential employees. These bigots might have enjoyed the short-term satisfaction of indulging their biases—but, more importantly, they lost any sense of virtue.

That sense of virtue fell to political activists and regulators. At its best, this transfer took the form of the Justice Department forcing the end of state-mandated racial segregation. At its worst, it took the form of laws like the Americans with Disabilities Act.

Since the mid-1970s, workplace diversity has been regulated into a compliance issue. Whether or not business people value diverse work forces, they have to obey a complex body of federal and local laws that try to control how people are hired, managed and—if necessary—fired.

The laws try to control these business functions. They don't always succeed in controlling them. In this book, we'll consider how the various federal—

**Abstract rules
are hard to
apply in the
real world**

and some state and local—laws that set out to regulate diversity have changed the nature of the process. They've changed it mostly for the worse. Diversity has lost the strengths of virtue and of regulation.

It used to be said that you can't legislate virtue. When the subject is the physical, racial and psychological make-up of the people you choose to employ, that's certainly true. Like so much else about the regulation- and litigation-mad 1980s and 1990s, even a notion as idealistic as diversity has been turned into a tool of distinction.

But you can avoid all this mess. Anti-discrimination law dictates that you hire the best people without consideration for outside prejudices. Everything else is politics added to the equation by interested parties—either for or against the laws. One of the keys to understanding diversity is seeing through the politics.

The body of anti-discrimination law has created a level of regulatory compliance that leaves most business people confused. The size and shape of a work force isn't as clear-cut an issue as workplace safety issues or even financial solvency rules. They're made up of people, so abstract rules are hard to apply fairly and generally.

So, common sense doesn't seem to apply. An employer with no bias in his or her mind can be found guilty of discrimination. A corporation that spends enough time and money can cloak bad behavior in the premise of compliance.

Cliches underlie the laws

Even more troubling: The cliche of business as a foursome of overweight white males playing golf and concocting ways to exclude women and racial minorities lingers just beneath the surface of some anti-discrimination law. It surfaces in a surprising number of regulatory guidelines and court decisions.

As a result, some employers who happen to be white or male are afraid to even address the issue

of color or gender at work. With charges of racism or sexual harassment so commonplace...the topics seem best left alone.

In a litigious world, it is often true that no news is good news. Reasonable human resources experts say that, if you haven't had diversity problems, you shouldn't go looking for them. Some legal experts revel in the uncertainty of this prospect. The one thing that's clear about it is that it makes lawyers and consultants important.

But there is hope of greater clarity in these matters. Though he's criticized by some legal scholars for his rigid ideology, Clarence Thomas—the Supreme Court Justice and former head of the Equal Employment Opportunity Commission—has written forcefully on the subject of workplace diversity.

In his concurring opinion to the key 1995 decision *Adarand Constructors, Inc. v. Federico Pena,* Thomas minced no words in describing how diversity law can interfere with diversity.

> I believe that there is a "moral [and] constitutional equivalence" between laws designed to subjugate a race and those that distribute benefits on the basis of race in order to foster some current notion of equality.
>
> Government cannot make us equal; it can only recognize, respect, and protect us as equal before the law.
>
> That [federal diversity laws] may have been motivated, in part, by good intentions cannot provide refuge from the principle that, under our Constitution, the government may not make distinctions on the basis of race....
>
> ...Unquestionably, "[i]nvidious [racial] discrimination is an engine of oppression." It is also true that "[r]emedial" racial preferences may reflect "a desire to foster equality in society." But there can be no doubt that racial paternalism and its unintended consequences can be as poisonous and pernicious as any other form of discrimination.

Moral and constitutional equivalence

Ranting and raving does little good

...These programs stamp minorities with a badge of inferiority and may cause them to develop dependencies or to adopt an attitude that they are "entitled" to preferences.

This argument states the most optimistic perspective on the hope of a society blind to bigotry.

In his book, *Forbidden Grounds: The Case Against Employment Discrimination Laws*, University of Chicago Professor Richard Epstein takes a harsher line. He argues that the modern civil rights laws are flawed to their heart because in negating freedom of association they have inexorably led to government coercion that threatens markets and, ultimately, liberty.

"At bottom are only two pure forms of legislation—productive and redistributive," Epstein writes. "Anti-discrimination legislation is always of the second kind. The form of redistribution is covert; it is capricious, it is expensive and it is wasteful."

But Clarence Thomas and Richard Epstein make their arguments in the artificial world of constitutional theory. As an employer, you have to make decisions in the real world.

There are plenty of people who will rant and rave about how the Equal Employment Opportunity Commission is an enemy of business. They scream that the Americans with Disabilities Act was a result of a conspiracy against the National Federation of Independent Businesses.

Ranting doesn't accomplish much, though. The ADA, Title VII of the Civil Rights Act of 1964 and class action lawsuits are all part of running a business in the real world. The EEOC is a fact of life in the real world.

All employers with more than 15 staff, public, private or nonprofit, come under the EEOC's Uniform Guidelines on Employee Selection Procedures. That covers 86 percent of the entire non-farm private-sector work force.

All of these employers can be sued by the EEOC for "discrimination" if the racial, ethnic and gen-

der mix of new hires diverges sufficiently from that of all other qualified applicants—for example, if the percentage of blacks hired is lower than the percentage of blacks applying.

Additionally, more than 400,000 corporations doing business with the federal government, covering about 42 percent of the private sector work force, have to file with the Office of Federal Contract Compliance Programs. This process is so onerous that the OFCCP's explanatory manual is about 700 pages long. Corporations with contracts of $50,000 or more must develop an "affirmative action plan" aimed at achieving staffing at all levels that is proportionate to the composition of the qualified local work force.

The EEOC's goals are, at their core, admirable. Its enforcement of those goals is sometimes problematic. But, as a business person it's your job to meet this challenge and keep ahead.

The EEOC can investigate your management policies and practices if it suspects discrimination. Or if someone has complained. Ranting and raving about this doesn't help you pass EEOC muster. This book aims to.

The following seven chapters will give you a background for understanding the spirit of workplace diversity law. They will also consider the essential letters of the law. They'll give you a working knowledge of how the laws are enforced and how you can comply.

This book will give you the tools to handle questions about diversity—firmly and finally. It will help you take control of these issues. It will help you return some of the virtue to diversity.

A brief history of workplace diversity

Once regarded as a laissez-faire arrangement beyond the pale of government regulation, employer-employee relations now form a large body of law that has become a highly competitive and lucrative legal specialty.

A greater awareness of laws by workers

The evolution of current workplace diversity law has its roots in the 1930s, when the unionization of the American work force helped create rules by which the employer-employee relationship was governed. But, as the United States made the transition from a heavily unionized industrial economy into a service economy, the focus shifted from labor organizations to regulatory agencies and to the courts.

It is also the offspring of 30 years of civil rights legislation designed to protect racial minorities, women, older people and other groups. These laws were originally directed at the government itself and other public institutions.

When the national outcry against unconstitutional, discriminatory treatment of minorities in America fueled the Civil Rights Act of 1964, the direction began to turn toward private-sector entities—particularly employers.

Hundreds of thousands of charges brought against employers and thousands of precedent-setting court decisions have almost completely altered the traditional principles of employment law. Each time the courts define—in detail—what constitutes unfair, unethical or discriminatory behavior, the risk of a company being sued rises.

Thirty years after the height of the civil rights movement, employment law is still evolving. Experts see a shift away from discrimination cases brought on the basis of rigid categories like race, gender and age to cases dealing with less certain categories like disabilities and sexual harassment.

The reasons for the increases in employee litigation are more complex than just an increase in the number of laws and regulations governing employer-employee relationships. There is a greater awareness of these laws by workers, and a seemingly greater willingness among people to turn to litigation as a way to resolve disputes with an employer. Worst of all, many employers invite these lawsuits by nervously avoiding politically incorrect topics.

Employees are certain

A whole generation of conditioning by popular media and scatter shot governmental regulation has made employees very certain about their rights—even when they are mistakenly certain. And they are certainly willing to exercise these rights.

In November 1993, the National Study of the Changing Workforce conducted by the New York-based Families and Work Institute revealed that the American work force remains deeply divided by race and gender.

Telephone interviews with a nationally representative sample of 2,958 wage and salaried workers found widespread perceptions of racial and sexual discrimination in the workplace. Employees of all kinds agreed that minority workers' chances for advancement were poorer than those of non-minority workers. And more than one-fifth of the workers interviewed reported they'd been discriminated against by their current employers.

Further, despite a 20-year influx of women into the work force, women managers surveyed were more than twice as likely as men to rate their career-advancement opportunities as "poor" or "fair," with 39 percent choosing those labels compared with 16 percent of men. In contrast, 84 percent of men rated their promotion chances as "good" or "excellent," compared with 60 percent of women.

Job discrimination complaints generally declined in the late 1980s due to lax enforcement by the EEOC and a series of Supreme Court decisions that made such lawsuits harder to win. But, in the wake of the passage of ADA into law, the numbers have bounced back up again.

The ADA has generated more than 15,000 lawsuits a year, most of which have been brought by people who already are employed but who now claim crippling disabilities, especially back ailments.

7

Arguing against the letter of the law

A major ADA precedent

But some ADA cases have been far more difficult than backaches. In a 1995 ADA case that had far-reaching implications, a U.S. District Court jury in Dallas awarded a former Coca Cola Co. executive $7.1 million after he was fired while being treated for alcoholism.

The verdict in *Burch v. Coca Cola* sent a shocking message to employers across the country: When employees undergo treatment for substance abuse, employers have a duty to accommodate them. And the courts will go to great lengths to enforce this duty.

The Texas jury concluded that Coca Cola violated Robert Burch's rights under the ADA when it fired him in 1993. Burch was terminated one month after he told his boss he had been diagnosed as an alcoholic. He was undergoing treatment at the time.

Coca Cola argued that Burch was fired for exhibiting "violent and threatening behavior." It portrayed Burch as an abusive manager, threatening coworkers and other business contacts with physical violence.

The company also argued—unsuccessfully—that alcoholism isn't a disease and shouldn't be considered a disability under the ADA.

Burch's lawyer, Jennifer Judin, offered a different story:

> Two days before Burch went into treatment, he was at a Coca Cola sponsored party which was preceded by a meeting of area service managers. At this meeting, the group made him a target of joking abuse. Everyone in the group—including Burch—had been drinking.

> At the dinner party, one of the speakers said that Burch should be sent to an obscure division of the company informally called "Siberia." Another manager, sitting at a table near Burch, said, "I bet his boss would like that." Again, this was all supposed to be ironic ribbing.

Burch mouthed an obscenity to the manager sitting near him and motioned that they should step outside. Nothing more happened.

After the party, Burch called a psychotherapist he had been seeing for some time. The humiliation of the incident had convinced him he needed to go into treatment.

Later that night, Burch's immediate supervisor went to a bar with some other Coca Cola executives and talked about the incident. The next day the supervisor called Coca Cola's human resources department to investigate Burch for other alleged episodes of violent and threatening behavior at work.

When Burch went into treatment for his drinking, the supervisor told him he couldn't come back to work. He'd been suspended with pay.

A short-time later, when Burch was one day short of finishing the outpatient portion of his treatment, the supervisor called him in and fired him for violent and threatening behavior.

Judin argued that Burch's behavior didn't warrant termination under Coca Cola's policy. And since the behavior didn't rise to the level of cause for termination, the company had a duty to allow him to go to treatment and return to work.

"As far as what motivated [the termination]—it's hard to say because no one will come forward. Maybe they viewed him as weak because he went into treatment," Judin said. "There's a very strong alcohol culture at Coke. Alcohol is part of the protocol for a lot of their functions."

The employee wins big

Her argument worked. Burch was awarded compensatory damages of $300,000 for mental anguish, back pay of $109,000, front pay of $700,000, and punitive damages totaling $6 million. However, the ADA limits compensatory and punitive damage awards to $300,000.

A spokeswoman for Coca Cola would only give the

common reply to such outcomes: "We disagree with the jury's decision and we are considering all options pending the final ruling. The $6 million component of the award is not allowed under the law. Under the ADA, there is a $300,000 cap on punitive damages."

However, Coke employees familiar with the case said there had been a "series of incidents" between Burch and his superiors that led to the investigation.

In the meantime, Judin and Burch were considering a constitutional challenge to the limit. "It's discrimination if an employer knows you have a disability and they fail to reasonably accommodate you. He wanted to be able to go to treatment and come back to work," Judin said with the conviction of a professional advocate. "Instead, they fired him."

According to the EEOC, the total number of discrimination complaints received in 1993 was 20 percent higher than in 1992. In fiscal 1993, the EEOC received a record 87,942 discrimination complaints and it expected to receive between 93,000 and 94,000 complaints in fiscal 1994.

Seen from a longer-term perspective, the number of discrimination suits in federal courts has risen sharply. It jumped more than 2,000 percent between 1970 and 1990. Federal lawsuits as a whole rose only 125 percent over the same period.

Contrary to a popular myth, it's not just executives who sue their employers. EEOC studies suggest that an hourly or minimum wage employee will initiate legal action as often as a highly paid executive.

To the degree that employment law has protected the innocent worker, it has been a positive change in the work force. But it also represents a real and measurable threat to even the fairest and most generous employer. Employee litigation is epidemic, and employers who are not armed with a working knowledge of the law and how it applies to them are vulnerable to potentially ruinous law-

suits.

Insuring the risk

No matter how fairly and equitably an employer treats employees, no matter how well a company follows legal advice, no matter how well a company trains key management personnel to be consistent and fair in their treatment of employees, discrimination remains a business risk.

A 1994 survey by Pennsylvania-based Jury Verdict Research showed that successful age bias claims resulted in average awards of $302,914, compared with $255,734 for gender discrimination, $176,578 for race bias and $151,421 for disability discrimination. The reason the awards are typically higher, according to JVR, is that victims tend to be employees who are higher paid because they have been with the company longer, and damages are based on the amount of lost income.

More disturbingly, JVR found that the average cost of a legal defense in an employment law case— win or lose—was more than $80,000.

Suits about discrimination in hiring used to outnumber suits about firing. In the 1990s, the reverse is true—by a factor of three or more. Most observers attribute this shift to a politicized workplace, since it's unlikely that an employer who *would not* discriminate in hiring workers *would* discriminate in firing them.

Meanwhile, insurance coverage for these disputes under general liability, umbrella liability, workers' compensation or directors and officers liability policies has proved unreliable. Discrimination claims are usually contested by insurers. And new business insurance policies are typically written with specific exclusions for so-called "employment practices liability."

Insurers will sell separate employment practices liability insurance. But this is also an unpredictable prospect. There is no standard EPL policy form. Thus, not only do policy terms and condi-

Common exclusions that limit EPL coverage

tions vary from insurer to insurer, but even the name given to the various policies is not uniform.

Although policy language varies, the most significant provisions are common to virtually all EPL policies, at least in some form.

Most EPL policies provide coverage for the three basic employment-related actions that can result in liability—wrongful termination, discrimination and sexual harassment. A caveat: the definitions of key terms can vary significantly from policy to policy.

For instance, certain policies include sexual orientation or preference in their definition of "discrimination" while others do not. This inconsistency reflects an inconsistency in the law. Federal law doesn't include sexual preference, some state laws do.

A few EPL policies are written to provide coverage for defense costs only. Most, however, cover defense and indemnity costs. The limits of liability under EPL policies generally range from $50,000 to $5 million with deductibles anywhere from $2,500 and up. The liability limits and deductibles apply to both indemnity and defense costs.

An EPL insurance policy will often include a provision for mandatory binding arbitration for any dispute regarding the interpretation of the policy. It remains to be seen, of course, whether binding arbitration will result in quicker and less costly coverage determinations.

A number of policy exclusions are common to most EPL insurance policies.

- Employer obligations under workers' compensation, disability benefits or unemployment compensation laws are not covered.

- Liability imposed under the Employment Retirement Income Security Act of 1974 is also not covered under EPL policies; neither are disputes arising under the Workers Adjustment Retraining Notification Act.

- Back pay, front pay and interest are usually covered. But most EPL policies exclude punitive damage awards and any loss arising out of fines, penalties, sanctions or multiple damages.

- The costs of implementing court-ordered programs and of other non-monetary damages are usually excluded.

The final issue to consider: EPL insurance usually doesn't cover claims that result from criminal, fraudulent or intentional wrongdoing. The exclusion of "intentional wrongdoing" is the most problematic—wrongful termination, sexual harassment and discrimination all usually assume or rely on intentionality.

Some legal experts argue that public policy prohibits an employer from being indemnified for a loss resulting from an intentional act of discrimination. Courts have reasoned that to do otherwise would encourage discrimination.

Smaller and mid-sized companies bought most of the EPL insurance coverage in the initial years it was available. Big companies tended to avoid EPL insurance in its early forms. Because these cases hadn't involved huge damages, big companies could afford to absorb the risks directly. But, as discrimination lawsuits grew in volume and size in the early 1990s, EPL coverage has grown in popularity.

Running scared

The move of big employers toward EPL insurance reflects a general trend away from facing diversity issues directly. Many employers try evasive efforts like heavy use of temporary workers or employee leasing to avoid liability. But none of these tactics work—you can face a sexual harassment or ADA claim from a temp or a leased employee just as easily as from a traditional one.

Smaller companies try to keep employment levels low enough so that laws like the ADA or Family and Medical Leave Act won't affect them. This may

be more effective—for a while—but it's still an abdication of the employer's position of authority.

Despite the proliferation of laws and regulatory guidelines, some employers get what little they know about acceptable workplace practices from loose talk, opinion and rumor. That's a model for losing control of an issue.

If nothing else, employers can go to the enforcement source for factual information. The EEOC works with employers and offers seminars, pamphlets and advice on smart workplace practices free of charge or for a small fee, depending on the service. While the EEOC should be an obvious resource, it is often the last place employers look for advice on workplace practices, because they tend to view the agency as unfriendly to business owners.

Just as some employers try to insure diversity issues out of their minds, others try to use lawyers or consultants to make the problems go away. They rely on outside attorneys—who often take a reflexive defensive stand when interacting with the EEOC or other enforcement agencies. That's usually counterproductive. Or they rely on diversity consultants who usually have even less impact on actual legal risks.

In an infamous 1987 article in *Society* magazine, Professor William Beer of Brooklyn College described certain attitudes to affirmative action and other diversity topics as one of "resolute ignorance."

Too many employers perpetuate this resolute ignorance by declining to disclose the costs they pay to manage diversity. "Our members would never say," the National Association of Manufacturers' Diane Generous predicted in the late 1980s. "They would be concerned they might be accused of complaining about how much money they had to spend on this."

Mastering diversity

It's not enough to manage diversity. You have to master diversity. If you let them, the EEOC, law-

yers and consultants will be happy to tell you how to run your company. And they'll emphasize concepts like compliance over concepts like quality or efficiency. They know how to measure compliance.

Workplace diversity makes a strong analogy to the problems that plagued workers' compensation systems in the late 1980s and early 1990s. The relevant laws set standards that demand compliance, but they offer few useful tools to meet that measure.

As an employer, you have to take control of your workplace environment. The laws don't tell you how to do it, employees can't and regulators don't have the commitment to try.

If you suspect—or worse yet, if you have no idea—whether your employment practices could be called into question, it's a good time to review your methods.

Performance reviews that provide honest evaluation of an employee's job performance and career path are a key method. Conducting reviews on a regular basis—annually, or every six months—is significant for two reasons: It can enhance employee performance by focusing on accomplishments and goals; and it provides evidence of an employee's progress or lack thereof.

But you need to be specific when you write reviews. Comments like "She's not a team player" don't offer much to the employee—and won't prove much if a lawsuit follows. Focus on specific events and particular behavior.

What employees want is to know they are being treated fairly. Programs outlining what an employee should do to receive a promotion can help assure them that they are.

Another method that many employers overlook or misjudge is their employee handbook. Used well, this can set the ground rules for employment without creating contractual obligations. Used badly, it sets nothing and creates unwanted contracts.

A few points that can help keep things going well:

Avoiding resolute ignorance with practical tools

Job descriptions play an important role

- include a prominent disclaimer, near the front of the handbook, stating that the book is not an employment contract;

- spell out clearly that employment is at your will and that employees can be terminated at any time and for any reason. Any modification of the "at-will" status is only binding if it's in writing and signed by a designated person;

- state that policies in the handbook can be amended at any time;

- list certain kinds of behavior—including discrimination, bias and sexual harassment—that you do not tolerate. Commit to taking disciplinary action (though it's best to keep the action non-specific) immediately upon discovering the behavior;

- outline a procedure that allows an employee to report prohibited or illegal behavior either through his or her supervisor or through a designated supervisor outside of his or her area;

- to the extent feasible, offer flexibility in matters like work schedules and sharing responsibilities. Managed carefully, these benefits cost you little and create a great sense of value among employees;

- state what you are for as well as what you forbid. Commit to a nondiscriminatory workplace that's consistent with existing diversity laws.

Another helpful step: Include a form for the employee to sign that indicates he or she has received and read it and understands its terms.

Last, it's become a near-necessity of modern business to write job descriptions for each kind of job you have. These descriptions don't have to be long—but they should describe the basic requirements and responsibilities of a job.

The Americans with Disabilities Act makes job descriptions important. The ADA prohibits employers from discriminating against people with disabilities who are qualified for a position and able to perform its essential functions.

If the job demands a certain kind of physical capability, describe it. If it includes particular pressures, name them. You have latitude to use your business judgment in writing these descriptions, as long as you do so in good faith and in advance of any kind of legal challenge.

A caveat: Don't get too legalistic in your handbook, job descriptions or anywhere else. In your role as an employer, you don't want to come off as a lawyer (even if you are one). You want to comply with the spirit of workplace diversity law. Save the legalisms for their proper—and unfortunate—place.

The bottom line

What's the return on an investment in mastering diversity? Reduced exposure to discrimination claims, lower absenteeism and turnover, full use of human resources, fewer conflicts and possible market growth—to name a few.

In September 1992, the Indiana-based Hudson Institute released updated results of *Workforce 2000*, its ongoing report on how the labor pool has changed. The report showed that white males were already in a minority in the workplace, and it forecast that 85 percent of the net growth in the U.S. labor force throughout the rest of the century would come from workers who are racial minorities, women or immigrants.

This isn't just the utopian talk of weepy-eyed American liberals. There are good business reasons to master diversity.

"Relationships people develop at work [are some of the] most complicated and get played out like family. People exhibit the same behaviors at work that they do in families. Business owners have to be sensitive to managing and motivating people to do a task," says Kevin Baker, a labor law attorney with the Mexican-American Legal Defense and Education Fund (MALDEF). "What law requires and what is good business practice are two different things."

Diversity is not just an employment term, it's a marketplace term. In a global economy, companies need to be responsive to the expectations of customers from different backgrounds.

More than one-third of the 578 companies responding to a survey conducted in April 1993 by the Olsten Corp., a New York-based temporary-personnel company, said they had a great need for employees with multicultural communications skills—"necessary for doing business in other nations and communicating with a diverse work force."

Diversity is to the 1990s what quality was to the 1970s. It's a business concept that's tough to define and usually requires major changes to corporate cultures. Unlike quality, you can't rely on statistical processes to implement it—as we'll see in the coming chapters—statistics play a complicated role in diversity law.

You can take control

But you don't have to shy away from these topics. You can take control of diversity—just as you can any other part of your business. We'll consider the rules in great detail throughout this book, but a general strategy does emerge: If you treat all job applicants, employees and former employees fairly and consistently, you're in better shape to treat any individual employee as good-faith business judgment dictates.

You don't have to worry about firing a problem person because she is a racial minority. You don't have to hesitate to hire a decent candidate because he's in a wheelchair. The legal problems associated with workplace diversity are real—but you can master them.

The truism that remains true in business is that good people—regardless of their size or shape or hue—are hard enough to find that no business person can afford to pass them over. In the modern world, business can't afford to indulge in the foolish luxuries of racial or gender biases.

Legislatures and courts don't always seem to understand this. Regulators rarely do. Regardless of which political party controls the congressional committees on Capital Hill, they keep passing anti-discrimination laws that cause as much trouble as they solve.

In the seven chapters that follow, we'll consider each of the main issues that affect workplace diversity. Using case studies, many based on the precedents that have shaped diversity law, we'll explore the issues that scare some and concern all employers.

A final caveat

Finally, a major caveat: As is true for any book like this, we'll consider the general issues and language of workplace diversity. You can use this as a primer for understanding the terms of the debate. But, if you're already facing a diversity problem—or a discrimination lawsuit—don't try to use this book in place of a lawyer. The cases we consider may not apply to your situation. The conclusions we reach may not fit the specific circumstances you have to resolve.

Chapter 1:
Disabilities

Introduction

Of all the federal laws that influence how you hire and manage workers, the most complicated and demanding is the Americans with Disabilities Act. If you can master the ADA, you can master any workplace diversity standard.

The ADA, which went into full effect in July 1994, provides employment and other protections to an estimated 43 million Americans with physical or mental disabilities. It requires that public accommodations be made accessible and that public entities and utilities provide needed services for disabled people. Movie theaters, restaurants and other public buildings must have entrances accessible to the disabled.

But issues of accessibility and services—as highly publicized as they might be—appear later in the law. Title I of the ADA deals with how employers deal with disabled workers and job applicants. That's the section we'll consider here.

The law forbids employers from discriminating on the basis of disability in hiring, promoting or compensating workers. It requires employers to make "reasonable accommodations" for disabled workers who can otherwise perform the essential functions of a job.

Its protection also extends to people currently well but with a history of disability, people wrongly perceived as having a disability and—to a limited

Even the definition of "diversity" causes confusion

extent—people related to individuals with a disability.

But what is a disability? What is a reasonable accommodation? When can a disabled employee legitimately be fired or moved to another job? Congress intentionally left these questions unresolved when it drafted the ADA in 1990. It meant for the federal courts to refine the important parameters of the law.

The biggest of these problems: The law's definition of "disability" is vague and subject to much conflicting judicial interpretation. (We'll consider this problem in greater detail later in this chapter.) People who support ADA say its definition of "disability" is "general." Critics call it irresponsible and dangerous.

The law applies to all employers with more than 15 full-time, permanent employees. The U.S. Equal Employment Opportunity Commission, which enforces the ADA, reports that about 666,000 businesses throughout the country must comply. Other reports estimate the number at closer to two million employers.

An employee has to ask for accommodation

When the job discrimination protections of the ADA took effect, some employers feared they'd be flooded with lawsuits from people with extreme learning disabilities (covered by the Act) seeking high-skill jobs and from people with AIDS (also covered by the Act) suing to keep jobs and benefits. There have been cases like these but, for the most part, there have been fewer of these than some employers had thought.

One reason the number of lawsuits has been—relatively—low: The ADA is as confusing to workers as it is to employers. It's as confusing to judges as it is to lawyers. It is, in general, a confusing and badly-written law.

Opponents, such as the Washington, D.C.-based National Federation of Independent Business, have

charged that the ADA is vague and burdensome. They argue that employers and business owners who try to comply might still be slapped with a complaint or suit.

For example, the ADA says that a disabled worker must inform his or her employer of any disability that requires accommodation—and the employer has to respond promptly or face harsh scrutiny from the EEOC. This process remains true, even if the worker's disability is clearly visible.

Offering accommodations before a disabled employee has requested them might show a good-faith effort to comply with the law, but it won't necessarily count as an accommodation of a future request. "Our lawyer has warned us that making accommodations that haven't been requested might create a higher level of expectation...and more expensive requests that we'd have to reasonably accommodate," says an executive with a California-based utility that employs a number of disabled workers.

So, some employers find themselves in the legalistic position of not making common-sense accommodations. This is clearly a bad position. Most employers are waiting to see how the courts define terms like "disability" and "reasonable" before making any difficult accommodations.

Small businesses face a disproportionately large risk on the ADA. By some estimates, they employ between 60 and 70 percent of working people who have disabilities. Small businesses are usually the most willing to comply with the federal laws—even though they usually lack the in-house legal and personnel specialists found at bigger employers.

Because the ADA is complicated and vague at the same time, you need to develop policies that will anticipate its requirements and allow you to meet the spirit of the law—as well as the business necessity of maintaining a diverse and qualified work force.

The law meant to cover major disabilities— not backaches

Congress abdicates discrimination issues to federal courts

Legislative and political history

President George Bush signed the Americans with Disabilities Act into law in August 1990. Surrounded by applauding disabled military veterans and professionals, he said the ADA's purpose was to provide a clear and comprehensive national mandate for the elimination of discrimination against people with disabilities.

The heart of the law demands that people with disabilities be recognized as members "of American society (who) should be given the opportunities other Americans take for granted," said Linda Kilb, managing director of the California-based Disability Rights Education and Defense Fund. But, even if the Act's heart was in the right place, its more important organs lay in nether regions.

Since the Bush signing ceremony, debate over the Act has focused on legal and financial implications that never came during the legislative debate. The bipartisan support that ADA enjoyed as a bill didn't reflect a general sense of cynicism that the politicians on Capital Hill felt toward the whole body of anti-discrimination law.

"It's been a fact of life for almost thirty years that Congress has abdicated issues of discrimination to the federal court system," says one staffer for a congressman who supported ADA. "Nobody wanted to be the heartless bastard kicking the crutches out from under a crippled veteran. So they packed this thing with the broadest language possible and passed the buck to the judges."

"There are no hard and fast rules," admitted Gary Marx, a Washington lawyer and editor of Disability Law Compliance Report, a monthly newsletter. "An attempt in Congress to give a hard and fast rule [to ADA definitions] was defeated."

"Congress has no earthly idea of what they did," said one human resources consultant who predicted ADA awards "are going to go through the roof." The general consensus among corporate types was that the broad language on the Act would have unanticipated consequences.

For example, if an employer instituted a managed care plan that required a disabled employee to switch from a local doctor to member doctor farther away, the employee could make an ADA claim.

When the law was being debated, the talk focused on physical handicaps and the cost of revamping buildings. Mental disabilities, for which accommodation costs are nearly impossible to quantify, went virtually unmentioned.

On the other side of the issue, energized—and newly numerous—disability rights activists argued that corporate fat cats were simply trying to crush the latest progressive movement.

"People are dying to jump on the ADA," complains a spokesperson for the Disability Rights Education Defense Fund. One way is to cut its funding. Another is to ban outright so-called "unfunded mandates," of which the ADA is one. A third is to politicize any controversial actions.

Title I of the ADA, the section which prohibits job discrimination against the disabled, took effect in July 1992 for companies with 25 employees or more. Two years later, in July 1994, the job protections extended to cover companies with 15 to 24 employees.

In the months immediately after the ADA became law, several political commentators made fun of a case involving a woman who claimed that she'd been discriminated against because of a chronic problem with body odor. The fuzzy language of ADA worked well for plaintiffs' attorneys. It forced federal courts to listen to a wide range of alleged disabilities—and the allowed requests for punitive damages.

One of the first ADA lawsuits to reach the federal courts didn't involve a struggling disabled veteran. It involved the kind of psychological problem that makes ADA critics like talk show host Rush Limbaugh squeal.

In a May 1993 lawsuit, Charlotte, North Carolina, Police Sergeant Mari Williams claimed the city had

Political spin started as soon as the ADA passed

refused to accommodate her medical condition, shift-work sleep disorder.

Williams claimed she couldn't sleep during daylight hours after working the third shift. Her problems were "interfering with the normal functioning of her body." She claimed that, as a result, she had been denied wages and promotions.

As a reasonable accommodation, Williams asked to work only during the first or second shift. She also sought unspecified damages related to her lost wages and promotions.

The city of Charlotte countered that Williams's disorder wasn't covered by ADA. City Attorney Henry Underhill insisted the city would fight the Williams claim. As this book went to press, it still was.

As the ADA has become the state-of-the-art in workplace lawsuits, lobbying groups have lined up to be included in evolving list of covered disabilities.

In 1994, the state supreme court in California ruled that an obese woman who'd sued a community health food cooperative that would not employ her because of her weight could be covered by the ADA if she could prove her obesity was caused by a physiological disorder.

This ruling got the so-called "size acceptance movement" rolling. Its spokespeople started pressing for inclusion of some 38 million fat Americans under the forgiving cover of the ADA.

"We're not going to take this kind of abuse anymore just because we're large," said Laura Eljaiek, the program director for the California-based National Association to Advance Fat Acceptance. "Size diversity exists, just like height diversity. We don't expect everyone to be 5' 9"."

NAAFA activists pointed to a Harvard University study, published in the *New England Journal of Medicine*, indicating that overweight people might not be able to control their condition.

The study tracked more than 10,000 adolescents, comparing those with similar educational and so-

cioeconomic backgrounds but different weights. After seven years, overweight men and women were less likely to have married, had completed fewer years of education, and had lower household incomes, lower self-esteem, and higher rates of poverty.

In their report, the Harvard researchers took the unusual step of suggesting that the ADA be extended to cover the overweight.

"This is a good example of the problems that a law like the ADA presents," says the Capital Hill legislative staffer whose boss voted for the law. "The politicians created all these protections, left the coverage issues unresolved and released the thing to the public. Now it's up to the judges and bureaucrats to decide what's what."

Enforcement

A claim under ADA begins at the Equal Employment Opportunity Commission, where the claimant employee files a charge of discrimination. EEOC complaints are confidential.

In the initial segment of a complaint, the "Parties" are named and their identities explained. Under the ADA, an employee or job applicant making a complaint must be a "qualified individual," which means someone affected by a disability. The defendant must be a "covered entity"—which means a company employing more than 15 full-time workers—or a "public entity."

The EEOC has 180 days from the date of the alleged discrimination to investigate the claim. It has to follow the same investigation guidelines that apply to any civil rights case—but this can include subpoenaing your business records, if you don't cooperate.

If the 180 days pass and the employee still isn't satisfied, he or she can request a right-to-sue letter. This letter says that the accusation is consistent with a legitimate discrimination claim—and it gives the employee the right to proceed with a

civil lawsuit in court. The letter means that the government doesn't plan to prosecute the case itself. But, in practice, it's a more powerful tool than that description suggests. Many employers take the right-to-sue letter as a sign that it's time to settle the claim.

Depending on its backlog of complaints, an EEOC office can take a year or more to complete an investigation. Some employees receive their right-to-sue letter, start and sometimes finish their civil suit before receiving the findings of the EEOC.

The EEOC process is regarded by plaintiffs' attorneys as a perfunctory rite of passage to the federal court.

But a caveat: An EEOC finding is admissible as evidence in a civil lawsuit.

Of course, not all complaints filed with the EEOC become lawsuits. Many times the complaint process begins when an employee asks for some type of accommodation and an employer does not want to comply.

Unexpectedly minor ailments

In the first several years of ADA enforcement, employers have been surprised by the kinds of disabilities claimed most often. The most likely ADA complaint: employees with back impairment asking for accommodation. These claims made up 18.8 percent of all ADA complaints handled by the EEOC through late 1994.

Other frequent ADA disabilities: Mental illness accounted for 9.8 percent of the total handled by EEOC and heart impairment was 4.1 percent. AIDS or HIV accounted for about 2 percent.

The alleged disability is only half of the ADA equation. An EEOC complaint also has to charge an employer with some kind of misconduct. These charges fall into three basic categories. Almost 50 percent of the complaints involved allegedly improper firings. Failure to reasonably accommodate a disabled person accounted for 22.7 percent. Fail-

ure-to-hire complaints made up only 13 percent of the filings—experts had expected this number be higher.

From July 1992 through January 1994, the number of people filing EEOC complaints related to ADA was 21,483. Of those, 7,386 had been resolved within eighteen months.

Of the charges that were resolved, 1,631 resulted in some type of benefit or relief to the charging party. In 2,366 cases, the EEOC ruled that no discrimination had occurred. 3,258 cases were closed administratively—meaning either the charging party dropped out of contact or the EEOC lacked jurisdiction because the employer had too few employees or the alleged discrimination occurred before the ADA took effect. These administrative closings are considered a win for the employer.

So, even after an ADA complaint has been made with the EEOC, your chances of resolving the issue in your favor are about three in four. The main conclusion here: Don't be intimidated by the EEOC complaint or the right-to-sue letter. If you've been careful about treating your workers fairly and you've developed enough documentation, your prospects of emerging without having to pay damages should be pretty good.

The EEOC seems to understand that ADA claims are difficult to prosecute. By November 1994, the agency had brought only five ADA cases to court. Of course, employees can sue you without the EEOC.

ADA cases, like most anti-discrimination cases, are usually filed in federal court. If they're filed in state court, they'll probably be moved to the federal. This is a relatively good thing for employers—federal courts tend to be more conservative in the damages they award in civil lawsuits.

An employee's attorney will usually approach an ADA case like a civil rights action, not a personal injury or a workers' comp case. The focus will not be on the poor, exploited worker; it will be on the courageous plaintiff who has adapted to hard cir-

Half the ADA claims involve wrongful termination

*Many factors—
Including
reputations—
can come into
play*

cumstances—and who has been treated unfairly by you, the bigoted employer.

The EEOC doesn't quantify how it decides whether to prosecute a discrimination complaint under ADA. Because it's moved in so few cases, you might think the grounds for making the decision are rigorous. But legal experts around the country don't agree much on what makes a strong ADA employment case.

The answer may depend on any of a number of divergent factors:

- the reputation of the employer for fairness towards employees (especially with regard to issues of disability, race, age, and gender)

- the specificity and corroboration of the employee's claims

- the employer's policies and procedures related to disabled employees

- the employer's history of attempts to reasonably accommodate disabled individuals

- the role of the ADA's most confusing language in the claim

- the employer's vulnerability to negative media exposure

- whether punitive damages might inflate any award

- whether the employee wants to return to the job or just wants monetary damages

- whether the claim involves social or political complexities such as AIDS/HIV status or drug use

- whether the employee makes a sympathetic claimant

- whether the employee can, in fact, be reasonably accommodated.

One early ADA court ruling that the EEOC did back involved a former executive with Illinois-based Allied Security Investigations Ltd. In 1992, middle-

level manager Charles Wessel was diagnosed with brain cancer. Though the cancer was treatable with conventional therapies, Allied Security coerced Wessel into retiring on medical disability.

Wessel wanted to keep working. Almost immediately, he regretted giving in to pressure from his supervisors and peers. He filed a complaint with the EEOC, which filed a lawsuit on his behalf arguing that he could still perform his job effectively, despite the illness.

In late 1993, an Illinois federal court ruled that Wessel had been wrongly fired because of the brain tumor. The trial jury awarded Wessel $572,000 (eventually lowered to $222,000 by the trial judge). The most important part of the ruling was that Wessel's immediate supervisor was held personally liable—to the tune of $75,000—under the ADA.

The day after the verdict, the Chicago office of the EEOC received dozens of calls from people asking how to file complaints against employers.

A post-mortem resolution

Eighteen months later—after Wessel had died—a federal appeals court rejected part of the reduced award. In May 1995, the Seventh Circuit Court of Appeals ruled that individuals could not be held personally liable under ADA. Its decision turned on the legal definition of "employer."

The court concluded that, because ADA applies to companies with as few as 15 employees, it couldn't be interpreted to single out supervisors for liability. The better definition focused on the relevant company as "employer." The appeals court allowed the damages against Allied Security to stand.

The EEOC didn't have much of an official response to the appeals decision—aside from saying that it would consider an appeal to the Supreme Court.

Even though individuals can't be singled out, attorneys like ADA cases because their fees may be awarded to a prevailing employee. In order to ob-

Managers and supervisors can't be singled out for liability

tain attorneys' fees, the worker has to include this request in the "prayer for relief" section of the initial complaint.

"There hasn't been a whole lot of litigation," one Richmond, Virginia, labor attorney complained to a local newspaper in 1994. "We've had ADA cases in this office, but to date we've settled everything" before it got to the court level....One reason is it's relatively new. Another reason is you go through the EEOC on it first, and a lot of these cases are resolved without going to court."

As if that were a bad thing.

The EEOC likes consent decrees

If the EEOC gets involved in an ADA lawsuit, it may encourage the employer to sign a consent decree—which is an enforcement tool for resolving cases quickly. The 1993 case *Estate of Mark Kadinger v. International Brotherhood of Electrical Workers* set the terms of ADA application to people with AIDS. It also shows what you might face if you ever have to consider signing a consent decree in the wake of discrimination charges.

The lawsuit was filed by the University of Minnesota Hospital and Kadinger's Estate in March 1993, alleging discrimination in violation of Title I of the ADA. Specifically, they charged that the IBEW (which, in the context of the lawsuit, was considered Kadinger's employer) violated the ADA by providing a health benefit plan that furnished Kadinger with lesser benefits because of his disability, AIDS.

The IBEW health plan capped lifetime benefits for AIDS and AIDS-related conditions at $50,000, while providing a lifetime maximum benefit up to $500,000 for other conditions. Kadinger had contracted AIDS several years earlier, but got sick for the last time in the fall of 1992. That's when he found out about the cap for AIDS benefits in the IBEW plan.

Two months after the lawsuit had been filed, the

EEOC joined Kadinger's lawsuit and became lead plaintiff.

The IBEW denied all allegations of discrimination. It also denied that it was a "covered entity" as defined by the ADA. However, with legal pressure mounting and the public profile of the case growing, the IBEW agreed to a consent decree.

The union agreed to:

- amend the terms and provisions of the Plan by deleting the following phrase, "except that the maximum lifetime benefit for Acquired Immune Deficiency Syndrome (AIDS) or AIDS-related conditions shall not exceed $50,000." The amendment was made retroactive to July 1992;

- provide annual training to all members who served as trustees for the Plan. The union agreed to use outside consultants mutually designated by it and the EEOC. Training subjects would include discrimination based on AIDS, discrimination based on disability, and discrimination-based distinctions in health benefit plans under the ADA;

- report on an annual basis the following information:

 1) all amendments to terms, provisions or conditions of the Plan,

 2) the justification for any term, provision, or condition of the Plan that singles out a particular disability, discrete group of disabilities, or disability in general, and

 3) the justification for any term, provision, or condition that singles out a procedure or treatment used exclusively, or nearly exclusively, for the treatment of a particular disability or discrete group of disabilities (e.g., exclusion of a drug used only to treat AIDS);

- pay the Estate of Mark Kadinger $100,000 for reimbursement of medical expenses otherwise covered by the amended Plan, and in full relief of all claims for compensatory, punitive, and other damages asserted in this litigation;

Signing a consent decree under mounting pressure

- contribute $2,500 to the Minnesota Aids Project in memory of Mark Kadinger.

The various parties involved in the lawsuit agreed that the consent decree constituted a fair, complete, and final settlement of the claims.

Compliance

The central issue in ADA compliance is the requirement that the employer must provide a "reasonable accommodation" to a disabled worker to enable that worker to perform the "essential functions" of his or her job.

Considered from another perspective, a reasonable accommodation is any procedure that enables a disabled person to work successfully at a particular place of business. For example, personalized training is one accommodation that works in many situations. Training is the type of accommodation that benefits both you and your employees—they have a better understanding of their jobs, you have a better informed staff.

You have to foot the bill for these accommodations. The government won't do it—at least not directly. Insurance won't do it. The cost of modifying a property to comply with a reasonable ADA accommodation is excluded from employment practices liability coverage and even from specific ADA liability insurance.

But you have some control over how you handle these issues. Smart employers look to the definition of "reasonable" as their guide for what "accommodations" they have to make. The ADA itself says that a reasonable accommodation can't alter the essential nature of a job or result in "significant difficulty or expense" for you.

You don't have to make an accommodation that imposes any "undue hardship" on your business. Fears or morale problems associated with co-workers are not factors indicating that undue hardship exists. Financial loss may be.

The ADA doesn't define how much you must spend

as a "reasonable accommodation" to help a qualified disabled worker perform on the job—but the President's Job Accommodation Network has projected that 15 percent of ADA accommodations cost nothing and 51 percent cost $500 or less.

The Network suggests low-cost approaches to ADA compliance. Among its examples:

- placing a desk on wooden blocks so a wheelchair can fit under it,

- widening a stall in a bathroom for wheelchair or walker access,

- buying a telephone amplifier for hearing-impaired workers,

- providing a quiet room for employees who need medical procedures like peritoneal dialysis or insulin injections.

So-called "failure to accommodate" complaints can be avoided by following a few basic rules.

Providing a "reasonable accommodation" doesn't mean you have to consent to a worker's every request. If an employee does request an accommodation you find unreasonable, analyze the situation and offer an alternative you find acceptable. Also, be prepared to document how your suggestion is more reasonable than the worker's request.

If you've thought about it at all, you may envision an ADA accommodation as a physical adaptation—a wheelchair ramp or special ergonomic computer keyboard. Think more creatively than that.

The EEOC encourages employers to see ADA as a case-specific process. This is a departure from its guidelines for compliance with other civil rights statutes. Outside of ADA, your best compliance strategy is to treat all employees in exactly the same manner. The opposite is true for ADA compliance.

This lack of standard can create some problems. It's possible that you would make the exact same accommodation for two employees who have exactly the same disability and still get into trouble. A reasonable accommodation takes into account

not only the needs of the job, but also the needs of the individual.

An EEOC spokesman admitted that the definition of "reasonable accommodation" also depends on the employer in question—as well as the employee. "A big company like GM or IBM may be held to a more expensive standard than the corner grocery store. You have to look at it on a case-by-case basis."

In one Virginia case, a convenience store employee with vision problems found it difficult to perform some job functions. She requested that another clerk be scheduled to work with her. However, business was slow during her shift, and the employer did not want the added cost of another employee. The EEOC sided with the employee, saying that scheduling a second worker would be a reasonable accommodation. The employer ended up settling the case. The employee was near retirement age, and the employer provided her cash to carry her until she could receive her Social Security benefits.

Reasonable accommodation

Like so much else about the ADA, the ultimate definition of "reasonable accommodation" will be left to the federal courts to determine.

In its broadest sense, accommodation means taking extra steps to increase the productivity, tenure, and job satisfaction of disabled workers. Specific accommodations can include everything from flexible hours to family counseling.

Another key compliance issue is asking about disabilities in job interviews or on applications.

Asking whether an applicant has a history of back problems and, in some cases, even asking if he or she has "an impairment that may interfere with the ability to safely perform the job" is illegal.

What EEOC enforcement guidelines do allow you to ask, during the pre-offer interview process, is whether a job applicant can fulfill the terms of a

job description without reasonable accommodation.

However, if the applicant says he or she needs an accommodation to do the job, you can't ask what the accommodation might be. You can only ask that after you've hired the person. And, if you don't hire the applicant who needs the accommodation, be prepared to defend your decision to the EEOC. Be ready to provide the job description at issue, establish that the qualifications in the description are legitimate and show that the person you did hire met the qualifications as well or better than the person you didn't hire.

Writing a job description for every position in your company is an essential part of complying with the ADA. It's perhaps the best tool the law allows you for taking control of the hiring process. The law itself says:

> ...consideration shall be given to the employer's judgment as to what functions of a job are essential, and if an employer has a written description before advertising or interviewing applicants for the job, this description shall be considered evidence of the essential functions of the job.

In the 1993 case *Wooten v. City of Columbus*, an Ohio appeals court considered the case of a former city employee making disability discrimination claims against the city. Starting in 1986, Roger Wooten worked for the city of Columbus Department of Public Utilities as a "provisional plant maintenance mechanic."

Prior to his employment with the city, Wooten suffered substantial hearing loss as a result of exposure to high noise levels while employed at Buckeye Steel. The city was aware of his hearing loss at the time he was hired.

The responsibilities of Wooten's job with the city were articulated in a clear, detailed job description. The position required the performance of corrective and preventative maintenance on a variety of mechanical equipment. Physically, it required

An employee who fell through the cracks—and sued

the ability to exert up to one hundred pounds of force occasionally, fifty pounds of force frequently, and up to twenty pounds of force constantly.

The job was in the competitive class under the civil service system, which meant that all provisional employees had to take and pass a competitive examination administered by the Civil Service Commission before receiving a permanent appointment.

In October 1989, Wooten suffered another significant work-related injury—a right inguinal hernia. He was granted approximately five months' injury leave, during which he was operated on twice in an attempt to repair his hernia.

Wooten returned to work in March 1990 when, in a matter of days, he sustained a reinjury and again suffered a hernia. A third operation ensued, after which his physician placed a permanent twenty-pound lifting restriction on Wooten's activities. Wooten returned to work under the lifting restrictions in April 1990.

Soon after Wooten's return, the city concluded that his inability to lift more than twenty pounds prevented him from performing all the duties of a plant maintenance mechanic. The city argued that the Division of Water had no "light duty" positions which Wooten could perform. Wooten was placed on disability leave.

While Wooten was on this leave, the civil service commission administered a competitive examination for all provisional plant maintenance mechanics. Because he was not notified, Wooten did not take the examination. In March 1991, Wooten was terminated from his employment—allegedly because he had not taken the civil service examination. This meant that his name did not appear on the civil service eligibility list for plant maintenance mechanics.

In April 1992, Wooten filed his complaint, alleging handicap discrimination in violation of the ADA, the Rehabilitation Act of 1973 and Ohio state law.

The trial court ruled for the city, in part because its detailed job description established that it had little choice but to put Wooten on leave. He clearly could not perform job requirements.

Wooten appealed this decision, arguing that the law's definition of reasonable accommodations included revision of job descriptions and modified or part-time work schedules. But the higher court supported the lower court's conclusion.

It ruled that the city's job description defined basic standards that Wooten couldn't meet.

ADA and hiring

The EEOC has issued guidelines for pre-employment questioning and medical exams under the ADA. These guidelines are designed to help EEOC investigators analyze charges filed against employers. Specific questions are listed that are unlawful. Some examples:

- "Do you have AIDS?"

- "Have you ever filed for workers' compensation?"

- "What prescription drugs are you taking?"

- "Have you ever been treated for mental illness?"

You may want to test a job applicant to find out for yourself whether he or she can meet the physical requirements of the position. The ADA is very explicit about how medical testing can be done. It states plainly:

> [An employer] may require a medical examination after an offer of employment has been made to a job applicant and prior to the commencement of the employment duties of such an applicant, and may condition an offer of employment on the results...if:
>
> ...all entering employees are subject to such an examination regardless of disability;
>
> ...information obtained regarding the medical condition or history of the applicant is collected

The ADA demands very particular filekeeping

and maintained on separate forms and in separate medical files and is treated as a confidential medical record...and;

...the results of such examination are used only in accordance with this title.

Be careful of making too many of these conditional job offers, though. Withdrawing an offer because a disabled applicant failed a physical test is a good bet to result in an EEOC complaint. You'll need to have your written job description and records of all other physical tests ready. And make sure the test is administered in a consistent manner.

Because the ADA is structured like other civil rights law, it encourages claims of pretext—that you're lying about why you didn't hire someone. It's not hard to imagine an angry applicant projecting pretext onto a withdrawn conditional job offer. He or she could claim that you made the test extra difficult because you didn't want someone with a disability working for you.

Also, note that the ADA requires employee medical information be kept confidential and in a separate, limited-access file. This has been a compliance issue from the beginning. In 1994, the EEOC sued an Indiana lumber company for, among other things, failing to maintain separate employee medical files.

The last major point to remember about ADA compliance is that the law adds to the body of federal regulations that can find discrimination in effect—even if there's none in intent. Business practices which, at first glance, do not appear to discriminate may, in practice, create a discriminatory burden.

For example, a no-fault attendance plan that calls for firing an employee after 15 absences, regardless of the reason for absence, could be seen as discriminatory against disabled people.

However, the ADA lawsuits which have reached trial in the first few years of the law suggest that—despite the EEOC's recommendations—policies

applied fairly to all employees can withstand charges of discrimination.

Definitions

The major legal issues raised by the ADA fall into two categories: definitions and applications.

The first kind of problem you're likely to encounter is an unclear definition. Three phrases pose the bulk of these problems:

- "qualified individual with a disability,"
- "reasonable accommodation," and
- "undue hardship."

We'll consider each of these in turn.

The ADA itself defines "qualified individual with a disability" as:

> an individual with a disability who, with or without reasonable accommodation, can perform the essential functions of the employment position such an individual holds or desires.

This definition remains a little murky. The meaning of the word "disability" seems to hold the key to understanding who can rightly make a claim. Elsewhere, the ADA defines "disability" as:

> a physical or mental impairment that substantially limits one or more of the major life activities...a record of such impairment or being regarded as having such an impairment.

Congress intentionally left the definition of disability under ADA open-ended to ensure that as many people as possible are protected. The Justice Department and the federal Equal Employment Opportunity Commission offer an "illustrative list" of impairments.

These include:

- blindness and eye impairments;
- speech and hearing problems;
- contagious and non-contagious diseases, including AIDS;

- birth and genetic defects;
- mental retardation;
- emotional illnesses;
- cancers;
- heart disease; and
- recovering drug abuse and alcoholism.

This list is so broad that it doesn't offer much help. This area has become a confusing mess for employers. The EEOC says that it is working to define disability more exactly.

The key to defining this term seems to lie in what the law means by "major life activities." Generally, the phrase means basic acts that the average person in the general population can perform with little or no difficulty. (Someone familiar with insurance might recognize the phrase from long-term disability insurance and other complicated coverages.)

In any case, it sounds pretty subjective. The EEOC regulations get a little more specific. They define "major life activities" as:

> functions such as caring for oneself, performing manual tasks, walking, seeing, hearing, speaking, breathing, learning and working.

Of course the EEOC hastens to add that "this list is not exhaustive."

The 1995 federal case *Pamela McKay v. Toyota Motor Manufacturing*, U.S.A. turned on whether carpal tunnel syndrome limited major life activities.

McKay began working for Toyota in March 1992 in the body weld division of the car maker's Georgetown, Kentucky, plant. Within a few weeks, she began complaining of pain in both of her hands, forearms and wrists, as well as numbness and tingling.

Initially, McKay was referred to a physician employed by Toyota and sent home to rest. Although she returned to work after several days, the pain

and swelling returned and she was then referred to Dr. Tsu-Min Tsai, an orthopedic surgeon, who diagnosed McKay with carpal tunnel syndrome caused by her work. McKay was given medication, splints for her arm and wrist, and physical therapy. Tsai restricted McKay's work by limiting the amount of weight she could lift and requiring that she not use vibrating tools.

Over the next year, McKay continued to work for Toyota as often as she was able in a variety of positions. She continued to be treated by a number of physicians and physical therapists, all who restricted her from performing work using vibratory tools and limited the amount of weight she could lift.

McKay claimed that, although she requested employment in several vacant light or medium duty positions, Toyota declined her requests. She also claimed that Toyota refused to provide her with work conforming to the restrictions placed upon the use of her hands and arms.

On the other hand, Toyota claimed that it made a considerable, ongoing effort to accommodate McKay. This effort included:

- granting her a medical leave of absence;

- placing her in modified light duty jobs;

- placing her in two rehabilitative work conditioning programs;

- referring her to Toyota's job placement committee;

- extending her initial evaluation period because of her medical leave of absence;

- providing her with several work reintroduction periods; and

- approving her transfer to the job of her choice.

However, Toyota terminated McKay in June 1993, citing excessive absences from work as the cause. McKay filed a lawsuit in December 1993, alleging that her employment was terminated in violation

One company's explanation: it tried to accommodate

Carpal tunnel syndrome doesn't count as a major disability

of the ADA, the Kentucky Equal Opportunities Act, and the Kentucky Civil Rights Act.

Toyota argued that McKay was not a "qualified individual with a disability" because she did not have a physical or mental impairment which substantially limited one or more major life activities.

McKay argued that she is a "qualified individual" because she is substantially limited in the major life activities of "working" and "caring for oneself."

In support of her argument that she was substantially limited in the major life activity of working, McKay relied on the testimony of two orthopedic surgeons—including Tsai—and a vocational expert, Dr. Ralph Martin Crystal. According to McKay, Tsai's testimony supported her claim because:

- he diagnosed her with carpal tunnel syndrome;

- he determined that she has a 10 percent disability in the right arm and a 6 percent permanent impairment to her body as a whole: and

- he placed McKay under work restrictions following her injury.

McKay also cited Crystal's statement that she "would be someone who would be considered to have a disability under the ADA." McKay also relied on the statement of Crystal that she was "perceived as impaired." However, Crystal was unable to support this statement.

McKay herself admitted that her condition did not substantially limit her ability to perform personal hygiene tasks or most household functions. The only household function McKay claimed to be substantially limited in was mopping. The court rejected this claim soundly: "Merely being limited in the ability to perform housework such as mopping does not constitute a substantial limitation in the ability to care for oneself."

The trial court exercised broad discretion in considering McKay's claims. And the ADA allows this. The Act provides that when a court is determining

whether an impairment substantially limits a major life activity, it should consider the following factors:

- the nature and severity of the impairment;

- the duration or expected duration of the impairment; and

- the permanent or long-term impact, the expected permanent or long-term impact, or the expected permanent or long-term impact of or resulting from the impairment.

Furthermore, the ADA allows a court to consider the following additional factors:

- the geographical area to which the individual has reasonable access;

- the job from which the individual has been disqualified because of an impairment, and the number and types of jobs utilizing similar training, knowledge, skills or abilities, within that geographic area, from which the individual is also disqualified because of the impairment (class of jobs); and/or

- the job from which the individual has been disqualified because of an impairment, and the number and types of other jobs not utilizing similar training, knowledge, skills or abilities, within that geographic area, from which the individual is also disqualified because of the impairment (broad range of jobs in various classes).

The court concluded that McKay had not established that she was significantly restricted in her ability to perform a class or range of jobs as compared to similarly situated persons with comparable training, skills and abilities. Therefore, she was not substantially limited in the major life activity of working.

"At the time of her termination from Toyota, McKay was a 24 year old college graduate, working on earning her teaching certificate," it wrote. "Given her educational background and age, she is quali-

fied for numerous positions not utilizing the skills she learned as an automobile assembler. Merely because she can no longer perform repetitive factory work does not render her significantly limited under the ADA."

It issued a summary judgment in favor of Toyota, dismissing McKay's claims.

A few conditions are excluded

In drafting the ADA, Congress did list a number of conditions that are excluded from the law's protections. These include psycho-sexual disorders such as pedophilia, exhibitionism and voyeurism. Certain other psychological disorders are also excluded from protection, including compulsive gambling, kleptomania and pyromania.

On the other hand, allergies are covered as disabilities under ADA. And in 1994, a federal court ruled that obesity could be considered a disability under the law.

The definition of who's covered by ADA includes people with a substantially limited ability to work. The employment section of the law prohibits you from using this substantially limited ability as a basis for not hiring someone to work for you. That's circular logic at best, an anti-employer bias at worst. In either case, it's shaky law—individual lawsuits will have to iron out the wrinkles over time.

Once you've identified workers covered by ADA, you have to make reasonable accommodations for their disabilities. This carries you directly into the second complicated definition.

The law says that "reasonable accommodation may include:

> ...making existing facilities used by employees readily accessible to and usable by individuals with disabilities; and

> ...job restructuring, part-time or modified work schedules, reassignment to a vacant position,

acquisition or modification of equipment or devices, appropriate adjustment or modifications of examinations, training materials or policies, the provision of qualified readers or interpreters, and other similar accommodations for individuals with disabilities."

If you've ever signed a contract, you'll recognize the phrase "may include" as trouble. And the trouble continues throughout the passage.

The law doesn't actually define reasonable accommodation. It merely begins a list of examples and invites courts to add their thoughts. EEOC annotations don't make any progress toward a definition that has any deductive value. They just give more examples to illustrate the law's examples.

The EEOC interpretive guidelines say: "The reasonable accommodation requirement is best understood as a means by which barriers to the equal employment opportunity of an individual with a disability are removed or alleviated." That's as close as officialdom has come to a conceptual definition. The guidelines then go on to give another incomplete illustrative list of examples.

Not only are these definitions lists—they're inexact ones. They mix very general responses (job restructuring...modified work schedules) with very specific (providing interpreters).

Faulty Assumptions

As you can conclude from the list of accommodations that the definition includes, the ADA anticipates that fairly straightforward physical disabilities would generate the bulk of claims. The specific corrective measures mentioned in the definition— "equipment or devices [and] training materials"—all address easily identified physical handicaps.

But, as the complaint numbers from the enforcement section show, a large number of ADA claims stem from mental and emotional disabilities. ADA cases nationwide have included claims based on

The employer's tool: a claim of undue hardship

such inexact disabilities as Post Traumatic Stress Disorder and alcoholic tendencies.

As the cases throughout this chapter show, a large number of ADA claims also involve so-called "soft-tissue disabilities" like carpal tunnel syndrome that defy easy identification. The corrective measures that address these kinds of disability might include juggling schedules and modifying policies.

Once again, the list is illustrative—not complete. Angry employees or former employees can suggest new accommodations not mentioned in the law. You'll have to convince the EEOC or a federal judge that the suggestions aren't reasonable.

Since the definition of what's reasonable is so open-ended, proving something's not reasonable becomes difficult.

Finally, the ADA says that an employee cannot demand accommodation if it creates an "undue hardship" on the employer. It states:

> The term "undue hardship" means an action requiring significant difficulty or expense...

> ...In determining whether an accommodation would impose an undue hardship on [an employer], factors to be considered include:

> ...the nature and cost of the accommodation...

> ...the overall financial resources of the [employer] involved in the provision of the reasonable accommodation; the number of persons employed [by the employer]; the effect on expenses and resources, or the impact otherwise of such accommodation...

> ...the type of operation or operations of the [employer], including the composition, structure and functions of the workplace...the geographic separateness, administrative, or fiscal relationship of the facility...in question to the [employer].

Again, this is more a description of undue hardship than a definition that could be useful in a specific lawsuit. The EEOC's definition goes a little

farther, including anything "unduly costly or disruptive" to an employer's on-going business. Whether a particular change causes undue hardship will ultimately be tested in court cases.

"Until some of these cases get through to the Supreme Court, we will have different verdicts for similar situations," one North Carolina-based attorney told a local newspaper. He went on to say that most of the claims he'd handled concerned substance abuse. Otherwise, "We are seeing a lot of people claiming mental disability as a reason for disciplinary problems in the workplace."

The vague definitions in the ADA create a number of hazy conflicts with other workplace laws.

Collective bargaining agreements present one such trouble spot. If a disabled employee is not reasonably accommodated when asking for a job modification, he or she can file a complaint. But if the requested accommodation bumps—or otherwise affects—a person with more seniority, that person can charge the employer with an unfair labor practice.

"That's a question of greater rights that I'd just as soon have no part of," says one Ohio-based labor attorney. "It would depend what kind of union you're dealing with. Some of the higher-skill craft guilds have a real hard time with workplace anti-discrimination laws. They see [the laws] as something that undermines their franchise."

The ADA itself defers to collective bargaining agreements on several points, one of which is the definition of the "essential functions" of a particular job. This suggests that the law might defer to union deals in other contexts, too.

Perceived disability

The ADA's workplace coverage also extends to problems that are "perceived as disabling" and people "regarded as having...an impairment" but in reality do not. People who don't have a disability but who are discriminated against because of

Drug and alcohol abuse pose a major ADA problem

something like a facial birthmark or a burn scar can file an ADA complaint with the EEOC.

The ADA explains this issue with more clarity than usual:

> Is regarded as having an impairment means:
>
> 1) does not substantially limit major life activities but is treated by [an employer] as constituting such limitation;
>
> 2) Has a physical or mental impairment that substantially limits major life activities only as a result of attitudes of others toward such impairment; or
>
> 3) Has none of the impairments defined [previously] but is treated by [an employer] as having a substantially limiting impairment.

But notice that this is still a list of examples. The reason it's more clear than other lists is that the language implies these are the only three situations in which perceived disability occurs.

You should also note that this section of the law specifically regulates the "attitudes of others." So, a protected disability may not actually be a disability at all. It may just be something people mistakenly think is a disability.

For example, a Texas-based beverage company refused to hire an experienced salesman because he had some facial nerve damage that had been caused by an ear operation. The man didn't actually suffer any impairment, but a casual observer might think that he did. The salesman's complaint was still with the EEOC in early 1995.

The ADA also applies to situations in which an employer discriminates against someone related or married to a disabled person. In this model, any action you take on the assumption that an employee or job applicant would be hindered because of care responsibilities or other ties can be challenged just as if it were directed at the disabled person.

Drug and alcohol use

Illegal drugs and alcohol present complicated compliance problems under ADA. People currently using illegal drugs aren't protected. People using doctor-prescribed drugs are. So are recovering alcoholics or drug addicts not currently using.

Drinking alcoholics pose the real complication here. The law is—not surprisingly—vague and possibly contradictory. Certain sections say that a drinking alcoholic doesn't have ADA protection. Other sections imply a drinking alcoholic may be covered, as long as his or her job performance isn't affected.

If you can document that drinking has affected an employee's performance—and if that employee doesn't acknowledge the problem—you can terminate with some certainty. You can hold an alcoholic or drug addict to the same performance standards that apply to other employees. And the ADA does allow you to test for illicit drugs and alcohol, as long as these tests are administered consistently and in compliance with other workplace and privacy laws.[1]

The caveat: The employee may later admit an alcohol problem and try to lodge a complaint against you. But the ADA is fairly clear about the need to self-identify.

Workers who volunteer—the legal term is "self-identify"—that they have an alcohol problem are protected by the ADA. Even if they have received some discipline and are on tract toward termination, they'll be protected by ADA if they admit a problem and ask for help.

You have to be careful about approaching an employee that you think has a drug or alcohol problem. If you encourage the person to seek help, he or she might sue you, claiming your comments were a negative response based on a perceived disability.

You can request that, in return for being granted leave to get help, an employee signs a return-to-

If employees "self-identify," they can claim ADA protection

[1] We considered *Burch v. Coca Cola Co.*, a useful example of ADA application to alcoholics, at page 8 of the Introduction.

A doctor with a serious drug problem claims ADA violation

work agreement outlining certain goals upon his or her return—passing an alcohol or drug test or proof of attendance at AA meetings. This kind of agreement can explicitly say that the employee will be terminated if he or she fails to follow the outline.

The 1995 Colorado case *State Board of Medical Examiners v. Roger Woods Davis* took place in state court, but it cited the ADA and brings up a couple of interesting points about drug use in connection with a job.

Davis, a physician, first became addicted to drugs in the late 1960s during his medical residency. Having trouble sleeping, he began taking the barbituate sodium pentothal, which he easily obtained from an anesthesia preparation room. He continued using the drug on a regular basis for nearly three years until co-workers discovered him. He was taken by police to another hospital and detoxified.

After two subsequent hospitalizations for depression, Davis resigned his residency and moved to Utah to start a private practice. Although his trouble sleeping continued, he didn't seek medical treatment. Instead, he used tranquilizers, antihistamines, and muscle relaxants.

Personal problems get worse

In 1975, Davis started to use the narcotic Demerol—allegedly to solve his sleep problems. In March 1975, after learning that he had been reported to the Utah medical licensing authority, he took an accidental overdose of Valium, Benadryl, and morphine, and was hospitalized again.

The Utah medical board, learning that Davis was still using drugs illegally, placed his license on probation for a minimum of five years conditioned on monthly psychiatrist visits and random urine screening for narcotics.

Four years later, the Utah board revoked Davis's medical license after finding that respondent had

improperly prescribed Demerol for himself, had intercepted Demerol intended for patient use and had stolen sodium pentothal from a hospital operating room. This revocation was later reconsidered to allow Davis to perform limited functions.

In 1984, with the understanding that Davis had improperly and excessively used sodium pentothal, barbiturates, and Demerol, the Colorado Board of Medical Examiners granted him a three-year probationary license. He successfully completed this probationary period.

As part of his rehabilitative and pain management practice, Davis performed cryoanalgesia, a procedure which freezes nerves with liquid nitrogen. He learned this technique by reviewing articles and manufacturers' videotapes. In an information sheet prepared for distribution to patients, however, he professed to have learned the procedure at the Mayo Clinic in Rochester, Minnesota.

During cryoanalgesic procedures, Davis administered intramuscular injections of Demerol to his patients. He obtained the Demerol from a hospital pharmacy and kept it in a locked drawer in his office desk.

Early in January 1991, Davis began using Demerol again. By keeping inadequate records of the Demerol used on patients, he diverted enough of the drug that, by the third week of February 1991, he was injecting himself daily.

Colorado Springs police detectives first contacted Davis in February 1991, in connection with an investigation into excessive prescriptions of Ritalin obtained by one of his patients. When they questioned the large volume of Demerol prescriptions in his pharmacy records, Davis denied using it himself.

In February 1991, Davis asked a patient to help him get some Demerol, allegedly to replace some that was missing from his office. He later instructed the patient to retrieve some Demerol prescriptions from his home mailbox which he indicated would be split between the patient and himself. The pa-

Court rules that current, illegal use doesn't fall under ADA

tient, accompanied by police officers, filled the prescriptions and placed Davis's portion of the Demerol in his mailbox. Davis was then arrested.

About the same time as the mailbox incident, Davis entered an inpatient drug treatment program. While in a subsequent outpatient program, Davis continued to use Demerol on several occasions. After detailed charges were filed against him by the Colorado medical board, he entered an inpatient recovery program in Georgia designed specifically to treat health care professionals.

An administrative law judge concluded that Davis had engaged in acts of unprofessional conduct in violation of the Colorado Medical Practice Act. After oral argument before a hearings panel, the Colorado board revoked Davis's medical license. Davis appealed the order.

Although Davis didn't dispute that he suffered from a chemical addiction problem, he argued that his chemical dependency qualified as a disability under the ADA. He maintained that he was not using drugs illegally at the time of the Colorado board's hearing about his license. Thus, he claimed protection of the ADA because of his status as an addict in recovery.

The Colorado Court of Appeals didn't see it that way. It ruled:

> Addiction is a disability according to the ADA; consequently, the ADA may provide protection to addicted individuals. This protection, however, does not extend to an individual who is currently engaging in the illegal use of drugs, including narcotics, regardless of the user's state of addiction to the drugs.

> Current illegal use of drugs includes uses that occurred recently enough to justify a reasonable belief that a person's drug use is current or that continuing use is a real and ongoing problem.

> Contrary to Davis's contentions, under the ADA, there need not be actual illegal use of drugs at

the time of the disciplinary hearing or other employment-related action in order to find that an individual does not qualify as a person with a disability because of a current illegal use of drugs.

The court concluded that Davis's history of recurrent illegal drug use, the risks of relapse, and his relatively short period of recovery supported the medical board's finding that "continuing [drug] use is a real and ongoing problem." The revocation was upheld.

ADA and AIDS

The employment section of the ADA makes no specific mention of whether AIDS—or any other communicable disease—counts as a qualified disability. The EEOC makes a special point to stress that ADA does extend its protections to people with AIDS or the related Human Immuno-Deficiency Virus, commonly called HIV. It bases this argument on the legislative history of the law, which does include mention of AIDS as a disability.

The fact that the EEOC extends ADA employment anti-discrimination protections to people with AIDS poses one of the law's most difficult and politically-sensitive compliance problems.

The law does explicitly state that you can require that an employee not pose a direct threat to the health of others. It defines "direct threat" as:

> a significant risk of substantial harm to the health or safety of...others that cannot be eliminated or reduced by reasonable accommodation. The determination that an individual poses a "direct threat" shall be based on an individualized assessment of the individual's present ability to safely perform the essential functions of the job. This assessment shall be based on a reasonable medical judgment that relies on the most current medical knowledge and/or the best available objective evidence.

Courts around the country agree that public re-

**Risk
assessment
becomes a
key part
of compliance**

sponse to AIDS tends to be exaggerated and should be contained as a matter of public policy.

As one state court said in a late 1980s lawsuit involving AIDS in the workplace: "AIDS is the modern day equivalent of leprosy. AIDS, or a suspicion of AIDS, can lead to discrimination in employment, education, housing and even medical treatment."

The World Health Organization expects 15 million new adult HIV infections by the year 2000. Two-thirds of large businesses and one-fifth of small ones employ people with AIDS. The younger your employees, the more likely you are to experience some sort of AIDS issue—people between the ages of 25 and 44 account for three-fourths of all AIDS cases.

If your inclination is to think that an employee with AIDS would pose a direct threat to co-workers, you're not alone. Quite a few employers and business groups feel that AIDS should not be an ADA protected disability. As many as half of the ADA lawsuits in the first three years of the law involve AIDS and employment.

The only legal way to prohibit a person with AIDS from your workplace is to prove that the disease poses a direct threat to others or interferes with essential job functions.

In determining whether an individual would pose a direct threat, the law says that the factors you can consider include:

1) The duration of the risk;

2) The nature and severity of the potential harm;

3) The likelihood that potential harm will occur; and

4) The imminence of the potential harm.

But, EEOC guidelines hold that:

An employer...is not permitted to deny an employment opportunity to an individual with a

disability merely because of a slightly increased risk. The risk can only be considered when it poses a significant risk, i.e., high probability of substantial harm; a speculative or remote risk is insufficient.

Either the EEOC or a court will have to agree with your assessment in order to allow a prohibition. In most cases, this agreement is difficult to gain. The best available medical evidence shows that the virus cannot be transmitted through normal workplace contact.

The ADA makes a pointed effort—and rightly so—to separate AIDS protection from issues of sexuality or sexual orientation. Though it doesn't explicitly mention AIDS in the employment section, the law does include the following language:

> Disability does not include...transvestism, transsexualism...gender identity disorders not resulting from physical impairments, or other sexual behavior disorders....

> Homosexuality and bisexuality are not impairments and so are not disabilities....

"The politicians were so afraid of the fact they were including AIDS as a protected disability that they went to great lengths to exclude any sexual deviancies they could think of," says a former congressional staff member involved in the ADA's passage.

The ADA imposes standards which you must observe when interviewing, employing or discharging a person with HIV or AIDS. As with any other disability, you have to consider the individual's current ability, not the effect of the disease on future ability. And you have to provide reasonable accommodation to employees with HIV infection and AIDS to enable them to perform their jobs.

Reasonable accommodation also may include reducing an employee's travel requirements, or allowing the employee to work at home.

You can't base decisions on the future stages of AIDS

57

One of the biggest AIDS lawsuits under ADA

Pay attention to group benefits

The ADA/AIDS issue that's surfaced most often is insurance or other benefits being denied to employees with the disease.

For example, a class-action case against Pennsylvania-based Allied Services Division involved an attempt to limit health insurance coverage to $5,000 for those with AIDS. The company backed down and restored the coverage.

The ADA requires benefits offered to disabled employees to meet specific standards. A group health plan may apply uniform limits on benefits if the plan does not target individuals with specific disabilities.

But your group health plan can legally implement measures to control costs for HIV infection and AIDS. For example, active management of an employee's case to determine the most efficient course of treatment may decrease cost. Most HMO and PPO programs offer this kind of management.

Because there's so much confusion about the health risks posed by people with AIDS or HIV, a good ADA compliance plan should address how your company handles AIDS-related employment issues. You should stress that you don't tolerate discrimination against any protected disability—including AIDS.

The 1995 federal case *RGH v. Abbott Laboratories* dealt with the harsh mix of AIDS and the ADA. RGH—public documents only used the man's initials—was hired by Abbott in August 1983, as a scientific technician in the company's Chemical Agriculture Products Division.

In September 1984, he transferred to the bio-safety suite in the Abbott Diagnostics Division as a technician adviser, where he began working with the Human Immunodeficiency Virus. Eight months later, in May 1985, he was involved in an HIV exposure accident.

RGH provided a blood sample the day of the exposure and nine days later. He also provided a blood

sample prior to transferring to the bio-safety suite. After the accident Abbott's Director of Corporate Employee Health and Bio-Safety Officer informed RGH that he had tested positive for HIV on all three samples.

After learning of his HIV status, RGH transferred at his own request to another department where he remained until a June 1989 reorganization. Before his transfer, RGH's employment history was characterized by several "commendable" evaluations by his supervisors and included several promotions.

Effects of a reorganization

Shortly before a corporate reorganization in 1989, RGH asked to be considered for a tissue culture manager position soon to be vacated. Although otherwise qualified for the position, RGH was not considered because he was not a medical doctor or Ph.D.

Following the reorganization in June 1989, RGH was transferred to another research group but continued to do the same work he had been doing for several years. In October 1989, RGH asked to be transferred, as other employees were doing. However, his supervisor said that since RGH was the only person working on his particular project, he could not transfer.

In March 1990, RGH received a performance evaluation with an "S" rating, signed by his immediate supervisor and the division manager. The evaluation noted performance deficiencies including:

- that, at his grade level, RGH should work more independently;

- that he needed to improve his attention to detail; and

- that he was not sufficiently productive.

Two months later, in May 1990, RGH asked to be considered for his immediate supervisor's position, which was about to become available. The divi-

sion manager did not consider RGH for the position.

In August 1990, RGH received a memorandum informing him that his work in the fermentation group was unsatisfactory due to "incomplete redbook documentation and incomplete adherence to experimental protocols." (The "redbook" is a book in which Abbott scientists document tasks that need to be accomplished in each experiment or fermentation.)

Subsequently, he was placed on a three-week remedial plan. RGH did not receive a salary increase in September of 1990—the month after he was placed on the remedial plan. The division manager told RGH that the failure to grant a pay increase stemmed from RGH's unsatisfactory performance as noted in the August three-week remedial plan.

In early 1991, RGH spoke with another division manager about a transfer. That manager told RGH that he could not transfer an employee with RGH's performance evaluation rating to another department. During that conversation, RGH told the other manager that he was infected with HIV and that he could not handle the stress level in his current position.

The other division manager indicated that RGH would have to remain where he was until he proved himself.

In March 1991, RGH received a performance evaluation with a rating of "S minus" from his new supervisor and another manager—both of whom were unaware of RGH's HIV status at the time. The evaluation noted several performance deficiencies.

Specifically, the evaluation noted "RGH's difficulty completing tasks in a timely manner; his need to substantially decrease his error rate; his disregard for critical detail; his need to improve organization, uses of attitude and documentation; and minor improvements in his redbook."

On the initial draft of the evaluation, RGH had

received a rating of "S" (satisfactory, the middle of five ratings—sufficient performance for continued employment and the lowest sufficient for promotion). There were also other discrepancies between the draft and the final version of the evaluation. For example, the initial draft noted that RGH's redbook documentation had "improved," while the final evaluation noted only a "minor improvement." Also, the comment "needs to improve his attitude" was added to the final evaluation in its "Areas for Improvement" section.

Difficult performance reviews

In July 1991, RGH received a performance update from his division manager which noted several performance problems. Subsequently, in December of 1991, after the unsatisfactory completion of the plan, RGH was demoted. He was also transferred to a different division.

In July 1992, RGH met with his new supervisor to discuss performance deficiencies. He did not receive a salary increase that year. In December, he interviewed for the position of Clinical Research Associate. In February 1993, the company informed him that he was not selected for the position because of his "demonstrated inability to work independently."

In May 1993, at his request, RGH was granted an extended medical leave of absence. A month later, he filed a complaint with the EEOC. After obtaining a right-to-sue letter in July 1993, RGH filed a lawsuit against Abbott. He was fired a short time later.

In his lawsuit, RGH made several charges, including that:

- Abbott engaged in unlawful employment practices in violation of the ADA by discriminating against him because of his HIV status;

- at least one person promoted instead of him did not have any supervisory experience or as much education as RGH had;

Retroactivity is important if allegations pre-date 1992

- while some of the deficiencies noted in his reviews were true, others were not;

- Abbott deliberately lowered his rating to create the impression that his performance was worse than it actually was during the rating period;

- his failure to receive several pay increases was not due to his performance but due to his medical condition; and

- his HIV status was the reason he was not selected for supervisory positions.

RGH did not allege that he'd acquired the virus as a result of the May 1985 accident. Instead, he argued that the accident was the reason that his supervisors knew about his condition.

In a series of affidavits, at least three of his supervisors said that they had no knowledge of RGH's HIV status. Without offering evidence to the contrary, RGH disputed their claims, arguing that "virtually all" of his supervisors knew about his HIV status.

RGH did not discuss the incongruity between his claim that he was discriminated against on the basis of his HIV status and the fact that he was promoted after his HIV status was known to Abbott. The trial court stated that "It seems unlikely that Abbott would choose to effectuate its discriminatory animus by first promoting RGH and then later engaging in discriminatory conduct."

Many of RGH's allegations of discriminatory conduct involved conduct that predated the ADA. The appeals court concluded that ADA could not be applied retroactively. It wrote:

> There can be little doubt that the ADA dramatically altered the substantive rights of employers and employees by creating new liabilities and imposing new duties—rather than merely affecting procedural or remedial aspects of existing rights....Moreover, the legislative history of the ADA is absolutely devoid of language that would support the retroactive application of the Act.

The court also noted that, although the ADA had been enacted in July 1990, Congress had delayed the effective date of Title I—which deals with employment—for twenty-four months. As stated by President Bush in enacting the ADA, "The phase-in periods and effective dates will permit adequate time for businesses to become acquainted with the ADA's requirements and to take the necessary steps to achieve compliance."

Regardless of the retroactivity of the law, RGH's burden was to prove that he'd been discriminated against on the basis of his disability. To do so, he could either present direct or circumstantial evidence of disability discrimination or employ an indirect method of proof. In order to make the indirect case—known legally as a "prima facie" case—he had to show that:

- he was within the protected class;
- he was meeting the legitimate expectations of his employer;
- he suffered an adverse employment action; and
- employees not in the protected class were treated more favorably.

The court allowed that RGH had established a prime facie claim—but it concluded that Abbott's explanation for its actions was credible.

As one instance of discriminatory treatment, RGH cited Abbott's failure to hire him for the Clinical Research Associate position in January 1993. An Abbott manager said that "the decision not to select RGH for the position was based on RGH's demonstrated past inability to work independently, as reflected in his performance history."

More significantly, all of the managers involved in the decision testified that they had no knowledge of RGH's medical condition at the time they decided not to select him for the Clinical Research Associate position.

RGH offered no evidence that the supervisors making this decision were aware of his medical

An inference based on assumptions doesn't hold up well

The heavy burden of proving pretext

condition. Instead, he suggested an inference based on the following assumptions:

- managers of the departments in which RGH worked had access to his personnel file which contained references to RGH's exposure incident;

- RGH's supervisors were given a notice that he should not be exposed to infectious agents; and

- rumors regarding RGH's HIV status had been spread at Abbott.

RGH also claimed that Abbott's failure to give him a salary increase in August 1992 was a discriminatory action. The court rejected that claim, too. "Abbott contends that RGH's deficient performance constitutes a legitimate nondiscriminatory justification for failing to grant RGH a pay raise and that RGH has failed to raise a genuine issue as to whether this justification is a pretext for discrimination," it ruled.

Even if RGH had established that his supervisors knew about his HIV status—which he didn't—the court pointed out that:

> ...knowledge of a plaintiff's disability alone cannot be the basis of inferring discriminatory action....In the absence of any probative evidence supporting the inference that [his supervisors] knew of RGH's medical condition, a fact finder could not reasonably conclude that their decision to not hire RGH was motivated by a discriminatory intent. For the foregoing reasons, the Court finds that Abbott's failure to select RGH for the CRA position cannot sustain his discrimination claim.

The mere fact that initial drafts of RGH's performance evaluations had been subject to revision before being finalized could not support an inference of discriminatory intent. The Court ruled that RGH had not raised a genuine issue as to whether Abbott's nondiscriminatory justification for not raising his pay—namely, unsatisfactory performance—was a pretext for discrimination.

"Although the Court sympathizes with RGH's most difficult circumstances, there is insufficient evidence to raise a genuine issue of material fact as to his claims of disability discrimination," it concluded.

Legal issue: ADA and mental health

The ADA clearly includes mental illness in its definition of disability. But, because mental illness often defies objective diagnosis or treatment, complying with the law in this regard may be the most difficult of all legal issues.

Mental health experts generally argue that the ADA protects people whose mental illness can be treated but who may be unfairly stigmatized. They feel it's right that an employer should look at the "skills of a worker and not their disabling condition."

But the mental health language in the law has lead to some intractable disputes. Providing a ramp for someone in a wheelchair is easy to understand; accommodating the mentally ill is not. Reasonable accommodations can include everything from providing private offices for entry-level clerical workers to tolerating undeniably offensive behavior in employees who deal with clients.

In 1993, Hamden, Connecticut, School Superintendent David Shaw was arrested and pleaded guilty to drunken driving. After newspapers reported that at the time of his arrest Shaw had been wearing women's clothing, he disappeared for 10 days. When he returned, the school board had changed the locks on his office and refused to give him a new key. He filed complaints at the EEOC, accusing the board of discrimination because of his mental disorder—alcoholism.

The charges didn't proceed very far. Shaw dropped them after the school board agreed to pay him a partial salary for three years plus lifetime medical and life insurance benefits if he would resign. The board agreed to the settlement partly out of fear that it might lose a lawsuit under the ADA.

Mental disabilities defy objective diagnosis

A common mental disability claim: bipolar disorder

"Even though there was public sentiment that you don't want a superintendent acting in this manner, termination would have been difficult because of the ADA," said Jeffrey Pingpank, an attorney for the Hamden school board.

Surely, some people attach an unfair stigma to mental disorders. And many people inaccurately link these disorders with violent behavior. But the ADA's constraints in this context are onerous.

In general, the ADA simultaneously limits the tools you can use to respond to certain problematic employees and expands the potential liabilities these same employees pose. In mental health cases, the lack of firm rules makes this bad situation even worse.

"Whatever you do to comply with ADA, you have to do three-fold in mental illness cases," says one Washington, D.C.-based employee benefits specialist. "And I'm not sure that's always possible. In the mental illness cases I've seen—and I'm talking about real problems, not just stress—the employer usually has no choice but to pay the disabled employee to go away."

The first lawsuit involving the ADA's mental disorder protections went to trial in Oklahoma in June 1994. It involved a public school district employee.

Speech pathologist Vicki Perryman was fired by the Pauls Valley Public School District after her supervisors learned that she did not have ovarian cancer, as she had claimed, but a mental disorder.

Perryman suffered from bipolar disorder—an extreme form of manic depression. Her mental problems began in early 1993, when she began to believe that she had ovarian cancer. Though not physically ill, she convinced her parents, co-workers and friends that she was suffering from the disease.

Though she was institutionalized briefly, Perryman never showed any violent tendencies. She was released from the psychiatric facility and told by

psychiatrists that she was fit to return to work, as long as she followed a lithium therapy they prescribed.

The school district demanded that she turn over her medical records to prove she was fit for work. On the advice of her lawyer, she refused but did provide two letters from psychiatrists who treated her. Both said she could return to work and wasn't a danger to herself or anyone else.

The school district decided to fire Perryman anyway. One official said, "When you've got a teacher handling children, it's our duty to make sure that the teacher is able and not posing a danger."

The school district's attorney said he would try to establish at the trial that schools are different from other workplaces because children are more vulnerable. And he acknowledged that including mental illness as a protected status presents a perplexing problem for any employer: "If mental illness is to be treated just like someone in a wheelchair, what kind of accommodations must be made? How do you protect other workers...or students?"

The case was still pending a year later.

ADA and ADD

Without much doubt, the worst extreme of the ADA's awkward handling of mental disabilities is its coverage of Attention Deficit Disorder.

ADD is the prototype of the sort of mental illnesses psychiatrists call "non-severe." These disorders are defined by vague criteria, impossible to scientifically disprove and allegedly afflicting vast numbers of sufferers.

The American Psychiatric Association's diagnostic manual admits there are "no laboratory tests that have been established as diagnostic" for ADD. In lieu of a scientific definition, psychiatric journals follow the model of the ADA and offer noncomprehensive lists of examples. Among other objectionable things, people with ADD:

**Experts don't
agree on how
many people
suffer from
ADD**

- get into power struggles, which they prefer to negotiation;
- show bad judgment;
- act impulsively;
- talk excessively;
- become irritable when interrupted or forced to make changes;
- procrastinate;
- are disorganized;
- are forgetful;
- are easily distracted;
- don't like to go through established channels;
- don't respect set procedure;
- start projects with a flourish and then abandon them.

The definition doesn't suggest any causal link between the ailment and the symptoms.

ADD is vaguely defined, even for a psychiatric disorder. It seems to occur more often in children—but a growing number of experts say that it occurs in adults more often that anyone realized. Estimates of its incidence typically range from one to five percent of the population. A brochure distributed by the ADA Information Center claims that ADD affects "3 percent to 10 percent" of the population.

It's typical of the biases in ADA that the law doesn't let an employer claim a direct threat unless a disability "poses a significant risk" of harm to others—but allows a "non-severe" impairment to count as a disability.

Truth told, there's little objective evidence that most people diagnosed with ADD have a medical or biologically-based condition. But people who've been diagnosed with ADD may qualify for lengthy extensions of testing periods in tests.

People with ADD also have ADA protection if they are diagnosed with the condition and let their

employers know about it. This translates into an ugly paradigm: A problematic employee finds a psychiatrist willing to diagnose ADD, notifies you of the condition and then demands that you accommodate inappropriate or unprofessional behavior.

What can you do?

First, thoroughly document the behavior of any employee who self-identifies ADD. Scientifically, the ADD claimant's case will always be a little weak—the ADA allows that. You have to counter with strong substantiation. If you can show that the symptomatic behavior caused business losses, you've got the beginning of an ADA defense.

Second, make only the most reasonable of reasonable accommodations. The President's Committee on Employment of People with Disabilities (which reported an average of one to two ADD calls a day in early 1995) suggests the following ADD accommodations:

- providing tape recorders for audio memos;
- playing white noise to cover distracting conversations;
- moving the employee away from high-traffic areas;
- repeating and simplifying instructions;
- color-coding task files; and
- offering memory aids, such as personal assistant devices, alarm clocks, flow-charts, stick-on notes and cue cards.

As a rule of thumb, you should accommodate passive ADD symptoms—like forgetfulness and organizational problems. You don't necessarily have to accommodate active symptoms—like unprofessional behavior and insubordination.

Just be sure you can show that these active symptoms directly caused some sort of hardship—a lost account, a staff defection, a jeopardized contract. If the ADD-suffering employee files a complaint, hire an attorney who can argue this hardship was undue.

The key to ADD solution: document unprofessional behavior

ADA prohibits discrimination based on genetic tendencies

Until the courts refine the ADA's coverage of ADD or the psychiatric trade refines the definition of the disease, Attention Deficit Disorder will remain the nightmare of ADA compliance.

Genetic testing

In March 1995, the EEOC issued a special policy which held—in part—that the ADA forbids an employer from basing personnel decisions on a worker's genetic predisposition toward disease. The policy was included in a long document expanding new definitions of certain disabilities. It was circulated without any public announcement.

It's understandable that the EEOC didn't want to publicize this ruling. It constituted yet one more EEOC interpretive double-standard that worked in favor of employees. If an employee would enjoy a greater benefit by identifying a dormant disability—as in the case of a recovering drug addict—the agency ruled that the ADA supported disclosure. If an employee would enjoy a greater benefit by not identifying a dormant disability—as in the case of someone with a genetic tendency toward cancer—then it prohibited disclosure.

The problem with the ADA is that allows—and even invites—this kind of contradictory analysis.

"People are very fearful of going in for genetic screens" because they worry the test results could end up in the hands of their bosses, EEOC commissioner Paul Steven Miller said at the time that the guideline was announced. And, because people feared the tests, he insisted that "[genetic testing] is an area we felt falls squarely within the ADA."

Many patients are reluctant to undergo such tests because of fear that the results will be used against them. The EEOC worried that bad news on genetic tests might persuade a employer to hire someone else—or fire a disability-prone employee preemptively to avoid lost work days or higher health insurance premiums.

And this guideline would only apply to employers. Because the EEOC based its interpretation on the

broad language in Title I of the ADA, the ban on using genetic tests only applied to employment decisions. Insurance companies, which use the tests more often then employers, could continue to do so.

Since the language of the ADA says nothing about genetic testing and potential disability, the EEOC was paving new ground with its ruling. The agency worried that its wording might be misinterpreted to suggest that, since everyone has at least a few mutant genes, everyone could be considered disabled.

This is a problem that the ADA constantly poses to federal regulators—that its language is so broad it makes the law meaningless.

Announcing its new guideline, the EEOC pointed out that, to qualify under the terms of the ADA, an employee or job applicant must show not only that he or she has a genetic defect but also that he or she has been "regarded as disabled" by an employer and discriminated against because of that perception.

If a pre-employment medical exam shows a genetic predisposition toward breast or colon cancer, you can't withdraw the job offer because you think the person might get cancer at a later date. This would constitute a perceived disability. You're treating the individual as if he or she were disabled even though there's no current problem.

For illustration, the EEOC offered a hypothetical example of genetic discrimination. You make a conditional offer of employment and then learn that the applicant has a gene that increases her risk of colon cancer. Although the woman is healthy and may never get cancer, you withdraw the offer because you're worried about future productivity and insurance costs. The woman would be protected under the ADA and could sue you for discrimination.

Summing up most business people's response to the genetic guideline, one New York-based employment lawyer said, "It used to be that plaintiffs' at-

torneys concocted these shaky extensions of the law. Now the [EEOC] does this part for them. But, no matter who advances the theory, the courts still have to decide whether or not these interpretations will stand."

Pensions and other benefits

As the *Kadinger* case that we considered earlier shows, benefits like health insurance and pension investment are likely to be a growing issue in ADA claims. (As the general population grows older, this will be true in all matters.)

The 1993 case *Kevin Holmes v. City of Aurora* dealt with the ADA and pension benefits.

At the time of the lawsuit, Holmes was a thirty-three year old police officer who had diabetes. He'd been hired by the City of Aurora Police Department in April 1985. Shortly after being hired, Holmes applied for admission into the city's Police Pension Fund.

The Fund's Board of Trustees unanimously denied Holmes' first application for membership in the Pension Fund based on the fact that he was an insulin-dependent diabetic.

In March 1988, Holmes again applied for admission into the Pension Fund and demanded a hearing in front of the Board. The Board denied this second application and refused plaintiff's request for a hearing based on its previous decision on the matter.

Holmes filed suit in Illinois state court seeking review of the Board's denial of his application. The Illinois trial court reversed the Board's decision to deny his admission to the Pension Fund. The Illinois appellate court, however, reversed the trial court's decision, holding that the trial court did not have jurisdiction to hear Holmes' case because he had failed to comply with the Illinois Administrative Review Act's 35-day filing requirement for seeking judicial review of an administrative action.

In October 1992, Holmes applied once again for

admission into the Pension Fund. This time, he based his application on the newly-enacted ADA and a new, local human rights ordinance. The Board again denied his application.

Holmes then filed a three-count complaint in federal court, alleging that in denying his 1992 application for admission into the Pension Fund, the Board and the city violated the ADA. He sought to be admitted into the Police Pension Fund or to be provided with a reasonable accommodation, allowing him to enjoy pension benefits comparable to those available to other Aurora police officers.

The Pension Fund's Board of Trustees argued that state pensions laws prevented it from rehearing Holmes' application for admission into the Pension Fund in October 1992. Therefore, the state law did not allow it to accommodate his disability under the ADA.

The Board also argued that the ADA should not apply to its refusal to admit Holmes into the Pension Fund because the ADA was not in effect in 1985—when it first denied his application.

Holmes countered that he was not seeking retroactive application of the ADA, nor was he claiming that the Board had violated his rights under the ADA when it denied his application to the Fund in 1985. What he did claim was that the Board violated the ADA when it denied his application for admission into the Pension Fund in 1992.

This court ruled that Holmes was not attempting to apply the ADA retroactively to the Board's 1985 conduct. It agreed with Holmes that the Board's denial of his 1992 application constituted an action covered by the ADA.

Looking for a useful technicality, the Board argued that it was not a "public entity" as defined in Title II of the ADA. Title II of the ADA prevents a "public entity" from excluding a "qualified individual with a disability" from participation in its services, programs, or activities. A "public entity" is defined under the ADA in relevant part as: "any State or local government; any department, agency,

special purpose district, or other instrumentality of a State or States or local government...."

The court concluded that the Board was a public entity in the context of the ADA.

A loophole for pension disputes

Finally, the Board argued that, under Section 501(c) of the ADA, it was exempt from the restrictions of the ADA based on its status as an administrator of benefit plans.

Section 501(c) establishes a limited exemption to the provisions of the ADA for insurers and for entities that administer benefit plans, provided that this exemption is not used as a subterfuge to evade the purposes of the ADA.

Holmes argued that the insurance exemption did not apply because the Board was using the exemption as a subterfuge because it was based on stereotypical notions about people with diabetes and not based on sound actuarial principles as required by the ADA.

He charged that the Board did not consider the cost or feasibility of providing him with the retirement, disability and survivors' benefits that were part of the benefits provided to non-disabled police officers.

The Board claimed that it based its decision to deny Holmes admission into the Pension Fund on numerous medical reports which stated that his medical condition presented an unreasonable risk to the viability of the fund. For this reason, it argued it was not using the insurance exemption as a subterfuge to avoid the provisions of the ADA.

The court found a factual dispute regarding whether the insurance exemption should apply in the case. For this reason, it refused the Board's request for a summary judgment dismissing Holmes' claim. It concluded its decision with an increasingly common instruction: "The parties are strongly urged to discuss the settlement of this case and report on the status thereof" within thirty days.

Legal strategies

So far, we've considered the legal issues that the ADA poses. Some of these have been pretty esoteric. Now, we'll turn our attention to the basic details of how an ADA claim works—and what you can expect if you face one.

As we've noted already, an employee or job applicant has to start by filing an ADA complaint with the EEOC. If the EEOC cannot settle a case, a plaintiff can file a private suit under the disabilities law.

A court can force a company to hire, reinstate or promote a worker and make up for any lost pay. In addition, companies may have to pay compensatory and punitive damages for acts of intentional discrimination. Those damages are limited to $50,000 if an employer has 100 or fewer workers.

A lawsuit under the ADA will usually include the following elements:

- a description of the discriminatory act;

- a link to the specific violation of the ADA, citing Title and Section;

- a suggestion of the defendants' discriminatory intent;

- a plea for damages;

- if applicable, a request for punitive damages; and

- a demand for jury trial.

In any ADA case, you and your attorneys should be prepared to face a preliminary injunction early in the proceedings. This will force you to take corrective actions—hire, rehire or promote the employee or applicant—while the trial goes on. If the employee or applicant seeks a preliminary injunction, his or her attorneys will have to identify the irreparable harm that will result if you continue your allegedly illegal behavior.

Whether or not you face a preliminary injunction, your most common answer to ADA charges will

usually include a general denial of the allegations or sufficient information to admit or deny the allegations. You can also make what's called a "common-sense" defense, if the details of the lawsuit are illogical or contradict themselves.

Then, you can also make so-called "affirmative defenses." We've already considered ADA affirmative defenses in context of how they might occur. These include:

• a direct threat to the safety of self or others,

• an undue burden on the employer's business, and

• a good faith effort to reasonably accommodate the employee.

Once the lawsuit has been filed and you've responded, the employee or applicant's attorney will start making inquiries. If you don't cooperate in providing information to these questions, the court can force you to answer. It's generally a better idea to cooperate.

Information the employee or applicant requests may include:

• the identity of potential perpetrators or witnesses to the alleged discrimination;

• the employment application and any notes or records from interviews;

• job descriptions that were in place at the time of the alleged discrimination in order to establish what you considered the essential functions of the job;

• records related to the employee's job performance like employment policies and performance reviews;

• any evidence relating to whether the employee or applicant was able to perform the essential functions of the job;

• records of conversations or written memos related to the employee's physical or mental condition;

- the identity of anyone involved in the employee's medical file or workers' comp case management;

- documents or memos related to reasonable accommodation efforts; and

- evidence of other complaints or lawsuits involving discrimination in order to attempt to establish a pattern of discrimination.

They'll ask for a lot of paperwork because they want to prove you violated your own rules.

When lawyers for the employee or applicant interview witnesses to the case, they will be looking for information relating to how other employees perceived the person making the charges—and how they perceived your response to that person.

Specific questions may include what the witness knows about:

- the employee or applicant's ability to perform the essential functions of the job;

- the employee or applicant's educational and experiential qualifications;

- the nature of the employee or applicant's disability;

- your policies and procedures regarding disability and the application of those policies and procedures;

- the employee or applicant's requests for reasonable accommodations; and

- the relationship between you and the employee or applicant as compared to your treatment of non-disabled workers.

As we've noted before, the focus on the civil rights aspect of an ADA case means the disabled person's attorneys will portray their client as an underdog overcoming obstacles with heroic determination. They'll portray you as a greedy or inconsiderate miser hoarding wealth and privilege.

You have to keep your composure—and make sure your lawyers do, too. Your opponent in an ADA case will usually be the law itself, not the person trying to use it.

A favorite tactic: prove you broke your own rules

Establish your compliance— then argue undue burden

Occasionally, you may choose to question whether a disability actually qualifies under the ADA. This doesn't usually work because the law allows so many conditions to qualify. Besides, attacking a disabled person in court may encourage sympathy for the employee or applicant.

You should be able to convince a judge or jury that you and your company are committed to encouraging diversity in the workplace. You should be able to do this by more than just talk. You should have a well-documented track record of legal compliance as well as good-faith support. This track record should include so-called "prophylactic measures," which essentially mean preventative efforts like training managers about ADA compliance and publicly stating that your company doesn't tolerate discrimination.

You, your human resources director (if you have one) and the employee's immediate supervisor should talk about reasonable accommodation attempts, the consistent application of policies and procedures and the employee's performance or applicant's qualifications. Co-workers may also serve as witnesses to the employee's ability—or inability—to perform the essential functions of the job.

Once you've established your compliance, then firmly argue your case—that the employee's demands pose an undue burden or direct threat to the safety of others.

The 1995 case *Rehnee Aikens v. Banana Republic, Inc.* offers a good example of how ADA claims work, procedurally.

One Instructive Case

Aikens suffered from a visual impairment known as macular degeneration—a progressive degeneration of the back of the retina. The condition, which was first diagnosed in the mid-1970s, had caused her vision to deteriorate to an acuity of 20/400 by the mid-1990s.

Aikens was hired by Banana Republic in August 1987 as a part-time sales associate at a store in Houston, Texas. When that location closed, Aikens was transferred to another area store.

In May 1991, the store manager promoted Aikens to the position of stockroom manager and increased her pay by fifty cents per hour. The manager erroneously classified Aikens as an assistant manager, which allowed her to receive incentive bonuses based on the store's performance.

In May 1992, a new store manager discovered that Aikens' job classification had been miscoded. Within a month, the new manager corrected Aikens' job code to reflect her true job classification. Although Aikens' job duties and responsibilities did not change after her job classification was corrected, she was no longer entitled to receive incentive bonuses or attend manager meetings.

In December 1992, Aikens gave Banana Republic notice that she would be resigning her position in two weeks. In January 1993, Aikens filed a charge of discrimination against Banana Republic with the EEOC.

In November 1993, after receiving a right-to-sue letter from the EEOC, Aikens filed a private lawsuit against Banana Republic. In the suit, she alleged discrimination under the ADA in connection with her reclassification to stock person, claiming that it was a demotion.

To recover under the ADA, Aikens had to prove that she had been discriminated against on the basis of her disability. To do so, she could either present direct or circumstantial evidence of disability discrimination or employ the indirect method of proof.

The Texas court noted that, "Although the case law is scant regarding the ADA...the few courts that have addressed claims brought under the Act have looked to Title VII and the Rehabilitation Act to provide guidance as to the elements which constitute a prima facie case of disability discrimina-

The employee needs evidence of intent to discriminate

tion.... As with discrimination cases generally, the [employee] at all times bears the ultimate burden of persuading the trier of fact that she has been the victim of illegal discrimination based on her disability."

It ruled that Aikens had not produced sufficient evidence to establish a prima facie case under the ADA. She hadn't offered any evidence to show that she was treated less favorably than other employees, was replaced by a non-disabled person, or was otherwise discriminated against due to her handicap.

Aikens' only claim of discrimination was her alleged demotion from assistant manager to stock person. In her deposition, Aikens stated that when the new store manager arrived, she informed Aikens that she had been mistakenly coded with an assistant manager's title instead of the appropriate stockroom title. When asked if she had any reason to believe that the coding was anything but a mistake, Aikens responded, "No, I do not."

Aikens conceded at trial that her job responsibilities and hourly pay did not change once the clerical mistake was discovered. She was simply no longer eligible for incentive bonuses because her classification was not that of an assistant manager, as she had no sales duties.

She didn't produce any evidence indicating that her job reclassification had been based on her visual impairment or that her classification as an assistant manager in the first instance was not simply a mistake. In fact, she admitted at deposition that she was never criticized because of her job performance and conceded that no one at Banana Republic ever indicated her job was in any danger due to her disability.

"Thus, no inference can arise that her alleged demotion was based on her disability," the court wrote.

The employer meets its burden

In addition, Banana Republic met its burden of demonstrating a legitimate non-discriminatory reason for Aikens' job reclassification. Banana Republic produced sufficient evidence, unrefuted by Aikens, that the original coding of her position as that of an assistant manager was a mistake and her subsequent reclassification was merely a correction of the prior error.

Later, she filed a supplemental complaint to add a claim of constructive discharge, in which she contends that she was forced to resign her position in December 1992 due to her demotion in June 1992.

To determine whether a constructive discharge has occurred, a court has to analyze the disputed circumstances from the standpoint of a reasonable employee. The working conditions must have been "so difficult or unpleasant that [a] reasonable person in [the employee's] shoes would have felt compelled to resign."

The Texas court ruled that Aikens had not demonstrated the requisite intolerable working conditions.

Aikens claimed that she left Banana Republic because she was under "pressure" from the store manager. However, she didn't cite any specific instance of "pressure" that made her employment intolerable. And she did admit that everyone in the store was under "pressure" from the manager and that she was not singled out as the sole recipient of the "pressure."

The specific management problem Aikens could recall was being "nitpicked" by the store manager. This "nitpicking" incident allegedly occurred when the manager performed some of Aikens' job duties of checking in part of a shipment.

The court noted sharply that "the mere fact that Aikens experienced pressure or was nitpicked does

Being "nitpicked" doesn't establish discrimination

not establish such intolerable working conditions as to give rise to a constructive discharge." It cited an appeals court ruling that held:

> Every job has its frustrations, challenges, and disappointments; these inhere in the nature of work. An employee is protected from a calculated effort to pressure him into resignation through the imposition of unreasonably harsh conditions, in excess of those faced by his co-workers. He is not, however, guaranteed a working environment free of stress.

Finally, the court made all the technical distinctions moot by finding that Aikens' claims predated the ADA. Although the law was enacted on July 26, 1990, Congress delayed its effective date as applied to private employers until July 26, 1992.

The court concluded that "applying the ADA retrospectively would completely undermine the express purpose of the grace period that was purposefully built into the Act. Accordingly, courts have uniformly construed the Act to apply only to wrongful conduct occurring after July 16, 1992."

Aikens' job had been reclassified on June 24, 1992. If any alleged violation occurred, it was more than one month prior to the ADA taking effect. Thus, Aikens' handicap discrimination claim based upon her alleged demotion was not actionable under the ADA.

Accordingly, the court granted Banana Republic's motion for summary judgment.

A last note on legal strategies: The ADA is one of the few federal statutes that in its actual statutory language encourages the use of alternative dispute resolution (ADR)—which usually means arbitration.

In drafting the ADA, congress encouraged creativity in resolving reasonable accommodation issues. One description of the resolution process even dictates that employer and employee must communicate with each other, sharing respective views of what constitutes a reasonable accommodation.

And, as we've seen before, the law encourages a "case-by-case" approach to ADA compliance.

ADA issues are therefore well-suited for private arbitration. It is almost always quicker and cheaper than litigation.

Related laws

The ADA interacts with a number of other federal workplace laws. In some cases, it supports and extends rights created for employees. In other cases, it conflicts. Here's a brief summary of the major laws that relate to ADA.

The 1973 Rehabilitation Act bans discrimination against the disabled by federal contractors. The Rehabilitation Act is a weaker version of the broader and more general ADA. But most of the case law used to support early ADA cases came from disputes over the Rehabilitation Act. If any of your business comes from federal contracts, an employee or job applicant may also cite the Rehabilitation Act as a legal reinforcement of the ADA claims.

Because the ADA is a civil rights law, angry employees or job applicants may also cite the Equal Protection Clause of the Fourteenth Amendment to the U.S. Constitution. They argue that disabled people are members of a so-called "suspect class" and their claims subject to a "strict scrutiny" analysis—which makes legal claims easier to substantiate. Lawyers often try to bring Fourteenth Amendment employment law cases; discrimination is one place these claims work.

A largely unresolved issue is how the ADA relates to workers' compensation. The main conflict: Can you enforce a policy of terminating employees who take more than a certain amount of leave, regardless of the reason?

The answer is a qualified yes. You can terminate the employee and not be held liable under the ADA if you document that you offered a doctor-approved job accommodating the employee's injuries and the employee declined the new position.

Workers' comp claims are also linked with ADA claims

The ADA and workers' compensation issues overlap in many cases. With workers' comp reform the law in most states, labor attorneys look with growing interest at ADA. The 1995 Alabama supreme court case *Milley Bullion v. JMBL, Inc.* makes a good example of this variation.

In February 1990, JMBL employed Bullion on a part-time basis as a cashier at one of its grocery stores. Later, it transferred her to the produce department of its store. Bullion suffered an on-the-job injury to her back in April 1990.

As a result of her injury, Bullion was unable to return to work until April 1992. She received a permanent partial impairment rating of between 7 and 18 percent. When she initially returned to work, her physician restricted her hours of work and restricted her lifting. Bullion was later released from all work restrictions and was permitted to work eight-hour shifts.

She requested that a stool be placed near the cash register in order to accommodate her need to alternate between standing and sitting. JMBL granted that request. Later, she was put on part-time status as a cashier, and she worked on that basis until she was laid off in April 1993.

In July 1993, Bullion sued JMBL, alleging that she had been terminated solely for maintaining an action against JMBL to recover workers' compensation benefits. In November 1993, Bullion amended her complaint, contending that her termination violated the Americans with Disabilities Act of 1990.

On September 19, 1994, the trial court entered a summary judgment in favor of JMBL. Bullion appealed.

A JMBL store manager testified that after Bullion returned to work in April 1992, she complained about not being a full-time employee. The manager was unable to schedule Bullion for more hours because her personal schedule conflicted with the hours he needed her to work and because the store did not have a full-time position available.

The president of JMBL testified that the store was preparing to relocate to a larger facility. Bullion was selected to be laid off because JMBL needed to reduce the number of its part-time employees during the transition.

Laying off an injured worker

On April 18, 1993, JMBL's president advised Bullion that she was being laid off effective April 19. On April 21, Bullion reapplied for employment with JMBL, stating in her employment application that she preferred full-time work on the day shift and that she was available to work Monday through Friday but not on Saturdays or Sundays.

The president said that he had made the decision to lay off Bullion and that his decision was based on the fact that two managers had reported that "Bullion had a bad attitude, was difficult to work with, was loud and abusive, and did not care about JMBL's customers."

The court also heard testimony indicating that Bullion had made racist remarks to customers, was obnoxious, and was unruly while at work.

Bullion argued that JMBL terminated her employment because her injury disabled her and required her to use a stool—a special accommodation.

There was no dispute that Bullion had a physical impairment, or that this impairment to some degree affected her ability to stand and sit. Further, the EEOC's ADA guidelines state that standing and sitting are major life activities.

However, JMBL established a legitimate, nondiscriminatory reason for the action, and Bullion presented no substantial evidence to indicate that the reasons offered by JMBL for her termination were a pretext. So, the trial court issued a summary judgment in favor of JMBL, rejecting Bullion's claims.

In reviewing that decision, the state supreme court concluded:

ADA says that standing and sitting are major life activities

ADA works well in combination with other laws

Bullion failed to present substantial evidence creating a genuine issue of material fact as to whether the reasons offered by JMBL for her termination were a pretext for an impermissible termination. Accordingly, the trial court properly entered the summary judgment in favor of JMBL on Bullion's claim of retaliatory discharge in violation of [ADA].

Accordingly, the trial court properly entered the summary judgment in favor of JMBL on Bullion's claim of alleging a violation of the ADA. The state supreme court upheld that decision.

In some instances—especially having to do with job-related insurance benefits—the ADA seems to conflict with the Employee Retirement Income Security Act of 1974. The ADA says that job-related benefits have to be available for disabled employees just as for non-disabled. However, ERISA says that you can't give a certain group of employees benefits that come at the cost of benefits available to other employees. Legal experts say that ERISA prevails against ADA in this regard. So you can't offer disabled employees health insurance if it negatively impacts the insurance you offer all employees. A major caveat here, though: This issue may change with new court rulings.

In general, the ADA works in conjunction with other workplace diversity laws. If circumstances allow, don't be surprised to see ADA claims bundled with claims under the Age Discrimination in Employment Act, Title VII of the Civil Rights Act of 1964, the Civil Rights Act of 1991 or the Family Medical Leave Act. We will consider these other laws in coming chapters.

Conclusion

The ADA stands apart from other workplace anti-discrimination law because of its vague language, broad subject matter, harsh enforcement standards and strained logic. The basic concepts that support the law—what counts as a disability, what constitutes a reasonable accommodation of that

disability and when an employer has to make that accommodation—all remain loosely defined.

Congress, in drafting the ADA, explicitly left these issues unanswered and assumed that the federal courts would resolve any confusion. Political theorists might argue that this was a terrible abandonment of legislative responsibility.

Employers, grounded in reality, are left with an evasive law that they have to obey.

But you can comply with ADA, slippery language and all. Compliance requires a careful eye for making unbiased employment policies and scrupulous attention to record keeping. But—to torture a line from the famous Frank Sinatra song—if you can make it there, you can make it anywhere.

To review everything we've considered in this chapter, here are some practical suggestions for complying with the ADA.

- Understand the broad scope of the definition of "disability." Disabilities can include mental impairments—such as Attention Deficit Disorder—and ailments such as migraine headaches, AIDS, alcoholism and drug addiction, even unusual sensitivity to tobacco smoke.

- The law prohibits you from asking job applicants about the existence, nature or severity of disabilities they might have. But you can ask about an applicant's ability to perform specific job functions.

- Document the basic functions of every job at your company. You can go through a job description and make sure an applicant can perform each function in it. If you turn down a disabled job applicant for a particular position because he or she can't perform the work required, you can better defend yourself against discrimination charges if you already have the basic functions of the job documented.

- So-called "prophylactic measures," such as alerting middle managers to the perils of the

Take a flexible view of what's covered by ADA

interview process and the termination process, stressing diversity in the workplace, updating job descriptions, and appointing a company ADA officer, can all serve to reduce your risk of ADA liability.

- Check your application, interviewing, hiring and medical examination processes. Make sure prospective employees are not asked questions regarding impairments or disabilities which are unlawful. The key to ADA compliance is documentation.

- Pre-employment physicals are only allowed after a conditional offer of employment is made, and the results may not be used to discriminate unless the person cannot perform the essential functions of the job or poses a direct threat to safety or health.

- Medical exams of current employees can only be performed if they are job-related and consistent with business necessity.

- The law requires "reasonable accommodation" for a disabled employee's needs—such as restructured job duties, modified work schedules, special equipment or alterations to physical facilities. Before you face an issue, establish a procedure for handling accommodation.

- Adopt a liberal view of what is a reasonable accommodation.

- Employees who want accommodation should first make an oral request, then repeat the request in writing. The request must be specific— for a tape recorder or a move to another desk.

- Your accommodation policy should include limits at which the time and money you spend accommodating people become an undue hardship. These limits will be different for different companies and different kinds of jobs. The larger your company and the more senior the position, the more you should be prepared to spend.

- Whenever you're considering or making an accommodation, communicate with the employee or applicant. Avoid any kind of antagonistic response. Many times the employee has a good idea about providing accommodations that are reasonable.

- If you're not going to make the accommodation, you should state the reasons in a note and file it.

- If a disabled employee at a profitable company needs a device to accommodate his or her needs, declining to purchase the device can be risky. Juries evaluating whether an accommodation poses an "undue burden" on an employer often look straight at the bottom line.

- Supervisors should take care not to raise issues of disability—especially questions of alcoholism or drug abuse, mental problems, emotional problems or politically-charged diseases like AIDS. Refer employees who show signs of these problems to an employee assistance program.

- If feasible, refer problem employees to an employee assistance program in which they can talk about trouble they're having on the job. This serves as an official forum for them to address shortcomings or discuss problems. It works especially well in the case of suspected alcohol or drug abusers—they'll have a harder time claiming perceived disability.

Recent research conducted jointly by NEC America's Oregon plant and the University of Oregon balances the sober implications of other reports. Its findings suggest that companies can voluntarily accommodate employees with severe mental disabilities by teaching co-workers basic training strategies.

Perhaps more significant, employees regard these training skills as useful in their day-to-day responsibilities, beyond any involvement with disabled employees.

One training program that worked well for ADA compliance

Choosing certain managers for training

The training techniques employed in the NEC study weren't new. They have been used widely in training people with severe mental disabilities. But recently, in the wake of the ADA, increased interest in the disabled has created an opportunity for management consultants to consider these approaches.

A focus on training

The purpose of the study was to determine the ability of employees to train severely disabled workers after a two-day seminar on training techniques. The study was conducted at NEC America's Oregon plant.

Established in 1985, the plant employs 625 employees. It manufactures fiber optic transmission systems, digital microwave radio systems, cellular telephones, data modems, and very small aperture terminals. Plant employees work in "zero-defect" teams and have been instrumental in the company's rapid growth.

Department supervisors selected five employees to learn the procedures for training workers with disabilities. Four had no previous experience working with disabled employees; one had minimal experience.

The training seminar focused on a "task analytic" process useful for troubleshooting, process improvement, and process investigation.

Through lecture and practice, the five employees trained five other employees, who had moderate to severe mental retardation. The employees were organized into five teams, each consisting of a trainer and an employee with mental disabilities. One team dropped out of the study for personal reasons. All four of the other employees who learned the training skills became more efficient trainers after the two-day seminar, as indicated by the increased ability of the disabled employees to do the jobs covered in training.

The NEC study produced two other notable results. First, the workers with disabilities required less help from the trainers as the workers learned their tasks.

The second result occurred in the weeks after the training. All but one of the trainers reported using the new training skills daily on the job. All perceived an increase in their ability to train any employee as a result of the seminar.

In the end, training employees with disabilities requires daily implementation of fairly straightforward techniques. This persistence overcomes the main problem facing training programs—that theories discussed in seminars rarely make it to the shop floor.

Daily implementation is the key

CHAPTER 2:

AGE

Introduction

During the 1990s, workers over 50 are the fastest growing segment of the American work force. The Department of Labor's Bureau of Labor Statistics found that the median age of the labor force was 37.2 years in 1992. It projects that figure to be 39.2 in 2000 and 40.5 in 2005. Through that period, the number of people age 50 to 65 will increase at more than twice the rate of the overall population.

However, the same Bureau found that in 1992 about 738,000 people 55 or older were unemployed and actively looking for jobs—a rise of more than 50 percent in five years.

These conflicting statistics suggest that, while other workplace diversity issues may attract more media attention, the one you're most likely to face in the coming years is age discrimination.

In March 1995, the American Association of Retired Persons—belying its name—released a study showing that age discrimination occurs today in hiring more than 25 percent of the time. The study, "Employment Discrimination Against Older Workers: An Experimental Study of Hiring Practices," was conducted in cooperation with the Fair Employment Council of Greater Washington, D.C.

The AARP and FEC conducted the study by mailing comparable resumes for two applicants—one for a 57-year-old and the other for a 32-year-old—

Older people seem to fare worse in the workplace

to a random sample of 775 large firms and employment agencies around the country. The older applicant received a less favorable response in 26.5 percent of the 79 tests in which a position was available.

In one of the study's examples, two resumes were sent to a Fortune 500 company for the same management position. While the younger applicant received a request from the human resources manager for more information, the older applicant was told by the same person that no appropriate positions were open.

"Age discrimination is more insidious [than other discrimination]. People are now more conscious of race biases and sex biases. They are not as aware they have an age prejudice," says AARP lawyer Sally Dunaway. "When you look at two people with the same experience and basic skills and the only difference is age, a lot of [age discrimination] must be based on myths about older people."

Age bias suits are fast becoming a fact of business life. The number of age-discrimination complaints filed with the Equal Employment Opportunity Commission grew from just over 11,000 in 1980 to almost 20,000 in 1993.

So, a growing number of older workers are reading that they're being discriminated against. That's an impression you have to battle.

But there's a considerable upside here. For one thing, older people often do make excellent employees. For another, the law protecting older people from workplace discrimination is probably the most sensible of any dealing with diversity issues.

Discrimination against people 40 years old and older is generally prohibited by the federal Age Discrimination in Employment Act of 1967. The ADEA bans employers from hiring, firing, paying and setting other terms of employment based on age.

One of the problems unique to age discrimination is that in most company-wide layoffs, highly-paid middle managers suffer most of the cuts. This

makes sense in many cases, because middle level managers whose greatest career asset is seniority make an inviting target to budget-cutters. But most of these people fall into the age group protected under ADEA.

Age is something that affects everyone

Another reason age discrimination deserves special attention is that older workers are the one protected group to which everyone can belong. Most people don't become disabled in their working lives. Many people don't have families. Essentially no one can change their race or gender (and diversity laws don't grant protection to people who try).

But everyone can be over 40. Most people plan to be working past 50. So-called "ageism" strikes a chord of fear in people of all ages. For this reason, age discrimination can have a greater effect on overall employee morale than any other diversity issue.

Age discrimination inverts the normal dynamic of diversity issues. The political background has little clarity—no one's really sure what age counts as old—but the law makes clear, if arbitrary, distinctions.

Charges of age discrimination don't just make you look like a heartless fiend. They often plant seeds of doubt about your company's financial health in general. As we'll see throughout this chapter, age bias problems can make your staff, vendors and even customers wonder about your solvency. Legally, there's no reason for this distinction—it's strictly an emotional difference.

As one New York-based labor lawyer says: "There's no one more interested in the rights of a 40-year-old than a 39-year-old."

The problem you face as an employer: The 40-year-old and the 39-year-old are often competing for the same job or promotion.[1]

[1] Technically speaking, a 1983 federal court decision held a two year age difference isn't enough to make an ADEA claim. But another ruled that five years was.

Legislative and political history

ADEA was passed into law in 1967, as an extension of the workplace protections offered by Title VII of the Civil Rights Act of 1964. Congress had considered, but rejected, including age as a protected category in Title VII.

The law came at the beginning of the ascent of older Americans' lobbying groups—most notably the AARP—to the top of the Capitol Hill political heap. Age was the one vocal interest group that Title VII had left unprotected.

The ADEA's one major problem: It started protection at the age of 40.

Senior advocates and gerontologists make distinctions among older Americans. Most begin the category at age 50 or 55. (Generally speaking, the term "elderly" applies to people over 65, "aged" applies to people over 75 and "very old" to people over 85.)

The ADEA was amended in 1978 to protect workers age 65 to 70.

The major advocacy-support group for seniors in America, the AARP, accepts members who are as young as 50. So many members of the Washington-based group are not retired that the AARP established a worker equity department in 1985 as part of its advocacy programs division.

The department keeps busy filing complaints and lawsuits alleging possible discrimination on behalf of its job-seeking members throughout the country. One spokesman said the department averages 500 written inquiries a month.

An employee in his or her early 40s is often at the peak of his or her career. How much does this employee have in common with someone in his or her early 60s, nearing retirement? Not that much—unfortunately. The employee in his or her early 60s is less likely to sue for age discrimination than the younger older person.

According to one EEOC attorney, most age discrimination claims come from people between the

ages of 40 and 55. "It's a fact that the agency doesn't like to admit...but ADEA claims are often 44-year-olds suing because they've been replaced by 36-year-olds," the EEOC lawyer says. "You hear more about the odd case of 60-year-old grandmother being fired. But since the early 1980s, the ADEA has become a revenge mechanism for people caught in corporate downsizings."

The Bureau of Labor Statistics inadvertently seems to agree with the argument that 40 is too young for "older American" status. The Bureau doesn't begin its own older American statistics until age 55. And, even then, the numbers aren't bad. People 55 and older have a 4.2 percent unemployment rate, compared to 5.5 for people aged 25 to 54.

But these figures miss thousands of so-called "discouraged workers," people who want jobs but feel none are available and stop looking. In one recent year, federal officials counted 168,000 "discouraged workers" 60 and older. In this group, voluntary retirees sometimes turn job seekers because, under pressure to decide quickly on time-limited incentive programs, they fail to gauge the full personal or financial impact of not working.

Bureau of Labor Statistics data also shows that it takes on average 18 weeks for someone 55 to 64 to find a new job, versus nine weeks for a younger person.

This gets to the main defense for the ADEA. Once displaced, older workers generally find reemployment difficult. "Employers still have difficulty hiring workers over age 55," says Robert MacDicken, director of corporate training programs at the National Council on the Aging (NCOA). "One company we worked with in New Jersey had 200 people who took early retirement. Of the ones who wanted to work, 80 percent were still unemployed after a year."

These sorts of arguments about age discrimination quickly blur into the worst kind of political posturing. "It's often unintentional, so it can be a very subtle kind of discrimination," said one se-

A revenge mechanism for people caught in downsizings

Seniors claim biases against them defy hard data

niors advocate. This fits closely with the recurring belief that the prejudices against older workers are so ingrained in the culture that they defy hard data.

Always be careful of alleged discrimination that defies hard data.

As unlikely as it sounds, the oxymoron "unintentional discrimination" does have a function under the ADEA. Because the law follows the procedural model set by Title VII, it allows so-called "disparate impact" findings.

We'll consider this theory in greater detail elsewhere. In this context, it's enough to say that disparate impact means a policy or action that's explicitly neutral may be found to be discriminatory if it affects a protected group differently than everyone else.

For example, if you wrote the requirement "recent college graduate" into a job description for a management trainee, you would probably argue that the term is neutral. A person from any racial, gender or age group could be a recent college graduate. However, a job applicant who's over 40 could argue that, in practice, the requirement illegally eliminates qualified older people from consideration. This would be a disparate impact argument. It's difficult—but not impossible—for an applicant or employee to make.

This complexity is a central part of age issues—not because the law is complicated, but because social and political notions of age are. Even the most focused advocates of rights and protections for older workers have a hard time articulating a more simple argument.

In the early 1980s, groups like the AARP thought that intensive public relations and educational efforts would convince employers to invest in the employment of older workers.

"In the beginning, I was more optimistic that if we corrected the stereotype, if we could document productivity...it would help change attitudes," said

a spokeswoman for the Commonwealth Fund, a private foundation which studies the role of older people in the workplace. "I really thought the reports would have had more of a positive impact, but we are running against the economic trends and some deep-rooted bias."

"Everybody saw [older workers] as reliable, like a Saint Bernard," complained an AARP spokesman after the group released another report about employer attitudes. "[Employers] love them, but they won't hire them. And we really couldn't get at why. None of the negative stereotypes show up in the answers, but even positive stereotypes cause pigeonholing...they use words like *mature* and *dependable*, but they don't look at individual skills and characters....It does just come down to age-ism."

Being pigeonholed by well-meaning compliments isn't quite the same as not being interviewed because you're black or being paid less money because you're a woman. But the law prohibits subtle discrimination just as clearly as it does overt discrimination.

One spokesman for the NCOA predicts that "age discrimination will be the civil rights issue of the next decade," mostly because an increasing number of the people who fought for civil rights in the 1960s are now middle aged.

Enforcement

The ADEA applies to companies employing 20 or more full-time employees. Until 1986, the law only protected workers between 40 and 70 years old. That year, it was amended to eliminate the 70-year-old upper limit (though it exempts collective bargain agreements in place at the time that mandate retirement at an age over 70).

As with the ADA and other federal employment law, employees must first take their ADEA complaints to the Equal Employment Opportunity Commission.

A condescending image of loyalty and reliability?

The objective numbers from EEOC

The law makes it illegal:

...to fail or refuse to hire, or to discharge any individual, or otherwise discriminate against any individual with respect to his compensation, terms, conditions or privileges of employment because of such individual's age [or]

...to limit, segregate, or classify employees in any way which would deprive or tend to deprive any individual of employment opportunities or otherwise adversely affect his status as an employee because of such an individual's age.

It extends the same rules to employment agencies and labor unions.

Though the number of age bias complaints bounced up and down through the 1980s and 1990s, from 1992 to 1994 it accounted for roughly 20 to 25 percent of all complaints filed at the EEOC.

The EEOC's national statistics show 17,009 age discrimination charges made in fiscal year 1994. Of those, 13,942 were resolved. Some 5,021 were closed for administrative reasons, 6,872 were found to have no reasonable cause, and 2,049 were considered meritorious for the charging party.

A private lawsuit can proceed if the EEOC has not resolved a complaint within 60 days. If the EEOC dismisses the complaint, a civil lawsuit alleging the claims must be brought "within 90 days after the date of the receipt of" the notice from the EEOC that it is not proceeding.

(Because the ADEA follows the procedural lead of Title VII, the Civil Rights Act of 1991 shortened the time-frame for age bias claims. Under prior law, an employee generally had two years to bring an age discrimination claim, regardless of how long it took the EEOC to determine whether and how it would proceed on the claims.)

Jury trials have been available in age bias suits since the ADEA was first put on the books in 1967. (By contrast, people claiming discrimination based on race, sex, religion and national origin have only

been entitled to jury trials since the Civil Rights Act of 1991.)

The EEOC and many employment lawyers take an activist position in soliciting age bias cases. In cases that do make it to trial, the employee often stands in a good position to win some money.

Age discrimination suits can prove especially lucrative—that is, costly to you. Average jury verdicts for age discrimination are 175 to 300 percent higher than those for sex, race or disability discrimination, according to one report from Jury Verdict Research Inc.

The average age discrimination jury award between 1988 to 1992 was $450,289—compared with $255,734 for sex discrimination, $176,578 for race discrimination and $151,421 for disability discrimination. (The ADA is expected to increase that last item.)

An important observation: Most ADEA complaints involve terminations, layoffs and benefits disputes. Very few involve failure to hire or failure to promote.

Even though age bias awards are large, there's still a sizable difference between an employee feeling victimized and proving it. "Any discrimination case is difficult because almost always you're dealing with what's going on in someone's mind as opposed to concrete evidence," says one North Carolina-based attorney. "It's very difficult to prove and even if you get a jury verdict, it almost always gets overturned."

Employment lawyers complain that age discrimination is hard to prove because employers usually say they have other reasons for getting rid of an older worker. They also talk about a historical reticence on the part of older workers to press lawsuits. More than half the respondents in one AARP survey were unaware of their right to press age discrimination complaints. Others are afraid of being stigmatized.

One reason the big ADEA awards are overturned

An average jury award of nearly $500,000

so often is that juries sympathize with employees—but they don't pay attention to the law.

An illustrative case

The 1994 appeals court decision *Rand v. CF Industries, Inc.* involved an attorney who made age discrimination charges against a company which had terminated him from his position as assistant general counsel.

In the spring of 1988, Joseph Rand contacted Robert Liuzzi, president of CF Industries (CFI), to inquire about a job. Liuzzi expressed interest in Rand's application and arranged an interview. In June 1988, Rand visited CFI where he was interviewed by Liuzzi and the company's vice president for Human Resources. During the meeting, Liuzzi told Rand that for all practical purposes he was hired.

Nonetheless, Liuzzi asked Rand to interview with other CFI executives. Rand subsequently interviewed with Paul Obert, CFI's General Counsel, and several other executives.

Obert's retirement plans were discussed several times during the interview process. Liuzzi told Rand that when Obert retired, Rand would become CFI's General Counsel. Liuzzi also said that Obert would probably stay at CFI for only a year or so—and that under no circumstances would Obert be allowed to stay after age 65, CFI's mandatory retirement age.

But when Rand met with Obert for an interview over dinner, he heard a different story. Obert told Rand that he was having a dispute with CFI over his retirement. According to Rand's notes, Obert said that he needed to stay on for another four to seven years for financial reasons, and that federal law prohibited CFI from forcing him out at age 65.

In any event, Liuzzi offered Rand a position as CFI's Assistant General Counsel and Assistant Secretary. Rand began work in January 1989. When he started, he was given an employee manual that

stated CFI was committed to a continuous appraisal policy—this meant employee performance was documented and communicated to CFI's employees on a regular, on-going basis. The manual also stated that CFI employees worked on an at-will basis.

Rand's first year at CFI went well. This was reflected in his performance review; Obert rated his performance as superior, gave him a $27,500 bonus and the maximum salary increase. In a section dealing with promotability, however, Obert stated that he did not plan to retire for another 5 years and 8 months.

Rand had his first bad experience at CFI shortly after Obert prepared the glowing review. Liuzzi asked Rand to draft a letter of intent concerning a possible purchase of assets. Liuzzi also asked Rand to oversee related tasks, including a search of records at the Securities and Exchange Commission which was supervised by a legal department staffer named Rosemary O'Brien.

Rand angered both O'Brien and Liuzzi as a result of his work on this project. Later, O'Brien told Liuzzi that Rand had harassed her by repeatedly demanding documents; had second-guessed her judgment as to the appropriate search methodology; and had embarrassed her during a telephone conference with an outside attorney.

Separately, Liuzzi became angry because Rand failed to provide revised letter drafts properly or on time. At one point Liuzzi warned Rand that unless he received a satisfactory document, "there were going to be personnel changes."

Rand's relationship with CFI deteriorated rapidly after January of 1990—and Obert's retirement plans played some part in this process. Rand asked for a company car, even though only the General Counsel received a company car under CFI's policy. This perquisite took on greater importance after Obert reiterated his intent to defer retirement for another five years. The car request was declined.

Ultimately several CFI executives told Liuzzi that

Senior people battle for choice positions

they were not pleased with Rand. By fall of 1990, Liuzzi called O'Brien again for the specific purpose of learning her opinion about Rand's conduct in general.

In December 1990, Obert met with Rand to tell him he was fired. Obert told Rand that CFI had decided to terminate his employment because things were not working out. Rand was surprised and angered by CFI's decision. Rand's animosity persisted even though CFI gave him a severance package that included a $20,000 payment in lieu of the annual bonus Rand would have received for 1990.

Rand sued CFI in early 1991. Rand met the standard of a prima facie charge. He was age 49 when discharged; he produced some evidence that he was satisfying his employer's expectations; and his replacement was age 40.

Rand argued that CFI's reasons for his discharge were incredible because CFI never documented or communicated his performance problems despite its continuous appraisal policy. The court thought Rand's reliance on CFI's policy was misplaced because it did not state or imply that CFI was obliged to communicate problems before it decided to discharge an employee. Nothing in CFI's policy manual prohibited Liuzzi's action.

Rand appealed the trial court's conclusions. But the appeals court supported them. "There is no need to belabor the point: several CFI executives told Liuzzi that Rand was overbearing, tactless, and arrogant," it wrote. "As a result, they were unwilling to seek his counsel. According to Liuzzi the damage caused by Rand's conduct was irreparable, because he could neither order Rand to become less offensive, nor order other CFI executives to seek Rand's counsel."

Rand criticized CFI's generous severance package as evidence of illegal behavior. The appeals court said the charge proved nothing. "In effect, he argues that his severance package was so good that CFI must have had an ulterior motive—to buy off

his age discrimination claim....[But he doesn't] produce evidence from which a jury could reasonably infer that CFI's stated reasons for his discharge are unworthy of credence. His case rests almost exclusively on his uncorroborated assertion that no less than eight CFI executives are lying in an effort to hide CFI's age discrimination."

Finally, the appeals court found that most of Rand's arguments were directed towards the wisdom of Liuzzi's actions, not the factual basis for the decision. If Liuzzi consulted with only a few key people and concluded that Rand had to be fired, that was enough. "Any pretext determination is concerned with whether the employer honestly believes in the reasons it offers, not whether it made a bad decision," the court concluded.

Compliance

It is not illegal to replace an employee with someone who is paid less. But if your preference for younger employees is based even in part on age, you may be susceptible to ADEA claims.

The ADEA does allow age standards where they constitute a "bona fide occupational qualification reasonably necessary to the normal operation of a particular business."

The Act allows you to "discharge or otherwise discipline an individual for good cause."

However, discriminating on age plus a neutral factor is prohibited. For example, you can't force job applicants or employees over 40 to pass a physical test that you don't require of people under 40.

Employers don't usually make overtly discriminatory statements—like "We didn't hire you because you're too old." If you do say something like this and you get sued, your only defense is to prove that you would have reached the same conclusion even if age hadn't been a factor. That's difficult.

You can make less direct policies or statements— like "We need to reduce the age of our work force" or "We need to project a youthful image." But you

A severance package so good that it implies wrongdoing?

Age standards sometimes count as BFOQs

shouldn't. Saying something like that doesn't prove that a particular decision was motivated by age discrimination. It does, however, establish a general bias against older applicants or employees—which again shifts the burden in a lawsuit from the person making the complaint to you. You'll have to prove that legitimate factors influenced your decision.

You can ask job applicants their age, if you add (and follow) the disclaimer that the information won't be used in the decision-making process. But, like making general comments about projecting a youthful image, this kind of question can shift the burden of proof from the litigious applicant to you. And it suggests a pattern of improper behavior that's likely to attract an EEOC investigation.

You can only consider a job applicant's age when it's a "bona fide occupational qualification." EEOC Guidelines describe a so-called "BFOQ" in the following way:

> An employer asserting a BFOQ defense has the burden of proving that (1) the age limit is reasonably necessary to the essence of the business and either (2) that all or substantially all individuals excluded from the job involved are in fact disqualified, or (3) that some of the individuals so excluded possess a disqualifying trait that cannot be ascertained except by reference of age.

A frequently-used example of a BFOQ would be a job in construction, where physical strength is an issue. But, even then, a fit and robust older worker would be protected. A better example—and one the courts have upheld—commercial airlines can hire younger pilots.

The fact that a job is entry-level or at the beginning of a long-term career track is irrelevant. So, you shouldn't use words like "potential" in job descriptions or policies, because they may imply a bias toward people who will stay in a job for a longer time.

Still, more ADEA claims stem from terminations

and down-sizings than hirings. The law allows certain jobs related to public safety—like police officers and firefighters—to use age limits. Otherwise, you can't use age as a reason to let someone go.

If you decide to get rid of 10 percent of your work force, it's important how you proceed. It's not technically necessary to preserve the racial and sexual balance of the workplace, but it's important to be aware of that. The goal is to keep the best-qualified people and to evaluate in a neutral environment.

Be careful about requiring employees to sign waivers not to sue. In some states, employers requiring employees to sign a waiver giving up rights to sue the company must provide at least 21 days for consideration.

Illinois-based retailing giant Sears, Roebuck & Co. got caught in this bind. In an earlier suit, the EEOC charged that Sears did not allow employees enough time before signing a lawsuit waiver. "The EEOC alleges that Sears violated the ADEA by conditioning receipt of severance benefits on the execution of a waiver and release," said one Chicago-based EEOC attorney.

The EEOC asked a federal court to declare the waivers Sears received in a six-month period during 1992 invalid, as well as require the retailer to re-offer a separation package to eligible employees who didn't accept it. Sears, which had cut nearly 100,000 jobs between 1990 and 1992, disputed the charges.

One good point to remember: Offering someone over 40 another job instead of termination—even if he or she doesn't accept the offer—goes a long way in preventing an expensive ADEA claim.

In the 1986 case *Palmer v. U.S. Forest Service*, an employee was offered the research meteorologist position in Georgia to replace a job he lost in California due to a reduction in force. He declined to accept the job, alleging the Forest Service knew he would not be able to accept the Georgia position because it would be injurious to his wife's health.

Waivers against lawsuits don't always hold up

Flexible work alternatives help older employees transition out

But the employee didn't inform his supervisors about his wife's health condition. He didn't produce any evidence that the Forest Service was aware of his inability to move, except for a declaration made after his discharge. On the contrary, in a standard personnel form, he had stated that he was available for a transfer or reassignment, with or without a promotion, in three other domestic locations as well as Australia and Europe. And he didn't decline the replacement position until the last day the offer was held open.

The meteorologist sued the Forest Service, claiming a violation of ADEA. But the court rejected his claim.

Massachusetts-based Polaroid Corporation has developed a "flexible work alternative" program to help its older workers make decisions about retirement—and help them ease into the process.

"We're convinced that people shouldn't retire precipitously," a company spokesman told one local newspaper. "People shouldn't jump from full-time work to full-time leisure. We try to ease that transition."

Toward this end, the company offers several options designed for its 55-plus employees. One is called "rehearsal retirement." It allows older employees to take a leave of absence for three to six months. If they don't like the leave, they're entitled to come back to the same job—no questions asked.

Another program enables older workers to reduce their hours, from a 40-hour work week to a 32-hour work week—down to a minimum of 20 hours a week.

In addition, the company offers one-on-one retirement counseling sessions and life planning seminars, which cover retirement, pensions, profit sharing, employee stock options and other benefits issues. These seminars are open to employees of all ages.

The last point about complying with the ADEA: It's probably easier than you think. A variety of

studies—some polling human resources executives at many firms, others focusing on particular companies—have found that workers over 40 are more reliable, have lower rates of absenteeism and higher productivity and are as easy to retrain as their younger colleagues.

Legal issues

Age bias claims usually deal with inference rather than smoking guns. A plaintiff alleging discrimination under the ADEA may proceed under either of two theories: disparate treatment or disparate impact. Under the disparate treatment theory the employee must show discriminatory motive by the employer. Discriminatory motive need not be shown under the disparate impact theory.

The requirements under this theory, however, may be more exacting. It means an employee has to prove either that the explanation you offer is a pretext hiding discriminatory intent or that there are statistical discrepancies that establish disparate impact.

For an employee to prove disparate treatment based solely on statistics he or she must show a "stark pattern" of discrimination unexplainable on grounds other than age. The issue in a disparate treatment case is "whether a particular isolated historical event was discriminatory." Statistical evidence that shows "chance is not the more likely explanation [is] not by [itself] sufficient to demonstrate that [age] is the more likely explanation for an employer's conduct."

Statistical data can indicate what the courts call "a pervasive pattern" of discrimination. For example, if you interview ten job applicants under 40 and ten over 40 for five positions—and four of the five people you hire are under 40—a court might find this sufficient grounds to suggest illegal behavior. Next, the court is likely to use an analytic tool like standard deviation analysis to rule out chance. If that follows, the burden shifts to you to prove you haven't discriminated.

The shifting burden in disparate impact cases

But, from the applicant or employee's perspective, that scenario includes several big if's. This gets back to the complaints lawyers make about how difficult it is to win discrimination cases.

If the employee doesn't have direct evidence or significant statistical data, he or she can try to make a prima facie case of discrimination following the Title VII model established in the 1973 Supreme Court decision *McDonnell Douglas Corp. v. Green.*

To create a prima facie charge, the employee has to establish five things:

1) that he or she is a member of a protected group (in the ADEA context, that means over 40);

2) that the employer had a job opening for which he or she applied;

3) that he or she met all of the qualifications defined by the employer or could perform all of the essential job functions;

4) that he or she didn't get the job; and

5) that the employer continued to accept job applications or hired someone not in the protected class (in the ADEA context, someone under 40 or "substantially younger").

If an employee who's suing makes this case, you have to prove that your motivation was not anything prohibited by the ADEA. The law says you can consider "legitimate factors other than age," which some lawyers say means you have to prove your motives weren't just fair but also "legitimate."

Fortunately, most courts don't support that argument. They just ask that you provide a nondiscriminatory reason for your action that's "clear and reasonably specific." In the 1980 federal appeals court decision *Smithers v. Bailar*, the employer explained that the younger job applicant was "more articulate and could present himself in his position more clearly." The court allowed that explanation.

Pretext is hard to prove. The 1987 appeals court

110

case *Kier v. Commercial Union Insurance Companies* shows how hard it is for an employee to do this.

Morton Kier was hired by the Chicago Office of Commercial Union Insurance Companies as a staff attorney in 1973; at that time, Kier was 45 years old. The office employed four staff attorneys and one managing attorney. In May of 1981, the managing attorney for the Chicago office left and Commercial began its search for a replacement.

On the suggestion of the departing managing attorney, Kier was asked to run the office until a replacement could be found. The assistant vice president handling the search for a new managing attorney invited all current staff attorneys, including Kier, to apply. Kier and two other staff attorneys in the Chicago office applied for the position of permanent managing attorney. Only Kier was called in for a second interview.

About the same time, John Milano, an executive of another insurance company in Chicago, was contacted by an unidentified employment recruiter. The recruiter was searching on behalf of a major Chicago insurance company for a managing attorney who was "40, 45, 50 at most." The recruiter never identified the company, but circumstantial evidence supported a finding that the recruiter called on behalf of Commercial.

An employee responds to a rumor

While still under consideration for the job, Kier heard the false rumor that the managing attorney position had been filled. Just prior to hearing the rumor, Kier had received a memo from Commercial's corporate offices, sent to all managing attorneys, regarding the preparation of a training manual for new attorneys.

Acting on the rumor and feeling slighted, Kier testified that he chose the training manual project as a "convenient vehicle" to express his disappointment in being passed over for the managing attorney position. He told his superiors that he would

not work on the manual and sent a copy of his response to the assistant vice president in charge of hiring the new managing attorney.

Approximately one week after sending the letter, this assistant vice president called Kier and told him he was fired. According to Kier, the VP said, "You believe in rumors, and I can't have a man working for me who believes in rumors or who takes action on the strength of rumors. You are insubordinate, and you are fired." Kier, in fact, was not fired until two or three months later, after the VP had secured the agreement of his superiors to fire Kier.

Kier testified that he knew that termination might result from his refusal to cooperate in the preparation of the training manual. In the meantime, Kier had apologized and asked to be retained as a staff attorney. The VP told Kier that, if the new managing attorney requested it, he could stay on.

The managing attorney who was eventually hired for the Chicago office was in her early 30s. She did not request that Kier stay on. In fact, reviewing his work history, she fired him.

Kier sued Commercial for wrongful termination, in violation of ADEA. Kier alleged that Commercial fired him because of his age. Statistical evidence he presented showed that new attorneys hired were substantially younger than those previously employed. Kier was not alleging discriminatory hiring—but that his firing was influenced by this bias.

The trial court allowed the statistics to be presented because statistics don't generally prove discrimination. Indeed, the trial court had concluded that the particular statistics Kier presented were not relevant to his charge of discrimination.

The trial court noted that there was no evidence that any other attorneys were fired or forced to leave because of age. In fact, of the three remaining staff attorneys who eventually left, one was less than 40 years of age and another left after Kier himself had called for his discharge on several occasions.

Nevertheless, the trial jury returned a verdict for Kier and awarded $77,227 against Commercial. The district court found the jury verdict unsupportable and entered judgment for Commercial notwithstanding the verdict. Kier appealed.

The major dispute: Whether the evidence presented to the jury furnished a rational basis for a verdict for Kier.

"For a reasonable jury to infer that Commercial violated ADEA, Kier had to show that Commercial's proffered reasons for discharge were a pretext," the appeals court noted. "A plaintiff may demonstrate pretext either directly, by showing that a discriminatory reason more likely motivated the employer or indirectly, by showing that the employer's proffered explanation is unworthy of credence."

Kier's complaint was based on wrongful discharge as a staff attorney. Therefore, the appeals court ruled, "Commercial's decision to seek a younger permanent managing attorney, even if true—and even if discriminatory—is not relevant to Kier's case."

The court found that the inference created by the testimony about the recruiter working for Commercial, especially in the absence of any showing that others were fired or forced to leave, was insufficient to support a jury verdict regarding a wrongful termination claim. For the jury verdict to stand, Kier would have to have shown that firing an attorney for failure to work on the training manual was a pretext. He didn't do that.

"Kier argued that [his refusal to work on the training manual] was entirely justifiable given how hard he had worked before hearing the rumor that Commercial had hired someone else. Kier missed the point of violations under ADEA," the appeals court concluded. "Even if we were to accept the proposition that Kier's letter was justified and that Commercial had treated Kier unfairly—that would not amount to a violation of ADEA. An employer can fire an employee for any reason, fair or unfair, so

long as the decision to terminate is not based on age or some other protected category."

Once you've given your reason for your decision, the burden switches back to the applicant or employee to show that the reason you've given is a pretext hiding discriminatory intent. This proof can consist of many things—but the most common is proof that you've enforced policies inconsistently. This is where erratic or incomplete documentation can create serious problems.

Willfulness and liquidated damages

An issue that's true under ADEA—and most workplace diversity laws: Willfulness increases the size of verdicts.

In the 1985 Supreme Court decision *Trans World Airlines v. Thurston*, the court held that:

> to say that violation of ADEA is "willful" if [the] employer either knew or showed reckless disregard for matter of whether its conduct was prohibited by the ADEA was acceptable way to articulate [a] definition of "willful."

> But, where [the] employer did not know that its conduct violated the Act [and its] officers acted reasonably and in good faith in attempting to determine whether their plan would violate Act, conduct was not "willful."

The 1989 case *Benjamin v. United Merchants and Manufacturers* was a stinging loss for a willful employer. United Merchants, a textile manufacturer, emerged from bankruptcy in 1978. But, like much of the American textile industry in the early 1980's, it continued to experience business difficulties.

As a result of its losses, it undertook a corporate restructuring which was followed by the discharge of a number of employees, including Peter Benjamin.

At the time of Benjamin's termination, the value of the U.S. dollar was rising, making it more diffi-

cult for American companies to compete successfully for foreign business. Benjamin, who was in his late 50s when he was fired, had been in charge of United Merchants' international sales, which had declined prior to his discharge.

Benjamin was fired in 1983 after 38 years with the company, during which time his responsibilities had substantially increased. His interest in the company's pension plan had fully vested. Five months later, he was replaced with a 41-year-old employee who was not vested in the employer's pension plan.

United Merchants argued that it had demoted Benjamin twice for poor performance, though it did not memorialize the asserted demotions in any of its business records. Benjamin's separation notice stated that United Merchants would reemploy him, and the box on that form indicating "Unsatisfactory work" was not checked.

Benjamin argued that the decline in foreign sales that cost him his job was due to the then rising dollar, and not to his performance. He sued United Merchants.

The trial court found ample evidence for the jury to have found that United Merchants' asserted reason for firing Benjamin—poor performance— was pretextual. A jury could properly have determined that United Merchants decided to discharge Benjamin because of his age.

The ADEA provides that a plaintiff may be entitled to liquidated (double) damages, but "only in cases of willful violations." The trial judge instructed the jury that: "[a] dismissal is not willful simply because the plaintiff shows that United Merchants knew about the age discrimination law. [The] action was willful if you find that the defendant deliberately, intentionally, on purpose and knowingly violated the law, or if it shows a reckless disregard for whether its conduct violated the law."

The jury ruled that the termination was willful. Damages for Benjamin's lost salary amounted to $155,986—which were doubled by the trial judge to $311,972.

A long-time employee replaced with a newer, younger hire

Willfulness best thought of as one end of a range

United Merchants appealed the decision. The appeals court focused its review on the issue of willfulness.

"The ADEA prohibits such terminations even when the company is undergoing a legitimate business restructuring or work force reduction. Age need not be the sole reason for discharge in order to find an ADEA violation," the appeals court wrote. "The jury was entitled to conclude that [United Merchants'] asserted reasons for Benjamin's discharge were not credible, and that his age and consequent entitlement to a pension tipped the employer's decision against him."

It suggested "willfulness" is most easily understood when the term is analyzed along a continuum. Using that concept, at one extreme there is no liability for liquidated damages when an employee proves only that the employer acted negligently, inadvertently, innocently, or even, if the employer was aware of the applicability of the ADEA, and acted reasonably and in good faith.

The opposite point of the spectrum is revealed when an employee establishes that the employer had an evil motive: such showing is sufficient for double damages, but is not necessary for an award of liquidated damages.

"Middle of the spectrum double damages may properly be awarded when the proof shows that an employer was indifferent to the requirements of the governing statute and acted in a purposeful, deliberate, or calculated fashion," the court wrote. "The difficulty lies in distinguishing between indifference to the ADEA and negligent attempts to comply with its dictates. An employer acting with indifference is one who acts without interest or concern for its employees' rights under the ADEA at the time it decides to discharge an employee....When there is evidence in the record that the employer acted reasonably and in good faith—even though it later turns out that employment termination violated the ADEA—double damages are not warranted."

However, it upheld the lower court's conclusion that United Merchants may have acted willfully. It also allowed the liquidated damages.

Not all charges of willful violation work so strongly against the employer. In the 1982 federal appeals court decision *Parcinski v. Outlet Company*, the court defended the employer's rights to hire and fire as he or she sees necessary.

Walter Parcinski was discharged from his job at The Edward Malley Company of New Haven, Connecticut, in June 1977. At the time of his termination, he was sixty-three years old and had been with Malley for thirty-two years.

Parcinski's termination occurred after The Outlet Company decided to acquire Malley as the eighth store in its department stores division. Outlet purchased the debt-ridden Malley store for $100 plus assumption of Malley's indebtedness. In the hope that it could convert Malley into a profitable operation, Outlet planned to operate its new acquisition as a branch store. Buying and merchandising would be handled through Outlet's central office in Providence, Rhode Island. This new scheme of organization entailed the elimination of Malley's buying and merchandising staff of which Parcinski was a member.

In May 1979, Parcinski sued Outlet under the ADEA. Parcinski claimed that "Outlet did not pursue options other than the mass firings of the Malley buyers, although these options were available." It "did not follow a policy of attrition...did not reduce salaries across the board...change the relationship between salaries and bonuses [or] offer outplacement facilities of any kind."

The trial jury returned a verdict for Parcinski in the amount of $93,500, to which the court added $93,500 in liquidated damages for willful violation of the ADEA.

Outlet appealed the decision and won a decisive victory. The appeals court ruled that Parcinski had produced "no evidence that age was a consideration in the relocation decision. Neither did

Corporate restructuring works as a legitimate reason

Parcinski show any practices by [Outlet] that could raise an inference of discriminatory animus."

Outlet had provided an explanation—namely a corporate restructuring—to answer Parcinski's prima facie case. So, the former employee had to prove pretext. The appeals court concluded that he did not meet that burden. The appeals court found that the "mass firings" which took place in this case undermined, rather than supported, Parcinski's claim of individual discrimination.

"The [ADEA] does not forbid essential corporate belt-tightening having no discriminatory motivation," it concluded. "The evidence shows that the decision to eliminate Malley's buying staff was made prior to any consideration of the buyers' ages."

Malley's precarious financial situation, the economic benefits accruing to branch operations, and the fact that Outlet operated its other department stores as branch outfits all demonstrated that the reorganization was "a business decision made on a rational basis."

Most importantly, the appeals court made the following conclusion:

> The [ADEA] does not authorize the courts to judge the wisdom of a corporation's business decisions. The ADEA does not require an employer to accord special treatment to employees over forty years of age. It requires, instead, that an employee's age be treated in a neutral fashion, neither facilitating nor hindering advancement, demotion, or discharge. Since membership in the protected age group is constantly expanding, any rule which mandated preferential treatment for members of the group eventually would limit, and in some cases virtually eliminate, employment opportunities for younger men and women.

Mitigating circumstances

Some courts have ruled that a person who alleges employment discrimination and is later found to

have misbehaved—by lying on a resume or stealing corporate records, for example—should be barred from suing the employer. The worker would have been fired had the employer known of the misconduct when it occurred, the argument goes.

Other courts have held that misconduct should not shield an employer from liability for discrimination but can be used to limit damages awarded to a plaintiff.

The doctrine of after-acquired evidence has cropped up more often as the number of discrimination complaints has grown.

The 1995 U.S. Supreme Court decision *Christine McKennon v. Nashville Banner Publishing Co.* illustrates the case.

Christine McKennon, a 62-year-old secretary, was terminated in 1990 by the Nashville Banner after 39 years at the company. The newspaper said she was laid off because of financial constraints; she claimed age discrimination and filed suit in 1991.

During a deposition, McKennon revealed that, while still employed, she copied confidential records, including financial reports, as "protection" and showed them to her husband.

The Banner claimed it would have fired McKennon for copying the documents had it known about her actions at the time. This "after-acquired" evidence should have precluded her discrimination complaint, it argued.

AARP filed a brief supporting McKennon. The McKennon case shows that, despite the law, older workers often suffer the most when downsizing occurs, an AARP attorney said—in a familiar refrain. The Supreme Court ruled that the after-acquired evidence supported the Banner's termination of McKennon.

Good faith efforts to mitigate older workers' losses don't always work. The 1982 federal appeals court case *John Rose v. The National Cash Register Corporation* considered whether an attempt to limit an older worker's losses helped an employer's position.

An important factor in terminations: after-acquired evidence

Avoid statements about youthful image

Rose worked more than twenty years as salesman in NCR's Grand Rapids, Michigan, office. In the mid-1970s NCR started a reorganization of its sales force which included a reduction in the sales staff. The company instituted this reduction through a program entitled Reduction In Force (RIF), technically the equivalent of a layoff.

Rose was terminated as part of the RIF—"riffed" in common parlance—in June 1976. He was replaced with a man under 30.

In his lawsuit, Rose alleged that NCR sought to establish a new "younger image." Accordingly, it began to hire only young employees. Rose testified that a vice president of NCR's midwest region told him: "Men your age, there isn't going to be any future in the new NCR."

NCR denied that RIF program was designed to terminate older employees. It argued that Rose had been fired because of continued substandard performance—and that his termination was recorded as a RIF only because of his supervisor's desire to afford him the fringe benefits available under the program.

NCR's primary argument was that Rose failed to establish prima facie case of age discrimination. As we've seen elsewhere, federal courts have held that the ultimate burden borne by a plaintiff in an age discrimination action is that of proving "he was discharged because of his age."

The trial court concluded that Rose had, in fact, established a prima facie case. He proved that he'd been replaced by a younger employee and offered evidence of discriminatory intent.

NCR then argued the Portal-to-Portal Pay Act stating, "if the employer shows to the satisfaction of the court that the act or omission giving rise to such action was in good faith and that he had reasonable grounds for believing that his act or omission was not a violation of the Fair Labor Standards Act of 1938, as amended, the court may, in its sound discretion, award no liquidated damages or award any amount thereof not to exceed [a statutory limit lower than the jury award against NCR]."

The trial court rejected this argument, too. The jury found NCR liable to Rose for terminating his employment in violation of ADEA. It awarded Rose $25,000 in lost wages and $20,650 in fringe benefits.

The jury also concluded that NCR's violation of the ADEA was willful, so it doubled the award.

NCR appealed the decision—and the willful damages. But the appeals court upheld the award. It concluded "that Congress altered the circumstances under which such awards would be available in ADEA actions by mandating that such damages be awarded only where the violation of the ADEA is willful....where the jury determines that an employer's violation of the ADEA was willful, the trial judge is not obligated, as a prerequisite to an award of liquidated damages, to consider the employer's protestations of good faith."

The final message: Laying off rather than firing an older worker (or any worker, for that matter) may seem like an act of kindness, but it doesn't accomplish very much if the former worker sues.

Age bias and downsizing

"Downsizing often targets older persons because of the money they make. When a company downsizes sometimes they happen to choose one plant because it has more older workers. We think that's age discrimination and corporations say it's cost saving. Salary becomes a proxy for age," says the AARP's Sally Dunaway. "Courts are presently split on this and it's a very hot issue right now."

"Corporate downsizing inevitably leads to age discrimination cases," says Stephen Bokat of the National Chamber Litigation Center, part of the U.S. Chamber of Commerce. Since older workers are often more skilled and better paid, the ADEA is often their only tool for regaining jobs or getting back pay. They use it freely.

No matter what you call it—"downsizing," "reengineering" or "streamlining"—you need to

Older workers have hard feelings about "downsizings"

tread carefully when you're terminating more than a few employees.

If you drop even a few dozen people at once, you can practically depend on age discrimination claims. No other circumstance proves so well how intensely older workers feel about being let go in downsizings.

In a January 1995 letter to the *Atlanta Constitution*, one angry former employee illustrated the problem:

> At age 51, I was robbed of my retirement benefits after 33 years as an engineer at Georgia Power Co. I was simply told that it was due to downsizing of our department. I received a generous severance package for signing a waiver of claims against my employer (big mistake), but it is no compensation for lost retirement benefits.
>
> A recent AARP survey got 10,000 responses from downsizing victims. About half are still unemployed. Only 10 percent had found employment comparable in pay and benefits to their previous job. The remaining 40 percent were underemployed. I am a contractor on a job that requires me to be away from home and my two school-age sons four days a week. My paycheck is about 60 percent of my former salary, and with fewer benefits.
>
> "Overqualified" and "skills and experience don't match our needs" are heard many times. Translated, they mean that you are too expensive and too old. Of the 68 of us who got the ax that day in March, 61 were age 40 and older. My job was not eliminated. It was given to a younger, less expensive employee the next day.
>
> The Age Discrimination in Employment Act is supposed to protect workers age 40 and older, but EEOC has a backlog of 20,000 charges and is of little help in fighting age discrimination cases. Large corporations know this and thumb their noses at the law. The savings from firing older workers far outweigh the costs of defending any lawsuits.

This system must be corrected. Large numbers of skilled and willing older workers are in danger of being unemployed and not having the resources to retire. More workers need to fight back against such callous treatment by the corporate robber barons.

A caveat that this example illustrates: Most age complaints are filed by white males. As we've noted before, this may stem from the fact so many older workers are terminated in large numbers during corporate restructurings or downsizings.

Remember the letter-writer's phrase "downsizing victims."

Some legal experts suggest a social reason. Age discrimination is "the first type of discrimination white men experience...whereas women and minorities have already experienced it earlier in life," says Dianna Porter, public policy director for the Washington D.C.-based Older Women's League.

Although most employers are more honest about their decision, some companies use downsizing to get rid of their older, more highly-paid employees.

As you might guess, groups like the AARP keep close scrutiny on the effects of corporate downsizing on older workers. "We look at downsizing and early retirement incentive programs and [have] found a correlation in how they have both gone up and down over the past ten or more years," says Cathy Ventrel-Monsees, manager of worker equity at the AARP. "In the early '90s, we're seeing an upsurge in charges....The disturbing trend is that employers have become more callous. They are more willing to risk age discrimination lawsuits because the courts have become more conservative."

Programs that offer bonuses or added pension benefits only to workers under a certain age are a clear violation of federal laws against age discrimination. But, under the ADEA, a retirement plan isn't illegal if the employer can show that the plan "is not a subterfuge to evade the purposes" of the law.

Experts apply social theories to ADEA enforcement

Early retirement packages must not be subterfuges

Employers who offer early retirement programs argue they don't reflect an effort to discriminate, because workers excluded from the plans still receive all the retirement benefits to which they are legally entitled. Instead, the plans represent a legal and humane way to avoid layoffs.

"Companies really need some flexibility in handling their work force," says Mark Ugoretz, executive director of the ERISA Industry Committee, a lobbying group that represents companies on pension and benefit issues. "They're pressed by economic forces on the one hand and state and federal benefit mandates on the other, both of which increase the cost of employment."

Most employers say the benefits of early retirement plans outweigh the liabilities. The programs help prevent companies from becoming top-heavy with older, highly paid workers. Encouraging early retirement also helps clear an upward path for younger workers.

Participation in early retirement plans is usually voluntary, with workers signing agreements waiving their rights to sue. Employers argue that they need to obtain waivers when they offer workers early retirement incentives, such as the equivalent of two years' pay or other benefits, so they won't be susceptible to age-bias lawsuits after providing the retirement packages.

About a fourth of the large companies surveyed in the late 1980s by the congressional General Accounting Office said they required employees accepting an early retirement or other enhanced-benefit offers to waive their rights to sue under the ADEA.

Seniors' rights advocates argued that older workers, not knowing their legal rights, are often coerced into signing the waivers.

In response to these arguments, the EEOC issued a compliance guideline that established a checklist which regulators said would make waivers "knowing and voluntary." Courts have upheld the guideline as a valid way to ensure worker protection when employers seek waivers.

Another point to consider when structuring an early-retirement offer: Beware of ERISA non-discrimination rules. Companies that use financial incentives to induce employees to retire early can offer benefits through the regular company benefit or in some form of lump sum payments. Most companies choose the former option.

The ADEA does allow you to demand the retirement of certain senior-level employees. Specifically, the law says:

> Nothing in this Act shall be construed to prohibit compulsory retirement of any employee who has attained 65 years of age and who, for the two year period immediately before retirement, is employed in a bona fide executive or higher policymaking position, if such an employee is entitled to an immediate nonforfeiture annual retirement benefit...which equals in aggregate at least $44,000.

But this exception doesn't come into play in most downsizing circumstances. The courts have limited the definitions of "executive" and "higher policymaking position" to the highest echelon of executives. The terms don't apply to middle-level managers.

Benefits for older employees

The ADEA requires employers to provide workers with equal benefits except when they can show there are special age-related costs, such as higher insurance premiums.

The law permits "bona fide seniority systems" as well as "any bona fide benefit plan such as retirement, pension or insurance plan which is not a subterfuge to evade the purposes of this Act...."

More and more companies review their retirement plans. Companies may offer financial planning to encourage workers not to rely on social security or the company for retirement but to plan for themselves.

You can't stop benefits arbitrarily at a certain age

"It amazes me that companies still have disability policies that shut off benefits at age 70," says a Texas-based human resources consultant. "An employer cannot still do that. If you implement that kind of policy, you are liable." This observation applies even if the decision comes from your insurance company rather than your own handbook.

In the 1989 decision *Public Employees Retirement System of Ohio v. Betts*, the Supreme Court considered the applicability of the ADEA to retirement systems. The 7-2 ruling invalidated the need for employers to show cost justification for age-based differences in employee benefits.

June Betts was employed as a speech pathologist by the Hamilton County Board of Mental Retardation and Developmental Disabilities. Betts was covered by the Public Employees Retirement System of Ohio (PERS). This system provided two types of retirement.

First, the age-and-service retirement benefits were available to employees who had:

- at least five years of service and were 60 years old,

- 30 years of service regardless of age, or

- 25 years of service and were 55 years old.

Second, the disability retirement benefits were available to employees who suffered permanent disability with at least five years of service and were under 60 years old.

In 1976, PERS modified the disability retirement plan so payments made to a retiree would be no less than 30 percent of that person's final average salary. Under the particular factual situation in this case, Betts retired due to Alzheimer's disease.

She was forced to retire under the age-and-service plan rather than the disability plan because she was 61 years old. As a result, her retirement benefits were almost $200 a month less than the amount guaranteed under the disability plan's 30 percent of the final salary.

Under a 1979 Department of Labor bulletin, an exemption to ADEA was available under Section 4(f)(2) of the Act if an employer could show that age-based differences in employee benefits had a cost justification.

The Supreme Court examined the age-based distinction between the two types of PERS Ohio retirement plans. It concluded that these plans were bona fide and subject to the section 4(f)(2) exemption from the ADEA if they were not "a subterfuge to evade the purposes" of the Act.

The Court rejected Betts's argument that any age-based distinction in a retirement plan was a subterfuge unless there was an economic justification for the distinction. Instead, it applied the plain meaning of the word subterfuge to be "a scheme, plan, stratagem, or artifice of evasion."

Justice Kennedy, writing for the Court's majority, concluded:

"By requiring a showing of actual intent to discriminate in those aspects of the employment relationship protected by the provisions of the ADEA, section 4(f)(2) redefines the elements of a plaintiff's prima facie case instead of establishing a defense to what otherwise would be a violation of the Act. Thus, when an employee seeks to challenge a benefit plan provision as a subterfuge to evade the purposes of the Act, the employee bears the burden of proving that the discriminatory plan provision actually was intended to serve the purposes of discriminating in some nonfringe-benefit aspect of the employment relation."

Betts is important because the Supreme Court addressed the application of the section 4(f)(2) exemption in a factual setting involving a retirement plan modified after the adoption of the ADEA. Specifically, the Court cited the section 4(f)(2) exemption of the ADEA:

> [It is not unlawful for an employer] to observe the terms of...any bona fide employee benefit plan such as a retirement, pension, or insurance plan, which is not a subterfuge to evade

The employee has to prove subterfuge

the purposes of this chapter, except that no such employee benefit plan shall excuse the failure to hire any individual, and no such...employee benefit plan shall require or permit the involuntary retirement of any individual...because of the age of such individual.

The decision made it easier for employers to plan benefits that scale back programs. An example: If an employer offers life insurance to compensate for premature death, when an employee reached retirement age it would be possible to end this benefit.

Betts shifted the burden of proof to the employee. Only when an employee can prove that an age-based difference in employee benefits is a subterfuge being used to discriminate in areas (such as hiring, firing, promotion or wages) that are not related to fringe benefits can the employee challenge a plan's provision.

The employer no longer has to establish that an age-based distinction in a retirement, pension, or insurance plan is justified on the basis of cost. Thus, businesses' exposure to an employee's claim of age discrimination is reduced.

This doesn't mean you can freely manipulate benefits for older workers downward. In an important 1988 ruling, a federal district court in California ruled that the Farmers Group insurance companies had engaged in age discrimination by limiting payments to employees working beyond age 65.

The EEOC supported the suit on behalf of 53 workers who claimed only to have lost earnings from Farmers' profit-sharing plan. AARP represented another 31 workers who claimed they were denied payments from both the profit-sharing and pension plans.

Farmers' policy held that when workers turned 65 their retirement benefits would freeze. This meant older workers did not receive profit-sharing payments, losing an annual bonus that typi-

cally amounted to 15 percent of their salary. Nor did they get credit under Farmers' pension plan for years worked beyond their 65th birthday, in some cases cutting their pensions nearly in half.

Farmers argued that its policies fit within the section 4(f)(2) exemption. But the court didn't agree. It awarded over $1.5 million to the older workers.

Three years later, in August 1991, the Ninth Circuit Court of Appeals upheld the judgment. The appellate court concluded that the Farmers Group "embraced every opportunity to restrict benefits for older workers and ultimately went too far" by "driving them into retirement."

What constitutes a pension benefit?

Other court decisions have extended the definition of what counts as a protected pension benefit under ADEA to include things like corporate savings plans. The 1983 case *Jackson v. Shell Oil Company* considered this kind of issue.

Lawrence Jackson was employed as a sales representative in Shell's animal health business when Shell sold the business to Diamond Shamrock Corporation in 1979. As part of the acquisition, Diamond Shamrock agreed to employ most of the employees with comparable salaries, benefits and seniority.

Because Diamond Shamrock agreed to hire them, Shell planned to terminate the animal health sales personnel (with the exception of one young woman who wanted to transfer out of sales).

When asked by other employees about the possibility of transfers within Shell, the executive overseeing the transaction allegedly said: "The reason we cannot transfer you into other departments and divisions in Shell is because we can go out and hire younger people, better qualified, from colleges and universities and pay them $16,000 rather than $30,000."

When asked if animal health sales personnel could put in applications for re-employment, the same

A case of blatant age discrimination

executive allegedly said: "...remember, you will be put into the same pile as the younger people from colleges and universities that we can hire for $16,000."

In the same meeting, a Diamond Shamrock executive told the employees that Diamond would continue to employ them in "essentially their current jobs." Jackson asked the Diamond Shamrock executive for assurance that the new company would not demote him, terminate him, or reduce salary. The executive said he couldn't give that kind of assurance.

Jackson later told his immediate supervisor that he wasn't interested in working for Diamond Shamrock. His supervisor—and several other supervisors—tried to convince Jackson to change his mind and make the transition to the new company.

Jackson didn't listen. He passed up meetings with Diamond Shamrock managers during the transition period because the new company's benefits—especially its savings plan—were not comparable to those he had received from Shell. Jackson worried that, because of his age and high salary, Diamond Shamrock might fire or demote him.

Jackson made repeated requests to transfer out of the division being sold to Diamond Shamrock. All were denied. Only one animal health sales rep—Ann Wendell, a 30-year-old woman with an indifferent record of performance during two-and-a-half years with Shell—transferred to another division.

Jackson was 43, had 12 years experience with Shell and was making $28,000. His work was highly regarded. He had been a senior sales rep for two years and had trained other salespeople.

He was fired in April 1979. Following his discharge, Jackson tried to get other comparable sales work in the local area but was only offered entry level positions. Because he had a real estate license, he decided to go into that field. But he wasn't able to match his salary at Shell. In February 1980, he sued Shell under the ADEA.

Shell's defense was—among other things—that Diamond Shamrock's desire to buy the animal health division as a "going concern" necessitated that sales staff go with the business. To transfer a salesperson upon request would have encouraged others to make same request and thus undermine Diamond Shamrock's purpose in making the purchase.

Jackson argued that Shell's explanation was pretextual because, if not for his age, his request for transfer would have been granted. He pointed to the transfer of Wendell as evidence that Shell's reasons were unworthy. He also pointed to the comments made by the Shell executive as evidence that age was more likely the actual reason Shell refused his transfer requests.

An Oregon jury determined that Jackson's refusal to accept the job with Diamond Shamrock was reasonable. Shell appealed. The appeals court supported the district court's verdict.

The appeals court looked to the fact that, of the two employees who requested transfers, "the one who was less qualified, had less experience, and was substantially younger was transferred, while the other—highly qualified and the most experienced in the department but also oldest—was not. This is substantial evidence of pretext that 'a reasonable mind might accept as adequate to support [the] conclusion,' that but for Jackson's age his request for transfer would have been granted."

Mandatory retirement

You can base a mandatory retirement age on a bona fide occupational qualification. But, if you do this, you have to prove that the age limit is reasonably necessary to the essence of the business. You also have to prove either that all people excluded from the job are in fact disqualified or that some possess a disqualifying trait that can't be measured except by reference to age.

If you claim that a mandatory retirement age is based on concern for public safety, you have to

Age must be a legitimate proxy

prove that it does indeed effectuate that goal—and that there is no acceptable alternative which would better or equally advance it with less discriminatory result.

The 1985 Supreme Court decision *Western Air Lines v. Criswell* reiterated when mandatory retirement ages are allowed under ADEA.

Western Air Lines operated a variety of aircraft, some of which required three crew members in the cockpit: captain, first officer and flight engineer. It required that flight engineers retire at age 60.

Generally, flight engineer was the only cockpit assignment available to people over 60. The Federal Aviation Administration prohibited people over that age from serving as pilot or first officer on commercial flights. To defend this policy, the FAA cited the theory that "incapacitating medical events" and "adverse psychological, emotional, and physical changes" occur as a consequence of aging. However, the FAA had not established a mandatory retirement age for flight engineers.

Charles Criswell had reached his 60th birthday in the early 1980s. The collective bargaining agreement between Western and its pilots' union allowed cockpit crew members to obtain open positions by bidding in order of seniority. Criswell applied for reassignment as a flight engineer to avoid mandatory retirement.

Western denied his request, reasoning that Criswell was a member of its retirement plan—which required all crew members to retire at age 60. He sued.

The trial jury held that Western's mandatory retirement rule did not qualify as a bona fide occupational qualification—even though it had been adopted for safety reasons. It held for Criswell and awarded damages. The airline appealed, arguing that jury instruction on the BFOQ defense was insufficiently deferential to its legitimate concern for the safety of its passengers.

The appeals court found no merit in Western's

BFOQ defense to the mandatory retirement rule. It ruled that "to make a bona fide occupational qualification defense, an employer must establish that age is a legitimate proxy for safety-related job qualifications and that it is impossible or highly impractical to deal with older employees on an individualized basis." It ruled that Western had not done this.

Western pressed the case to the Supreme Court, arguing that a flight engineer does have critical functions in emergency situations and would cause havoc if he or she had a medical emergency.

Western relied on two different kinds of job qualifications to justify its mandatory retirement policy. First, it argued that flight engineers should have a low risk of incapacitation or psychological and physiological deterioration. On a more specific level, Western argued its flight engineers had to meet the same performance standards as its pilots. It was therefore logical to extend the FAA's age-60 retirement rule for pilots to flight engineers.

Criswell argued that physiological deterioration is caused by disease, not aging. He maintained that it is possible to determine—on basis of individual medical examinations—whether cockpit crew members, including those over 60, are physically qualified to fly.

He went on to point out that Western had been able to deal with health problems of pilots on an individual basis. Certain pilots grounded because of alcoholism or cardiovascular disease had been recertified by the FAA and allowed to resume flying.

Also, other large commercial airlines had employed flight engineers over the age 60 without any reduction in their safety records.

The Supreme Court held that the FAA, Western and other airlines had recognized that the qualifications for flight engineer were less rigorous than those required for pilot. It noted that "half the pilots flying in the U.S. [are] flying for major airlines which don't require second officers to retire at the

Airline stresses "critical functions"

133

"A substantial basis" for comparing jobs

age of sixty, and...there are over 200 such second officers currently flying on wide-bodied aircraft."

Finally, the high court concluded, "Unless employer can establish a substantial basis for believing that all or nearly all employees above an age lack the qualifications required for the position, the age selected for mandatory retirement less than 70 must be an age at which it is highly impractical for the employer to insure by individual testing that its employees will have the necessary qualifications for the job."

It upheld the verdict for Criswell.

An important side-effect of the ADEA lawsuits that proliferated through the 1970s and 1980s: mandatory retirement policies fell all over the country. Utah, Maine, California, Florida and New Hampshire eliminated mandatory retirement in state and local government and the private sector. Nationally, the mandatory retirement age was raised to 70 for private employees and virtually eliminated for federal workers under 1978 amendments to the ADEA.

But, as the 1990s have developed, this trend is being reversed. In February 1995, congress's Economic and Educational Opportunities Committee approved legislation that permitted states and localities to set mandatory retirement ages for public safety workers such as police and firefighters. (Congress had exempted public safety workers from the ADEA in 1986 because of the physically and mentally demanding nature of their jobs, but the exemption had expired at the end of 1993.)

Ted Bobrow, a Washington spokesman for the AARP, said the bill could force the retirement of workers who still can perform their duties. "People of all ages need to be judged by their ability to do the job," he said. A better approach would be to develop ways to assess workers' abilities as they age, he said—reflecting the Supreme Court's conclusion in *Criswell v. Western Air Lines*.

Although the AARP opposed the bill, it attracted bipartisan support on the committee. Under the

bill, public safety workers would be permanently exempt from ADEA, which would allow local law enforcement agencies and fire departments to set mandatory retirement ages for their employees.

Advocate groups like the AARP stress the need for employing people longer—to lessen their dependence on federal programs like Social Security and Medicare. These groups complain about stereotypes that older workers are more expensive, unadaptive and troublesome.

Retirement policies and pensions

Sometimes, employers will set mandatory retirement policies because having lots of older workers negatively impacts pension benefit funds. This raises far more difficult issues. The 1982 case *EEOC v. Home Insurance Company* is a good example.

Since 1948, Home had maintained a noncontributory retirement plan for its employees. Under the terms of the plan that were in effect until December 1973, the "normal retirement age" (i.e., the age at which an employee was allowed to retire and receive full pension benefits without actuarial reduction) was 65. The mandatory retirement age was also 65.

The plan allowed employees to retire between the ages of 55 and 65 at reduced pensions. During the period 1969 through 1972, a substantial number of Home employees had opted for early retirement with reduced pension benefits. The average age of such early retirees was under 62.

In response, Home amended its plan—effective January 1974—to lower both the normal and the mandatory retirement ages from 65 to 62. The amount of pension benefits, which accordingly became payable at age 62, was increased.

The earliest age at which an employee could retire early with reduced benefits remained 55, and the percentages of accrued benefits payable to those who retired early were increased.

A big insurer juggles benefits—and wins

In December 1978, the EEOC, after receiving a complaint from a Home employee and attempting informal negotiations with Home, commenced a lawsuit. It argued that Home had violated ADEA by lowering the mandatory retirement age from 65 to 62.

Home answered that, in enforcing the lower mandatory retirement age, it was simply observing the terms of a bona fide employee retirement plan and hence was acting lawfully under ADEA. It also argued that in lowering the mandatory age it had acted in good faith reliance on, and in conformity with, interpretations of the ADEA by the Wage-Hour Administrator of the Department of Labor.

The EEOC contended that Home's action was not protected by the ADEA because its actions were "mere subterfuge to evade compliance with the Act," and that the good faith reliance defense was not available to Home because its action was not in conformity with the administrative rulings to which Home pointed.

A federal trial court in New York rejected the EEOC's charges and dismissed the lawsuit. The EEOC appealed.

The appeals court focused on the question: Was Home's lowering of its mandatory retirement age for employees subterfuge to evade compliance with ADEA?

Home maintained that it lowered normal and mandatory retirement ages because of a legitimate business issue—namely, that "spontaneous early retirements" left it with no adequately trained employees to fill vacated positions.

Home told its employees that lowering the mandatory retirement age would quicken the pace of promotional advancement. It also said that advancement would add substantially to each individual employee's retirement income.

The trial court had found this argument valid. It believed that, by lowering both mandatory and normal retirement ages to 62, Home hoped to avoid

aggravation of the preexisting problems and also to take steps toward reducing the original difficulties.

The appeals court also found this argument plausible.

"Since unpredictable retirements occurred between ages 62 and 65, now all would occur at fixed predictable dates related to employees," the appeals court concluded. "Since many of its employees were already retiring early...retirements that previously had occurred unpredictably between the ages of 62 and 65 presumably would now all occur at fixed predictable dates...."

Generally, the trend against mandatory retirement policies seeks to end so-called "golden handshake" incentives, which encourage older workers to leave. But the statistics indicate that, in the 1990s, use of these plans has actually increased.

It's ironic. As government has stepped up protections, the exodus of older workers has accelerated. Most companies are willing to pay exit bonuses as a kind of insurance against possible age discrimination suits by ex-employees.

Walter Connolly, a Washington D.C.-based attorney who works with employers in age discrimination suits, defends such "preventive maintenance work." He says, "There's no such thing as a jury of your peers if you're a corporation."

Few workers—most of them in service industries and government—make it beyond the traditional retirement age of 65. A report from the U.S. Senate's Special Committee on Aging has found that, "Out of 27 million people over the age of 65, fewer than 3 million (11 percent) are in the work force. That number hasn't changed in three decades, even though the size of the older population has grown. It's like the nation has set a quota: We've got room for 3 million and that's it."

Legal strategies

So, what do you do if you're faced with an ADEA claim?

Lawyers complain that ADEA is an "empty promise"

The AARP receives about 100,000 requests each year for a guidebook which explains age discrimination laws. But most people who seek such information never file formal complaints, in part because of the odds against winning.

"It's an empty promise," says AARP lawyer Sally Dunaway. "We have great law, but there is no way in reality to get recourse because very few people can hire attorneys" for court cases, "and the EEOC [doesn't] have enough attorneys to represent everyone who has been discriminated against."

Activists for older workers make a familiar argument about how discrimination occurs. They say that employers, who know they can't act blatantly, find indirect ways to discriminate. One AARP manager reflects this perspective: "[Employers] demote people. Encourage them out. And there is a lot of age harassment—people have their assignments taken away, or their support help."

In terms of the insurability of age discrimination lawsuits, some employers find coverage under employment practices liability policies. But the majority of discrimination claims still fall under general liability policies.

Historically, discrimination has not been covered under commercial general liability policies because it doesn't involve property damage or bodily injury. But lawyers for angry employees look for ways to make their complaints reach into insurance coverage.

Some courts have ruled that the mental distress which accompanies discrimination is a "bodily injury," which can trigger coverage under a standard CGL policy. Also, some age discrimination lawsuits include common law liability issues like negligence and slander. These charges are often covered under a personal injury endorsement to the CGL policy.

Age discrimination claims—like other discrimination issues—also lend themselves to class actions. "I'm told by the people themselves age discrimination is rampant and companies have learned how

to get around it," says Lorraine Clark, work force programs representative for the AARP's Texas regional office.

As we've noted before, ADEA claims also mix well with other discrimination claims. Clark continues: "We know for a fact you do better if you have a class action or if you can combine more than one factor" such as race or sex discrimination.

A good procedural example of an ADEA claim came in the 1986 case *Williams v. Edward Apffels Coffee Company.* It combined age and race discrimination claims.

Between 1979 and 1981, Arnold Williams—an elderly black male—worked intermittently as a temporary or "casual" employee of Apffels, a San Francisco Bay Area gourmet food company. Williams asked to be considered for permanent work on at least three occasions. In each case, Apffels hired someone other than Williams for the permanent position.

Williams' last request for permanent employment occurred when he was hired to fill in for a regular employee who was dying of cancer. Williams claimed that the plant foreman told him that he would eventually be hired on a permanent basis. Williams also claimed that the foreman demanded a cash kickback in exchange for the promise of permanent employment—which Williams paid.

After the regular employee died, Apffels hired someone other than Williams as a permanent replacement.

Williams filed a complaint against Apffels with the California Department of Fair Employment and Housing, alleging discrimination on the basis of race and age. The EEOC, under a work-sharing agreement it had with the state agency, investigated Williams' complaint. It found insufficient evidence to sustain a discrimination charge. It issued Williams a right-to-sue letter.

Williams filed a complaint against Apffels and two line managers, alleging employment discrimina-

tion based on race and age. The company filed a motion for summary judgment dismissing the charges—which the court granted. Representing himself, Williams appealed that judgment.

He claimed disparate treatment rather than disparate impact. Disparate treatment claims under the ADEA are analyzed according to the same standard used to analyze disparate treatment claims under Title VII of the Civil Rights Act of 1964. Williams easily satisfied three of those requirements. First, as a person over forty, he belonged to a class protected by the ADEA. Second, he had applied to Apffels for available permanent jobs as a "packer" and as a "mechanic." Third, despite being qualified—by the admission of Apffels own managers—Williams had been rejected for both jobs.

The court made a less direct interpretation of the circumstances to find that Williams met the final requirement. Because he had been part of a pool of temporary workers from which Apffels had chosen a permanent employee, the court ruled that the job did not "remain open" after Williams' rejection. The court admitted this reading was a stretch, but concluded that the "Supreme Court did not intend that the...requirements be read inflexibly. Williams does not have to show that any discrete period of time elapsed between the moment he was rejected and the moment someone else was hired; it is enough, for purposes of the fourth...requirement, that the position remained open after the qualified candidate applied for the job, and that someone else was ultimately selected."

Williams had shown that: the packer's job was declared open on June 26, 1981, but not filled until August 10, 1981; and he was considered an applicant for the job during that entire period.

The appeals court found that Williams was clearly within a protected group and had suffered an adverse employment decision. Williams satisfied the *McDonnell Douglas v. Green* standards and had established facts that created an inference of dis-

crimination. He had therefore established the "causal connection" required for a prima facie case under the California Fair Employment and Housing Act. The burden shifted to Apffels to offer a nondiscriminatory reason for not hiring Williams.

Apffels claimed that it had hired someone other than Williams as a packer because the other candidate was "more qualified" and that it had not hired Williams as a mechanic because of his "lack of prior job related requirements."

So, Williams had to prove that Apffels' reason was a pretext.

Williams was not required to offer additional evidence, beyond that offered to establish his prima facie case, in order to prove pretext. However, he offered copies of: the employment applications submitted to Apffels by the five people Apffels hired over him; and Apffels' salary records for those five employees. These documents revealed a great deal of specific factual information about the five individuals Apffels had hired instead. The group consisted of:

- a 20-year-old white male with no work experience, He was the son of the shop foreman Williams claimed had demanded a kickback in exchange for a permanent job;

- a 24-year-old white male with one previous job in general construction and two installing hot tubs. He was a personal friend of the shop foreman's son;

- a 19-year-old Hispanic male who had had one previous job as a cabinet maker. He was a relative of an Apffels employee;

- a 40-year-old white male with experience in maintenance and installing insulation. He was a relative of another Apffels employee; and

- a 33-year-old Hispanic male with experience in shipping and receiving for a food producer. He was a personal friend of several Apffels employees.

A kickback scheme for assigning work

Williams argued that this information raised factual questions about whether Apffels' explanation for not hiring him was pretextual. The court agreed that the hiring of young men with little experience—and, in most cases, relatives of Apffels employees—raised questions about whether hiring decisions were, as Apffels had asserted, "made on merit alone."

"By contrast, Apffels produced scant evidence in support of its motion for summary judgment," so the appeals court overturned the lower court's decision on the discrimination claims.

That left Williams' fraud claims related to the alleged kickback scheme the shop foreman had initiated. The lower court had rejected this claim because Williams had no contract or other written evidence of the alleged promise.

Though he didn't have a written contract, Williams did have an interesting witness. He submitted the sworn affidavit of Art Ordonez, who worked in a liquor store patronized by both Williams and the shop foreman. Ordonez stated that every Friday, which was Apffels' payday, Williams came into the liquor store and purchased two fifths of Early Times whiskey. He left the bottles with Ordonez, with instructions to give them to the shop foreman. Ordonez kept the bottles on a shelf below the counter and gave them to the shop foreman when he came in later and asked for them.

The appeals court found that this testimony tended to support William's allegation of a kickback arrangement. The "alleged facts which, if true, state an adequate claim for fraud and deceit," it concluded. The appeals court ordered the lower court to reconsider the fraud charges.

The fact that you haven't replaced an employee with a younger employee isn't necessarily fatal to his or her claim. Replacement by an older employee suggests no discrimination, unless there is other direct or circumstantial evidence to support an inference of discrimination.

Conclusion

Complying with age-discrimination laws is relatively easy, compared with other workplace diversity issues. And the broad applicability of these laws should give you a strong incentive to comply. Everyone can be over 55—so everyone relates to older workers.

The main difficulty in complying with age discrimination law is that federal ADEA starts protecting employees at age 40. That means a lot of people in the prime of their careers qualify as a protected group. This is particularly true of white-collar and service-industry workers.

More specifically, you'll probably want to consider the following points when considering age discrimination issues:

- Educate your managers about the Age Discrimination in Employment Act. Make it clear that all company policies and practices—as well as informal communications—comply with the law.

- Consider making policies to slow work-induced stress and encourage effective stress management. These issues are important to everyone, but are especially common in age discrimination claims.

- Offer benefits. General efforts to make the workplace comfortable for older workers—including retraining programs and flexible work schedules—can do more to mitigate claims than case-specific damage control.

- Consider management alternatives like horizontal transfers that open positions for younger workers while refocusing older workers through new training and challenges. Also, consider rotating employees through top positions, giving younger workers experience without shutting down older people.

- When interviewing older job applicants, avoid questions like: "How would you feel working with so many younger individuals?" or "Would

ADEA protection begins at 40 years of age

Document carefully and avoid jargon

you really be interested in starting all over again?" or "Do you have up-to-date job skills?"

- Avoid jargon like "You're overqualified" or "We need high-energy individuals" or "You have so much experience...."

- Make sure your hiring, management and firing processes are perceived as fair by all employees. Companies that give little thought to managing their communications are more likely to be involved in litigation.

- Permit employees to appeal. Appeals are generally informal and handled by the human resources department.

- Document early-retirement plans carefully. You need to establish clearly that your plans are voluntary and that employees have at least seven days to consider them. Avoid any sense of coercion.

- Make sure anything you call "layoffs" are only for legitimate business purposes and aren't a pretext for getting rid of someone.

- Consider how you structure layoffs. Legitimate business purpose may be easier to prove when an entire department is being eliminated, rather than a percentage of the overall work force.

- Know the health-related cost benefits issues of older workers. Fringe benefits—especially health care—become more important to older workers.

You don't have to do all of this yourself. Explore community resources available to your older workers. As is true for other diversity issues, don't hesitate to make the first move in contacting public agencies and special interest groups. You may think of them as being unsympathetic to your perspective—and they may be. But they usually have information and services useful to the relevant parts of your work force.

CHAPTER 3:

RACE, ETC.

Introduction

The broadest, and most general, of all workplace
diversity laws is Title VII of the Civil Rights Act of
1964. It applies to the greatest number of work-
ers. It also sets the legal and procedural frame-
work that other diversity law follows—either di-
rectly or generally.

The Supreme Court, in its 1971 decision *McDonnell
Douglas v. Green*, made its most basic argument
for Title VII:

> There are societal as well as personal interests
> on both sides of [the employer-employee] equa-
> tion. The broad, overriding interest, shared by
> employer, employee, and consumer, is efficient
> and trustworthy workmanship assured through
> fair and racially neutral employment and per-
> sonnel decisions. In the implementation of such
> decisions, it is abundantly clear that Title VII
> tolerates no racial discrimination, subtle or oth-
> erwise.

The Supreme Court has also written that Title VII's
primary purpose is "to assure equality of employ-
ment opportunities and to eliminate those discrimi-
natory practices and devices which have fostered
racially stratified job environments to the disad-
vantage of minority citizens."

That's a reasonable goal. Equal opportunity forms
the basis of just about any comprehensive work-
place diversity program. The problem is that the

interpretation of the law hasn't stopped at merely assuring equal opportunity.

In the *McDonnell Douglas* ruling, the Supreme Court also ruled that, to achieve the purpose of equal opportunity, Congress "proscribe(d) not only overt discrimination but also practices that are fair in form, but discriminatory in operation."

This gets to the problem that most employers face with workplace diversity issues: You can still be found guilty of wrongdoing, even though your actions aren't "overt."

If you've faced diversity problems already, you know how difficult issues of other-than-overt discrimination can be. Not only is the letter of the law extremely complicated in these contexts, but spirit of the law is unclear. Enforcement officials and regulators don't always agree on what Title VII means in a given situation. Imagine the confusion that an aggressive lawyer can cause.

The 1981 Supreme Court case *Texas Department of Community Affairs v. Burdine* set significant precedent for how employers can respond to Title VII claims. Next to *McDonnell Douglas, Burdine* is the most often-cited Title VII case.

The Texas Department of Community Affairs (TDCA), hired Joyce Ann Burdine in January 1972, for the position of accounting clerk in the Public Service Careers Division (PSC). PSC provided training and employment opportunities in the public sector for unskilled workers. When hired, Burdine possessed several years' experience in employment training. She was promoted to Field Services Coordinator in July 1972. Her supervisor resigned in November of that year, and Burdine was assigned additional duties. Although she applied for the supervisor's position of Project Director, the position remained vacant for six months.

PSC was funded completely by the United States Department of Labor. The Department was seriously concerned about inefficiencies at PSC.

In February 1973, the Department notified the Executive Director of TDCA, B. R. Fuller, that it

would terminate PSC the following month. TDCA officials, assisted by Burdine, persuaded the Department to continue funding the program, conditioned upon PSC's reforming its operations. Among the agreed conditions were the appointment of a permanent Project Director and a complete reorganization of the PSC staff.

After consulting with personnel within TDCA, Fuller hired a male from another division of the agency as Project Director. In reducing the PSC staff, he fired Burdine along with two other employees, and retained another male as the only professional employee in the division.

Burdine had maintained her application for the position of Project Director and had requested to remain with TDCA. Burdine soon was rehired by TDCA and assigned to another division of the agency. She received the exact salary paid to the Project Director at PSC, and the subsequent promotions she has received have kept her salary and responsibility commensurate with what she would have received had she been appointed Project Director.

Burdine filed suit in federal district court, alleging that the failure to promote and the subsequent decision to terminate her had been based on gender discrimination in violation of Title VII.

The court relied on the testimony of Fuller that the employment decisions necessitated by the commands of the Department of Labor were based on consultation among trusted advisers and a non-discriminatory evaluation of the relative qualifications of the individuals involved. He testified that the three individuals terminated did not work well together, and that TDCA thought that eliminating this problem would improve PSC's efficiency.

The court accepted this explanation as rational and found no evidence that the decisions not to promote and to terminate Burdine were prompted by gender discrimination. She appealed.

The Court of Appeals affirmed the District Court's finding that Burdine was not discriminated against

Preferring a man to an equally qualified woman

147

Setting up the shifting burden of proof

when she was not promoted. However, it reversed the District Court's finding that Fuller's testimony sufficiently had rebutted Burdine's prima facie case of gender discrimination in the decision to terminate her employment at PSC.

The appeals court reaffirmed that the employer charged with discrimination in a Title VII case bears the burden of proving by a preponderance of the evidence the existence of legitimate nondiscriminatory reasons for the employment action. The employer also must prove by objective evidence that those hired or promoted were better qualified than an employee or applicant not chosen.

The court found that Fuller's testimony did not carry either of these burdens. Therefore, it reversed the judgment of the trial court and sent the case back for computation of back pay.

Because the decision of the appeals court about the burden of proof borne by the employer conflicted with interpretations of precedents adopted by other appeals courts, the Supreme Court agreed to consider the case.

The Supreme Court focused on the following issues: After the employee has proved a prima facie case of discriminatory treatment, does the burden shift to the employer to persuade the court by a preponderance of the evidence that legitimate, nondiscriminatory reasons for the challenged employment action existed? What sort of burden does the employer have?

To satisfy this intermediate burden, the employer need only produce evidence which would allow a court to conclude that the employment decision had not been motivated by discriminatory animus. "The Court of Appeals would require the [employer] to introduce evidence which, in the absence of any evidence of pretext, would persuade the court that the employment action was lawful," the Supreme Court wrote. "This exceeds what properly can be demanded to satisfy a burden of production."

The Supreme Court held that, when an employee has proved a prima facie case of discrimination,

an employer bears only the burden of explaining the nondiscriminatory reasons for its actions. It does not bear a burden of persuading the court by a preponderance of the evidence that nondiscriminatory reasons for the challenged employment action existed. In legal terms, a "preponderance of evidence" is a difficult thing to establish.

Also, the court ruled there is no requirement that the employer hire a minority or female applicant whenever that person's objective qualifications are equal to those of a white male applicant.

Most important, the court concluded:

> Title VII does not demand that an employer give preferential treatment to minorities or women. It does not require the employer to restructure his employment practices to maximize the number of minorities and women hired. Title VII gives the employer the discretion to choose among equally qualified candidates, provided the decision is not based upon unlawful criteria.

In short, the high court ruled that—despite technical details—the ultimate burden of proving that an employer intentionally discriminated against an employee remains at all times with the employee. It defended this conclusion on three points.

First, the employer's explanation of its legitimate reasons must be clear and reasonably specific. Second, although the employer does not bear a formal burden of persuasion, it does have an incentive to persuade the court that the employment decision was lawful. Third, the liberal discovery rules applicable to any civil suit in federal court are supplemented in a Title VII suit by the employee's access to the EEOC's investigatory files concerning the complaint.

Given these factors, the court felt the employee wouldn't find it particularly difficult to prove an employer's explanation pretextual. Finally, it ruled: "The fact that a court may think that the employer misjudged the qualifications of applicants does not expose him to Title VII liability."

The essential language of Title VII

Throughout this chapter, we'll look at exactly what Title VII says and how the federal courts have interpreted its meaning. While opinions may vary on fine points, the fundamental rules of compliance with this law do emerge.

Despite all the intricate and complicated analysis that has been heaped on top of this law, it has a very basic core. Consider Title VII's most essential language:

It shall be an unlawful employment practice for an employer

1) to fail or refuse to hire or to discharge any individual, or otherwise to discriminate against any individual with respect to his compensation, terms, conditions, or privileges of employment, because of such individual's race, color, religion, sex, or national origin; or

2) to limit, segregate, or classify his employees or applicants for employment in any way which would deprive or tend to deprive any individual of employment opportunities or otherwise adversely affect his status as an employee, because of such individual's race, color, religion, sex, or national origin.

That's an understandable premise. Keep it in mind as you read through the rest of this book.

Legislative and political history

The Civil Rights Act of 1964 was preceded by the federal Civil Rights Act of 1866. This older law, passed soon after the end of the Civil War, was designed to protect newly-freed slaves from unfair treatment in business or other walks of life.

The older law is still called upon in modern discrimination cases. For example, in the 1989 case, *Patterson V. McLean Credit*, the Supreme Court considered an employee's claims of racial harassment under section 1981 of the 1866 Act.

The Civil Rights Act 1866 applies to employers

without regard to number of employees. It is an often-cited element of the federal labor code.

Brenda Patterson, a black woman, worked for the McLean Credit Union as a teller and a file coordinator for over ten years. In July 1982, the credit union fired her. Patterson sued, alleging that she had been harassed, passed over for promotion and ultimately discharged because of her race. In her lawsuit, she cited the 1866 Civil Rights Act, which provides:

> All persons within the jurisdiction of the United States shall have the same right in every State and Territory to make and enforce contracts, to sue, be parties, give evidence, and to the full and equal benefit of all laws and proceedings for the security of persons and property as is enjoyed by white citizens....

The Supreme Court affirmed that the Act did prohibit discrimination in the making and enforcement of private (non-governmental) contracts. However, the Court, in a 5 to 4 decision held that racial harassment is not actionable under the Act. Justice Anthony Kennedy wrote that racial harassment in the employment setting is not technically interfering with making or enforcing a contract.

In an attempt to explain the impact of his conclusion, Kennedy wrote:

> The law now reflects society's consensus that discrimination based on the color of one's skin is a profound wrong of tragic dimension. Neither our words nor our decisions should be interpreted as signaling one inch of retreat from Congress' policy to forbid discrimination in the private, as well as the public, sphere. Nevertheless, in the area of private discrimination, to which the ordinance of the Constitution does not directly extend, our role is limited to interpreting what Congress may do and has done. The statute before us, which is only one part of Congress' extensive civil rights legislation, does not cover the acts of harassment alleged here.

This literal interpretation is an example of what

legal experts call "strict construction" of a law. Even though Kennedy admitted the larger social and political issues involved in a case like Patterson's, he refused to read broad meaning in a narrow law.

Kennedy's decision means that employers are not subject to legal action under the 1866 Act unless the alleged harassment has an adverse impact on an employee's making of or enforcement of a contract. However, more recent civil rights law extends the protections first mentioned in the 1866 Act.

What the law's drafters said

The Civil Rights Act of 1964 was passed into law during a period of heightened tensions among racial groups in the United States. Throughout the initial consideration of the Act, critics charged that it would destroy the workplace and business as Americans knew them.

Some opponents even argued that the language of Title VII—the section of the 1964 Act that deals with employment issues—was a political attempt to socialize U.S. businesses.

But the proponents won the debate by stressing the common-sense intent of the 1964 Act. Minnesota Senator Hubert Humphrey, an avid supporter of the Act, argued that Title VII would:

> ...simply...make it an illegal practice to use race as a factor in denying employment. It provides that men and women shall be employed on the basis of their qualifications, not as Catholic citizens, not as Protestant citizens, not as Jewish citizens, not as colored citizens, but as citizens of the United States.

This is a perspective that you may find useful to remember when you're dealing with Title VII—and all workplace diversity—issues.

Right away, one of the key issues raised in Title VII cases was the so-called "pattern or practice" of discrimination that the law sought to eradicate. In many Title VII legal disputes, the various sides would fight over whether an employer's actions

constituted a pattern or practice. And they still do—this remains a key issue today.

The "pattern or practice" language in Title VII was not intended as a term of art, and the words reflect only their usual meaning. Again, Senator Humphrey explained:

> [A] pattern or practice would be present only where the denial of rights consists of something more than an isolated, sporadic incident, but is repeated, routine, or of a generalized nature. There would be a pattern or practice if, for example, a number of companies or persons in the same industry or line of business discriminated, if a chain of motels or restaurants practiced racial discrimination throughout all or a significant part of its system, or if a company repeatedly and regularly engaged in acts prohibited by the statute.
>
> The point is that single, insignificant, isolated acts of discrimination by a single business would not justify a finding of a pattern or practice....

This interpretation of "pattern or practice" appears throughout the legislative history of Title VII and is consistent with the understanding of the identical words as used in similar federal legislation. Nevertheless, an employee who wants to sue you under Title VII will try to find some way to establish that your allegedly discriminatory behavior constituted this kind of pattern or practice.

In 1972, Congress enacted the Equal Employment Opportunity Act, which amends and expands Title VII. The 1972 Act created the Equal Employment Opportunity Commission to enforce workplace anti-discrimination laws (the Justice Department had had that responsibility before).

The EEOC isn't just an enforcement agency—it does some interpretation of anti-discrimination law. However, its interpretations aren't absolutely binding.

At the head of the EEOC is a group of commis-

sioners, appointed by the president. These commissioners decide which workplace anti-discrimination laws the agency will emphasize—and how it will do so. The "how" in this equation creates some controversy. When Supreme Court Justice Clarence Thomas was head of the EEOC, he changed the agency's approach from partially pursuing every complaint it received to choosing only those complaints that it deemed significant—and pursuing those to legal completion.

In the 1972 Act, Congress also expanded the scope of Title VII to prohibit seniority systems or other management tools that perpetuated discrimination. It also extended Title VII protections to employees of state and local governments.

By the late 1980s, political sentiments in the country had taken a turn toward the conservative and the U.S. Supreme Court had a new chief justice. William Rehnquist—whom Ronald Reagan elevated to the position—began to give a conservative tone to the Court's agenda. In 1989 alone, critics claimed it "drastically rewrote the law of civil rights" in the course of half a dozen decisions (including the Patterson case mentioned earlier in this section).

These claims were probably a little overblown. But they were effective. They put in place a series of congressional bills that—as a group—eventually became the next big step in workplace diversity law.

The Civil Rights Act of 1991 expanded various aspects of existing workplace diversity law. It came in the wake of what some people considered a decade of erosion of civil rights law under presidents Ronald Reagan and George Bush.

The biggest change that the 1991 Act affected: It made jury trials and punitive damages available for Title VII claims. Before passage of the 1991 Act, cases had been heard by federal judges and awards had been limited to back pay and attorney fees.

Small business was first exempted from Title VII

to avoid costly litigation. The initial coverage applied to employers of 100 or more. Through the 1960s and 1970s, that number gradually shrunk to 25 or more employees. Finally, in the wake of the 1991 Act, the number dropped to 15 or more employees.

Some lawmakers said that Congress wanted jury trials in discrimination cases because some members believed federal courts were dominated by white male judges who, in awarding damages to plaintiffs, undervalued the pain and suffering of discrimination or sexual harassment.

1991 revisions added juries, trials, bigger awards

Proponents argue that the 1991 Act caps punitive damages at $300,000 (or less, depending on the number of individuals employed by the employer). But most employers—and all commercial insurance companies—immediately assumed that the change would increase the cost of diversity noncompliance. Some experts even predicted it would double average lawsuit damages.

Whatever the actual effect of the changes, the 1991 Act clearly increased both the risk of being sued for discrimination and the amount of financial damage a judgment could cause.

Among other changes: The 1991 Act allowed courts to compensate for things such as emotional distress. It strengthened the Title VII language outlawing racial and ethnic discrimination—including sexual harassment. It permitted employees who win discrimination cases to recover expert witness and legal fees. It expanded protections to employees of Congress and presidential appointees—and people appointed by elected state officials. It also allowed challenges of seniority systems that effectively locked out people in protected groups.

In passing the 1991 Act, Congress seemed more willing to accept the risk that employers would adopt quotas than either the Supreme Court or the Congress that passed the 1964 Act. It watered down Title VII's original, strong prohibitions against quotas. Even though the law still says that it does not condone quotas, newer language undermines that position.

confusion over the phrase "business necesssity"

In the debate over the 1991 Act, congressional supporters clearly intended the changes in the burden of proof model to effectively regulate the conduct of employers.

In addition to shifting the burden of proof, the 1991 Act mandates that an employer must show that "the challenged practice is job related for the position in question and consistent with business necessity." It also states, somewhat ambiguously, that it intends to "codify the concepts of *business necessity* and *job-related*" that had been central to Supreme Court decisions prior to 1989.

Like the business justification provisions, this provision expands the elements of an unlawful employment practice—and thus increases the legal burdens of employers.

Despite its overall effect, the 1991 Act does try to strengthen some of the anti-quota language of the original Title VII. It prohibits so-called "race-norming"—the practice of adjusting scores of applicants in specified groups to make it easier for members of those groups to qualify for jobs or promotions. The 1991 Act makes it unlawful for an employer "to adjust the scores of, use different cutoff scores for, or otherwise alter the results of employment-related tests on the basis of race, color, religion, sex, or national origin."

Some employers—mostly large ones—have complained that this part of the 1991 Act also works against them. They say that race-norming offers one of the few reliable tools for avoiding disparate impact claims.

"This is a typical example of how ridiculous these laws can be," says a risk manager for a west coast municipal agency. "They create all of these exposures to unintended violations—then they prohibit the management tools that best prevent the problems. Stopping prejudice isn't enough. [Lawmakers] want to program employers how to think."

Prophylactic versus retroactive application

When and how Title VII claims can be made is a key legal issue for workplace diversity.

Some activists—and even some sloppy lawyers—will argue wrongly that Title VII is designed to compensate for discrimination that occurred in the past. People who do this are confusing Title VII anti-discrimination law with affirmative action programs (which we consider in detail in Chapter 6). The problem is that they occasionally convince judges to see things their way.

In *Griggs v. Duke Power Co.*, the Supreme Court concluded that the primary objectives of Title VII were what it called "prophylactic"—to achieve equal employment opportunity and to remove the biases that favor certain employees over others. The law is meant to fix specific, existing problems—not to mete out justice for old ones or to remedy broad societal wrongs.

Griggs concluded that Title VII prohibits "not only overt discrimination but also practices that are fair in form but discriminatory in practice." Under this basis for liability, which is known as the "disparate impact" theory and which is involved in this case, a facially neutral employment practice may be deemed violative of Title VII without evidence of the employer's subjective intent to discriminate that is required in a "disparate treatment" case.

In *Griggs*, a class of utility company employees challenged the conditioning of entry into higher paying jobs upon a high school education or passage of two written tests.

Despite evidence that "these two requirements operated to render ineligible a markedly disproportionate number of Negroes," the appeals court had held that because there was no showing of an intent to discriminate on account of race, there was no Title VII violation.

This landmark opinion established that an employer may violate the statute even when acting in complete good faith without any invidious intent.

Title VII should remove barriers—not right old wrongs

Workers must have "full and fair opportunity" to perform

Griggs ruled that a neutral practice that operates to exclude minorities is nevertheless lawful if it serves a valid business purpose. "The touchstone is business necessity," the Court stressed.

The court wrote that, because "Congress directed the thrust of the Act to the consequences of employment practices, not simply the motivation... Congress has placed on the employer the burden of showing that any given requirement must have a manifest relationship to the employment in question."

Finally, because "Title VII does not...permit [the employer] to use [the employee's] conduct as a pretext for the sort of discrimination prohibited by [law]," the employee "must be given a full and fair opportunity to demonstrate by competent evidence that the presumptively valid reasons for his rejection were in fact a cover up for a racially discriminatory decision."

In a disparate treatment case there is no "discrimination" within the meaning of Title VII unless the employer intentionally treated the employee unfairly because of race. Therefore, the employee retains the burden of proving the existence of intent at all times.

In a disparate treatment case, the employee's initial burden, which is not onerous, is to establish "a prima facie case of racial discrimination," that is, to create a presumption of unlawful discrimination by "eliminat[ing] the most common non-discriminatory reasons for the plaintiff's rejection....The burden then must shift to the employer to articulate some legitimate, nondiscriminatory reason for the employee's rejection."

In contrast, intent plays no role in the disparate impact inquiry. The question, rather, is whether an employment practice has a significant, adverse effect on an identifiable class of workers—regardless of the cause or motive for the practice. The employer may attempt to contradict the factual basis for this effect; that is, to prevent the employee from establishing a prima facie case.

But when an employer is faced with sufficient proof of disparate impact, its only recourse is to justify the practice by explaining why it is necessary to the operation of business. Such a justification is a classic example of an affirmative defense.

The Act itself says:

> "Nothing contained in this subchapter shall be interpreted to require any employer...to grant preferential treatment to any individual or to any group because of the race...or national origin of such individual or group on account of an imbalance which may exist with respect to the total number or percentage of persons of any race...or national origin employed by any employer...in comparison with the total number or percentage of persons of such race...or national origin in any community, State, section, or other area, or in the available work force in any community, State, section, or other area."

This language pretty clearly prohibits reverse-discrimination, quotas and the kind of preferred treatment that is often called "retroactive relief."

However, a number of courts—including the Supreme Court—have interpreted certain retroactive, sweeping elements in Title VII. In its 1975 decision *Albemarle Paper Co. v. Moody*, the Supreme Court ruled that by giving Title VII courts broad discretion Congress intended "to make possible the fashion[ing of] the most complete relief possible," and that federal courts have "not merely the power but the duty to render a decree which will so far as possible eliminate the discriminatory effects of the past as well as bar like discrimination in the future."

The Court believed that retroactive relief for victims of discrimination served this purpose by providing the "catalyst which causes employers to...evaluate their employment practices and to endeavor to eliminate, so far as possible, the last vestiges" of discriminatory practices.

It also ruled that Title VII doesn't need actual acts

A key point: Title VII doesn't mean preferential treatment

Diversity laws may protect people who never applied for a job

of discrimination to occur in order to take effect. It can apply to situations in which people don't apply for jobs or promotions because they're afraid they'll be discriminated against.

This whole area of workplace diversity law is problematic. The best way to avoid it: prevent the kind of claim that invites a judge to poke into the past. This kind of claim usually involves discrimination at the policy level. It also usually involves some degree of publicity or corporate-level expression.

The Supreme Court described this kind of claim in the *Albemarle* decision:

> If an employer should announce his policy of discrimination by a sign reading "Whites Only" on the hiring-office door, his victims would not be limited to the few who ignored the sign and subjected themselves to personal rebuffs.

> ...The same message can be communicated to potential applicants more subtly but just as clearly by an employer's actual practices by his consistent discriminatory treatment of actual applicants, by the manner in which he publicizes vacancies, his recruitment techniques, his responses to casual or tentative inquiries, and even by the racial or ethnic composition of that part of his work force from which he has discriminatorily excluded members of minority groups.

> ...When a person's desire for a job is not translated into a formal application solely because of his unwillingness to engage in a futile gesture he is as much a victim of discrimination as is he who goes through the motions of submitting an application.

> ...The denial of Title VII relief on the ground that the claimant had not formally applied for the job could exclude from the Act's coverage the victims of the most entrenched forms of discrimination. Victims of gross and pervasive discrimination could be denied relief precisely because the unlawful practices had been so successful as totally to deter job applications from members of minority groups.

160

The Court based this conclusion on the theory that a limitation on the powers granted to courts by Title VII would be inconsistent with the "historic purpose" of the law to end discrimination.

If you find yourself in a situation in which people who never applied for jobs are claiming they hesitated because they thought you'd be biased against them, you have some protections in the law.

In the same *Albemarle* decision that opened up this trouble, the Supreme Court also wrote:

> To conclude that a person's failure to submit an application for a job does not inevitably and forever foreclose his entitlement to seniority relief under Title VII is a far cry, however, from holding that nonapplicants are always entitled to such relief.

This person claims that he or she was deterred from applying for the job by your discriminatory practices. That's not easy. To begin, he or she has to prove he or she would have applied for the job had it not been for the alleged practices.

As is generally the case, the 1991 Act takes an even more confusing stand on the issue of retroactive application. As a result, the Supreme Court has had to make more conservative rulings about its application. In 1994, the Court issued two decisions concerning when and how the 1991 Act applies to conduct that predated the law's enactment.

In *Rivers v. Roadway Express, Inc.*, the Court ruled that the section of the 1991 Act that expanded the 1866 Act's prohibition against racial discrimination in making contracts does not apply in cases involving conduct that occurred prior to the passage of the 1991 Act.

In *Landgraf v. USI Film Products*, the Court concluded that the section which gives employees the right to seek compensatory and punitive damages in Title VII cases also does not apply in cases involving preenactment conduct.

In *Landgraf*, the Court found that there was no

clear statement in the text or legislative history of the 1991 Act whether Congress had intended it to apply to cases involving predated conduct. In this regard, the Court noted that one of the most "deeply rooted" rules of legislative construction is the presumption that laws should not be applied retroactively.

The Court went on to say that, because legislatures are influenced by political pressures, they "may be tempted to use retroactive legislation as a means of retribution against unpopular groups or individuals." So, it requires Congress to "make its intention clear" before a statute will be found to have a retroactive effect.

The Court admitted that it's not always easy to determine whether a law applies "retroactively" to a particular case. "A statute does not work retrospectively merely because it is applied in a case arising from conduct [predating] the statute's enactment...or upsets expectations based in prior law."

It noted that punitive damages by their nature "share key characteristics of criminal sanctions" and that retroactive application of such provisions "would raise a serious constitutional question." While compensatory damages "may be intended less to sanction wrongdoers than to make victims whole...they do so by a mechanism that affects the liabilities of [employers]." They would also impose "an important new legal burden" on employers.

Disparate impact

The Supreme Court has acknowledged that Title VII can be violated by "not only overt discrimination but also practices that are fair in form but discriminatory in practice." This is one of the most difficult—and some say most outrageous—aspects of Title VII. Even though an employer has no intention to discriminate, he or she may be liable if neutral practices lead to a discriminatory result.

These disparate impact claims involve employment

practices that are facially neutral in their treatment of different groups but, in practice, treat one group more harshly than another—and cannot be justified by business necessity. Proof of discriminatory motive is not required under a disparate impact theory. For that reason, employment law attorneys love to make these claims.

During the 1980s, the Supreme Court issued rulings that made discrimination more difficult to prove. The Supreme Court's 1989 decision *Wards Cove Packing Co., Inc. v. Atonio* was one of the catalysts for congressional action on civil rights, and many different aspects of that decision were addressed in the resulting legislation.

Wards Cove involved disparate impact claims against two companies that operated salmon canneries in remote and widely separated areas of Alaska. The canneries operated only during salmon runs in the summer months. They were inoperative and vacant for the rest of the year.

In May or June of each year, a few weeks before the salmon runs began, workers would arrive and prepare the equipment and facilities for the canning operation. Most of these workers possess a variety of skills. When salmon runs were about to begin, the workers who would operate the cannery lines arrived and remained as long as there were fish to can.

After the runs, the canneries were closed down, winterized, and left vacant until the next spring. During the off-season, the companies employed only a small number of individuals at their headquarters in Seattle, Washington, and Astoria, Oregon.

Salmon must be processed soon after they are caught—so, the work during the canning season was intense. For this reason, and because the canneries were located in remote regions, workers were housed at the canneries and had their meals in company-owned mess halls.

Jobs at the canneries were of two general types: "cannery jobs" on the cannery line, which were

A complex case defines terms of disparate impact

Claims of racial stratification

unskilled positions; and "noncannery jobs," which fell into a variety of classifications. Most noncannery jobs—machinists, engineers, boat crews, quality control personnel—were classified as skilled positions.

Cannery jobs were filled predominantly by nonwhites: Filipinos and Alaska Natives. The Filipinos were hired through Local 37 of the International Longshoremen's and Warehousemen's Union pursuant to a hiring agreement with the local.

Noncannery jobs were filled predominantly by white workers, hired during the winter months from the companies' offices in Washington and Oregon.

Virtually all of the noncannery jobs paid more than cannery positions. The predominantly white noncannery workers and the predominantly nonwhite cannery employees lived in separate dormitories and ate in separate mess halls.

A class of nonwhite cannery workers who had been employed at the canneries, brought a Title VII action against the Wards Cove companies. The class members alleged that various hiring and promotion practices—including nepotism, a rehire preference, a lack of objective hiring criteria and separate hiring channels—were responsible for racial stratification and denied nonwhites employment as noncannery workers on the basis of race.

The trial court rejected all of the class members' disparate treatment claims. It also rejected the disparate impact challenges involving what it called "subjective" employment criteria used to fill these noncannery positions.

But Wards Cove's "objective" employment practices—including an English language requirement, alleged nepotism, failure to post noncannery openings and the rehire preference—were found to be subject to challenge under the disparate impact theory. These claims were rejected for failure of proof, though.

Judgment was entered for Wards Cove. The workers appealed.

The appeals court allowed the trial court's rejection of the disparate treatment claims—namely, the workers' allegations of intentional racial discrimination.

But it held that disparate impact analysis could be applied to subjective hiring practices. It also concluded that in such a case, "[o]nce the plaintiff class has shown disparate impact caused by specific, identifiable employment practices or criteria, the burden shifts to the employer," to "prov[e the] business necessity" of the challenged practice.

Finally, it ruled that the cannery workers had made a prima facie case for discrimination. Before the case went back to the trial court, the Supreme Court agreed to hear it.

Justice Byron White wrote that statistical evidence showing a high percentage of nonwhite workers in employer's cannery jobs and a low percentage of such workers in noncannery positions did not establish prima facie case of disparate impact in violation of Title VII.

"Although statistical proof can alone make out a prima facie case, the Court of Appeals' ruling here misapprehends our precedents and the purposes of Title VII, and we therefore reverse," it wrote. The "proper comparison [is] between the racial composition of [the at-issue jobs] and the racial composition of the qualified...population in the relevant labor market."

This kind of comparison—between the racial composition of the qualified persons in the labor market and the persons holding at-issue jobs—generally forms the proper basis for the initial inquiry in a disparate impact case. "Alternatively, in cases where such labor market statistics will be difficult if not impossible to ascertain, we have recognized that certain other statistics...are equally probative for this purpose," the court wrote.

It then concluded that, "Measuring alleged discrimination in the selection of accountants, managers, boat captains, electricians, doctors, and

Simple statistics don't always make the case

Employees have to isolate and identify wrongdoing

engineers...by comparing the number of nonwhites occupying these jobs to the number of nonwhites filling cannery worker positions is nonsensical."

The court concluded, "Racial imbalance in one segment of an employer's work force does not, without more, establish a prima facie case of disparate impact with respect to the selection of workers for the employer's other positions, even where workers for the different positions may have somewhat fungible skills (as is arguably the case for cannery and unskilled noncannery workers)."

If the percentage of selected applicants who are nonwhite is not significantly less than the percentage of qualified applicants who are nonwhite, the employer's selection mechanism probably does not operate with a disparate impact on minorities. In any case, "the percentage of nonwhite workers found in other positions in the employer's labor force is irrelevant to the question of a prima facie statistical case of disparate impact," the court wrote.

Concluding on the subject of statistics in Title VII cases, the court cited Justice Sandra Day O'Connor's opinion in the 1988 case *Watson v. Fort Worth Bank & Trust*:

> "[W]e note that the plaintiff's burden in establishing a prima facie case goes beyond the need to show that there are statistical disparities in the employer's work force. The plaintiff must begin by identifying the specific employment practice that is challenged....Especially in cases where an employer combines subjective criteria with the use of more rigid standardized rules or tests, the plaintiff is in our view responsible for isolating and identifying the specific employment practices that are allegedly responsible for any observed statistical disparities."

Perhaps the most important part of the Wards Cove decision came in the court's assertion that a disparate impact claim has to respond to some particular employment practice.

"As a general matter, [an employee] must demon-

strate that it is the application of a specific or particular employment practice that has created the disparate impact under attack," it wrote. "Such a showing is an integral part of the prima facie case in a disparate impact suit under Title VII."

Employees or job applicants who sue under Title VII have to demonstrate that the disparity they complain of is the result of one or more of the employment practices that they are attacking. They should specifically show that each challenged practice has a significantly disparate impact on employment opportunities for whites and nonwhites.

"To hold otherwise," the court wrote, "would result in employers being potentially liable for the myriad of innocent causes that may lead to statistical imbalances in the composition of their work forces."

Wards Cove was a major victory for employers in two respects. First, the decision made it more difficult for employees to establish a prima facie case of disparate impact. The court concluded that an employee "must demonstrate that it is the application of a specific or particular employment practice that has created the disparate impact under attack." Second, it placed the burden of persuasion on employees at all times, even after employers had made business necessity claims for challenged practices.

Business justification

The 1991 Act answered *Wards Cove* by providing that an employee doesn't have to demonstrate that a disparate impact is caused by a particular business practice—if that employee can demonstrate "that the elements of [an employer's] decision-making process are not capable of separation for analysis," in which case "the decision-making process may be analyzed as one employment practice."

The 1991 Act changed the burden of proof by mandating that, once an employee demonstrates disparate impact, an employer will be liable if he

Mixed-motive cases pose a growing problem

or she "fails to demonstrate that the challenged practice is job related for the position in question and consistent with business necessity." So the Act shifted the burden to the employer once an employee demonstrates disparate impact resulting from an employment practice.

The Title VII business justification model allows the burden of proof[1] to affect the decision of liability issues. It was for this reason that the Court in *Wards Cove* held that the burden of persuasion must remain with the plaintiff. It ruled that employers would otherwise be forced to adopt de facto quotas to protect themselves from costly litigation resulting from racial or gender differences in the makeup of their work forces—a result directly contrary to the will of Congress in enacting Title VII.

The 1991 Act tried to resolve a number of other questions raised by Supreme Court decisions. It sets up a standard for resolving so-called "mixed-motive" cases based on Title VII issues. This effort comes directly in response to the 1989 decision *Price Waterhouse v. Hopkins*.

In *Price Waterhouse*, the Supreme Court ruled that no violation of Title VII occurs if an employer would have made the same employment decision even in the absence of the discriminatory motive. The 1991 Act changes this rule by allowing an employer to be found liable if a discriminatory motive was "a motivating factor for any employment practice, even though other factors also motivated the practice."

In a more legal interpretation, the 1991 Act eliminates an affirmative defense that was available under *Price Waterhouse*. Employers can no longer escape liability by proving that they would have made the same decision absent discriminatory motives.

So, you have to be prepared to actively rebut charges of discrimination. If you fail to do this once an angry employee has established a prima facie case, a trial court may conclude that a violation has occurred and determine the appropriate rem-

[1] Technically, courts refer to the "burden of persuasion" for plaintiffs and "burden of production" for defendants rather than a "burden of proof" in disparate impact cases. Outside of legal circles, the terms are used interchangably.

edy. In other words, the court doesn't need direct evidence to rule a pattern or practice of discrimination exists and award what judges call "relief" to the employee.

This relief can be an injunctive order against continuation of the discriminatory practice, an order forcing you to keep records of future employment decisions and file periodic reports, or any other order "necessary to ensure the full enjoyment of the rights" protected by Title VII.

At the justification stage of a disparate impact case, the most important issue is whether a challenged practice serves the legitimate employment goals of the employer. The touchstone of this inquiry is a reasoned review of the employer's justification for his use of the challenged practice.

As the Supreme Court held in the 1978 decision *Furnco Construction Corp. v. Waters*, "Courts are generally less competent than employers to restructure business practices." Consequently, as it ruled in *Wards Cove*, "the judiciary should proceed with care before mandating that an employer must adopt a plaintiff's alternative selection or hiring practice in response to a Title VII suit."

Title VII versus seniority systems

One way that some applicants, employees and their attorneys can try to apply Title VII and the 1991 Act retroactively is to argue that discriminatory behavior which stopped years ago has caused inequities in your seniority system that continue to the present.

In passing the 1964 Act, Congress made clear that a seniority system is not unlawful because it honors employees' existing rights, even if the employer engaged in pre-Act discriminatory hiring or promotion practices. An otherwise neutral, legitimate seniority system does not become unlawful under Title VII simply because it may perpetuate pre-Act discrimination. As the Supreme Court has ruled: "Congress did not intend to make it illegal for employees with vested seniority rights to con-

Maintaining the practice of last hired/first fired

tinue to exercise those rights, even at the expense of pre-Act discriminatees."

When the 1964 Act was being debated in Congress, Title VII's proponents argued that seniority rights would not be affected, even where the employer had discriminated prior to the Act. Two of the senators who supported the law said:

> Title VII would have no effect on established seniority rights. Its effect is prospective and not retrospective. Thus, for example, if a business has been discriminating in the past and as a result has an all-white working force, when the title comes into effect the employer's obligation would be simply to fill future vacancies on a non-discriminatory basis. He would not be obliged or indeed, permitted to fire whites in order to hire Negroes or to prefer Negroes for future vacancies, or, once Negroes are hired to give them special seniority rights at the expense of the white workers hired earlier.

> ...Normally, labor contracts call for "last hired, first fired." If the last hired are Negroes, is the employer discriminating if his contract requires they be first fired and the remaining employees are white?

> Seniority rights are in no way affected by the bill. If under a "last hired, first fired" agreement a Negro happens to be the "last hired," he can still be "first fired" as long as it is done because of his status as "last hired" and not because of his race.

On this issue, Title VII reads:

> Notwithstanding any other provision of this subchapter, it shall not be an unlawful employment practice for an employer to apply different standards of compensation, or different terms, conditions, or privileges of employment pursuant to a bona fide seniority...system...provided that such differences are not the result of an intention to discriminate because of race...or national origin....

When the 1972 amendments were made to the 1964 Civil Rights Act, one congressional committee report modified this stand:

> Employment discrimination as viewed today is a far more complex and pervasive phenomenon. Experts familiar with the subject now generally describe the problem in terms of "systems" and "effects" rather than simply intentional wrongs, and the literature on the subject is replete with discussions of, for example, the mechanics of seniority and lines of progression, [and] perpetuation of the present effect of pre-act discriminatory practices through various institutional devices....In short, the problem is one whose resolution in many instances requires not only expert assistance, but also the technical perception that the problem exists in the first instance, and that the system complained of is unlawful.

So, Title VII generally protects existing seniority systems. But it doesn't protect systems that perpetuate the effects of prior discrimination. This distinction was first made in the Virginia federal court decision *Quarles v. Philip Morris, Inc.* The court in that case ruled that "a departmental seniority system that has its genesis in racial discrimination is not a bona fide seniority system."

This view has since enjoyed wide adoption in federal Courts of Appeals. The decision rests on the proposition that a seniority system that perpetuates the effects of earlier discrimination can't be legitimate if the intent to discriminate was part of its adoption.

The timing in question

The 1989 Supreme Court decision *Lorance v. AT&T Technologies, Inc.* held that the statute of limitations in cases challenging a facially neutral but allegedly discriminatory seniority system begins to run when the seniority system was adopted.

Lorance v. AT&T concerned the issue of when employees can challenge a modification in an estab-

lished seniority system if it creates a disparate impact among employees. Three female workers who had been hourly wage earners since the early 1970s were promoted to the skilled position of "tester." Originally, all seniority was based on the number of years of service regardless of the position held. On June 23, 1979, a collective-bargaining agreement signed by AT&T and the union representing the employees stated that seniority would be based on the position held rather than on plant-wide service.

Of the three women involved in the case, one had become a tester before the June 23, 1979 collective-bargaining agreement. The other two were promoted to the tester position after that date. All three were demoted during the 1982 economic downturn. None of these women would have been demoted if the plant-wide seniority system had been applicable.

The employees based their complaint on illegal sexual discrimination. They argued that the nonskilled wage earners were traditionally women and that the skilled testers were traditionally men. Therefore, they alleged that the seniority system was changed to protect males who had been testers for a shorter period of time than some women had been employed, and to discourage females from becoming testers.

Their claims of discrimination were filed under Title VII. In light of the fact that the women's complaint was not filed with the EEOC until 1983, the Supreme Court held that the challenge to the seniority system was barred.

The justices making up the majority agreed that the key time element is the date a facially neutral seniority system is adopted, not the date such a system has a discriminatory impact. Justice Antonin Scalia wrote:

> This "special treatment" [of seniority systems] strikes a balance between the interests of those protected against discrimination by Title VII and those who work—perhaps for many years—in

reliance upon the validity of a facially lawful seniority system. There is no doubt, of course, that a facially discriminatory seniority system (one that treats similarly situated employees differently) can be challenged at any time, and that even a facially neutral system, if it is adopted with unlawful discriminatory motive, can be challenged within the prescribed period after adoption. But allowing a facially neutral system to be challenged, and entitlements under it to be altered, many years after its adoption would disrupt those valid reliance interests that [Title VII] was meant to protect.

As it applies to businesses, the Supreme Court's decision in *Lorance* means that as long as a seniority system is not obviously discriminatory in its application to similarly situated employees, the business manager can take solace in knowing that the system cannot be challenged under Title VII 300 days (180 days if no complaint has been filed with a state or local agency) after it has been adopted.

The 1977 Supreme Court case *Teamsters v. United States* set many of the standards for Title VII seniority cases. The suit was brought by the EEOC against the Teamsters union, alleging that it had helped T.I.M.E.-D.C., a Texas-based freight company, engage in pattern and practice of discrimination against black and Spanish-surnamed people.

In separate cases, a single trial court enjoined the employer and the union from committing further violations of Title VII and provided modest relief for the people who'd suffered the discrimination. All parties appealed.

The central claim in both lawsuits was that the company had engaged in a pattern or practice of discriminating against minorities in hiring so-called line drivers. The black and Spanish-surnamed people who had been hired, the EEOC alleged, were given lower paying, less desirable jobs as servicemen or local city drivers.

A pattern or practice of discrimination in job placement

A union's role in a Title VII seniority dispute

During the initial trial, the EEOC and the company agreed to a consent decree which included adoption of an affirmative action program, an offer of retroactive seniority and modest cash awards.

The consent decree narrowed the scope of the litigation, but the trial court still had to determine whether unlawful discrimination had occurred. The validity of the union's collective-bargaining contract's seniority system also remained for decision, as did the question whether any discriminatees should be awarded additional equitable relief such as retroactive seniority.

The Court of Appeals ruled that relief awarded by the trial court was inadequate. It held that all black and Spanish-surnamed incumbent employees were entitled to bid for future line-driver jobs on the basis of their company seniority, and that once a class member had filled a job, he could use his full company seniority—even if it predated the effective date of Title VII for all purposes, including bidding and layoff. It also expanded other retroactive seniority available to the incumbent employees.

The trial court and the Court of Appeals both found that the seniority system contained in the collective-bargaining agreements between the company and the union operated to violate Title VII.

In their appeal to the Supreme Court, the company and the union argued that their conduct did not violate Title VII in any respect. The union further argued that the seniority system contained in the collective-bargaining agreements in no way violated Title VII.

For purposes of calculating benefits, such as vacations, pensions, and other fringe benefits, an employee's seniority under this system ran from the date he or she joined the company, and took into account total service in all jobs and bargaining units.

For competitive purposes, however, such as determining the order in which employees could bid for particular jobs, were laid off or were recalled

from layoff, it was bargaining-unit seniority that controls. So, a line driver's seniority, for purposes of bidding for particular runs and protection against layoff, took into account only the length of time he had been a line driver at a particular terminal. The practical effect was that a city driver or serviceman who transferred to a line-driver job would forfeit all the competitive seniority he had accumulated in his previous bargaining unit and start at the bottom of the line drivers' seniority list.

The vice of this arrangement was that it locked minority workers into inferior jobs and perpetuated prior discrimination by discouraging transfers to jobs as line drivers. While the disincentive applied to all workers, including whites, it was black and Spanish-surnamed people who suffered the most.

The trial court and Court of Appeals had stressed that a discriminatee who forfeited his competitive seniority in order finally to obtain a line-driver job would never be able to "catch up" to the seniority level of his contemporary who was not subject to discrimination.

Locked in a lesser position

An example would be a black man who was qualified to be a line driver in 1958 but who, because of his race, was assigned instead a job as a city driver. After the consent decree, he would be allowed to become a line driver. But, because he lost his competitive seniority when he transferred, he would forever be junior to white line drivers hired between 1958 and 1970. The white drivers would enjoy the preferable runs and the greater protection against layoff.

This built-in disadvantage to the prior discriminatee was held to constitute a continuing violation of Title VII, for which both the employer and the union who jointly created and maintain the seniority system were liable.

The Supreme Court admitted, "Although the origi-

A system built to discriminate can't be bona fide

nal discrimination occurred in 1958 before the effective date of Title VII the seniority system operates to carry the effects of the earlier discrimination into the present."

The union, while acknowledging that the seniority system may in some sense perpetuate the effects of prior discrimination, argued that the system was immunized from a finding of illegality. It argued that the seniority system was "bona fide" within the meaning of Title VII when judged in light of its history, intent, application and all of the circumstances under which it was created and is maintained.

More specifically, the union claimed that the central purpose of section 703(h) was to ensure that mere perpetuation of pre-Act discrimination is not unlawful under Title VII. And, whether or not it immunized the perpetuation of post-Act discrimination, the union claimed that the seniority system in question had no such effect.

Its position was that the seniority system presented no hurdle to post-Act discriminatees who sought retroactive seniority to the date they would have become line drivers. The union insisted that, under its collective-bargaining agreements, it would take up the cause of the post-Act victim and attempt, through grievance procedures, to gain full "make whole" relief, including appropriate seniority.

The EEOC responded that a seniority system that perpetuated the effects of prior discrimination pre-Act or post-Act could never be "bona fide" under section 703(h) of Title VII. At a minimum, Title VII prohibited application of a seniority system that perpetuated the effects on incumbent employees of prior discriminatory job assignments.

"Were it not for section 703(h), the seniority system in this case would seem to fall under the *Griggs* rationale," the court wrote. "The heart of the system is its allocation of the choicest jobs, the greatest protection against layoffs, and other advantages to those employees who have been line drivers for the longest time."

The advantages of the seniority system flowed disproportionately to white drivers and away from black and Spanish-surnamed drivers who might have enjoyed those advantages if the employer hadn't discriminated against them.

However, the seniority system was bona fide. It applied equally to all races and ethnic groups. To the extent that it locked employees into non-line-driver jobs, it did so for all.

The city drivers and servicemen who were discouraged from transferring to line-driver jobs were not all black or Spanish-surnamed—to the contrary, the majority were white. The placement of line drivers in a separate bargaining unit from other employees was rational, followed industry practice and was consistent with National Labor Relations Board precedents. The seniority system did not have its genesis in racial discrimination. It was negotiated and maintained free from any illegal purpose.

The Supreme Court concluded that the seniority system did not violate Title VII. But it went to considerable lengths to explain its decision.

It disputed the appeals court's more generous award:

> [Employees] who chose to accept the appellate court's post hoc invitation...would enter the line-driving unit with retroactive seniority dating from the time they were first qualified. A willingness to accept the job security and bidding power afforded by retroactive seniority says little about what choice an employee would have made had he previously been given the opportunity freely to choose a starting line-driver job.

More than anything else, the high court cited practicality as its reason for allowing the seniority system to stay in place:

> Although not directly controlled by the Act, the extent to which the legitimate expectations of nonvictim employees should determine when victims are restored to their rightful place is

limited by basic principles of equity. In devising and implementing remedies under Title VII...courts must "look to the practical realities and necessities inescapably involved in reconciling competing interests," in order to determine the "special blend of what is necessary, what is fair, and what is workable."

In *United Papermakers & Paperworkers v. United States*, another important case in this area, the Supreme Court ruled:

No doubt, Congress, to prevent "reverse discrimination" meant to protect certain seniority rights that could not have existed but for previous racial discrimination. For example a Negro who had been rejected by an employer on racial grounds before passage of the Act could not, after being hired, claim to outrank whites who had been hired before him but after his original rejection, even though the Negro might have had senior status but for the past discrimination.

In the 1991 Act, Congress responded to this ruling. It provided that, if a seniority system is adopted for a discriminatory purpose, the limitations period begins at the latest of three points: "when the seniority system is adopted, when an individual becomes subject to the seniority system, or when a person aggrieved is injured by the application of the seniority system or provision of the system."

Enforcement

Prior to filing a lawsuit under Title VII, complaints must be filed with the Equal Employment Opportunity Commission (EEOC) within 180 days of the alleged unfair employment practice. Alternatively, a complainant may take up to 300 days to file with the EEOC if a complaint was filed originally with a state or local agency.

If you're charged in a complaint filed with the EEOC, your best plan is usually to investigate the allegations, determine your potential liability and try to settle the claim as soon as possible. If the

case moves on, unsettled, and the commission finds illegal discrimination, you'll have to provide 100 percent relief as determined through a conciliation process overseen by the EEOC.

Cases that make it to court are usually those in which both private negotiations and the commission conciliation process have failed or those that the commission failed to address within an allotted period of time.

Some local agencies will take an even more aggressive approach than the EEOC to rooting out discrimination. In Washington, D.C., the municipal Fair Employment Commission uses checkers—equally qualified applicants of different races—to randomly test employers' practices. Other big city agencies have followed this lead.

(Local housing agencies have used checkers to uncover discrimination in renting practices since the 1970s. Their use in employment contexts began in the 1990s.)

The D.C. FEC made headlines in 1995 by alleging that a big local employment agency denied job referrals to black checkers while referring their white counterparts to jobs. In a federal lawsuit, it charged violations of the Civil Rights Act of 1866, Title VII of the Civil Rights Act of 1964 and the District of Columbia Human Rights Act.

As early as 1990, FEC checkers had found that employment agencies seemed to have a much higher rate of discrimination than other organizations. Two teams of checkers—each consisting of a white man and a black man—applied to the local company, though not for a particular job. In both teams, "the checker of color was treated in a negative manner," an FEC spokeswoman said.

For example, in the second team, the white applicant filled out an application and got a job, while the black applicant was not allowed to fill out an application.

The legal question was whether the checkers had standing to sue for discrimination. The FEC said

they did because they acted like and had no more information than real job applicants.

Although the FEC won in district court, the D.C. Circuit Court of Appeals ruled for the employment agency, finding that "people who misrepresent their credentials don't have a right to sue." The case was settled before it could be heard again at the trial-court level.

One neglected aspect of Title VII enforcement that got more attention in the 1990s was its protection against discrimination based on national origin. EEOC officials talk about the "triple A's" of national origin discrimination in employment: "accent, ancestry and appearance."

"Women's groups are concerned about sexual harassment, the AARP [American Association of Retired Persons] is concerned about age discrimination, the NAACP and others talk about race discrimination. Who talks about national origin?" one former EEOC commissioner says.

The EEOC is seeing an increase in the number of complaints concerning national origin. In fiscal 1987, there were 9,653 such complaints filed with the agency, representing 8.8 percent of the EEOC case load. In 1990, there were 11,688 complaints, representing 11.1 percent of all EEOC cases.

"Surprisingly, in national origin cases, we often find people of similar racial backgrounds discriminating against each other," says one EEOC investigator. "For example: A domestic unit of a Japanese company might resist hiring people of Korean extraction. Or a Pakistani entrepreneur won't hire a job applicant from Sri Lanka."

Compliance

Under Title VII, it is illegal for an employer to discriminate against anyone because of birthplace, ancestry or culture. It also is illegal to require that employees speak only English at all times at work unless it is necessary for conducting business. And employers are prohibited from discriminating on the basis of an individual's accent.

The law holds an employer responsible for the actions of managers. Even if only one person in an entire organization is responsible for a prohibited discriminatory action, a company can be held liable for that individual's actions. A manager hired by a company acts on behalf of and in the interest of his or her employer.

So you should set up some system of training and reviewing managers—and employees—to make sure they understand the terms of Title VII compliance.

Disparate treatment is the most easily understood type of discrimination. If you treat some people less favorably than others because of their race, color, religion, sex, accent or national origin, you've discriminated on the basis of disparate treatment.

Proof of discriminatory motive is critical in disparate treatment claim (though, in some situations, courts will infer it from the mere fact of differences in treatment). This kind of proof is difficult to establish. As a result, an employee making a disparate treatment claim might mention an inappropriate (or risque or vulgar or off-color) comment you made months before as evidence of discriminatory intent in a specific decision.

The best way to comply with Title VII's disparate treatment rules: Don't say or do anything that's overtly bigoted. This goes for daily conversations and operations as well as for more stressful periods of hiring, promoting or firing.

A caveat: Many people fall back on the explanation that an inappropriate remark was made sarcastically, ironically or humorously—and wasn't meant to be taken seriously. This argument rarely holds up to any kind of regulatory or legal scrutiny.

The solution: Don't make jokes or ironic quips about race, gender or disabilities at work. It invites misinterpretation and lawsuits.

Because the intent aspect of a disparate treatment lawsuit is tough to prove, many angry employees

and their lawyers prefer to make the disparate impact claims we've discussed already.

Because disparate impact discrimination is something that's proved after the fact, compliance with this aspect of Title VII is difficult to quantify. The best approach is to treat all employees as fairly and—more important—as consistently as you can.

The Role of Statistics

Statistical analyses serve an important—and complicated—role in cases in which the existence of discrimination is disputed. Federal courts have repeatedly approved the use of statistical proof to establish a prima facie case of racial discrimination in employment.

But, like any kind of evidence, statistics can be refuted. They come in infinite variety and can be manipulated in infinite ways. Their usefulness depends on surrounding facts and circumstances.

Statistics showing racial or ethnic imbalance are useful mostly because such imbalances are often a telltale sign of purposeful discrimination. Most judges and arbitrators will reasonably expect that nondiscriminatory hiring practices should result in a work force generally representative of the racial and ethnic composition of the population in the community from which employees are hired. Evidence of extreme disparity between the composition of a work force and that of the general population may be significant.

This remains true, even though Title VII imposes no requirement that a work force mirror the general population.

Some attorneys and human resources consultants may also advise you to keep some statistical record of employment patterns in your company. This can be a dangerous process, though. If an angry employee or job candidate finds out that you keep records of hiring and promotion of people in protected classes, he or she can try to use those records against you.

The better approach is to use the shifting burden of proof to your advantage. It's up to the person making a disparate impact claim to establish that statistical or prima facie discrimination occurred. If you use non-statistical and non-specific tools like policy statements and staffing goals, you're not doing anything that helps the claimant make the prima facie case.

In its 1971 decision *McDonnell Douglas v. Green*, the Supreme Court ruled that the prima facie burden can be met by showing that a qualified applicant, who was a member of a protected minority group, unsuccessfully sought a job for which there was a vacancy and for which the employer continued thereafter to seek applicants with similar qualifications. This justified the inference that the minority applicant was denied an employment opportunity for reasons prohibited by Title VII, and therefore shifted the burden to the employer to rebut that inference by offering some legitimate, nondiscriminatory reason for the rejection.

Even if McDonnell Douglas had had statistics that showed a general pattern of nondiscrimination in its hiring practices, it would have had to defend this single instance as non-discriminatory. This challenge is usually best met by establishing a consistent hiring policy and showing how the specific candidate failed to meet its terms.

The importance of *McDonnell Douglas* lies in its holding that an employee suing under Title VII carries the initial burden of offering evidence that creates "an inference that an employment decision was based on a discriminatory criterion."

If an employee makes a prima facie showing, a rebuttable presumption of discrimination arises and the burden of proof shifts to the employer to articulate a legitimate nondiscriminatory justification for its action. If the employer meets its burden, the presumption is dissolved and the burden shifts back to the employee to prove that the proffered reasons are a pretext for age discrimination.

Pretext can be established by showing either that

"Absolute or relative lack of qualifications"

a discriminatory intent likely motivated the employer or that the employer's explanation is unworthy of credence. At all times, the employee retains the ultimate burden of persuasion that he or she was the victim of intentional discrimination.

To demonstrate a "pretext for discrimination," an employee must show both that the employer's offered reason was false and that race discrimination was the real reason. An employee's own subjective belief of race discrimination, however genuine, cannot be the basis for judicial relief.

Although Title VII protects employees against racial discrimination in the terms and conditions of employment, it does not afford minorities special preference or place upon the employer an affirmative duty to accord them special treatment.

This model doesn't require direct proof of discrimination. But it does require that the employee demonstrate that his rejection did not result from the two most common legitimate reasons which you might cite: an "absolute or relative lack of qualifications" or the absence of a vacancy in the job sought.

So, if you can establish that one of these two reasons controlled your decision not to hire a candidate or promote an employee, you're in a good position to defend against a Title VII claim. This is why so many employers make a policy of always hiring and promoting the "most qualified" candidate for a position. It sets the framework for a defense based on relative lack of qualifications.

In *McDonnell Douglas*, the Supreme Court also offered employers at least one tool for defending themselves against Title VII discrimination claims. It wrote that an employer's isolated decision to reject an applicant who belongs to a racial minority does not show that the rejection was racially based. So the act of hiring or firing a person in a protected group doesn't mean anything by itself—the background of paperwork, management context and personnel history matters more.

Another compliance issue to consider is whether practices you use are fair in form but perpetuate the effects of prior discrimination. Among the findings that the Supreme Court made in *Griggs v. Duke Power:* "Under the Act, practices, procedures, or tests neutral on their face, and even neutral in terms of intent, cannot be maintained if they operate to freeze the status quo of prior discriminatory employment practices."

As we move more than a generation away from the passage of Title VII, the issue of prior discrimination might seem to become moot. But employment lawyers have tried—with some success—to expand the definition of "prior discriminatory employment practices" to include very general employment trends.

One example: Nepotism might count as a perpetuation of prior discrimination. The Supreme Court decision *Local 53 Asbestos Workers v. Vogler* involved a union that had a policy of excluding persons not related to present members by blood or marriage. The court observed: "While the nepotism requirement is applicable to black and white alike and is not on its face discriminatory, in a completely white union the present effect of its continued application is to forever deny to Negroes and Mexican-Americans any real opportunity for membership."

In general, Title VII compliance efforts boil down to a matter of negation rather than assertion. You need to make sure that actions you take or policies you generate don't establish any pattern or practice of discrimination.

If you're more ambitious, you can set up policies and procedures that will help you rebut any claims. But there's no way to comply with Title VII absolutely. No matter how conscientious you are, you may at some point face a discrimination claim you have to rebut. Unlike safety or financial regulations, workplace diversity standards are subjective—they depend more on whether an employee feels he or she has been wronged than whether your policies meet defined terms.

Negation is better than assertion as compliance tool

Statistics can rebut claims of intent

When a job applicant or employee seeks punitive damages under the 1991 Act, he or she has to prove discriminatory intent on your part. This is where your paper trail of good-faith staffing policy helps. The standard for punitive damages is that your failure to comply with its statutory responsibilities is so wanton as to imply a criminal indifference to civil obligations.

A last compliance point: Look at whatever costs it entails as a kind of self-insurance. Because the discrimination prohibited by Title VII usually involves intentionality—and always is illegal—insurance companies usually won't cover defense costs. So, legal fees and damages come directly out of your bank account. It's better to avoid the lawsuit altogether.

The 1991 appeals court case *EEOC v. Chicago Miniature Lamp Works* serves as a good illustration of how complicated the role of statistics can be.

Chicago Miniature Lamp Works was a manufacturer of light bulbs located in a largely Hispanic and Asian neighborhood on the north side of Chicago. In a lawsuit filed in the late 1980s, the EEOC alleged that the Lamp Works had discriminated against blacks in its recruitment and hiring of entry-level workers.

Entry-level jobs at the Lamp Works involved light manufacturing work and did not require any prior experience, particular educational background, or special skills. Basic manual dexterity and the ability to speak some English were the minimal qualifications required by the Lamp Works. The beginning pay was low and did not rise substantially over time.

Because the jobs did not require English language fluency, they had some special attraction to those persons who did not speak English as a primary language. To obtain new workers, the Lamp Works relied almost exclusively on "word-of-mouth." Employees would simply tell their relatives and

friends about the nature of the job—if interested, these people would come to the Lamp Works office and complete an application form. The Lamp Works did not tell or encourage its employees to recruit in this manner.

The only time the Lamp Works initiated this word-of-mouth process was during 1977 when it adopted an Affirmative Action plan. At that time, the Lamp Works asked one or two black employees to recruit black applicants from among their relatives and friends.

Because of the success of this process, the Lamp Works never advertised for these jobs, and only rarely used the state unemployment referral service.

The Lamp Works received applications whether or not it currently had an entry-level opening to fill. Whenever the Lamp Works needed to fill an opening, it would go through its applications on file in order, phoning applicants until one was reached at home. Only one person was hired for every fifteen that applied.

Until August 1980, the Lamp Works would start with the applications that were four to five months old and process them forward in time. After that date, the Lamp Works started with the most recent application and processed applications backward in time.

In 1970, the percentage of entry-level workers in Chicago who were black was 35 percent. In 1980, this percentage had increased to 36.4 percent. The trial judge used these percentages as a basis for comparison against the Lamp Works's work force in two ways. First, he compared them with the percentage of blacks in the Lamp Works's entry-level work force for the years 1970-1981. In addition, he compared them with the percentage of blacks hired by the Lamp Works for entry-level positions for the years 1978-1981.

The Lamp Works claimed that its word-of-mouth recruiting process was what defined its applicant pool. Thus, it had hired a greater percentage of

The line between disparate treatment and impact blurs

black applicants than non-black applicants. The court didn't go for this argument.

Between 1978 and 1981, the Lamp Works hired 146 entry-level workers. Nine of these workers (6 percent) were black. The trial court concluded that "the statistical probability of the Chicago Lamp Works's hiring so few blacks in the 1978-81 period, in the absence of racial bias against blacks in recruitment and hiring, is virtually zero."

Although the differences between expected number of black hires and actual numbers were less when the judge restricted the relevant labor market to smaller geographical area close to the Lamp Works's plant, he concluded that racial discrimination must have been the cause of disparities even in geographically smaller relevant labor markets. The judge also commented that a number of black applicants had the letter B handwritten on their applications.

The district court found the Lamp Works liable based on both a disparate treatment and a disparate impact model. The Lamp Works appealed this decision.

The appeals court ruled that the EEOC's claims of disparate treatment and disparate impact needed to be considered separately. However, it admitted that the line between disparate treatment and impact blurred in "pattern and practice" cases such as this one, because statistics could be used to prove both models.

For disparate treatment, plaintiff must prove "more than the mere occurrence of isolated or 'accidental' or sporadic discriminatory acts." Instead, the plaintiff must show that racial discrimination was the "standard operating procedure—the regular rather than the unusual practice."

Did the district court clearly err in deciding that the Lamp Works had intentionally discriminated against blacks in its recruiting and hiring practices?

The court ruled that the Lamp Works did recruit

by knowingly relying on word-of-mouth. When it adopted an Affirmative Action plan in 1977, it made an effort to tell its black employees to contact their friends and relatives in order to increase the effectiveness of its word-of-mouth network in the black community.

However, the appeals court ruled that it was impossible to determine intentional discrimination from the Lamp Works use of word-of-mouth recruiting.

Statistical evidence of disparities between minority representation in an employer's work force and minority representation in the community from which employees are hired can prove disparate treatment in a pattern or practice case. But the appeals court ruled that the EEOC had failed to make this kind of case.

Battling statistics

The appeals court reviewed the statistics considered by the trial court.

For the twelve years in dispute, the percentage of blacks in entry-level jobs at the Lamp Works was relatively constant, ranging from 4.5 to 6.5 percent. The total number of entry-level workers ranged from 202 to 396 over this period; the actual number of black entry-level workers ranged from 9 to 22.

Unlike the percentage of black entry-level workers, the percentage of Asian and Hispanic entry-level workers from 1970 to 1981 was not static—it increased. The representation of Hispanic workers ranged from 40 to 66 percent; Asian workers ranged from 0 to 16.5 percent.

In 1980, 36.4 percent of the entry-level workers in Chicago were black. However, only 6 percent of the factory workers (16 workers) at the Lamp Works were black. Because the expected number of blacks would have been 98 (36.4 percent times the total number of factory workers—268), the trial court had concluded that the actual number of black

The relevant labor market becomes a key factor

entry-level workers was 10.4 standard deviation units below the expected number in 1980. For all intervening years between 1970 and 1980, the number of the Lamp Works's black entry-level workers remained at least 9 SDUs below the expected number.

The Lamp Works argued that the EEOC's statistics were erroneous because they did not include the following considerations: relative commuting distance, shift preference and lack of an English fluency requirement.

The appeals court agreed with this argument. It ruled, "The missing neutral variables of relative commuting distance and language fluency requirements are too important to be ignored in this case. Our analysis of the [trial court's] findings leaves us with the definite and firm conviction that a mistake has been committed."

The appeals court found that the trial court's reliance on statistical evidence as proof of disparate impact was erroneous. It also criticized the EEOC's "simplistic model that used race as the only variable; the Lamp Works's racial composition compared to whole racial composition of Chicago."

The appeals court reasoned that statistical deviations are only as impressive as underlying hypothesis that generate them. It wrote that:

> Interest in the jobs at issue is...ordinarily an important consideration for proof of a Title VII pattern or practice case. The identification of a relevant labor market—the key issue in a class-based Title VII case—means not only identifying qualified potential applicants for the job at issue but also identifying interested potential applicants....In this case, the use of Chicago as a relevant labor market, with no weighing of distance, meant that no consideration was given to the fact that blacks living on the South and West Sides would be less willing to apply at the Lamp Works because of the commuting time involved."

Also, the trial court should have considered that

non-English speaking persons would be more willing to apply because of their inability to obtain jobs with English fluency requirements.

The Lamp Works's entry-level jobs were low-paying and required no special skills. Low-paying, unskilled jobs are more likely to be filled by those living closer to the site of the job, simply because the cost (including the opportunity cost of time lost) of commuting cannot be justified.

The appeals court put a great value in these factors, writing that "the district court uncritically accepted the assertion of the EEOC's expert that one and one-half hours was a reasonable commuting time for a low-paying entry-level job."

The appeals court also emphasized the importance of the jobs' minimal language requirements:

> Common sense dictates that a nondiscriminatory employer with no English fluency requirement will receive a disproportionate amount of applications from non-English speaking persons. Without more specific proof, it would be mere speculation to infer that discrimination, and not special interest on the part of women, Hispanics and Asians, caused the lack of representation for whites and males. Interest for the jobs at issue is a crucial element in the definition of the relevant labor market.

The appeals court ruled that the statistical deficiencies in the EEOC's case could have been overcome if the agency had presented more compelling anecdotal evidence. But the anecdotal evidence seemed to support the employer.

For applicants, the hiring rate for blacks was actually higher than the hiring rate for non-blacks. In reference to the "job applications [with] the letter B written by hand on them," the trial court didn't establish that it was race-coding—and the EEOC even stated that it "could have had some legitimate purpose." Besides, only 11 of about 70 applications from black people had the B's marked on them.

An active practice has to be shown by employees

In sum, the appeals court ruled that the trial court erred in concluding that the Lamp Works was liable under Title VII for disparate treatment of blacks.

It is uncontested that only 1 out of 15 applicants was hired. The central prerequisite for being hired was being home and near a phone when a position became open. That some black applicants were not hired is simply unpersuasive in the circumstances of this case without further evidence of discriminatory intent....This is one of those rare cases where the statistical evidence credited by the lower court does not support liability. Anecdotal evidence of intentional discrimination, only tangentially relied upon by the lower court, also fails to carry the day for the EEOC.

The lower court's ruling on the disparate impact charges didn't succeed, either. The appeals court cited *Wards Cove* in ruling that an employee must identify a particular employment practice that caused the disparate impact. The trial court considered the particular practice to be reliance on word-of-mouth recruiting. The appeals court had rejected this conclusion.

For the purposes of disparate impact, an active practice by the employer must be shown in order to establish causation. The appeals court concluded that:

Without...evidence of discriminatory intent, [the Lamp Works] is not liable when it passively relies on the natural flow of applicants for its entry-level positions. Its entry-level hiring practices were straightforward, simple, and effective. The EEOC's misspecified statistical model that ignored commuting distance and language fluency requirements, when unaccompanied by more probative anecdotal testimony, cannot support a ruling that [the Lamp Works] violated Title VII by discriminating against blacks. Therefore, the trial court erred in finding [the Lamp Works] liable under Title VII.

"Word of mouth is a risky way to go [when advertising job hiring] because that just duplicates the present work force. But there is no affirmative obligation on the employer to scour the countryside for different people," says MALDEF attorney Kevin Baker.

Title VII and class action

A legal issue common to all diversity claims and particularly relevant to Title VII claims is the class action. Groups of applicants or employees can often demand damages greater than the sum of many individual cases.

Generally, the laws applying to class actions are the same as those applying to single cases. The guidelines for avoiding problems remain the same. However, there are some technical differences. Most important of these: class actions make it easier to prove a pattern or practice of discriminatory behavior.

In the 1976 decision *Franks v. Bowman Transportation Co.*, the Supreme Court laid the ground rules for Title VII class actions. The employee group proved, to the satisfaction of a District Court, that Bowman Transportation "had engaged in a pattern of racial discrimination in various company policies, including the hiring, transfer, and discharge of employees."

Despite this proof, the trial court denied relief to certain members of the class because not every employee had shown that he or she was qualified for the job sought or that a vacancy had been available.

The Supreme Court ruled that the trial court had erred in placing this burden on the individual plaintiffs. The class had alleged a broad-based policy of employment discrimination. By "demonstrating the existence of a discriminatory hiring pattern and practice" the employees had made a prima facie case of discrimination. Stemming from that prima facie evidence, there were "reasonable grounds to infer that individual hiring decisions were made in pursuit of the discriminatory policy."

Presumptions are meant to level the legal playing field

Looking hard to find illegal behavior

The Supreme Court's ruling in *Franks* was consistent with the manner in which what judges call "presumptions" are usually applied. These presumptions can influence the shifting burden of proof in a Title VII case a lot. They're designed to reflect judicial evaluations of probabilities and to conform with a party's superior access to the proof.

Although the prima facie case did not conclusively prove that all of Bowman Transportation's decisions were part of the discriminatory pattern and practice, it did create a greater likelihood that any single decision was a component of the overall pattern.

In Franks, and in most Title VII class actions, the question of individual relief does not arise until it has been proved that the employer followed an employment policy of unlawful discrimination. The force of that proof does not diminish as the case progresses. The employer can't later claim that there's no reason to believe that individual employment decisions were discriminatory.

The proof of the pattern or practice opens an employer to far-ranging claims. It supports an inference that any particular employment decision, made during the period in which a discriminatory policy was in force, followed that policy. The EEOC or an employment lawyer needs only show that a person unsuccessfully applied for a job or promotion affected by the policy. The burden then rests on the employer to demonstrate that the individual applicant was denied an employment opportunity for lawful reasons.

Legal strategies

Few employers want to discriminate openly against qualified job applicants or employees. However, employment lawyers and other critics argue that people who do want to discriminate know enough about the law to avoid overt violations. Therefore, they claim even compliance with the letter of the law doesn't mean much.

Because these people are looking so hard for ille-

gal behavior, the most conscientious employer can face claims involving issues like so-called "mixed motive" discrimination. Mixed motive cases allege that, even though the specific reasons for an employment decision might be legal, illegal considerations came into play at some point.

The best example of a mixed motive discrimination case is the 1989 Supreme Court decision *Price Waterhouse v. Hopkins.* Unfortunately, the decision doesn't bode well for employers.

The case involved claims of intentional discrimination and disparate treatment against a protected group. Ann Hopkins had been a senior manager for several years in Price Waterhouse's Washington, D.C., office when she was nominated for partnership. There was significant disagreement among the partners over her nomination.

Thirteen of the 32 partners in her office who submitted comments on her candidacy supported her promotion, three recommended that her promotion be placed on hold for one year, eight stated that they had no informed opinion about her, and eight voted to deny her partnership.

Of the 662 partners in the firm at that time, only seven were women. Of the 88 persons proposed for partnership that year, only Hopkins was a woman. Forty-seven candidates were selected for partnership, 21 were rejected, and 20—including Hopkins—were deferred for reconsideration the following year.

Before the time for Hopkins's reconsideration came, two partners withdrew support for her, and she was told that she would not be considered at all. She resigned from the firm and sued, charging that Price Waterhouse had discriminated against her on the basis of gender in its decision to pass her over for partnership.

She argued, with the support of expert testimony, that the partnership selection process at Price Waterhouse was influenced by sexual stereotyping.

A woman described as "too macho"

A mixture of legitimate and illegitimate motives

The firm claimed that it legitimately emphasized interpersonal skills in its partnership decisions, and that on too many occasions Hopkins was overly aggressive and abrasive. However, she offered evidence that some of the partners reacted negatively to Hopkins's personality because she was a woman. One partner had described her as "macho"; another had suggested that she "overcompensated for being a woman"; still another had told her to take "a course in a charm school." These people may have thought they were being vague enough to avoid a lawsuit. They weren't.

Even one of Hopkins's supporters explained that she "ha[d] matured from a tough-talking somewhat masculine hard-nosed [manager] to an authoritative, formidable, but much more appealing lady [partner] candidate."

Even the partner who explained to Hopkins the decision to place her candidacy on hold acted foolishly. In order to improve her chances for promotion, he said, Hopkins should "walk more femininely, wear make-up, have her hair styled, and wear jewelry."

The trial court found that mixed motives were involved in the decision to deny Hopkins partnership. The trial judge "found that the firm had not fabricated its complaints about Hopkins's interpersonal skills as a pretext for discrimination ...[but he] held that Price Waterhouse had unlawfully discriminated against Hopkins on the basis of sex by consciously giving credence and effect to partners' comments that resulted from sex stereotyping."

The trial judge concluded that Price Waterhouse had failed to show, by clear and convincing evidence, that it would have placed Hopkins's candidacy on hold absent this discrimination.

The Supreme Court supported the trial court decision. Justice William Brennan wrote:

> ...Title VII meant to condemn even those decisions based on a mixture of legitimate and illegitimate considerations. When, therefore, an

employer considers both gender and legitimate factors at the time of making a decision, that decision was "because of" sex and the other, legitimate considerations—even if we may say later, in the context of litigation, that the decision would have been the same if gender had not been taken into account.

The Supreme Court concluded that, when an employee shows a discriminatory motive was sufficiently related to an employment decision, the employer will be liable under Title VII unless it proves that the same decision would have been made had discrimination not been a component in the decision.

In other words, once the employee has shown there were "mixed motives" in the case, the employer may show that it would have made the same decision in the absence of discrimination.

Differing from the lower courts in the case, the Supreme Court held that the employer may make this showing by the less rigorous standard of "preponderance of the evidence" rather than by "clear and convincing evidence" that it would have made the same decision without discrimination. But that's still a heavy burden for an employer to carry.

A last point: As Congress passes significant employment laws like the Civil Rights Act of 1991, many employers are opting out of the law.

The growing role of arbitration

Spurred by fears that federal juries will grant huge monetary awards in bias cases, a growing number of employers require employees to submit claims of discrimination, including sexual harassment, to binding arbitration.

Some companies unilaterally impose the restriction on non-union employees, while others insist job applicants forfeit their right to sue as a condition of employment. Even those that worry about forcing these conditions on employees will often make such agreements a condition for promotion, stock options or other benefits.

The 1991 Act chases many employers to arbitration

Different rules apply to existing employees and new hires

In one relevant case, a partner in a prestigious Chicago law firm claimed that—because she was a black woman—she had received less bonus money than other lawyers, was subjected to derogatory jokes and made the object of lewd remarks. She sued, alleging sexual and racial discrimination.

The federal judge hearing her case dismissed all of her charges. He cited a clause in an agreement she had signed when she was made a partner. It said all employee disputes must be submitted to binding arbitration.

In the 1992 decision *Gilmer v. Interstate/Johnson Corp.*, the Supreme Court upheld the legality of requiring licensed securities dealers to submit claims to arbitration panels, like the one established by the New York Stock Exchange. Citing *Gilmer*, a string of lower-court decisions has held that it is legal for companies to require new employees, or those accepting promotion, to agree to submit future complaints to arbitration.

The courts haven't ruled on whether it is legal for employers to tell existing employees that as of a certain date they have to submit claims of discrimination or harassment to arbitration.

Civil rights lawyers say that companies that require binding arbitration for employment discrimination complaints are thwarting the will of Congress as expressed in the 1991 Act—which allowed jury trials and larger damage awards.

Some companies prefer arbitration to trials because testimony and the decision can be kept confidential. And because arbitrators are often selected by both the employee and the company, managers have some control over who will ultimately judge a case.

The courts have sent mixed messages about whether a claim of retaliation is reasonably related to the original charge of discrimination. In the 1976 case *Jenkins v. Blue Cross*, a federal appeals court ruled that an employment discrimination plaintiff may present claims "like or reasonably related to

the allegations of the charge and growing out of such allegations."

In the 1985 case *Babrocky v. Jewel Food Co.*, the same court noted that this standard is "a liberal one in order to effectuate the liberal purposes of Title VII...."

However, in the 1993 case *O'Rourke v. Continental Casualty Co.*, the court held that allegations of retaliation did not meet the standard of being "like or reasonably related to the allegations of the charge and growing out of such allegations."

The *O'Rourke* court cited its earlier opinion in the 1988 case *Steffen v. Meridian Life Ins. Co.*, which also held that retaliatory discharge claims did not fall within the scope of the initial charge.

The *Steffen* court explicitly distinguished that situation from one in which the retaliatory conduct occurred after the initial charge of discrimination was filed. Specifically, the court noted:

> Steffen cites to a number of cases that have allowed a retaliatory discharge claim to proceed though the underlying charge did not mention retaliation....These cases, however, all involved situations where the alleged retaliation arose after the charge of discrimination had been filed or the employer was given clear notice from the EEOC that retaliation was at issue; thus, "a double filing...would serve no purpose except to create additional procedural technicalities when a single filing would comply with the intent of Title VII."...These cases are distinguishable from the present case where the alleged retaliatory acts occurred before Steffen's...charge of discrimination was filed.

Conclusion

Title VII claims are common. Since 1991, they've become more important than ever—because now they can include punitive damages in legal judgments.

Another, even more important, reason to under-

The addition of punitive damages changes a lot

stand Title VII is that all other federal workplace diversity laws—and some state laws—follow its procedural model. The shifting burden of persuasion and production between you and your employee makes employment lawyers rich and gives judges complexities to ponder.

Like so much else about workplace diversity, the key to beating a Title VII claim is to set up fair and consistent employment policies and to have the paperwork to back up your position. If you have this, courts and regulators have to allow the discretion of your business judgment in particular situations.

This process is defined by Title VII's disparate impact model. When you've been charged, you have to produce a nondiscriminatory business reason for a particular decision. And you need the paperwork to prove the reason you give is true. As long as your reason isn't discriminatory, the courts can't question your judgment.

CHAPTER 4:

FAMILY AND MEDICAL LEAVE

Introduction

A big part of the diversity movement is enabling employees to balance their work with their family life and not be penalized for it. Companies not doing so voluntarily were compelled to comply when the federal Family and Medical Leave Act took effect in August 1993.

When newly-elected President Bill Clinton signed the Family and Medical Leave Act into law in the winter of 1993, he called it a "matter of pure common sense and a matter of common decency...It will provide Americans what they need most—peace of mind," he said. "Never again will parents have to fear losing their jobs because of their families."

The FMLA, which applies to employers with 50 or more employees, grants full-time employees the right to take up to 12 weeks of unpaid leave a year for specified family and medical reasons—including care of certain family members.

During that time, the employer must continue to pay for the employee's health, dental and optical insurance, and at the end of the leave the employer must reinstate the employee to the same job or an equivalent one.

Because the FMLA is new, its final effects remain vague. This troubles small business owners who tend to shy away from uncertainty. Even the fed-

Early court decisions have been conservative

eral courts seem uncertain about how to interpret some of the FMLA's tricky language.

A few early court rulings have tended toward conservative readings of the law—which has kept the most aggressive employment lawyers focused on other matters. Most employers are pretty good about making allowances for faithful employees who have family problems. Also, the fact that the FMLA related most directly to health insurance and other employee benefits means the damages awarded in most of these cases aren't huge.

But the FMLA remains the unpredictable baby sibling of federal workplace diversity laws. As family households increasingly include both young children and aged grandparents, the working generation caught in the middle will come under greater strain.

When his wife was pregnant with their first child, Christopher Given, a longtime Shell Oil Co. employee, heard a news report about a new federal law allowing many workers unpaid leave and continued health benefits for such events as the birth of a child.

Several months later, he applied for leave and was able to witness the birth of Christopher Jr. and to spend the first two months of his son's life being a full-time parent.

Shortly after he returned to his job as a senior purchasing assistant, Given alleges he was fired in retaliation for having taken time off. Shell calls Given's allegations "groundless" and "untrue."

Given sued Shell in federal court, accusing it of violating federal law. Given's case was unusual because he took his grievance against Shell directly to court. His lawsuit sought restoration of his job, back wages and modest damages.

Although, statistically, women continue to make more family claims than men do, this is not a gender issue. As more men become single parents or exercise such nontraditional options as paternity leave, they find themselves subject to criticism for

departing from the traditional company man who gives all to the corporation while making family considerations secondary.

This effect may have profound changes on the way in which all people look at jobs. Besides, employment laws usually take a few years to find their places in the legal system. This was true of the ADA, which offers more and wider avenues of legal attack than the FMLA. As time passes, the FMLA will likely grow beyond its current add-on status to claims under other laws.

Legislative and political history

When he signed the FMLA, Bill Clinton said the legislation would "promote national interests in preserving family integrity." Clinton signed the bill into law as one of his first acts as president. The signing was orchestrated as a symbol of the direction Clinton sought in his presidency.

Congress has stated that the purposes of the FMLA include the following:

> ...to balance the demands of the workplace with the needs of families, to promote the stability and economic security of families, and to promote national interests in preserving family integrity;

> ...to entitle employees to take reasonable leave for medical reasons, for the birth or adoption of a child, and for the care of a child, spouse or parent who has a serious health condition....

To support its decision to pass the FMLA, Congress made six findings, three of which are usually cited in disputes over the law:

- it is important for the development of children and the family unit that fathers and mothers be able to participate in early child rearing and the care of family members who have serious health conditions;

- the lack of employment policies to accommodate working parents can force individuals to choose between job security and parenting;

The FMLA is built on altruistic intent

Legislative debate over family leave was minimal

- due to the nature of the roles of men and women in our society, the primary responsibility for family care taking often falls on women, and such responsibility affects the working lives of women more than it affects the working lives of men....

Under the FMLA, an eligible employee will be entitled to a total of 12 work-weeks of leave during any 12-month period for one or more of the following:

- Because of the birth of a son or daughter of the employee and in order to care for such son or daughter.

- Because of the placement of a son or daughter with the employee for adoption or foster care.

- In order to care for the spouse, or son, daughter, or parent, of the employee, if such spouse, son, daughter, or parent has a serious health condition.

- Because of a serious health condition that makes the employee unable to perform the functions of the position of such employee.

In addition, any eligible employee who takes leave under section 102 of the FMLA is entitled, on return from such leave, "to be restored" to the position of employment held by the employee when the leave commenced.

The legislative debate over this law was much less substantive than the debates over the ADA or Title VII of the 1964 Civil Rights Act. The law worked its way through a Democratic Congress in the last months of George Bush's presidency. It was a minor issue in the presidential campaign of 1992.

Through 1995, though, the courts had made little use of the scant legislative debate that surrounded the FMLA. Like the 1991 Civil Rights Act, the FMLA passed into law with little dispute.

This safe passage through Congress reflected the general public sentiment in favor of the law. However, about a year after the FMLA took effect, one

survey of managers and consultants found that employees may jeopardize their climb up the career ladder when they take family leave.

The survey, conducted by The Conference Board, a New York-based business research group, examined the workplace impact of the FMLA. In what the report termed an "unsettling finding," 64 percent of respondents said women have "some" or "substantial" reason to worry about job advancement if they take a leave, because of "prevailing attitudes" of co-workers and managers.

For men, the news was even worse: 75 percent of respondents said men face at least some risk when they opt for leave. That difference seemed to account for another study result. Respondents said they believed men are much more reluctant to take family leaves than women.

The survey polled over 100 members of The Conference Board's work-family research and advisory panel, which was composed primarily of work and family managers from large American employers. What made the results all the more striking: The group was largely drawn from the country's most "family friendly" companies.

The difference between general political sentiments and the specific realities of the business world highlighted the essential problems of issues that link family and work.

Even though the FMLA is an administrative hassle many agree on one point: that the act has ushered into the workplace new honesty about the weight of family concerns on employees.

But not everyone believes the law is being followed fairly. Noting that the current law applies to only about 44 percent of working women and 50 percent of working men, employee-rights advocates hope that the FMLA can be expanded to include employees of smaller companies and part-time workers. They also want to get rid of the law's geographic parameters and provide paid leaves for lower income workers.

The hard effects of taking substantial time off

The political fallout of family leave trends

"There is not as much secrecy now about 'Yes, I'm pregnant,' or 'Yes, I have elder-care responsibilities,' said Dana Friedman, co-president of the Families and Work Institute, a New York-based research group. The FMLA "is really opening up the door to talking about these issues and having companies better understand employees and what their family needs are."

"Business and market factors are dictating that the issues surrounding cultural diversity be taken more seriously," concludes a report by the Illinois-based management consulting firm Hatbridge House Inc. "It means a corporate culture that values everyone, with particular groups no longer being disadvantaged."

One report published by the New York-based working women's group, 9to5, said some employers may be trying to avoid FMLA compliance by hiring part-timers to work fewer than the 1,250 hours a year—about 25 hours a week—that help make an employee eligible for leave coverage. "If something is good and it's the right thing to do, you need to make it right for everybody," said Ellen Bravo, executive director of 9to5.

The Conference Board has defined three types of families that are most likely to need special support: adoptive families, single-parent families, and step-families or blended families.

After the FMLA's passage, Ohio Senator Howard Metzenbaum said, "This is a major, major step, but it does not go far enough. There will have to be a second and a third step so all Americans are covered."

Metzenbaum didn't have to wait long for steps two and three. Within twelve months, Congress had introduced a bill to take away the exemption for highly compensated employees. A number of union locals had arranged seminars on how to expand workplace rights under the law. Among the proposals discussed: demand "income replacement" to compensate workers for unpaid leave; relax the definition of "serious illness"; expand the definition of "family" so more people are eligible for leave;

and lengthen the list of reasons people can use to take paid leave.

No matter how compelling family leave sounds in legislative sessions, the FMLA remains problematic because it's so often abused. The 1994 case *Audrey Seidle v. Provident Mutual Life Insurance Co.* illustrates how this abuse can—almost—occur.

Seidle worked as a Claims Examiner at a Provident Mutual subsidiary in Newark, Delaware. She did not report to work for a whole week—from October 11 to October 15, 1993. When she returned to work on October 18, 1993, she was informed she was being terminated due to excessive absenteeism.

Seidle had been given an excused personal day off on October 11—but she didn't inform her employer about taking the rest of the week off. She sued Provident Mutual, alleging that her termination violated the FMLA. She claimed that her absence had been caused by the need to care for her ill four-year-old son, Terrance. She sought back pay from the date of her discharge, reinstatement or front pay, and other remedies available under the FMLA.

The parties agreed that, if the Court found that Terrance's illness did not constitute a "serious health condition" within the meaning of the FMLA, Seidle would not be entitled to the protection of the FMLA. So, the court focused on this narrow issue.

Specifically, the facts surrounding Terrance's illness were as follows:

> On October 11th, Terrance awoke from his sleep and began to vomit. He had a fever and runny nose. During the night, his temperature rose to 102 degrees. Seidle phoned his pediatrician, Patricia Camody-Johnston. Johnston's answering service told Seidle to monitor Terrance's temperature and, if his condition did not improve overnight, to bring him in to see Johnston the next day.

An earache that kept a mother home for a week

By the early morning of October 12, Terrance's temperature had dropped to 100 degrees. Seidle scheduled an appointment for Terrance to see Johnston that afternoon. The doctor diagnosed Terrance as suffering from a "right otitis media"—an ear infection. She prescribed an oral antibiotic to be taken over a ten-day period.

Johnston asked that Seidle bring Terrance back in two weeks to ensure that the ear infection had been cured. Johnston also told Seidle to keep Terrance home for two days. It was Johnston's "usual advice to a parent with a child with an ear infection that the child not return to day care...and remain home until the child has no more fever for at least 48 hours and feels better."

Later that evening, Terrance's fever had disappeared. He slept soundly that night.

On October 13, Seidle didn't take Terrance to his day care center. She kept him inside all day. He continued to take the antibiotic and Tylenol. He slept soundly again that night.

On October 14, Seidle kept Terrance home again. He didn't eat any lunch but did eat some "chicken nuggets and fries" for dinner. He slept soundly that night.

On October 15, Seidle stayed home with Terrance again because he "still had a runny nose and the day care would not allow him to be there."

On October 16 and 17—a weekend—Terrance's runny nose dried up and Seidle let him go outside for short periods. On October 18, Seidle took Terrance back to his day care center and went back to work.

Terrance had never had an ear infection prior to October 1993. Other than the October 13 visit, Seidle had no further communications, either in person or by telephone, with Johnston or any other health care provider regarding Terrance's ear infection. She never took

Terrance back to Johnston for a follow-up examination concerning his ear infection.

The FMLA includes an illustrative list of health conditions which qualify for coverage. The court ruled that ears infections are "conspicuously absent from the list of examples contained in the legislative history....Although Congress stated that the list of examples of serious health conditions was not intended to be exhaustive, an ear infection of the type suffered by Terrance certainly is not as severe as any of the illnesses listed."

Terrance's fever lasted no more than 24 hours. Treatment consisted of one 20-minute examination by his pediatrician and a 10-day regimen of antibiotics. The ear infection did not require any hospitalization or surgical intervention.

To qualify as someone suffering from a "serious health condition" under the FMLA, Terrance had to undergo "a period of incapacity requiring absence from his day care center for more than three days" and be under the "continuing treatment" of a physician. Seidle could not establish either point.

Terrance stayed home from his day care center on the fourth day because of the center's policy prohibiting children with a "runny nose" from attending. But there was no evidence that Terrance had more than a runny nose at that time. The court concluded, "A runny nose can hardly be classified as an incapacity."

And, even if Terrance had been legitimately absent from his day care center for more than three days, the evidence didn't show that the period of incapacity involved "continuing treatment by a health care provider" as defined by EEOC enforcement guidelines. The court ruled that the term "continuing treatment" meant "direct, continuous and first-hand contact by a health care provider subsequent to the initial outpatient contact."

Finally, Seidle argued that Terrance's ear infection was a serious medical condition because, left untreated, such infections can lead to diseases like meningitis.

The FMLA uses lists instead of definitions

However, Provident Mutual countered that "[t]o construe the FMLA to include conditions which, although minor in their initial stages, could evolve into serious illnesses would bring within the protections of the statute virtually every common malady....For example, a cut on a finger, a skinned knee or a common cold, if not cared for properly, could develop into something far more serious; yet no one would argue that Congress intended to cover such minor conditions under the FMLA."

The court concluded:

> ...Terrance did not have a "serious medical condition" as defined by Congress in the FMLA and by the Department of Labor in the Regulations. No matter where our sympathies may lie, the Court is duty bound to carry out the edict of the FMLA as mandated by Congress. Accordingly, Seidle is not entitled to the protection of the FMLA and her termination by Provident Mutual did not violate the FMLA.

Legal issues: pregnancy

In the context of FMLA, you do best not to think of pregnancy as a gender-specific issue. The law considers it a family issue. So, just as trendy couples use the term "we're pregnant" when only one is actually going to give birth, you should think of pregnancy as shared experience.

The pivotal 1976 Supreme Court decision *Martha Gilbert v. General Electric Company* shows why pregnancy works better as a family issue.

General Electric provided a disability plan for all of its employees. The plan paid a weekly nonoccupational sickness and accident benefit equal to 60 percent of an employee's normal straight-time weekly earnings. GE excluded disabilities arising from pregnancy from the plan's coverage.

A class of female employees sued GE, seeking a court ruling that the pregnancy exclusion constituted sex discrimination in violation of Title VII of the Civil Rights Act of 1964.

The class was made up of present or former hourly paid production employees at General Electric's plant in Salem, Virginia. Each of these employees was pregnant while employed by GE during 1971 or 1972—and each presented a claim to the company for disability benefits under the plan to cover the period while absent from work as a result of the pregnancy.

These claims were routinely denied. The members of the class each filed charges with the EEOC, alleging that GE's refusal to pay disability benefits for time lost due to pregnancy and childbirth discriminated against her because of sex. After sufficient time passed, the women filed a private suit.

Their complaint asserted a violation of Title VII. They sought damages and a court order forcing GE to include pregnancy disabilities within the plan on the same terms and conditions as other nonoccupational disabilities.

The plan also excluded temporary and permanent disabilities related to pregnancies. One GE employee in the class action had taken a pregnancy leave in April 1972 and was hospitalized with a non-pregnancy-related pulmonary embolism. She filed a claim for disability benefits under the plan solely for the period of absence due to the pulmonary embolism. GE rejected her claim "since such benefits have been discontinued in accordance with the provisions of the General Electric Insurance Plan."

The trial court held that the exclusion of pregnancy-related disability benefits from GE's employee disability plan did violate Title VII. The court found that normal pregnancy, while not necessarily either a "disease" or an "accident," was disabling for a period of six to eight weeks; that approximately "ten percent of pregnancies are terminated by miscarriage, which is disabling"; and that approximately 10 percent of pregnancies are complicated by diseases which may lead to additional disability.

The cost of providing pregnancy-related benefits

Benefits for childbirth as a gender equality issue

An employer uses a cost-differential defense

had become a key issue in the case. GE made what the courts call a cost-differential defense, which meant that it needed to keep costs of benefits to men and women as close to equal as possible.

The court noted evidence concerning the relative cost to GE of providing benefits under the plan to male and female employees. This evidence showed that—with pregnancy-related disabilities excluded—the cost of the plan per female employee was already as high as, if not substantially higher than, the cost per male employee.

It concluded that the inclusion of pregnancy-related disabilities within the scope of the plan would "increase GE's (disability benefits plan) costs by an amount which, though large, is at this time undeterminable."

On statistical issues related to the claims, the District Court ruled:

> The present plan is objectionable in that it excludes from coverage a unique disability which affects only members of the female sex, while no suggestion is made to exclude disabilities which can be said to affect only males. Additionally, the Court gives no weight to the suggestion that the actuarial value of the coverage now provided is equalized as between men and women. Defenses must be bottomed on evidence, and such, in this regard, is lacking here.

> Whatever inferences may be suggested by the statistical data presented, the Court simply cannot presume to draw any precise conclusions as to the actuarial value of the coverage provided under the present plan, or the effect of including pregnancy related disabilities on the basis of that limited data.

Ultimately, regardless of whether the cost of including such benefits might make the plan more costly for women than for men, the trial court determined that "(i)f Title VII intends to sexually equalize employment opportunity, there must be this one exception to the cost differential defense."

It entered an order enjoining GE from continuing to exclude pregnancy-related disabilities from the coverage of the plan, and providing for the future award of monetary relief to individual members of the class affected.

GE appealed. The Court of Appeals affirmed the trial court conclusion. GE pressed the case to the Supreme Court, which rejected the trial and appeals courts' conclusions.

The Supreme Court declined to follow a 1972 EEOC interpretive guideline that the class members relied on heavily. That guideline stated in pertinent part:

> Disabilities caused or contributed to by pregnancy, miscarriage, abortion, childbirth, and recovery therefrom are, for all job-related purposes, temporary disabilities and should be treated as such under any health or temporary disability insurance or sick leave plan available in connection with employment....(Benefits) shall be applied to disability due to pregnancy or childbirth on the same terms and conditions as they are applied to other temporary disabilities.

However, the guideline was not a contemporaneous interpretation of Title VII. More importantly, it flatly contradicted the position which the agency had enunciated at an earlier date, closer to the enactment of the governing statute.

"We have declined to follow administrative guidelines in the past where they conflicted with earlier pronouncements of the agency. In short, while we do not wholly discount the weight to be given the 1972 guideline, it does not receive high marks," the court concluded.

The high court ruled that the cost to insure against disability was effectively extra compensation to the employees, in the form of fringe benefits. If GE were to remove the insurance benefit and increase wages by an amount equal to that cost, there would be no gender-based discrimination.

"Pregnancy is not a disease at all..."

However, in that scenario, a female employee who wished to purchase private disability insurance that covered all disability risks would have to pay more than would a male employee who purchased identical insurance—due to the fact that her insurance had to cover disabilities related to pregnancy.

Writing for the majority, Justice William Rehnquist held that GE's plan did not violate the gender-discrimination aspects of Title VII—even though it excluded pregnancy-related disabilities. This was so because there was no indication that the exclusion of pregnancy disability benefits was a pretext for discriminating against women.

The court concluded:

> Pregnancy is, of course, confined to women, but it is in other ways significantly different from the typical covered disease or disability. The [trial court] found that it is not a disease at all, and is often a voluntarily undertaken and desired condition. We do not therefore infer that the exclusion of pregnancy disability benefits from petitioner's plan is a simple pretext for discriminating against women....

> Gender-based discrimination does not result simply because an employer's disability benefits plan is less than all inclusive. [GE's] plan is no more than an insurance package covering some risks but excluding others and there has been no showing that the selection of included risks creates a gender-based discriminatory effect.

Women have traditionally borne the brunt of child care in our society. To meet these family obligations, working women often require more flexibility in their work schedules than traditional corporations have allowed. Because of this need for flexibility, women have frequently found themselves blocked in their career path and stereotyped as lacking the commitment to the company that men are perceived to have.

Everyone dreads the mommy track

Recent debate on the "mommy track" indicates the extent of this stereotype in the corporate world. With the increasing divorce rate, employers are being forced to face the realities of single-parent families and the need to provide more family-friendly policies in the workplace.

For years, many women who took time off from work to have children lost their jobs while they were gone. Today, a woman taking maternity leave from work is protected by two laws: the FMLA and the Pregnancy Discrimination Act.

The PDA does not amend Title VII, but is part of Title 29 of the federal Labor Code and contains its own enforcement mechanism.

Indeed, the most common claims made under the FMLA involve pregnant women who take time off to have their children. In 1993, pregnancy-discrimination complaints to the EEOC reached a six-year high. After declining for several years, pregnancy-related filings rose 2.7 percent to 3,543 that year. That increase followed an 11 percent increase in 1992.

Problems remain, though. Many companies have maternity-leave programs that do not guarantee employees the same duties upon their return. And, through the late 1980s and early 1990s, widespread layoffs and mounting workplace tension over sex roles increased the unease that many employers feel.

The 1994 case *Karen Barnes v. Hewlett-Packard Company* crystallizes the conflicts that make pregnancy leave issues so difficult—and so politically potent.

Barnes, a former sales representative with Hewlett-Packard, sued the company alleging sexual discrimination in employment under the PDA and Title VII. She claimed that when she returned to work in September 1991—having been away for almost a year on combined maternity and parental leave—she was demoted and a few weeks later constructively discharged.

A white-collar employee takes a very long leave

If the FMLA had been in effect in 1990 and 1991, Barnes might have had a stronger case (although the year she took off was far more than allowed under FMLA). Instead, she tried to make the argument that parental leave is a gender-specific employment issue protected under Title VII.

Barnes had worked at Hewlett-Packard for 14 years, from 1977 until 1991. She held a variety of positions with the firm in California prior to becoming a sales representative in its Rockville, Maryland, office in January 1988.

In late July 1988, Barnes took leave to have a child, returning to work on November 1 of that year. She was reinstated to her previous job and made no complaint regarding her treatment in connection with that pregnancy. She continued with her training and functioned successfully as a sales representative for the next two years.

In September 1990, Barnes, again pregnant but this time with twins, requested and received medical leave due to back pain and insomnia. She received permission to remain on leave through her pregnancy.

This was consistent with Hewlett-Packard's policy, which not only granted expectant mothers leave to give birth, but medical leave in connection with any disability related to the pregnancy.

Barnes' twins were born in February 1991, and her maternity leave extended to May 17. She eventually requested additional "parental leave" through September 16.

Hewlett-Packard's policy regarding the interplay of maternity and parental leave during this period was:

> An employee on a medical leave for maternity purposes will have the option of a maximum four-month parental leave after the doctor has released her to work.

> Note: The parental leave for the birth mother is not an extension of the medical leave but is, rather, a personal leave with a job guarantee

for the four-month period following the doctor's release.

Barnes remained off the job until September 16. From the time she returned, she later claimed, she "was treated in a cold and harassing manner, given no tasks, direction or sales territory." She claimed that, in the weeks that followed, she was "demoted to the position of staff representative and although she would have no immediate reduction in pay (although there was no longer a commission potential and she could lose her company car), she would be ineligible to get a raise for a very long time."

Hewlett-Packard offered her the opportunity to find other positions within the company with her salary guaranteed for two years. Instead, Barnes chose in December 1991 to sign a Voluntary Severance Incentive, received one year's salary as severance pay and departed.

Almost immediately Barnes arranged a new job for herself in California at an annual salary $24,000 higher than her salary at Hewlett-Packard. Claiming the loss of certain other benefits, she filed her suit against Hewlett-Packard.

Barnes complained that she'd been subject to discrimination "because of her sex (availing herself of parental leave) in violation of Title VII." She had to make the claim on the basis of parental leave because her old job was waiting for her when her maternity leave ended in May 1991.

She claimed that Hewlett-Packard had an obligation to warn her of the possible consequences of her taking parental leave immediately following maternity leave. The trial court rejected that claim because it was aware of no law that charged an employer with "a legal obligation to describe to Barnes the universe of possible consequences that might attend her choice to go on parental leave."

The law didn't help her much elsewhere, either. The Pregnancy Discrimination Act of 1978 (PDA), which amended Title VII, made it illegal:

Combining Title VII claims with family issues

Key differences between maternity leave and family leave

to discriminate against any individual with respect to...conditions of...employment...because of or on the basis of pregnancy, child birth, or related medical conditions.

But Barnes had requested parental leave, not maternity leave. So, she argued that parental leave following maternity leave was gender-based and thus protected under Title VII. But the trial court noted that the proposition had been "consistently rejected from the outset." It cited the legislative history of the PDA:

> For example, if a woman wants to stay home to take care of the child, no benefit must be paid because this is not a medically determined condition related to pregnancy.

The court also noted that "all pertinent authorities since the inception of PDA are in accord that Title VII does not prohibit discrimination on the basis of child-rearing activities or parental leave."

It cited the 1985 case *Record v. Mill Neck Manor Lutheran School*, which stated the proposition more directly:

> Title VII, as amended by the Pregnancy Discrimination Act, does not protect people wishing to take child-rearing leaves as opposed to women wishing to take pregnancy leaves. A disservice is done to both men and women to assume that child-rearing is a function peculiar to one sex. Whether leaves for child-rearing should be protected from employer discrimination, as leaves for jury duty are, is not a question for this court to determine. Plaintiff does not claim that defendant's actions have a disparate impact on women nor that child-rearing leaves are only granted to women.

The court concluded that there is "a point at which pregnancy and immediate post-partum requirements—clearly gender-based in nature—end and gender-neutral child care activities begin." The fatal blow to Barnes' argument was that attending to the medical needs of one of her children— the reason she requested parental leave—could

have been done as well by her husband as by herself.

How to respond to happy news

Some employers are hobbled by a mixed response to news that an employee is pregnant. The generally positive feeling of encouragement and congratulations lowers defenses. The generally negative feeling of having to grant long leave—and possibly losing the employee—gives voice to unwise and possibly discriminatory thoughts. The result can be confusion and illegal behavior.

"Many employers assume a kind of parental or sibling attitude when they hear that an employee is pregnant. Even if there's good-will at the base of this response, it's completely wrong," says the human resources director for a California-based clothes company. "You have to treat it like any other disability. Don't assume any kind of familiarity because you feel happy for the person."

Amid intense pressure to cut costs, some employers may not even be conscious that they're less willing to accommodate unusual circumstances—and in the process discriminate against pregnant employees. Even though pregnant employees may cost a little more than non-pregnant employees—in terms of health benefits and down time—you can't make a staffing decision on that basis alone. If you make a negative decision about a pregnant worker, make sure you can support the decision with reasons having nothing to do with the condition.

A baby boomlet in the workplace has also added to the complexity of dealing with pregnant employees. Though fertility rates remained flat during the 1980s and 1990s, the proportion of employed women of child-bearing age who had given birth in the previous year rose from 51 percent in 1988 to 54 percent in 1992. This trend continued a steady increase from 31 percent in 1976, according to the U.S. Census Bureau.

Labor specialists say the current generation of

women entering the work force is more likely to take ambiguous or potentially discriminatory remarks seriously.

In November 1993, a state-court jury in San Jose, California, awarded one of the largest pregnancy-discrimination verdicts ever given to an individual. The jury awarded $2.7 million, including $1.5 million in punitive damages, to Lana Ambruster, a former claims adjuster for California Casualty Management Co.

Ambruster claimed her boss threatened to fire her if she returned from her honeymoon pregnant, then placed her on written probation two months later when she told him she was expecting a child. The 28-year-old woman was fired two months after that.

California Casualty contended that Ambruster's performance had been unsatisfactory for a significant length of time before her pregnancy and that she had been warned about the problem. The company said it had strong nondiscrimination policies and a good track record on pregnancy leave. It also said the allegedly discriminatory remarks by Ambruster's manager were taken lightly by other employees.

Steven Reaves, Ambruster's attorney, argued that California Casualty's "just joking" defense didn't explain the direct and specific statements that the supervisor made to the young woman. The jury agreed.

"This case revolved around some incredibly stupid comments made by [Ambruster's] managers," says one attorney familiar with the case. "You'd think there wasn't much chance that this kind of thing could happen everywhere—but you'd be surprised how often it does."

In a lawsuit filed in Virginia state court in August 1994, Linda Spencer claimed retail store chain Tultex Corp. illegally fired her because she was pregnant. According to the suit, Spencer had six years' experience with Tultex and had received several pay raises and promotions.

In May, Spencer began a maternity leave from her job as an administrative assistant. When she was ready to come back to work in July, she was told her job had been eliminated. A temporary worker was hired to fill Spencer's job when she went on pregnancy leave, and Spencer claimed that temp continued to fill her job.

Spencer sought reinstatement to her job and up to $1 million in damages. She named the maximum number of defendants in her suit: the company; John J. Smith, the company's vice president; and Ronald Cox, director of human resource management.

Spencer's lawsuit came on the heels of another discrimination suit against Tultex filed by a former employee. Tania Riddle, a highly paid merchandise manager at Dominion Stores Inc.—a Tultex subsidiary—also claimed that she lost her job because she was pregnant.

Riddle went on maternity leave in late April and was told by a Tultex executive in June that no job was available for her. Her suit contended that Tultex, through a reduction in salaried work force, filled her job with a male employee who had accepted a demotion. Riddle was not afforded the same opportunity to displace an employee with less seniority.

Lewis Drane, general manager of Dominion Stores, said that Riddle's job was a victim of restructuring, and the job she once held was "much more encompassing" now. "There were no jobs I felt [Riddle] was qualified for," he said.

Drane was a defendant in Riddle's suit, as was Smith, the company's vice president and the company itself.

"The 20- and 30-year-olds who are having children today grew up in an environment where they expected to be treated equally," says Kathleen Lucas, a San Francisco employment-law attorney. They won't tolerate the frustration—however indirect or ironic—that women in previous generations accepted.

The different perspective of young women today

221

Husbands use FMLA as aggressively as their wives

An early lawsuit filed in York, Pennsylvania, involving a young married couple going through a personal tragedy, was perfectly positioned to play on the emotions of jurors.

Frederick Young brought his FMLA lawsuit—also in state court—against Blockbuster Entertainment Corp. and his supervisor at the time, Cindy Lux. The video store employee claimed he wasn't allowed to leave work when his wife had a miscarriage.

According to the suit, Young's wife suffered a miscarriage during the early morning hours of March 12, 1994. He took her to the nearby hospital, left her in the care of medical personnel and reported for work at a Blockbuster Video outlet.

Arriving about 7:30 a.m., Young called Lux, his supervisor, explained the situation and asked for a leave to attend to the family emergency. Lux allegedly refused to grant the leave, telling Young "if he worked hard, he would get his mind off of it."

Young, believing he wrongfully was denied medical leave according to the FMLA, lodged a complaint with Blockbuster's human resources office. The complaint resulted in harassment from his superiors and co-workers. All of this culminated in his termination about six weeks after the miscarriage.

Young argued that his termination resulted from his attempt to exercise leave rights and was in retaliation for filing a grievance over his manager's handling of the request. Young's attorney said the FMLA specifically prohibits discrimination against employees in Young's predicament. Young had been employed by Blockbuster for more than three years.

Young claimed that his firing was motivated by his opposition to Blockbuster's unlawful and illegal conduct. He sought to get back his job and have Blockbuster pay back wages plus attorney's fees and other costs—as the FMLA allows.

In the same lawsuit, Young alleged intentional in-

fliction of emotional distress, calling Blockbuster's conduct "outrageous and extreme...cruel, inhumane and wanton." He asked for both compensatory and punitive damages.

Next to traditional maternity leave, other kinds of leave related to pregnancies form a distinct category of FMLA disputes. These stories have such visceral appeal that they overcome the technical limits of the law.

Five months into her pregnancy with triplets, Carla Seale went into premature labor and her husband, Randy, rushed her to the hospital. Although doctors were able to interrupt labor, it was clear that the lives of the unborn triplets were in peril.

Randy Seale asked his employer, New Mexico-based Associated Milk Producers Inc., for family medical leave so he could tend to his wife and soon-to-be-born children. His supervisor said he could have 12 weeks of leave with a doctor's note. But the same supervisor fired Seale from his job as a truck driver a week after getting the note, saying Seale hadn't shown up for work.

"It put me under a lot of additional stress," Carla Seale said. "We had to worry about his job and where we were going to get money for the bills, on top of worrying if the babies would make it."

The triplets were born in April 1993, about three months prematurely and have been hospitalized for most of their lives. The entire family had to move in with Carla Seale's parents because they ran out of money.

Randy Seale found other work, as a mechanic and truck driver, earning about half his previous salary. Saying that he wanted his old job back, he filed an FMLA complaint with the Labor Department. After failing to persuade the company to reinstate Seale, the Labor Department filed suit against Associated Milk Producers, charging it violated the law by firing Seale.

Sonny Pride, assistant region manager for the company, said his company was "flabbergasted" by the

A notorious case of employer-enforced sterility

lawsuit because the firm already had agreed to reinstate Seale after being approached by Labor Department officials.

Pride said Seale was terminated because he failed to keep the company informed of his intentions. The only remaining dispute between the department and the company, he said, was over whether the company owed Seale back wages. "He left at a time when we were in desperate need of drivers, but we understood his position," Pride said. "We would have never terminated him if he had done the proper paper work or at least called to say he could not do it."

The 1991 Supreme Court decision *Implement Workers of America v. Johnson Controls* set or clarified many of the ground rules for pregnancy discrimination cases.

Johnson Controls manufactured batteries which contained lead as a primary ingredient. Occupational exposure to lead entails a variety of health risks, including the risk of harm to any fetus carried by a female employee.

Before the Civil Rights Act of 1964, Johnson Controls did not employ women in its battery-manufacturing plant. Subsequently, it allowed women to work in the battery plant but emphasized to women who expected to have a child they should not choose a job which would have such exposure.

The company also required a woman who wished to be considered for employment to sign a statement that she had been advised of the risk of having a child while she was exposed to lead. The statement informed the woman that, although there was evidence "that women exposed to lead have a higher rate of abortion," this evidence was "not as clear...as the relationship between cigarette smoking and cancer," but that it was, "medically speaking, just good sense not to run that risk if you want children and do not want to expose the unborn child to risk, however small...."

From 1979 to 1983, eight employees became preg-

nant while maintaining blood lead levels above 30 micrograms per deciliter. This was OSHA's critical level for workers who planned to have a family. As a result, in 1982 the company again started excluding women from jobs that exposed them to lead.

The company's official policy defined "women... capable of bearing children" as "[a]ll women except those whose inability to bear children is medically documented." In other words, women who wanted the jobs had to prove they were infertile or had been sterilized.

It further stated that an unacceptable work station was one where, "over the past year," an employee had recorded a blood lead level of more than 30 micrograms per deciliter or the work site had yielded an air sample containing a lead level in excess of 30 micrograms per cubic meter. However, these jobs tended to be the highest-paying positions available in the Johnson Controls plant.

In April 1984, a group of employees denied jobs in the battery plant filed a class-action lawsuit in federal court. The class consisted of "all past, present and future production and maintenance employees" in United Auto Workers bargaining units at nine Johnson Controls plants "who have been and continue to be affected by [the employer's] Fetal Protection Policy implemented in 1982."

The class action challenged Johnson Controls' fetal-protection policy as sex discrimination violating Title VII and the Pregnancy Discrimination Act.

The trial court granted summary judgment for Johnson Controls. Applying a business necessity defense consistent with fetal-protection cases in other federal courts, it concluded that:

- while "there is a disagreement among the experts regarding the effect of lead on the fetus," the hazard to the fetus through exposure to lead was established by "a considerable body of opinion";

- although "[e]xpert opinion has been provided

which holds that lead also affects the reproductive abilities of men and women...[and] that these effects are as great as the effects of exposure of the fetus...a great body of experts are of the opinion that the fetus is more vulnerable to levels of lead that would not affect adults"; and

- the class of employees had "failed to establish that there is an acceptable alternative policy which would protect the fetus."

The class appealed. The Seventh Circuit Court of Appeals affirmed the summary judgment. It concluded that "the components of the business necessity defense the courts of appeals and the EEOC have utilized in fetal protection cases balance the interests of the employer, the employee and the unborn child in a manner consistent with Title VII." With its ruling, the Seventh Circuit became the first Court of Appeals to hold that a fetal-protection policy directed exclusively at women could qualify as a bona fide occupational qualification.

The class pressed its case up to the Supreme Court. The high court articulated the core issue as: May an employer exclude a fertile female employee from certain jobs because of its concern for the health of the fetus the woman might conceive?

The court ruled that Johnson Controls' fetal-protection policy explicitly discriminated against women on the basis of their gender. The company policy excluded women with childbearing capacity from lead-exposed jobs—and thus created a facial classification based on gender. Fertile men, but not fertile women, were given a choice about whether they wished to risk their reproductive health for a particular job.

And the policy was facially discriminatory because it required only female employees to produce proof that they were not capable of reproducing.

Employers can, under Title VII, discriminate against a protected class—including a gender—if a bona fide occupational qualification necessary to normal operations applies to that class. But the Supreme Court held that Johnson Controls' fetal-

protection policy was not one of the "certain instances" that comes within the BFOQ exception.

Johnson Controls argued that its fetal-protection policy fell within the so-called safety exception to the BFOQ. The high court responded that the safety exception was only allowed in narrow circumstances— "instances in which sex or pregnancy actually interferes with the employee's ability to perform the job." That wasn't the case in the battery plant.

The court then looked at the Pregnancy Discrimination Act and legislative remedies for pregnancy discrimination. It noted that: "[t]he second clause [of the PDA] could not be clearer: it mandates that pregnant employees shall be treated the same for all employment-related purposes as nonpregnant employees similarly situated with respect to their ability or inability to work."

It concluded:

> With the PDA, Congress made clear that the decision to become pregnant or to work while being either pregnant or capable of becoming pregnant was reserved for each individual woman to make for herself. We conclude that the language of both the BFOQ provision and the PDA which amended it, as well as the legislative history and the case law, prohibit an employer from discriminating against a woman because of her capacity to become pregnant unless her reproductive potential prevents her from performing the duties of her job.

In its use of the words "capable of bearing children" in the 1982 policy statement as the criterion for exclusion, Johnson Controls had explicitly classified on the basis of potential for pregnancy. Its policy did "not pass the simple test of whether the evidence shows treatment of a person in a manner which but for that person's sex would be different."

"All we had to do was stop using the policy," says Johnson Controls spokeswoman Denise Zutz of the settlement and compliance orders that fol-

lowed. "We have increased the amount of personal counseling with all employees....we've attempted to find more effective ways of educating employees about personal hygiene and work practices which impact levels of lead absorption."

But the company still believes its position was valid. "We believed we did the right thing. I don't think anyone today would have done anything differently," Zutz says. "The issue revolved around making a choice of possibly violating womens' rights versus protecting the health of the fetus. The company was more concerned about having played a role in a child being sick."

Johnson Controls' advice to other employers, Zutz says, is not to hesitate in setting policies that work for particular business necessities: "Doing nothing also has an impact. People have to recognize that the impact is just as important as doing something. Most companies are taken to task for responding too slowly—we were taken to task for trying to avoid a single problem. Sometimes people who try to be affirmative end up taking the heat."

Enforcement

The FMLA covers employers who employ 50 or more workers within a 75-road-mile radius of the employees' work site. It does not apply to part-time employees or those on the job less than a year.

It requires covered employers to grant up to 12 weeks unpaid leave in a twelve-month period to eligible employees. And it requires that the leave be granted not only to an employee with a serious condition, but to employees who need time off to care for a relative who has a serious health condition and to employees who have a new child through birth, adoption or foster child placement.

The FMLA defines a "serious health condition" as:

> ...an illness, injury, impairment, or physical or mental condition that involves—(A) inpatient care in a hospital, hospice, or residential medi-

cal care facility; or (B) continuing treatment by a health care provider.

The legislative history states that examples of "serious health conditions" include, but are not limited to, the following:

> heart attacks, heart conditions requiring heart bypass of valve operations, most cancers, back conditions requiring extensive therapy or surgical procedures, strokes, severe respiratory conditions, spinal injuries, appendicitis, pneumonia, emphysema, severe arthritis, severe nervous disorders, injuries caused by serious accidents on or off the job, ongoing pregnancy, miscarriages, complications or illnesses related to pregnancy, such as severe morning sickness, the need for prenatal care, childbirth and recovery from childbirth.

So, reasons for taking the leave include births and adoptions; care of a spouse, son, daughter or parent with a serious health condition; or a serious health condition of the employee.

According to Congress, it is these types of illnesses which "meet the general test that either the underlying health condition or the treatment for it requires that the employee be absent from work on a recurring basis or for more than a few days for treatment or recovery."

Similarly, with respect to children, "serious health condition" is intended "to cover conditions or illnesses that affect the health of the child, spouse or parent such that he or she is similarly unable to participate in school or in his or her regular daily activities."

On the other hand, Congress sought to exempt those "minor illnesses which last only a few days and surgical procedures which typically do not require hospitalization and require only a brief recovery period." According to Congress, these illnesses should be covered by the employer's sick leave policy.

The EEOC has expanded on this definition:

The terms that permit FMLA leave

For purposes of FMLA, "serious health condition" means an illness, injury, impairment, or physical or mental condition that involves:

(1) Any period of incapacity or treatment in connection with or consequent to inpatient care (i.e., an overnight stay) in a hospital, hospice, or residential medical care facility;

(2) Any period of incapacity requiring absence from work, school, or other regular daily activities, of more than three calendar days, that also involves continuing treatment by (or under the supervision of) a health care provider; or

(3) Continuing treatment by (or under the supervision of) a health care provider for a chronic or long-term health condition that is incurable or so serious that, if not treated, would likely result in a period of incapacity of more than three calendar days; or for pre-natal care.

"Continuing treatment by a health care provider" means one or more of the following:

(1) The employee or family member in question is treated two or more times for an injury or illness by a health care provider. Normally, this would require visits to the health care provider or to a nurse or physician's assistant under direct supervision of the health care provider.

(2) The employee or family member is treated for the injury or illness two or more times by a provider of health care services (e.g. physical therapist) under orders of, or on referral by, a health care provider, or is treated for the injury or illness by a health care provider on at least one occasion which results in a regimen of continuing treatment under the supervision of the health care provider—for example, a course of medication or therapy—to resolve the health condition.

(3) The employee or family member is under the continuing supervision of, but not necessarily being actively treated by, a health care provider due to a serious long-term or chronic condition or disability which cannot be cured. Examples include persons with Alzheimer's, persons who have suffered a severe stroke, or persons in the terminal stages of a disease who may not be receiving active medical treatment.

To implement the eight-page act, the EEOC issued 55 pages of regulations and 40 pages of commentary explaining them.

Employees who feel they've been denied legal benefits can file complaints with the Labor Department or sue their employers directly. The FMLA allows employees to select their forum; they can sue in either state or federal court for alleged FMLA violations. According to the Labor Department, any violation of the FMLA or the regulations amounts to an unlawful interference with, restraint or denial of FMLA rights.

The FMLA prohibition against "discrimination" means that employers will now have to add a new category to the laundry list of protected classes against which employment discrimination is prohibited: employees who take FMLA leaves.

In this way, the FMLA functions like workers' compensation. An employee can claim that a discharge or denied promotion constituted unlawful "discrimination" based on his or her history of taking FMLA leave. The FMLA virtually guarantees this kind of litigation by providing that an employee shall be awarded reasonable attorney fees in a successful lawsuit.

The enforcement provisions of the FMLA parallel those in the Fair Labor Standards Act, which is enforced by the Labor Department. "It's important to send an enforcement message that the Department of Labor is going to stand behind employees when their rights have been violated," said Maria Echaveste, administrator of the Labor Department's wage and hour division.

Fines are low, civil lawsuits are expensive

"We're fighting a certain culture that existed within the Labor Department that focused solely on complaints," said Echaveste. "If we let our enforcement depend solely upon those workers who complain, we will get people who are not necessarily representative of the more exploited or abused workers."

Despite the tough talk from the Labor Department, the law has few enforcement teeth and even fewer regulators to monitor compliance. The government can take an employer to court to force compliance and punish violators with a $500 fine. The bigger deterrent is the threat of civil action by employees.

Rather than wait for complaints, Labor Secretary Robert Reich instructed regional offices to "target" certain industries or individual firms with what one spokeswoman called "a high profile...to send the message to the employer community that we are enforcing the laws." Building maintenance firms, security companies and temporary employment agencies are among the sectors that may receive enforcement emphasis.

Reich has instructed the department to work with local employee advocacy groups to learn about possible cases.

Labor officials, who note that they have answered 130,000 requests for information, also point to what they consider a low number of complaints as evidence that the law is taking root. In the first 11 months, the Labor Department fielded 965 complaints, a relatively small number, officials say, considering that 1.5 million to 2 million employees were estimated to be eligible for leave in that period.

About 590 complaints proved to be violations of the law—primarily refusals of employers to return leave-takers to the same or similar jobs as required by the law—and 90 percent were resolved after labor officials contacted employers.

"While I wish the low number of complaints meant employers were finding it an easy law to live with,

we believe a lot of employers and employees don't know what the law is all about and what their rights are," the Labor Department's Echaveste said.

For their part, many employers and employer groups concede that the law has not caused the large-scale workplace disruption that some opponents of the legislation had predicted. At the same time, some say the administrative burden has been too heavy.

"Each leave has to be evaluated to see how much leave the person has already taken, what is the reason for the leave, does it qualify under the law, how much time does the employee have left under family leave versus how much time the employee is going to be out," a spokeswoman for Texas-based Southwest Airlines told one local newspaper.

Most FMLA complaints from employees charge employers with illegally denying them leave, firing them for taking time off, or failing to cover their health benefits while they are out. In most cases, the conflicts were resolved through mediation—sometimes with a single phone call.

The law exempts some "highly compensated" employees. Employers can exempt key salaried employees who are among their highest-paid 10 percent, if that's needed to prevent substantial and grievous economic harm to the employer.

Reich maintains that confusion and occasional resistance are to be expected in the early stages of a new law and that compliance will improve as more companies become familiar with the policy.

"The fact that 90 percent of the complaints were so easily resolved suggests to me that employers still have a long way to go to understand the law," Reich said.

Reich said his department would "stand behind these employees and any others whose rights have been violated."

If this sounds like political posing, it's just one example of that aspect of the FMLA. Parts of the Labor Department's FMLA enforcement guidelines

Mediation is a common tool for solving FMLA problems

reflect a gratuitous anti-employer bias. For example, the guidelines state that employers are expected not just to answer but to "responsively answer" employee questions about the law.

Several commentators have noted that such language implies that—without the law—employers might answer in a less-than-candid manner.

Donna Lenhoff, general counsel for the Women's Legal Defense Fund in Washington, D.C., which campaigned for the law's passage, shared the conventional wisdom about the FMLA's early enforcement: "In general, the Act is working pretty well. The number of complaints have been fairly small."

Compliance

American employment law continues to evolve in the direction of increasing the rights of employees and decreasing their obligations to their employers. The FMLA, like the Americans with Disabilities Act, represents an acceleration of this trend.

The FMLA permits you to require a medical certificate documenting the need for leave—including the date the condition began, probable duration and appropriate medical facts. However, the law prohibits you from requiring any information beyond the information covered by the Labor Department's "optional" medical certification form.

The medical certification must come from the employee's "health care provider," who can be a medical doctor, osteopath, podiatrist, dentist, clinical psychologist, optometrist, chiropractor, nurse practitioner, nurse midwife or even a Christian Science practitioner.

You can require, at your own expense, an employee to obtain a second medical opinion and if that's different from the first opinion, require a third opinion. However, you are not permitted to use your regular medical staff or industrial clinic physicians—professionals who are most likely to know the employee's job duties.

If you employ both spouses in a married couple,

you can offer one 12-week leave that they can split in any way they like.

Employees can substitute paid leave for any part of the 12 weeks of unpaid leave, or the employer can require the employee to make this substitution.

Leave can be taken in a way that permits the employee to work part-time, if both the employer and employee agree. Any leave taken on a reduced workday or reduced week schedule may be taken only when medically necessary.

The principal burden for employers is the cost of maintaining health insurance coverage for employees on leave. Employers covered by the FMLA must maintain any pre-existing health coverage during the leave period. Once the leave concludes, employers generally must reinstate the employee to the same or equivalent job and benefits.

If the employee decides not to come back, you have a right to recoup the cost of providing ongoing medical benefits. However, collecting on this kind of debt will usually be difficult—especially if the former employee takes the full 12 weeks of leave before informing you of his or her decision.

The federal government's General Accounting Office has estimated the cost of providing continued medical coverage to employees on FMLA leave at $674 million annually. The real cost to employers is probably higher. The GAO assumes that employers will experience no costs beyond that of maintaining health insurance coverage. In fact, many employers have the cost of recruiting and training replacement workers, whose productivity will likely be lower.

On a more useful note, the Small Business Administration has estimated the average cost per employee at $1,995.

Another cost driver is the required record keeping. Even though the Labor Department states that "no particular order or form of records" is obligatory, it lists numerous items of information that

SBA and other groups claim FMLA doesn't cost much

must be kept. The employer's records, for example, must designate leave taken under the act as "FMLA leave." Notices given to employees about the Family Leave Act must be retained in employee personnel files. Medical certifications must be maintained in separate, confidential files.

The administrative burdens of the new mandate are especially acute for smaller companies without legal staffs and personnel resources. And some employers resent the law because, they say, it gives the government an inappropriate right to meddle in their business.

Only 46 percent of employees responding to an informal survey by 9to5, the national association of working women, reported that their workplaces had posted information about the law, as required.

Before the FMLA was passed into law, many companies already had formal policies offering time off to workers because of pregnancy, sickness or family emergency. Others since have rewritten their benefits handbooks.

However, a survey of 300 West Coast employers in late 1994, by the University of California and the management consulting firm William M. Mercer Inc., showed that 4 in 10 companies were ignoring the statute.

The companies were asked if they were meeting the statute's major provisions: posting notice of family-related leave policies in the workplace, guaranteeing workers' jobs for up to 12 weeks and continuing their health benefits while on leave.

So, it seems that many employers remain confused about the law and that at least some are resisting it outright—because of threatened disruptions to their businesses or simple personal pique. "It has been as hard as we thought it would be if not harder because the confusion over what an employer has to do to comply with the law is tremendous," said Peter Eide of the U.S. Chamber of Commerce, which for years lobbied against such legislation.

Increasingly, companies use alternative human resource policies such as dependent care benefits, job sharing, flex time, work-at-home arrangements, parental leave policies, and child care to accommodate the family life of their employees.

Other groups insist the law is confusing

The mechanics of unpaid leave

When the FMLA passed into law, many employers feared that workers would be lining up to take 12 weeks off. That hasn't happened. The reason: The leave mandated by the FMLA is unpaid.

According to Labor Secretary Reich, the frivolous requests that companies feared have not materialized because most workers can't afford unpaid time off—let alone fight about it. Especially in times of emergency, when bills for medical care and other unanticipated expenses are piling up, employees need their jobs for income.

When an employee takes FMLA leave, paychecks stop. And there's no government compensation either, such as unemployment.

"The benefit of Family Medical Leave is keeping your job if you have to take the leave," says one California-based labor attorney. "Of course the leave is most valuable to employees who can afford to take it."

A survey conducted in 1994 by Illinois-based consultants Hewitt and Associates asked more than 600 clients, primarily large companies, how they were complying with the FMLA. Nearly 90 percent of the respondents expect less than 5 percent of their employees to request family leaves. About 30 percent predicted less than 1 percent of their work forces would request the leave.

"When you consider taking one income away for 12 weeks, that's going to hit the average family real hard," says one spokeswoman for the women's group 9to5. "What kind of benefit is 12 weeks without pay? I can't do that."

9to5 says U.S. Labor Department figures do not accurately reflect what is happening in the work-

place. The group has recommended a series of what it calls "improvements" to the FMLA. These include partial income supplements for employees and lower thresholds for the numbers of employees businesses must have before workers are covered.

Until these improvements become law (and the chance of that happening was significantly reduced by the 1994 elections), the economic reality remains that paid leave is a luxury that most employees can't afford.

Communication

With the awards available under ordinary compliance limited, many employees claim they don't know about the law—often because their employers have failed to tell them.

Employee complaints range from charges that their companies do not post the law as required to allegations that employers threaten to fire workers who take leave and deny promotions after the leave has ended.

Employee-advocacy groups argue that some employers don't comply because they don't understand the law, don't think it applies to them or think it's too costly and burdensome to administer.

"Unfortunately, the response by at least 20 percent of the employers is, 'We're going to ignore this, and we're just going to do what we're doing,'" says a spokeswoman for 9to5. "They're not giving them leave, not giving them their jobs back, firing them while they were on leave for a variety of reasons such as, 'We're going to restructure the department now, everybody stays except you.'"

9to5 claims that employees frequently have faced retaliation from employers for taking advantage of the leave. Among the so-called "improvements" to the FMLA that the organization supports: A more effective program for informing employees and employers about their rights under the law.

Widespread confusion seems to have hindered

employers' compliance, as well as employee usage of the law. Among the questions:

- When is a health condition considered serious enough to warrant a leave?

- What kind of proof is sufficient to document the illness for employers?

- Can companies apply different leave policies to different employee groups?

Companies are required to draft detailed statements of their leave policies for employees, but many have yet to circulate copies widely throughout the workplace.

One example of a point of confusion: An employee's department is restructured or the employee's job is eliminated during the period the worker is on leave. It's an open question how the courts will deal with job restructuring.

The law says that if a job is done away with in a reorganization while an employee is on leave, the company must offer another job, similar in pay and responsibility level. This means that the employer has to prove that the restructuring would have taken place even if the employee had been on the job.

Conflicts with other laws

A number of provisions of the ADA and FMLA overlap and some conflict. This means that practices you might have established to comply with one law may conflict with another.

Employees who receive or are eligible for Workers' Compensation benefits often are covered under FMLA or ADA, but not always. If an injury does not meet the ADA requirements, it may qualify as a serious medical condition entitling the employee to leave and protection under the FMLA.

If the FMLA entitles an employee to leave, you can't require that employee to take a job by providing a reasonable accommodation as defined by ADA. So an employee who takes leave for a back injury that

Potential conflicts between FMLA and ADA

qualifies as a serious health condition can't be forced to work in a special chair that would ease the effects of the injury.

However, you may be required to offer an employee the opportunity to take such a position under ADA.

A blanket rule that employees may not return to work until 100 percent recovered—which might work under the FMLA—is likely to violate the ADA, which prohibits adverse treatment of employees with disabilities if they are qualified and can perform the essential functions of the job, with or without reasonable accommodation.

When symptoms of her multiple sclerosis flared in January, Carol Rebak asked her employer for some time off. According to Rebak, her boss more than complied—he fired her, ordering her to leave the office immediately.

Rebak filed suit in U.S. District Court, claiming her dismissal violated the FMLA. The suit names as defendant the Koolvent Group Inc., parent company of Pennsylvania-based American Siding & Deck Inc., where Rebak had worked as assistant credit manager.

According to the suit, Rebak—a single mother of a 14-month-old girl— experienced symptoms of her illness after a busy stretch at the office in December 1993. She felt numbness in her hands and right leg, blurred vision and had digestive problems. She took a week of paid vacation in January but her condition did not improve, so she asked that her workday temporarily be shortened from 8 hours to 5 1/2 hours.

Her boss told her "your job requires full time" and refused the request. She said after he told her she might be better off at home, tending full-time to her daughter, he fired her and ordered her to leave immediately.

Rebak had been diagnosed with multiple sclerosis in 1989, a fact she said she disclosed in interviews before her hiring in September 1990. The degenerative disease causes the body's immune

system to attack tissue that covers nerve fibers in the brain and spinal cord.

Rebak said she had an exemplary work record and saw her salary increase from $13,000 to $19,500 over three-and-half years and had never previously missed work due to her illness.

Rebak claimed to have been out of work and unable to afford medical coverage since her dismissal, subsisting on $366 in unemployment benefits every two weeks. She complained that her condition has been worsened by stress and anxiety. A year and half later, her case was still being tried.

As we've seen already, things get even more complex when the FMLA conflicts with other employment laws. The 1995 case *Alaska Airlines Inc. v. Oregon Bureau of Labor* shows just how complicated the clashing laws can get.

The case involved an alleged clash between the Employee Retirement Income Security Act of 1974 and the Oregon Parental Leave Act with regard to the use of accrued sick leave benefits for parental leave.

Alaska Airlines' employees received employment benefits—such as sick leave, vacation pay, medical benefits, and disability benefits—under the Alaska Airlines Employee Welfare Benefit Plan. Labor agreements allowed customer service agents and mechanics to accrue eight hours of sick leave each month.

Two Alaska Airlines employees sought to use accrued sick leave benefits during parental leave. However, Alaska Airlines denied the employees' requests because a collective bargaining agreement limited the amount of sick leave an employee could receive under most circumstances.

The employees filed complaints with the Oregon Bureau of Labor because the state's Parental Leave Act entitled employees to twelve weeks of parental leave and allowed employees to use any accrued sick leave during parental leave.

The Oregon BOL issued cease and desist orders

Definitions of various plans shape resolutions

requiring Alaska Airlines to allow employees to use all accrued sick leave during parental leave. The airline sued in federal court to nullify the orders. It argued that the Employee Retirement Income Security Act of 1974 governed its Welfare Plan and preempted the state law.

Alaska Airlines argued that the Welfare Plan was an "employee welfare benefit plan" as defined by ERISA:

> ...any plan, fund, or program which was...established or maintained by an employer...for the purpose of providing for its participants...benefits in the event of sickness, accident, disability, death or unemployment, or vacation benefits....

The airline also argued that the ERISA preemption clause applied to rival state laws. The clause stated that:

> ...the provisions of [ERISA] shall supersede any and all State laws insofar as they may...relate to any employee benefit plan described in...this title....

> "State" is defined as "a State or any political subdivisions thereof, or any agency or instrumentality of either which purports to regulate, directly or indirectly, the terms and condition of employee benefit plans...."

The airline claimed that the two passages read together required a two-part test for determining whether a state law was preempted. First, did the state law "relate to" an ERISA plan? Second, did it "purport to regulate," either directly or indirectly, an ERISA plan?

Alaska Airlines concluded that the Oregon Parental Act did "relate to" its Welfare Plan because the Act expressly provided employee rights with regard to accrued sick leave even though the Welfare Plan governed sick leave benefits. Likewise, the Act "purported to regulate" the Welfare Plan because it directly regulated express terms in the Welfare Plan regarding accrued sick leave.

The Oregon BOL and the employees argued, on the other hand, that the state's Parental Leave Act merely guaranteed parental leave rights secured under federal law in the FMLA. Therefore, even if ERISA did preempt the Oregon Parental Leave Act, it did not preempt the FMLA's identical rights.

The BOL also made a more technical argument. It claimed that the ERISA preemption clause didn't apply because the Alaska Airlines program for paying sick leave was not an "employee welfare benefit plan" within the meaning of ERISA. The basis for this argument: Alaska Airlines paid sick leave benefits through ordinary payroll payments, rather than from a prefunded separate source.

The Oregon BOL concluded that federal labor law excluded from the definition of "employee welfare benefit plan" any plan where there was "[p]ayment of an employee's normal compensation, out of the employer's general assets, on account of periods of time during which the employee is physically or mentally unable to perform his or her duties, or is otherwise absent for medical reasons...."

This was, in fact, how Alaska Airlines structured its sick leave compensation. But the airline claimed that this method of payment didn't remove its Welfare Plan from ERISA coverage because Alaska Airlines was an agent of the trust that reimbursed the sick leave costs.

The trial court pointed out that not all employee benefit plans are covered under ERISA. Congress enacted ERISA to protect employees from the "mismanagement of funds accumulated to finance such benefits, and failure to pay employees the benefits as promised."

ERISA states in part that the term "employee welfare benefit plan" shall not include

> Payment of an employee's normal compensation, out of an employer's general assets, on account of periods of time during which the employee is physically or mentally unable to perform his or her duties, or is otherwise absent for medical reasons...and

Normal compensation versus special benefits

243

Payment of compensation out of an employer's general assets, on account of periods of time during which the employee, although physically and mentally able to perform his or her duties and not absent for medical reasons...performs no duties; for example (i) Payment of compensation while an employee is on vacation or absent on a holiday....

Congress' concern regarding the mismanagement of funds was not implicated by Alaska Airlines' sick leave payment plan because the airline pays employees sick leave benefits

- out of its general assets,

- at the employee's usual rate of compensation, and

- in the same paycheck as regular earnings.

There was no separate fund for the benefits which required administration to enable employees to receive the appropriate sick leave benefits. The trial court concluded that Alaska Airlines "disburses sick leave from its own funds. Consequently, the risk of not receiving sick leave benefits is identical to the risk of nonpayment of compensation for services rendered, one that Congress sought not to regulate through ERISA."

Accordingly, Alaska Airlines' payment of sick leave benefits, out of its general assets, did not constitute an ERISA "employee welfare benefit plan." Because ERISA was inapplicable to Alaska Airlines' sick leave benefits, there was no ERISA preemption.

The Oregon Parental Leave Act controlled the claims. Alaska Airlines had to pay the sick leave as parental leave.

Legal strategies

As we've seen throughout this chapter, the FMLA encourages mediation and settlement long before a dispute would ever reach trial. In the relatively few FMLA cases that have gone before juries, employers have done very badly.

For one thing, FMLA claims are usually bundled with claims under other anti-discrimination laws. Most often, these include the ADEA, Title VII and—even though it contradicts the FMLA in some key points—the ADA.

In the fall of 1994, one of the first FMLA cases went to court in Rhode Island. A woman who, in late 1993, had undergone extensive treatment for cancer sued a Providence law firm for terminating her employment before she could return to work. She bundled her claim with an age discrimination complaint.

Barbara Brown filed her lawsuit in state court against Tillinghast, Collins & Graham, seeking compensatory and punitive damages. She also filed age discrimination complaints with the Rhode Island Commission for Human Rights and the EEOC.

Brown claimed she had been given a leave of absence by the firm after she was diagnosed with breast cancer. She said she underwent treatment which included several months of chemotherapy, during which she lost all her hair. In October 1993, she received a letter from the firm's manager of human resources saying, "I am pleased to know that you will be ready to return to work soon," and outlining the conditions of Brown's return to employment.

However, on New Year's Eve, Brown received a letter at her home from the firm's executive director telling her that her job had been eliminated. The termination was effective the day the letter arrived. And the letter concluded, "This is a permanent layoff with no recall date." Brown had been with the firm for 24 years.

A year later, with her cancer in remission, Brown argued that the FMLA was supposed to assure better treatment for people in her position. "Going through what I went through was so stressful—wondering how my co-workers would react to my wig, for one thing—and to then find that I've been terminated from my job was quite a blow," she said. "I worried that my mental state would hurt my ability to fight the disease."

When leave lasts longer than FMLA-mandated 12 weeks

"The firm does not believe it is liable in any event or under any cause of action that Ms. Brown brought," said a Tillinghast Collins & Graham spokesman. He argued that Brown's termination was based on a reduction of staff and was done "for strictly economic reasons, having nothing to do with her medical leave."

The firm argued that Brown's termination passed several requirements of both federal and state family and medical acts. "First of all, she was not replaced by another person," a spokesman said. "Also, the termination was not done for a medical reason or reason of disability. Finally, she was given more time off than any of the family bills call for, in excess of what employers are required to give."

The firm pointed out that the FMLA allows for a leave of 12 weeks, and Brown's had lasted almost six months. It also claimed that Brown's status at the time of her leave was part-time—and that part-time employees are not covered by either state or federal acts.

"These regulations have made it very difficult for employers to terminate people, even for the best of reasons," the firm spokesman said. "You're falling all over each other with family leaves, medical leaves, disabilities acts, and human rights concerns about age and sex discrimination."

The firm still worried about going to court. Despite the fact that it believed it had a strong case for terminating Brown, it had offered her her job back twice in the weeks leading up to her filing. A year later the case was still pending.

The fall of 1994—about eighteen months after the law took effect—saw a number of FMLA cases come to trial. The most instructive of these involved a Nebraska woman who was fired for missing work to care for her schizophrenic son. The case was tried in federal court and, at least in the early rounds, went in favor of a large, deep-pockets employer.

This case involved a plea for preliminary injunc-

tion—a common tactic used by terminated employees making a claim under federal anti-discrimination laws. They try to get their job back as soon as they can, and then they proceed with the plea for damages.

As the employer facing discrimination charges, you have to fight these early rounds intensely. If the court orders the employee back to work, your prospects for winning the case turn slim.

In October 1994, Irene Suhulka asked U.S. District Judge William Cambridge to order her former employer, AT&T Technologies Inc., to rehire her pending the outcome of her FMLA lawsuit against the company. Her request was denied.

Suhulka went to court to get a restraining order that would allow her to return to work before the suit came to trial. To do so, she had to prove that there was a good chance she would win at trial and that without the restraining order she would suffer irreparable harm.

Cambridge ruled Suhulka had sufficient income and assets and would not suffer "irreparable injury" if not allowed to work at her old job until the lawsuit was concluded.

Suhulka had been fired in August. In her lawsuit, she argued that AT&T should have told her about the unpaid leave that was available to her when she needed to stay home with her son. She had worked for AT&T off and on since 1979 and continuously since 1988 as a production worker on a cable assembly line.

AT&T attorney Robert Rossiter argued that the company notified employees of the new federal law in August 1993 by placing brochures at doors of the plant.

Suhulka's son had been diagnosed eight years before with schizophrenia. He had been hospitalized several times and lived in halfway houses. For several years, he had lived with Suhulka.

Suhulka said a separation from her husband and the jailing of a second son left her without anyone

Noted absenteeism as a mitigating circumstance

to care for her schizophrenic son when he suffered a bad reaction to new medication in July 1994.

Suhulka said she missed work July 27—while she was already on notice for excessive absenteeism—to care for her son. Rossiter said she gave other reasons for her absence. George Parkerson, a deputy chief at AT&T's Nebraska plant, testified that Suhulka had had attendance problems over the years. Twice before, she had nearly been fired because of absenteeism. Because of that record, she had signed an agreement in which she promised to give 48 hours' notice before an absence.

In refusing to order the company to rehire Suhulka, Cambridge noted that she would have as much as $123,000 in cash and assets, including insurance proceeds and benefits due because of her husband's recent death.

He also said she would soon be receiving $1,690 a month in income from her husband's pension, Social Security benefits for her son, rental income and unemployment benefits.

Questions of who qualifies for protection aren't supposed to be as much of an issue under FMLA as under other anti-discrimination laws. However, familiar arguments crop up when the disputes head toward court. Some employers try to make the fair-treatment defense that works occasionally in Title VII and ADEA cases.

The problem with that strategy: Because disparate treatment isn't an issue in FMLA cases, the fair-treatment argument doesn't accomplish much. Even when you're faced with retaliation charges, your best bet is to disprove the claims all together. Arguing that you treat everyone the same way won't work—everyone can be protected by FMLA.

Two FMLA lawsuits filed in Florida state court both involved FMLA retaliation charges against Weight Watchers, Inc., a company that caters to and employs primarily women.

Carol Meile, a payroll coordinator for the weight

loss company for six years, contends in her March 1994 lawsuit that she was fired in November when she was six-and-a-half months pregnant.

The firing was to avoid compliance with the federal law that would have guaranteed her job or an equivalent after she returned from her planned maternity leave, her lawsuit claimed.

Meile's lawsuit was preceded by a co-worker's suit in November 1993 in which Elizabeth Richardson sued a Weight Watchers franchise and its president. That suit contended that Richardson was fired from her bookkeeping job six weeks into her maternity leave.

A Weight Watchers spokeswoman called the lawsuits baseless harassment by disgruntled former employees. The dismissals were part of an overall streamlining of the company, she said. Because all but one of the company's employees were women, it was inevitable that it would lay off someone who was pregnant or on maternity leave.

"We're all women here. Everybody's given birth. This is like somebody suing the NAACP because they're black," the spokeswoman said. The response assumed the FMLA charges were comparable to Title VII or Equal Pay Act claims. They aren't.

Another note of interest in these cases: The angry ex-employees didn't let the fact that the company had fewer than 50 employees stop them from suing. While the Weight Watchers franchise had 16 full-time employees, attorneys for the fired women argued the company had 50 or more employees on its payroll when salespeople were included.

As accommodation for family concerns becomes less stereotyped as a "women's issue," the stigma attached with being the care provider may lessen for women.

Conclusion

More than anything else, family leave issues are almost always complex—no matter how many

"We're all women here"...not much of a defense

**Family leave
issues are
always
complex**

guidelines the EEOC produces. For this reason, it's generally a good idea to be as flexible as you can afford to be in handling these issues.

The 1993 lawsuit *Nancy Ulloa v. American Express* makes a good concluding case for this kind of flexibility.

At the time of the lawsuit, American Express provided its employees with medical, personal and family leaves of absence. If an employee returned within a twelve-week period, American Express guaranteed reinstatement to the same or a similar position. But the company did not guarantee reinstatement for an employee whose leave lasted more than twelve weeks.

Ulloa was hired by American Express as a Customer Service Representative in May 1987. In this position, Ulloa was responsible for reviewing and analyzing correspondence from American Express' charge card customers.

Ulloa was provided with several salary and merit increases and performance awards during the course of her employment with American Express. In August 1990, Ulloa received a performance appraisal in which she was recognized for doing quality work. She was expressly praised for being the most productive employee in her unit.

On June 3, 1991, Ulloa took a leave of absence because she was pregnant. A few days later, Ulloa received a letter—dated June 11— from American Express' Manager of Benefits and Employee Activities. The letter told Ulloa that she was scheduled to return to employment from her leave of absence on July 30. The letter also said that Ulloa would be eligible for an unpaid medical leave of absence if she was still medically unable to return to work. The letter expressly stated, however, that: "In order to be eligible for reinstatement, the combined total leave must not exceed 12 weeks."

Ulloa had her child on June 19. Her doctor had to perform a radial episiotomy during the delivery. Because of the surgery, Ulloa experienced acute pain and discomfort in the weeks afterward. Her

doctor said that she should not return to work until mid-September. Ulloa told American Express about this and the company adjusted her return date to September 9.

On Friday, September 6, American Express' Manager of Human Resources notified Ulloa that she should not report to work because her position had been eliminated due to budgetary constraints.

The decision to eliminate a position from the customer service department had been reached by August. American Express did not have a specific policy to determine which employee would be terminated when the company decided to make a staff reduction. Ulloa was chosen because she had exceeded the twelve-week reinstatement limit.

Ulloa sued, alleging discriminatory termination under several federal laws.

She couldn't make a disparate impact claim, because the statistics supported American Express. At the time of Ulloa's termination, there were approximately 350 employees at its offices in south Florida. Seventy-five percent of these employees were female. Several dozen women in the facility had taken maternity leave during Ulloa's tenure— and all of those who returned within twelve weeks were reinstated. Several took leaves of absence exceeding twelve weeks. In those instances where a position was available when the employee returned to work after twelve weeks, even these employees were reinstated.

Ulloa couldn't claim disparate treatment using direct evidence because of the letter the benefits manager had sent. The trial court ruled:

> ...this letter clearly advised Ulloa that she would not be guaranteed reinstatement unless she returned to American Express within twelve weeks of June 3, 1991....this requirement is unambiguous because it expressly applies to all leave policies, including maternity leave....

So, Ulloa tried to make a disparate treatment case using indirect evidence. This meant the burden-

A star performer caught in a bad situation

A consistent policy wins the day for an employer

shifting framework that applies to disparate impact cases applied.

It was undisputed that Ulloa was pregnant, was qualified for the position, and was terminated. The court allowed the prima facie case to stand and American Express had to offer a legitimate reason for Ulloa's termination.

It did so by demonstrating a downturn in business during the period when Ulloa was on maternity leave. American Express had instituted a "1-800" telephone system which reduced the volume of cardmember mail, so the company decided to terminate an employee in the department that handled correspondence.

American Express also produced a legitimate non-discriminatory business justification for choosing to terminate Ulloa: She had violated the twelve-week reinstatement rule and was therefore not guaranteed a position upon her return from leave.

The court deemed this explanation credible, noting, "Economic necessity has been recognized as meeting the employer's burden of production."

So the burden shifted back to Ulloa to prove by a preponderance of the evidence that the legitimate reason offered by American Express was a pretext for discrimination.

Ulloa argued that, if she hadn't become pregnant, she wouldn't have taken a leave of absence. The court had already found that Ulloa would not have been fired if she had not exceeded the twelve-week reinstatement period; therefore, she argued, she was terminated because of her pregnancy.

The court didn't agree. "The problem with this circular argument is that it fails to present or rely on any credible evidence that Ulloa was treated differently than any other employee who exceeded the twelve-week reinstatement period."

American Express produced unrefuted evidence that all pregnant women on maternity leave—and all people on other medical leave—who returned from that leave after twelve weeks were not auto-

matically reinstated. It also offered at least two instances in which females on maternity leave were reinstated, even though they had been gone more than twelve weeks, because there were positions open.

"There is simply no evidence that American Express treated pregnant women any differently than other employees who violated reinstatement policy," the court concluded. "American Express may not have treated Nancy Ulloa with the kindness and fairness that should be the standard for employer-employee relationships within large multi-national corporations....Nevertheless, [federal law] does not require corporations to treat their employees with fairness or kindness. It only requires that American Express not discriminate against pregnant women."

CHAPTER 5:

GENDER

DISCRIMINATION AND

SEXUAL

HARASSMENT

Introduction

The growing role of women in the work force has raised questions about both subtle and overt discrimination. It has also raised questions about harassment and even assault. Three decades after the Civil Rights Act of 1964 made sexual discrimination illegal—and more than a decade since the courts defined sexual harassment as a form of discrimination—employers still struggle with how to detect, investigate and resolve such cases.

Virtually every company, no matter what size, has to deal with gender-related diversity issues. According to the U.S. Department of Labor, as of 1992 women comprised 45 percent of full-time workers in the civilian labor force. This number was up from 20 percent in 1920. And women dominate the ranks of part-time workers, making up nearly two-thirds of that category.

A 1993 poll conducted by Lew Harris and Associates found that almost one-third of all working women and 7 percent of men claimed to have been sexually harassed on the job.

Employment decisions, from hiring to promotions, generally involve a variety of objective and subjec-

Decisions can't be based on sex stereotypes

tive factors; decisions are often made by the group the candidate would be joining. Under these circumstances, subjective judgments of interpersonal skills and collegiality are vulnerable to gender stereotyping.

For example: A woman's criticisms of a policy are seen as picky or caustic while a man's are seen as detailed and incisive. This kind of double standard is simply illegal. You can't use it—and you can't allow the people who work for you to.

In the 1978 decision *City of Los Angeles v. Manhart*[1], the Supreme Court concluded:

> ...employment decisions cannot be predicated on mere "stereotyped" impressions about the characteristics of males and females. Myths and purely habitual assumptions about a woman's inability to perform certain kinds of work are no longer acceptable reasons for refusing to employ qualified individuals, or for paying them less.

Sexual harassment, the highest-profile gender diversity issue, has become—depending on which source you believe—the primary employment risk facing companies in the United States. The number of harassment complaints filed with the Department of Labor soared from 6,883 in 1991 to 10,532 filings in 1992.

Various studies predict that between 50 and 85 percent of American women will be victims of sexual harassment at some point during their academic or working life. Since the 1980s—and especially since the Clarence Thomas/Anita Hill scandal in 1991—charges of sexual harassment have taken on new social connotations, racial undertones and sexual orientations. These situations reflect the complexity that has characterized human sexual impulses since the beginning of time.

In the wake of this enormous historical perspective, the EEOC waited until August of 1994 to define the terms of sexual harassment.

To a noticeable degree, the EEOC model had the

[1] This case involved a pension plan which required female employees to contribute more than male employees. The difference was based on the undisputed fact that women live longer than men do—and thus would, as a class, draw on the pension longer than men would. The City argued that its policy, which meant that women took home less pay than men, was based on longevity rather than gender. The court rejected that argument.

opposite of the intended effect. It sent aggressive attorneys searching for alternative interpretations that could entrap the agency into giving grudging support. Chief among these variations: claims made by men that female superiors had harassed them.

What sense can you make of this legalistic soup? Clearly, employers need to be aware of the risks associated with gender bias in the workplace and take appropriate measures to remove it. The best guideline: Try to establish a sense of balance in your workplace. Don't let any person or gender group exert so much power that he, she or it can create gender-specific tensions.

Of course, that's just a general guideline. Specific situations tend to be more complicated. In this chapter, we'll consider some of these complications.

Legislative and political history

The political background of workplace gender issues defies easy review. Almost any observation can be disputed. Almost every conclusion invites some exception.

Because gender diversity issues usually depend on sex stereotypes, a few generalizations may be useful. In the United States, as in many countries and cultures, women have historically been socialized as passive and deferential while men have been socialized as aggressive and forceful.

The Equal Pay Act, passed by Congress in 1968, requires that employers give equal pay for equal work regardless of age, sex, national origin, etc. This eliminated the most overt practices of paying women and men differently for the same jobs. However, women's groups remain unhappy with broad disparities in the incomes of men and women.

Working women have always had to reconcile the impulses to act in a stereotypically feminine manner and to be aggressive enough to succeed in a performance-driven workplace. When relatively few

Men are starting to accuse women of harassment

257

Criticizing an employee for not acting "like a woman"

women worked, relatively few employers had to worry about accommodating this difficult mix.

The 1989 Supreme Court decision *Price Waterhouse v. Hopkins*[2] involved some of the most common gender biases. Legitimate concerns that Price Waterhouse had about Hopkins included her alleged inability to get along with subordinates and her weak relations with coworkers.

Illegitimate concerns included her so-called "macho" image, overly aggressive attitude, and "unfeminine" behavior and appearance. In other words, she did not act like a "woman." Price Waterhouse felt that these characteristics were inappropriate for a female partner.

The court found that the firm's illegitimate sex stereotyping did play a part in the denial of partnership to Hopkins. And this kind of employer response does occur frequently. There's not much than can be said about it other than it's wrong and it invites lawsuits.

In the 1990s, with women reaching numeric parity in most industries, the issue has become more central. Labor Department data show that men lost nine times more jobs than women in the 1990-91 recession and gained only about one-third as many jobs as women since then. As a result, more couples—including many with high-income jobs—are willing to sue over alleged bias "to protect the family's economic future."

Establishing policies that treat men and women as equally as possible is the obvious first step in a solution. But the political aspect of gender issues isn't so easy to resolve.

Even though the flood of women into the workplace has upended traditional gender prescriptions, some people still cling—consciously or unconsciously—to biased stereotypes. In today's corporate work environment, sex stereotyping is generally displayed in more subtle varieties.

Gender discrimination is relatively straightforward compared to the more difficult issue of sexual ha-

[2] This case, which ultimately turned on the complex issue of mixed-motive discrimination, is considered in greater detail in Chapter 3, page 170.

rassment. Legally, harassment is a form of discrimination. Practically, it's based on the respective perceptions of the perpetrator and the victim. Some people's harmless flirtation is other people's debasing malice. It's an issue obscured by a mix of political perspectives and subjective interpretation that make the Japanese folk tale *Rashomon* seem simple.

One example: The working women's lobbying group 9to5 was founded in 1973 by Karen Nussbaum, later director of the Labor Department's Women's Bureau. The organization's seed was planted when Nussbaum was a secretary at Harvard University. A man walked into the office where she was working, looked for her absent boss and exclaimed, "Isn't anybody here?"

But groups like 9to5 have tended to share the politicized stance of consciousness-raising movements, radical feminist groups and the anti-war movement. Their leaders often brag about their commitment to loosely-defined "activism." Too often, this creates an environment focused more on posturing than problem-solving.

And problems do linger. According to a 1992 *Wall Street Journal* article, "Persistent stereotypes about the way women manage family responsibilities are a major reason that only 3 to 5 percent of the top jobs at big companies are held by women."

This kind of institutional lean against women translates into serious problems if your company joins in. As we've seen before, the 1991 Civil Rights Act permits punitive damages in discrimination cases—including gender discrimination.

The mechanics of gender discrimination

Discrimination on the basis of sex is expressly prohibited by Title VII of the Civil Rights Act of 1964. The 1964 Act requires that persons of like qualifications be given employment opportunities irrespective of their sex.

Section 703 of the Act states:

Conflicts between BFOQs and sex stereotypes

It shall be an unlawful employment practice for an employer...to fail or refuse to hire or to discharge any individual, or otherwise to discriminate against any individual with respect to compensation, terms, conditions, or privileges of employment, because of such individual's...sex....

Notwithstanding any other provision of this title, it shall not be an unlawful employment practice for an employer to hire and employ employees...on the basis of...sex...in those certain instances where...sex...is a bona fide occupational qualification reasonably necessary to the normal operation of that particular business or enterprise....

One exception to this prohibition occurs when gender is a bona fide occupational qualification reasonably necessary to the normal operation of the business.

Conflicts between BFOQs and gender stereotyping often result in claims of disparate treatment. To be guilty of disparate treatment, an employer has to discriminate consciously against an individual on the basis of sex stereotypes.

In the 1971 Supreme Court decision *Ida Phillips v. Martin Marietta Corporation*, a female job applicant sued under Civil Rights Act of 1964 alleging that she had been denied employment because of her sex. The trial court in Florida granted summary judgment for Martin Marietta and the Court of Appeals affirmed. Phillips, the applicant, pressed her case to the Supreme Court.

Martin Marietta had bluntly informed Phillips that it was not accepting job applications from women with preschool-age children. However, it employed men with preschool-age children.

At the time Phillips applied, 70 to 75 percent of the applicants for the position she sought were women. Even more questionable: 75 to 80 percent of those hired as assembly trainees—the job Phillips sought—were women.

The Supreme Court held that a genuine issue of material fact existed whether family obligations of women having preschool-age children were demonstrably more relevant to job performance for a woman than a man.

It wrote:

> The Court of Appeals erred in reading [the 1964 Civil Rights Act] as permitting one hiring policy for women and another for men—each having preschool-age children. The existence of such conflicting family obligations, if demonstrably more relevant to job performance for a woman than for a man, could arguably be a basis for distinction under...the Act. But that is a matter of evidence tending to show that the condition in question "is a bona fide occupational qualification reasonably necessary to the normal operation of that particular business or enterprise."

Because the facts of the case didn't lend a conclusion on whether Martin Marrietta's terms counted as a BFOQ, the high court overturned the summary judgment.

In a concurring opinion, Justice Thurgood Marshall—who built his reputation in the early years of the civil rights movement seeking fair treatment for all people—doubted that a prohibition against hiring women with young children could ever count as a BFOQ. He disagreed that:

> a "bona fide occupational qualification reasonably necessary to the normal operation of" Martin Marietta's business could be established by a showing that some women, even the vast majority, with preschool-age children have family responsibilities that interfere with job performance and that men do not usually have such responsibilities.

> Certainly, an employer can require that all of his employees, both men and women, meet minimum performance standards, and he can try to insure compliance by requiring parents, both mothers and fathers, to provide for the

You can't bring up "proper" domestic roles

care of their children so that job performance is not interfered with.

But...I fear that...the Court has fallen into the trap of assuming that the Act permits ancient canards about the proper role of women to be a basis for discrimination.

Marshall then cited the EEOC's *Guidelines on Discrimination Because of Sex,* arguing that the prohibition against job discrimination based on sex in the 1964 Act was intended to prevent employers from refusing "to hire an individual based on stereotyped characterizations of the sexes." Even characterizations of the proper domestic roles of the sexes were not to serve as predicates for restricting employment or promotion opportunities.

Although Thurgood Marshall was never characterized as being particularly friendly to employers, his definition of fair treatment for both sexes in the *Martin Marietta* ruling works well. Considering the inconsistent demands and gratuitous activism of some lobbying groups who focus on sexual issues in the workplace, Marshall's analysis stands out as a reasonable approach.

So-called "head of household" benefit systems that some employers offer pose problems under Title VII's language prohibiting gender discrimination. Employees sometimes claim that these programs unfairly benefit men over women.

The 1983 federal appeals court case *Wambheim v. J.C. Penney Co.* allowed a limited head-of-household rule. It shows how technically complex a relatively simple concept can become.

Penney offered medical and dental insurance to employees who worked at least 20 hours per week. The company covered about 75 percent of the cost and there were three contribution rates for employees:

- for the employee only;

- for the employee and one dependent, whether spouse or child; and

- for the employee and two or more dependents.

From 1955 to 1971, only male employees could obtain coverage for their spouses. In 1971, the head-of-household rule was adopted, allowing any employee to obtain coverage for a spouse if the employee earned more than half of the couple's combined income, excluding interest and investment income, disability benefits, social security, and pensions.

Penney continued coverage for all wives who were formerly included until the suit was filed.

Seventy percent of Penney's employees were female and most of these women worked in low-paying sales positions. Women held 6.7 percent of the profit-sharing management positions and 35.5 percent of the lower-level management positions. Only 37 percent of the women, but 95 percent of the men covered by the medical plan, received dependent coverage. Only 12.5 percent of the married female employees qualified as heads of household, while 89.34 percent of the married males qualified.

A group of female employees sued, charging that Penney's head-of-household rule violated Title VII gender discrimination protections and was itself a pretext for discrimination.

The district court's first decision granted Penney's motion for summary judgment dismissing the charges. It held that the facts did not establish a prima facie case of discrimination. The employees appealed.

The Ninth Circuit Court of Appeals reversed the lower court, ruling that proof of the head-of-household policy's disparate impact established a prima facie case of discrimination. It sent the case back for trial.

Following that trial, the lower court entered judgment for Penney. It concluded that Penney had established a business justification for its head-of-household rule and that the rule was not a pretext for discrimination. The employees appealed again.

Cost defenses don't always work

The case was unusual because it alleged a disparate impact violation of the Title VII bar against discrimination with respect to "compensation, terms, conditions, or privileges of employment." Disparate impact theory had been developed in cases alleging violation of Title VII's separate prohibition against discrimination in respect to "employment opportunities or...status as an employee."

The appeals court had already decided that the employees had made a prima facie case. So, Penney had to justify its policy by demonstrating "that legitimate and overriding business considerations provide justification."

The appeals court considered Penney's justification for its head-of-household rule. The company had explained that the rule was designed to benefit the largest number of employees and those with the greatest need. It concluded that dependent children and spouses covered under the rule had the greatest need for dependent coverage.

"Qualifying spouses are less likely to have other medical insurance. It seeks to keep the cost of the plan to its employees as low as possible, so that the needy can afford coverage. If all spouses are included, the contribution rates will increase," the company claimed.

The employee groups argued that Penney's defense was an impermissible cost defense without merit. They cited the Supreme Court's 1978 decision *Manhart*, which—as we've already seen—held that the cost difference of providing benefits to male and female employees is not a legitimate justification for gender discrimination.

The appeals court ruled that *Manhart* wasn't relevant. Penney had offered legitimate and overriding business justifications for adoption of its head-of-household rule. These justifications were dependent on comparative earned income, so they did not conflict with Title VII's requirement of nondiscriminatory employment practices.

Finally, the employees tried to argue that Penney's business justification defense was a pretext for

impermissible discrimination. But the appeals court didn't agree with this argument, either. "Penney historically has discriminated against women in providing benefits," it ruled. "It could have chosen other methods to determine spousal eligibility for coverage."

More than anything else, the appeals court had to defer to the lower court's finding of fact—which could only be overturned if found "clearly erroneous." The appeals court wasn't convinced that a clear mistake had been made.

Equal protection

The U.S. Constitution's Fourteenth Amendment makes it illegal for a state to deny people "equal protection of the laws." This amendment has been much-disputed since it was ratified in the years after the Civil War. Originally designed to protect newly-freed slaves from unfair treatment at the hands of state governments, the amendment has been interpreted by courts to cover a lot of legal ground—including the rights of women in public employment or education.

In 1994, a federal appeals court ruled that South Carolina's state-run—and all male—military college, The Citadel, had to enroll a woman it had inadvertently admitted. In issuing this ruling, the court rejected the Citadel's argument that it accomplished an important educational goal by maintaining an all-male military college. And the state had to give equivalent educational opportunity to women.

Constitutional issues don't always have a direct application to private-sector employers, but they do shade the general tone of diversity issues. Almost always, treating men and women differently in public matters violates the Fourteenth Amendment. The law leaves the door slightly open to single-sex schools because, in the absence of clear evidence of harm, diversity and personal choice are valued over legal direction.

Fourteenth Amendment claims in gender cases

The equal protection clause and pregnancy

As we've seen before, pregnancy usually works better as a family leave issue than a gender-discrimination issue. The 1974 Supreme Court decision *Geduldig v. Aiello* set many of the terms for this distinction.

In *Geduldig*, a disability insurance system funded entirely from contributions deducted from the wages of participating California state employees did not include pregnancy and related disabilities in its coverage. A group of female employees sued, claiming the system violated the Equal Protection Clause of the Fourteenth Amendment because its exclusion of pregnancy disabilities represented gender discrimination.

An important factor: The *Geduldig* case was not a Title VII claim, but an equal protection claim.

In affirming the legality of the disputed plan, the Supreme Court noted that:

> We cannot agree that the exclusion of this disability from coverage amounts to invidious discrimination under the Equal Protection Clause. California does not discriminate with respect to the persons or groups which are eligible for disability insurance protection under the program. The classification challenged in this case relates to the asserted underinclusiveness of the set of risks that the State has selected to insure.

This point was emphasized again later in the opinion:

> ...this case is thus a far cry from cases like *Reed v. Reed* (1971), and *Frontiero v. Richardson* (1973), involving discrimination based upon gender as such. [The] insurance program does not exclude anyone from benefit eligibility because of gender but merely removes one physical condition—pregnancy—from the list of compensable disabilities.

> While it is true that only women can become pregnant, it does not follow that every legislative classification concerning pregnancy is a sex-based classification....

Normal pregnancy is an objectively identifiable physical condition with unique characteristics. Absent a showing that distinctions involving pregnancy are mere pretexts designed to effect an invidious discrimination against the members of one sex or the other, lawmakers are constitutionally free to include or exclude pregnancy from the coverage of legislation such as this on any reasonable basis, just as with respect to any other physical condition.

Most importantly, the Supreme Court concluded:

The lack of identity between the excluded disability and gender as such under this insurance program becomes clear upon the most cursory analysis. The program divides potential recipients into two groups: pregnant women and nonpregnant persons. While the first group is exclusively female, the second includes members of both sexes."

The court allowed that:

...pregnancy-related disabilities constitute an additional risk, unique to women, and the failure to compensate them for this risk does not destroy the presumed parity of the benefits, accruing to men and women alike, which results from the facially evenhanded inclusion of risks. To hold otherwise would endanger the common sense notion that an employer who has no disability benefits program at all does not violate Title VII even though the "underinclusion" of risks impacts, as a result of pregnancy-related disabilities, more heavily upon one gender than upon the other.

The disability benefits plan was not in itself discrimination based on sex. However, the fact that there was no sex-based discrimination as such was not the end of the analysis. If it was true "that distinctions involving pregnancy are mere pretexts designed to effect an invidious discrimination against the members of one sex or the other," then a gender discrimination case could exist.

A distinction which, on its face, was not sex re-

"Ladies' Nights" and other promotions don't comply

lated might still violate the Equal Protection Clause if it were in fact a subterfuge to accomplish a forbidden discrimination. But the Geduldig claims didn't raise any question of excluding a disease or disability comparable in all other respects to covered diseases or disabilities and yet confined to the members of one race or sex.

Another related point: Some courts have used the equal protection theory to rule gender-based promotions, such as so-called "ladies' night" discounts at bars, a form of gender discrimination.

In the late 1980s, the California Supreme Court ruled that price breaks granted solely to women discriminate against men and work to degrade both genders by reinforcing "harmful stereotypes."

"...business establishments must provide equal advantages and privileges to all customers no matter what their sex," Chief Justice Rose Bird wrote. Reversing lower court rulings that such discounts were standard business practice, Bird wrote:

> Courts are often hesitant to upset traditional practices such as the sex-based promotional discounts at issue here. Some may consider such practices to be of minimal importance or to be essentially harmless. Yet, many other individuals, men and women alike, are greatly offended by such discriminatory practices.

The court dismissed the argument that the discounts promoted legitimate social goals by encouraging men and women to socialize and because they help women, who generally earn less than men. "The clubs' profit motive is obvious," Bird wrote. "[The nightclub] waives the cover charge for women not because women on the average earn 59 cents for every dollar earned by men but because it wants to earn as many dollars as it can for itself."

The court noted that promotions still could be used, as long as they weren't based on sex. Also, a business could offer discounts to patrons who present a special coupon, wear a certain color shirt or have a particular bumper sticker.

"The key is that the discounts must be applicable alike to persons of every sex, color and race, instead of being contingent on some arbitrary, class-based generalization," Bird concluded.

In 1984, the state supreme court in Washington had upheld discounts for women at Seattle Supersonics basketball games, noting that "women do not manifest the same interest in basketball that men do." Bird rejected this conclusion, calling the statement by the Washington court "sexual stereotyping."

The Equal Pay Act

A more concrete factor influencing workplace gender issues is the 1968 Equal Pay Act. The Act states plainly that:

> No employer having employees subject to any provisions of this [law] shall discriminate... between employees on the basis of sex by paying...a rate less than the rate he pays wages to employees of the opposite sex...for equal work on jobs the performance of which requires equal skill, effort and responsibility and which are performed under similar working conditions.

The Act defines itself as narrow in scope. It applies only to wage differences between men and women. It does not apply to issues of race, age, disability, sexual orientation or any other potential protection class.

As the Supreme Court has declared:

> Congress' purpose in enacting the Equal Pay Act was to remedy what was perceived to be a serious and endemic problem of employment discrimination in private industry the fact that the wage structure of "many segments of American industry has been based on an ancient but outmoded belief that a man, because of his role in society, should be paid more than a woman even though his duties are the same."

However, the Act applies to both genders equally. Even though women have historically been paid

The Equal Pay Act applies evenly to both genders

less than men for similar work, men can make a claim if their employers pay women more for the same work.

The Act doesn't address gender or sex issues in regards to hiring, managing, promoting or firing employees. It only applies to issues of compensation. An employee has to turn to Title VII or other anti-discrimination laws to make legal claims about broader employment issues.

In all successful cases, the Act allows the award of back wages and attorney's fees. It also allows certain liquidated damages (effectively the same as punitive damages) equal to the same amount in back wages, unless the employer can show that he or she had made a good faith effort to comply with the law.

The Act follows the enforcement model of the Fair Labor Standards Act. This means employees can sue privately or make a complaint to the EEOC. If the EEOC chooses to try the case, the employee cannot begin a separate private lawsuit until the public action has been completed. Also, an employer can't fire an employee because that employee is taking part in an Equal Pay Act lawsuit.

Unlike the FSLA, the Equal Pay Act applies to all jobs—whether they are executive, managerial, supervisorial or labor. The only exemptions made by the Equal Pay Act are seasonal businesses, certain small retail sales operations, certain agricultural operations and a few kinds of local newspapers and utilities.

Finally, the Equal Pay Act limits comparisons of pay for men and women to single "establishments." Unequal pay at different establishments may be allowed under the law. However, the definition of an establishment may change according to the circumstances of a case.

Generally, an establishment means a physical plant—claims can't usually compare women's wages in a Tennessee factory with men's wages in a New York corporate headquarters. But a court may allow this kind of comparison, if the employ-

ees making the charges can offer a compelling argument.

Otherwise, what constitutes similar work? A single job with a single job description entails similar work, regardless of the gender of the person who holds it. But the Equal Pay Act allows different jobs to be deemed similar—if they have so-called "quantitative equality."

The test for quantitative equality includes four parts:

- skill, which refers to the objective level of ability or dexterity required to perform job tasks;

- effort, which refers to physical or mental exertion required to perform job tasks;

- responsibility, which refers to the degree of accountability a job entails—measured by supervisory, decision-making and business-impact standards; and

- working conditions, which refers to the surroundings and hazards that a job entails.

In a series of Equal Pay Act decisions[3], the federal courts have ruled that the skill, effort and responsibility of different jobs must be "equal" in order for the jobs to compare. Working conditions only have to be "similar."

The Equal Pay Act allows four defenses for paying unequal wages for work that the EEOC, another agency or a court deems equal. These four exceptions are:

- a bona fide seniority system,

- a merit system,

- a system which measures earnings by quantity or quality of production, or

- a differential based on a factor other than gender.

If an angry employee can prove that you pay men and women differently for the same work, you're defense will rely on a well-documented explanation that fits one of these four models.

[3] The most useful of these is the 1974 Supreme Court decision *Corning Glass Works v. Brennan*, which considered a lower-paid day shift that was mostly women and a more highly paid night shift that was mostly men.

The definition of "similar work" can be difficult

A definition of violation and four defenses

On its face, the Equal Pay Act contains three restrictions pertinent to most compensation disputes. First, its coverage is limited to those employers subject to the Fair Labor Standards Act. So, the Act does not apply to businesses engaged in retail sales, fishing, agriculture, and newspaper publishing. Second, the Act is restricted to cases involving "equal work on jobs the performance of which requires equal skill, effort, and responsibility, and which are performed under similar working conditions." Third, the Act's four affirmative defenses exempt any wage differentials attributable to seniority, merit, quantity or quality of production, or "any other factor other than sex."

The Equal Pay Act is divided into two parts: a definition of the violation, followed by four affirmative defenses. The first part can hardly be said to "authorize" anything at all: it is purely prohibitory. The second part, however, allows employers to differentiate in pay on the basis of seniority, merit, quantity or quality of production, or any other factor other than sex, even though such differentiation might otherwise violate the Act.

The fourth affirmative defense of the Equal Pay Act, however, was designed to confine the application of the Act to wage differentials attributable to sex discrimination. Equal Pay Act litigation, therefore, has been structured to permit employers to defend against charges of discrimination where their pay differentials are based on a bona fide use of "other factors other than sex."

The 1968 Bennett Amendment to Title VII was offered as a "technical amendment" designed to resolve any potential conflicts between Title VII and the Equal Pay Act. Thus, with respect to the first three defenses, the Bennett Amendment guarantees that courts and administrative agencies adopt a consistent interpretation of like provisions in both statutes. Otherwise, they might develop inconsistent bodies of case law interpreting two sets of nearly identical language. More importantly, incorporation of the fourth affirmative defense could

have significant consequences for Title VII litigation.

The federal courts have interpreted the Bennett Amendment to incorporate only the affirmative defenses of the Equal Pay Act into Title VII. The Amendment bars sex-based wage discrimination claims under Title VII where the pay differential is "authorized" by the Equal Pay Act.

Enforcement

The Labor Department and the EEOC enforce the federal laws that prohibit gender discrimination. On paper, the rules governing how you can treat men and women in the workplace are identical to those relating to how you treat racial minorities, older people and the disabled.

In practice, though, the politicization of gender issues influences enforcement. In the late 1980s, the Labor Department launched an initiative designed to shatter the "glass ceiling"—artificial barriers that prevent qualified women from advancing into middle and senior levels of management.

In the report that resulted from that initiative, the department said that its study of nine of the largest American companies found that each had a point beyond which women (and racial minorities) had not advanced. It also reported that the glass ceiling existed at a much lower management level than first thought.

Since that report was issued, the Labor Department has turned its attention to smaller businesses. In the early 1990s, the department joined with the Small Business Administration in an effort to help small companies eliminate discrimination.

The SBA joint venture is the carrot. The Labor Department also has a couple of sticks. Its best tool for enforcing anti-discrimination laws is its Office of Federal Contract Compliance Programs, which oversees the activities of companies that do business with the government. If you don't do

*Changing
enforcement
strategies
among
federal
agencies*

business with the Feds, you don't have to worry about this aspect of enforcement.

But the EEOC has a broader purview. "The way the EEOC has worked in the post-Clarence Thomas days has been more opportunistic. They're looking for colorful cases," says a Washington, D.C. lawyer who lobbies the agency on behalf of small businesses. "No matter how small an operation you are, they'll come down on you if you've done something really horrible to an employee. They want cases that they can write press releases about."

This approach has the desired effect. It makes most employers worried that they might inadvertently foster a suitably colorful discrimination case.

No matter who you are or what your company does, you're susceptible to gender and employment problems. A woman who sued Vassar College—the New York-based historically woman's school—in federal court contended it violated federal law by underpaying her and not promoting her higher than assistant biology professor because she was married. She won at trial in 1994, proving that the college had intentionally discriminated against older or married women science professors.

The court ordered Vassar to pay her double for the last nine years, and to give her the permanent position she had been denied.

In general, an employer's prospects aren't good if this kind of dispute goes to trial. Most courts seem inclined to interpret gender anti-discrimination laws and guidelines broadly. In 1987, the Supreme Court wrote the often-cited decision *Rotary International v. Rotary Club of Duarte*, which required Rotary clubs in California to admit women.

In 1977 the Rotary Club of Duarte, California, admitted Donna Bogart, Mary Lou Elliott, and Rosemary Freitag to active membership. International notified the Duarte Club that admitting women members is contrary to the Rotary constitution. After an internal hearing, International's board of directors revoked the charter of the Duarte

Club and terminated its membership in Rotary International. The Duarte Club's appeal to the International Convention was unsuccessful.

The Duarte club and two of its women members filed a suit alleging that the termination violated California's Unruh Act, which entitles all persons, regardless of sex, to full and equal accommodations, advantages, facilities, privileges, and services in all business establishments in the State.

The trial court concluded that neither Rotary International nor the Duarte Club was a "business establishment" within the meaning of the Unruh Act. The court recognized that "some individual Rotarians derive sufficient business advantage from Rotary to warrant deduction of Rotarian expenses in income tax calculations, or to warrant payment of those expenses by their employers...." But it found that "such business benefits are incidental to the principal purposes of the association...to promote fellowship...and...service activities."

The California Court of Appeals reversed. It held that both Rotary International and the Duarte Rotary Club were business establishments subject to the provisions of the Unruh Act. For purposes of the Act, a "business embraces everything about which one can be employed," and an "establishment" includes "not only a fixed location...but also a permanent commercial force or organization or a permanent settled position (as in life or business)."

The appeals court ruled that, although Rotary clubs are nonprofit associations, they are businesses under state law—in part because members use the clubs to make and maintain professional contacts.

The appeals court also identified several "business-like attributes" of Rotary International, including its complex structure, large staff and budget, and extensive publishing activities. The court held that the trial court had erred in finding that the business advantages afforded by membership in a lo-

The definition of "business establishment" controls some disputes

Be wary of the "state's compelling interest" to end discrimination

cal Rotary Club are merely incidental. It stated that testimony by members of the Duarte Club "leaves no doubt that business concerns are a motivating factor in joining local clubs," and that "business benefits [are] enjoyed and capitalized upon by Rotarians and their businesses or employers."

It rejected the Rotary International's argument that its policy of excluding women is protected by the First Amendment.

The California court ordered the International to reinstate the Duarte Club as a member and permanently enjoined it from attempting to enforce the gender requirement against the Duarte Club. The decision was part of a 1980s trend toward opening previously all-male clubs to women, especially when the clubs were used in any way to conduct business.

The U.S. Supreme Court recognized that the right to engage in activities protected by the First Amendment implies "a corresponding right to associate with others in pursuit of a wide variety of political, social, economic, educational, religious, and cultural ends." For this reason, "[i]mpediments to the exercise of one's right to choose one's associates can violate the right of association protected by the First Amendment...."

However, it limited these business-related rights in the Rotary case. It ruled:

> Even if the Unruh Act does work some slight infringement on Rotary members' right of expressive association, that infringement is justified because it serves the State's compelling interest in eliminating discrimination against women.

It affirmed the ruling of the California Court of Appeals in favor of the Duarte group.

An attorney for the Rotary organization warned that if the U.S. Supreme Court refused to reconsider its decision, the ruling could be expanded into challenges against the membership require-

276

ments of any private, non-religious club. "Today it is Rotary. What is it going to be tomorrow? I think it is shocking that courts would inject this kind of sweeping control over private membership clubs," he told one newspaper.

Compliance

The 1987 Supreme Court decision *Johnson v. Transportation Agency of Santa Clara County* considered how diversity programs that try to address gender issues can work.

In 1978, the Santa Clara County, California, Transportation Agency voluntarily adopted an affirmative action plan for hiring and promoting minorities and women. The plan provided that, in making promotions within a traditionally segregated job classification in which women had been underrepresented, the Agency would consider the gender of a qualified applicant.

The plan was intended to achieve a statistically measurable yearly improvement in hiring and promoting minorities and women in job classifications where they had been underrepresented. Its long-term goal was to attain a work force whose composition reflected the proportion of minorities and women in the total area labor force.

The plan set aside no specific number of positions for minorities or women, but required that short-term goals be established and annually adjusted to serve as the most realistic guide for actual employment decisions.

In December 1979, the Agency announced a vacancy for the position of road dispatcher. None of the 238 positions in the pertinent Skilled Craft Worker job classification, which included the dispatcher position, was held by a woman. Twelve employees applied for the promotion, including Diane Joyce and Paul Johnson.

Joyce had worked for the County since 1970, serving as an account clerk until 1975. She had applied for a road dispatcher position in 1974, but

A male and female candidate are equally qualified

was found ineligible because she had not served as a road maintenance worker. In 1975, Joyce transferred from a senior account clerk position to a road maintenance worker position, becoming the first woman to fill such a job. During her four years working in road maintenance, Joyce had occasionally worked out of class as a road dispatcher.

Johnson began with the County in 1967 as a road yard clerk, after private employment that included working as a supervisor and dispatcher. He had also unsuccessfully applied for the road dispatcher opening in 1974. In 1977, his clerical position was downgraded, and he sought and received a transfer to the position of road maintenance worker. He also occasionally worked out of class as a dispatcher while performing that job.

Nine of the applicants, including Joyce and Johnson, were deemed qualified for the job and interviewed by a two-person board. Seven of the applicants scored above 70 on this interview, which meant that they were certified as eligible for selection by the appointing authority. Johnson was tied for second with 75, while Joyce ranked next with a score of 73. A second interview was conducted by three Agency supervisors, who recommended that Johnson be promoted.

Prior to the second interview, Joyce had contacted the County's Affirmative Action Office because she feared that her application might not receive disinterested review. The Affirmative Action Office contacted the Agency's Affirmative Action Coordinator, who was responsible for keeping the Director informed of opportunities to accomplish staffing objectives.

At the time, the Agency employed no women in any Skilled Craft position and had never employed a woman as a road dispatcher. The Affirmative Action Coordinator recommended to the Director of the Agency, James Graebner, that Joyce be promoted.

The qualified candidates were again interviewed

and the Agency, pursuant to the plan, ultimately passed over Johnson and promoted Joyce. Johnson sued the Agency, claiming gender discrimination in violation of Title VII.

The U.S. District Court for the Northern District of California agreed with Johnson. It found that the Agency had violated Title VII because Joyce's gender was the determining factor in her selection.

The Agency appealed. The Ninth Circuit Court of Appeals agreed with it. The appeals court ruled that the absence of an express termination date in the plan was not critical, since the plan repeatedly expressed its objective as the attainment, rather than the maintenance, of a work force mirroring the labor force in the County.

In short, the Agency's consideration of Joyce's gender in filling the road dispatcher position was lawful because the plan had been adopted to address a conspicuous imbalance in the Agency's work force.

The Court of Appeals made another interesting ruling: It wrote that the fact that the plan established no fixed percentage of positions for minorities or women made it less essential that the plan contain an explicit deadline.

Johnson pressed the case to the Supreme Court.

The high court focused first on whether or not the pre-existing imbalance in the Agency's work force was legitimate. Justice William Brennan, writing for the Court, ruled that it was:

> ...while women constituted 36.4 percent of the area labor market, they composed only 22.4 percent of Agency employees. Furthermore, women working at the Agency were concentrated largely in EEOC job categories traditionally held by women: women made up 76 percent of Office and Clerical Workers, but only 7.1 percent of Agency Officials and Administrators, 8.6 percent of Professionals, 9.7 percent of Technicians, and 22 percent of Service

Preferences can address "conspicuous imbalances"

279

Short-term goals can be adjusted often

and Maintenance Workers. As for the job classification relevant to this case, none of the 238 Skilled Craft Worker positions was held by a woman.

For the Skilled Craft category in which the road dispatcher position at issue here was classified, the Agency's aspiration was that eventually about 36 percent of the jobs would be occupied by women.

The plan adopted short-term goals and adjusted them annually to serve as most realistic guide for actual employment decisions. The court noted that:

> Where a job requires special training...the comparison should be with those in the labor force who possess the relevant qualifications. The plan sought to remedy these imbalances through "hiring, training and promotion of...women throughout the Agency in all major job classifications where they are underrepresented." Thus, Joyce was hired....

At the time Joyce was hired, the Agency was still in the process of refining short-term goals for Skilled Craft Workers. The established short-term goal for that year (1982) was three women for the 55 expected openings in the job category—a target of six percent.

The plan mandated that annual short-term goals be formulated that would provide a more realistic indication of the degree to which factors like gender should be taken into account in filling particular positions. It expressly directed that numerous factors be taken into account in making hiring decisions, including specifically the qualifications of female applicants for particular jobs. It stated clearly that goals "should not be construed as quotas that must be met" but as reasonable aspirations in correcting the imbalance in the Agency's work force.

The Supreme Court rejected Paul Johnson's argument that, since only the long-term goal was in place for Skilled Craft positions at the time of Joyce's promotion, it was inappropriate for the

Director to take into account affirmative action considerations in filling the road dispatcher position.

Despite the fact that no precise short-term goal was yet in place for the Skilled Craft category, the Agency's management nevertheless had been clearly instructed that they were not to hire solely by reference to statistics. The high court considered this "a moderate, flexible, case-by-case approach to effecting a gradual improvement in the representation of minorities and women in the Agency's work force." So, it was consistent with Title VII goals.

Justice Brennan went on to conclude:

> The plan did not set aside any positions for women. Rather, [it] merely authorizes that consideration be given to affirmative action concerns when evaluating qualified applicants. As the Agency Director testified, the sex of Joyce was but one of numerous factors he took into account in arriving at his decision.

> Similarly, the plan requires women to compete with all other qualified applicants. No persons are automatically excluded from consideration; all are able to have their qualifications weighed against those of other applicants.

> Seven of the applicants were classified as qualified and eligible, and the Agency Director was authorized to promote any of the seven....

So, the plan allowed the Agency to maintain a level of quality in its staff. The selection process was not like ones envisioned by Justice Antonin Scalia in his criticism of affirmative action programs— namely that the beneficiaries of the programs would be employees who were merely not "utterly unqualified."

In general, the key to complying with gender diversity laws is the same as for complying with any other diversity law. You want to treat all types of people fairly and make no broad assumptions about what certain types of people will do or be good at or be bad at.

Consideration is lawful, set-asides may not be

Gender-based assumptions never stand up to challenge

In specific, gender issues are defined in terms of gender stereotyping. The EEOC's regulations provide:

> The Commission believes that the bona fide occupational qualification exception as to sex should be interpreted narrowly. Labels—men's jobs and women's jobs—tend to deny employment opportunities unnecessarily to one sex or the other.

> ...the following situations do not warrant the application of the bona fide occupational qualification exception:

> ...The refusal to hire a woman because of her sex, based on assumptions of the comparative employment characteristics of women in general. For example, the assumption that the turnover rate among women is higher than among men.

> ...The refusal to hire an individual based on stereotyped characterizations of the sexes. Such stereotypes include, for example, that men are less capable of assembling intricate equipment; that women are less capable of aggressive salesmanship. The principle of nondiscrimination requires that individuals be considered on the basis of individual capacities and not on the basis of any characteristics generally attributed to the group.

> ...The fact that the employer may have to provide separate facilities for a person of the opposite sex will not justify discrimination under the bona fide occupational qualification exception unless the expense would be clearly unreasonable.

The costs of gender stereotyping

Human resources experts, activists and—increasingly—courts focus on the liabilities created by gender stereotyping. Like other diversity issues, appearances have an impact in these cases. To foster a positive work environment, enhance pro-

ductivity, and avoid legal liability, you should avoid the appearance of gender stereotyping in the workplace.

In the *Price Waterhouse* case (which we considered earlier in this chapter and in Chapter 3), the partners had established an atmosphere that made employees believe the firm was run by an old boys network. This allowed gender stereotyping to flourish and influence employment decisions. The firm denied that it had ever endorsed discriminatory behavior—and Hopkins never suggested that there was official endorsement. On paper, Price Waterhouse seemed to comply with all relevant anti-discrimination laws.

But the unofficial comments that partners made to Hopkins were ridiculous. They reflected unfair notions of women's roles. Worse still, they suggested the childish posing of middle-aged accountants who should have known better trying to act like curmudgeonly power brokers of the old school.

"This is really more often the case these days," says one Washington, D.C.-based attorney who was involved in the Price Waterhouse case. "People from the Baby Boom generation reach a certain level of seniority in a company...and they don't know what to do. So they try to act like their fathers...or fat cat businessmen from old movies. [They are] thirty-five-year-olds with baby faces drinking martinis at lunch and smoking cigars all afternoon. And then—whoops—they let loose some zinger about how Mary down the hall who's really bright and billing tons of hours is too much of a ball-buster to ever deal with clients. They're just not thinking."

How can you avoid these kinds of problems? How do you rein in the swaggering yuppie who's complaining about the pushy dames in the office between puffs on his Macanudo?

- Don't tolerate managerial or supervisory comments that include unfounded generalizations about what men or women "tend to be" or "should be like." Even said in jest, these kinds

Defending bad comments as jokes is a bad idea

of comments create misperceptions—and not just among people who'll sue. People who hear salty comments in a closed meeting are more likely to let something stupid slip in the hallway.

- Don't personalize reviews or evaluations. Keep the focus on the job. In the *Price Waterhouse* case, the partners could have limited their comments to something like "Hopkins has problems with staff relations and lacks appropriate interpersonal skills." Instead, they decided to add their impressions of her personality—which led to the inappropriate remarks.

- Within reason, try to use gender neutral terms in supervisory comments and company documents. Taken to the extreme, this can turn into awkward political correctness. However, having a paper trail of gender neutral policies makes discrimination more difficult to prove.

- Train managers and supervisors to avoid stereotyping language in recruitment, performance evaluations, promotions, memos and public documents. These guidelines should apply in all business contexts—whether in the office or outside. Supervisors should carefully consider what they say, even in private conversations with subordinates or peers.

- Establish objectivity whenever you can. Even seemingly non-quantifiable areas such as interpersonal skills can be objectified with behavioral rating scales. Where objectivity is impossible, try to establish consistency. Consistency may be the hobgoblin of little minds, but it lessens the chance of discrimination lawsuits.

- Review the composition of your work force on a regular basis. Diversity laws can't tell you whom to hire or promote, but they can indicate where problems lie. Knowing that angry employees can use statistical trends to establish prima facie discrimination, you can look for potential problems. Segregation of women into lower-level jobs may indicate a pattern of behavior based on improper gender stereotypes.

- Be aware that isolated individuals in otherwise homogeneous environments make many discrimination and harassment claims. Promoting a single woman to a senior position doesn't solve your gender mix problems. It may actually increase them. This doesn't mean you should adopt broad quotas—in fact, it means the opposite. Promote people who deserve to be promoted. That strengthens their position.

- Keep policies clear and update them regularly. When information and criteria are ambiguous, stereotypes can provide structure and meaning to confused employees. Stereotypes shape subjective perceptions most when data are open to multiple interpretations.

If the employers in either the Price Waterhouse or Martin Marietta cases had followed these guidelines, the companies probably wouldn't have faced the precedent-setting lawsuits they did. At least they wouldn't have allowed the behavior cited in the respective cases.

Reverse gender discrimination

The influx of women to the work force has had another complicating effect on gender issues. A growing number of men have based legal claims on illegal gender stereotyping.

Probably the best-known—and most instructive—case of males claiming sexual harassment, hostile environment and gender discrimination came to light in late 1994. Throughout that fall, Joseph Egan, Tracy Tinkham and six other Boston-area employees of the California-based diet marketer Jenny Craig Inc. sued the company or filed complaints with the Massachusetts Commission Against Discrimination (that state's employee-friendly version of the EEOC).

Jenny Craig, which caters primary to female customers, employs primarily female supervisors and managers.

The most vocal of the employees, Egan told a story of compliments on his looks that escalated to fe-

Telling a male employee he'll need a sex change to advance

male supervisors asking awkward personal questions and admitting that they had had sexual fantasies about him.

"If a man had said that, it would be on talk shows all over the place," Egan told one newspaper. "But when it happens to men, it's no big deal. It's like, 'You're a guy. So what?'"

Egan, who'd worked at Jenny Craig for four years as a salesman and store manager, quit in February 1994. The state agency investigating his claims found probable cause of gender bias. This finding sent Egan and Jenny Craig to mediation. If that failed, the agency would draft a settlement by itself.

In his complaint, Egan claimed his supervisor asked him to fix her car, check the daily flavors at a local yogurt shop and drive her around in his car at lunchtime so that she could secretly observe her boyfriend. He claimed that, aside from the illegal treatment, he'd been denied promotions because of his gender. He had asked to be sent to corporate headquarters for training, which other managers at his level had received, but the request was denied.

Egan argued that he resigned because the company treated and demoted him unfairly and curtailed his income and promotion potential.

Another former employee claimed that an assistant regional manager tried to discourage him from joining the company, saying that it was "improbable" that a man would be able to relate to women with low self-esteem and other problems associated with being overweight.

During a staff meeting, one male employee was discussing an open position with four or five of his female supervisors. As the conversation ended and he turned to walk away, one of the women called out that the only way he could be promoted was if he got a sex-change operation or wore a push-up bra. The man admitted the comment was probably meant as a joke, but he claimed it was part of a pattern.

Some women who worked in management for Jenny Craig were sympathetic to the claims made by the Massachusetts group. One former sales trainer in the Boston area said, "They were somewhat singled out....It was really a woman-oriented company."

Another former manager said, "You just had to have this up, peppy...mentality, and [some managers] felt that the men just didn't fit in. [The company] did not want to hire men because men wanted management, men wanted more money, they wanted it faster, because they had families."

Jenny Craig Inc.'s official response was a broad denial of the charges that Egan and the other former employees made. It covered all of the essential aspects of a workplace diversity claim:

> ...claims of discrimination asserted by several former male employees...are unwarranted and, we believe, insupportable. ...Considering the seriousness of the problem of gender discrimination and sexual harassment in our society and the workplace, it is unfortunate that the limited resources of governmental agencies and the judiciary must be wasted on such frivolous claims.

> ...compliance procedures are in place and enforced to prevent gender or other discrimination in the Company's diverse work force.

> ...our employee training programs emphasize personal growth, and that advancement within the Company is based only on demonstrated performance and ability.

Even though the company's response was well-structured, it couldn't undo the ruling by the Massachusetts Commission Against Discrimination. The company settled several of the men's claims. Terms were kept confidential.

Cases of male sexual discrimination are still relatively rare. In 1993, only nine percent of the 12,000 sexual harassment suits filed with the EEOC were brought by men.

Assuming that men don't fit in a "peppy" culture

More complicated sex disputes also occur

Men filing these complaints complain they get little sympathy, since in the view of a lot of women and minorities all of corporate America is a support group for white males. Also, many men don't understand why other men would take offense at women's suggestive sexual comments.

Sexuality versus gender

As we've seen before, the Americans with Disabilities Act explicitly excludes sexual orientation as a disability. So, homosexuals, bisexuals and people with other nontraditional sexual orientations can not seek special protection—because of their orientations—under that law.

While Title VII of the Civil Rights Act of 1964 doesn't include language addressing sexual orientation one way or the other, the case law that has followed it does not recognize sexual orientation as a protected status.

One sexual harassment issue that has come up a number of times: Does the word "sex" in Title VII protect transsexuals from discrimination? To be sure, this is an issue that most employers won't have to face. But it does show why some diversity experts like to make a distinction between *sexuality* and *gender*.

In the 1984 decision *Ulane v. Eastern Airlines, Inc.*, a federal appeals court in Illinois held that: Title VII does not protect transsexuals; and, even if the transsexual employee was considered female, the trial court made no factual findings necessary to support a conclusion that the employer discriminated against her on this basis.

Kenneth Ulane was hired in 1968 as a pilot for Eastern Air Lines, Inc., but was fired as Karen Frances Ulane in 1981.

The court told the story: "[Ulane] was diagnosed a transsexual in 1979. Although embodied as a male, from early childhood [Ulane] felt like a female. Ulane first sought psychiatric and medical assistance in 1968 while in the military. Later, Ulane

began taking female hormones as part of her treatment, and eventually developed breasts from the hormones. In 1980, [Ulane] underwent sex reassignment surgery."

After the surgery, Illinois issued a revised birth certificate indicating Ulane was female, and the Federal Aeronautics Administration certified her for flight status as a female.

Eastern was not aware of Ulane's transsexuality, her hormone treatments, or her psychiatric counseling until she attempted to return to work after her reassignment surgery. Eastern knew Ulane only as one of its male pilots. It fired the legally female Ulane. Ulane filed a charge of gender discrimination with the EEOC, which subsequently issued a right-to-sue letter. She did.

The trial court recognized that homosexuals and transvestites do not enjoy Title VII protection, but distinguished transsexuals as persons who, unlike homosexuals and transvestites, have sexual identity problems. The judge agreed that the term "sex" in Title VII does not comprehend "sexual preference," but held that it does comprehend "sexual identity."

The district judge based a ruling in favor of Ulane on his finding that "sex is not a cut-and-dried matter of chromosomes." He concluded that sex is in part a psychological question—a question of self-perception—and in part a social matter—a question of how society perceives the individual.

The appeals court didn't agree, ruling: "While the [court] does not condone discrimination in any form, it was constrained to hold that Title VII does not protect transsexuals, and that the district court's order on this count therefore must be reversed for lack of jurisdiction."

It did not define "sex" in such a way as to mean an individual's "sexual identity." It ruled: "The words of Title VII do not outlaw discrimination against a person who has a sexual identity disorder, i.e., a person born with a male body who believes himself to be female....a prohibition against discrimi-

nation based on an individual's sex is not synonymous with a prohibition against discrimination based on an individual's sexual identity disorder or discontent with the sex into which they were born."

More importantly, the appeals court found no cause to conclude that Eastern had discriminated against Ulane as a female. The trial court's findings all centered around the conclusion that Eastern did not want "[a] transsexual in the cockpit."

The Court of Appeals reversed the order of the trial court and ruled in favor of Eastern. And it interpreted the law to apply to gender, a thing which is controlled by chromosomes, but not to sexuality, a thing which is controlled by psyche.

Legal strategies

Employers should document all employment decisions that affect the balance and distribution of gender in their workplaces. Every action and response relevant to employment, hiring, firing, and promotion should be written down and placed in each employee's file.

For example, if a woman is denied partnership or a promotion, the reasons for the denial should be documented in gender neutral terms. There should be no implication that gender influenced the decision in any way. For example, the evaluations of Ann Hopkins in the *Price Waterhouse* case stated that she was "too macho." Such a phrase is a perfect example of a gender-influenced evaluation.

Supervisors and managers should learn to identify and avoid biased phrases or words in documentation. If a lawsuit does arise that claims impermissible stereotyping, gender-neutral documentation provides strong evidence that the reason for the denial was completely legitimate.

Under disparate impact theory, an employer could have a facially neutral employment practice, such as an experience requirement, that results in the significant exclusion of women as a protected

group under Title VII. Courts have generally found facially neutral employment tests or qualifications that have a disparate impact to be illegal when those tests or qualifications are not required for performance of the job.

Most importantly, no employer should make job distinctions that relate—even indirectly—to gender. The 1977 appeals court decision *Mary Laffey v. Northwest Airlines, Inc.* has become a touchstone of gender discrimination cases. It shows how not to classify jobs.

Between 1927 and 1947, all cabin attendants employed on Northwest's aircraft were women, whom Northwest classified as "stewardesses." In 1947, when the company initiated international service, it established a new cabin-attendant position of "purser," and for two decades it adhered to an undeviating practice of restricting purser jobs to men.

In implementation of this policy, Northwest created an all-male cabin-attendant classification "flight service attendant" to serve as a training and probationary position for future pursers. Northwest maintained a combined seniority list for pursers and flight service attendants and a separate seniority list for stewardesses.

It was not until 1967, when a new collective bargaining agreement was negotiated, that stewardesses first became contractually eligible to apply for purser positions. But the airline maintained barriers to entry for women.

Stewardesses who bid unsuccessfully for purser positions were permitted a review of the company's action only if they had four years of service for the company "on flights to which a purser has been assigned."

Flight service attendants who became pursers were given credit for their entire service on the purser seniority list, while stewardesses who became pursers received no seniority credit for their service as stewardess. They were required to go to the bottom of the purser seniority list.

Duties performed by different positions should be distinct

Because of an overlap at the upper end of the stewardess salary scale and the lower end of the purser salary scale, senior stewardesses who became pursers did not receive any greater pay as purser for a significant period of time.

In 1970, after three years of ostensibly open admission purser status, Northwest had 137 male cabin attendants all as pursers and 1,747 female cabin attendants all but one as stewardesses.

The sole female purser at that time was Mary Laffey, who bid for a purser vacancy in 1967, after nine years' service as a stewardess. Although the purser position was scheduled to be filled in November 1967, processing of her application was delayed because Northwest needed to administer new tests to purser applicants. These tests had never previously been used in selecting pursers. During the interim between Laffey's application and her appointment Northwest hired two male pursers without benefit of any tests.

Finally, in June 1968, Laffey became a purser. She was placed on the bottom rung of the purser-salary schedule and received less than her income as a senior stewardess.

In 1972, a class made up of Northwest stewardesses sued the airline, alleging gender discrimination in violation of Title VII.

In gauging whether Northwest's pursers and stewardesses performed equal work, the trial court analyzed in great detail Northwest's flight operations and its use of different categories of cabin attendants. Duties performed did not differ significantly in nature as between pursers and stewardesses—they both had to check cabins before departure, greet and seat passengers, prepare for take-off, and provide in-flight food, beverage and general services. Both had to complete required documentation, maintain cabin cleanliness, see that passengers comply with regulations and deplane passengers.

All attendants had to be knowledgeable in first aid techniques and able to handle the myriad of medi-

cal problems that arise in flight. Food service varied greatly between flights, but pursers engaged in no duties that are not also performed on the same or another flight by stewardesses. Another important duty—building goodwill between Northwest and its passengers—depended on the poise, tact, friendliness, good judgment and adaptability of every cabin attendant, male or female.

Northwest argued that, after January 1971, pursers as a group have spent more nights away from home than did stewardesses. But the trial court found that these longer trips didn't constitute substantially dissimilar working conditions.

Northwest argued that it hired, trained and promoted male pursers in the belief that they would exercise leadership and be "responsible and accountable for the entire cabin service staff." On the other hand, stewardesses functioning as senior cabin attendants on particular flights would be responsible for coordination of cabin service on the entire flight but would be "accountable" only for the manner of service in their assigned sections of the aircraft.

The trial court found that, in practice, this distinction between levels of responsibility and accountability was illusory:

> Only in the purser's formal relationship with the Company does his accountability differ from the non-purser senior cabin attendant and that difference is derived from status rather than as a function of the job....

> ...Cabin service attendants are employed to serve and protect Company passengers. The "supervisory" functions of senior cabin attendants whether purser or stewardess are less important, and require no greater skill, effort or responsibility, than the other functions assigned to all cabin attendants.

The trial court concluded that Northwest had discriminated against women cabin attendants on the basis of sex, in violation of Title VII and the Equal Pay Act, by compensating stewardesses and purs-

Another important issue: differences in pay scales

ers unequally for equal work on "jobs the performance of which requires equal skill, effort and responsibility and which are performed under similar working conditions."

More specifically, the court found that Northwest had discriminated in "willful violation" of the Equal Pay Act:

a) by paying female stewardesses lower salaries and pensions than male pursers;

b) by providing female cabin attendants less expensive and less desirable layover accommodations than male cabin attendants;

c) by providing to male but not to female cabin attendants a uniform-cleaning allowance; and

d) "by paying Mary Laffey a lower salary as a purser than it pays to male pursers with equivalent length of cabin attendant service."

The trial court ordered various types of relief. The airline appealed.

The company's gender statistics changed significantly after suit was filed, when Northwest began to diversify gender ratios in different occupations. Some men were placed in the lower-paid categories by demoting pursers and by hiring new male applicants as "stewards" who were paid at the stewardess rate.

On appeal, Northwest did not challenge the trial court's conclusion that it had violated Title VII by refusing to hire female pursers. Instead, it focused on whether the payment of unequal salaries to stewardesses and pursers violated Title VII and the Equal Pay Act.

The purser wage scale ranged from 20 to 55 percent higher than salaries paid to stewardesses of equivalent seniority.

Northwest also attacked the trial court's holding that stewardesses and pursers were entitled to equal pay, and the corollary finding that stewardesses who became pursers were improperly de-

nied credit for their stewardess seniority on the purser seniority list. The company also disputed the court's conclusion that it had violated Title VII by its policies regarding cleaning allowances and layover accommodations.

The appeals court reiterated that:

> The Equal Pay Act forbids this pay differential unless greater skill, effort or responsibility is required to perform purser duties. Title VII likewise proscribes inferior sex-based compensation plans for women and, additionally, extends its protection to ban conditions of employment imposed discriminatorily upon women employees.

The appeals court ruled that the trial court's finding that Northwest's purser and stewardess jobs were essentially equal in duties and responsibilities was logically consistent with its conclusion that Northwest impinged on Title VII by blocking the entry of women into the purser category. Any gender-based barrier to obtaining a particular job is forbidden by Title VII—unless specifically exempted.

Among the employer prerogatives prohibited by Title VII are those which "limit...or classify his employees or applicants for employment in any way which would deprive or tend to deprive any individual of employment opportunities...because of such individual's...sex...."

Northwest classified its cabin attendants prominently as all-female stewardesses and all-male pursers. It barred women from the ranks of the latter, though they were capable through existing employment and accrued experience to meet all legitimate criteria. "That plainly was outlawed by Title VII as a sex-founded deprivation of employment opportunities, not the least of which were the superior emoluments which Northwest bestowed on the purser position," the appeals court ruled.

Skill, effort or responsibility have to define pay differences

Sexual harassment is a completely different issue

Sexual harassment

Even though it is a particularly politically charged issue, gender discrimination is relatively easy to manage. Sexual harassment—which many people wrongly equate with gender discrimination—is an entirely more difficult matter.

Federal courts have ruled that harassment is a form of discrimination, and the two phenomena certainly encourage one another and can coexist. As far as liabilities and potential court awards go, harassment poses greater risk.

One of the most frequently cited sexual harassment cases is the 1986 Supreme Court decision *Meritor Savings Bank v. Mechelle Vinson*. Most sexual harassment lawsuits decided in federal court rely on the terms and definitions set out by this decision.

In 1974, Mechelle Vinson met Sidney Taylor, a vice president of what later became Meritor Savings Bank and manager of one of its branch offices. When Vinson asked about employment at the bank, Taylor gave her an application, which she completed and returned the next day. Later that same day, Taylor called her to say that she had been hired.

With Taylor as her supervisor, Vinson started as a teller-trainee and was eventually promoted to teller, head teller, and assistant branch manager. She worked at the same branch for four years.

In September 1978, Vinson notified Taylor that she was taking sick leave for an indefinite period. On November 1, the bank fired her for excessive use of that leave. She sued the bank from wrongful termination and violating Title VII by allowing Taylor to sexually harass her over a long period.

Vinson claimed that shortly after her probationary period as a teller-trainee, Taylor invited her out to dinner and, during the meal, suggested that they go to a motel to have sexual relations. At first she refused, but out of what she described as fear of losing her job she eventually agreed.

According to Vinson, Taylor made repeated demands upon her for sexual favors—usually at the branch, both during and after business hours. She estimated that over the next several years she had intercourse with him some 40 or 50 times. She also claimed that Taylor fondled her in front of other employees, followed her into the women's restroom when she went there alone, exposed himself to her, and even forcibly raped her on several occasions.

She said that because she was afraid of Taylor she never reported his harassment to any of his supervisors and never attempted to use the bank's complaint procedure.

Taylor denied Vinson's allegations of sexual activity. He said that he never fondled her, never made suggestive remarks to her, never engaged in sexual intercourse with her, and never asked her to do so. He claimed that Vinson made her accusations in response to a business-related dispute. The bank also denied Vinson's allegations—and asserted that any sexual harassment by Taylor was unknown to the bank and engaged in without its consent or approval.

The trial court ultimately found that Vinson "was not the victim of sexual harassment and was not the victim of sexual discrimination" while employed at the bank. It believed that sexual harassment doesn't pass muster if there was no economic effect on the alleged victim's employment.

After noting the bank's express policy against discrimination, and finding that neither Vinson nor any other employee had ever lodged a complaint about sexual harassment by Taylor, the court ultimately concluded that "the bank was without notice and cannot be held liable for the alleged actions of Taylor."

Vinson appealed. The Court of Appeals ruled in her favor. It noted that a violation of Title VII may be predicated on either of two types of sexual harassment:

Direct economic impact and hostile environment

297

Title VII is not limited to tangible discrimination

- harassment that involves the conditioning of employment benefits on sexual favors; and

- harassment that, while not affecting economic benefits, creates a hostile or offensive working environment.

The Court of Appeals reversed the lower court decision because Vinson's complaint was of the second type and the trial court had not considered whether a violation of this type had occurred.

The appeals court also ruled that the trial court's conclusion that any sexual relationship between Vinson and Taylor had been voluntary was irrelevant. As to the bank's liability, the appeals court held that an employer is absolutely liable for sexual harassment by supervisory personnel, whether or not the employer knew or should have known about it.

It held that a supervisor, whether or not he possesses the authority to hire, fire, or promote, is necessarily an "agent" of his employer for all Title VII purposes, since "even the appearance" of such authority may enable him to impose himself on his subordinates.

The bank pressed the case to Supreme Court, which agreed to consider it. The high court started its review by noting two points about Title VII's application to sexual harassment cases.

First, the language of Title VII is not limited to "economic" or "tangible" discrimination. The phrase "terms, conditions, or privileges of employment" illustrates a legislative intent "to strike at the entire spectrum of disparate treatment of men and women" in employment.

Second, the EEOC issued enforcement guidelines in 1980 which specified that "sexual harassment" is a form of sex discrimination prohibited by Title VII. The EEOC guidelines supported the view that harassment leading to noneconomic injury can violate Title VII. In fact, they described kinds of workplace conduct which may be actionable under Title VII: "[u]nwelcome sexual advances, re-

quests for sexual favors, and other verbal or physical conduct of a sexual nature."

Even more to the point, the 1980 guidelines provided that certain kinds of sexual conduct constitutes sexual harassment, whether or not it is directly linked to an economic quid pro quo. This held true if "such conduct has the purpose or effect of unreasonably interfering with an individual's work performance or creating an intimidating, hostile, or offensive working environment."

Most importantly, the high court ruled that:

> ...since the Guidelines were issued, courts have uniformly held, and we agree, that a plaintiff may establish a violation of Title VII by proving that discrimination based on sex has created a hostile or abusive work environment.

In reaching this conclusion, the Supreme Court cited the 1982 federal appeals court case *Henson v. Dundee* approvingly. That decision had held:

> Sexual harassment which creates a hostile or offensive environment for members of one sex is every bit the arbitrary barrier to sexual equality at the workplace that racial harassment is to racial equality. Surely, a requirement that a man or woman run a gauntlet of sexual abuse in return for the privilege of being allowed to work and make a living can be as demeaning and disconcerting as the harshest of racial epithets.

Vinson's allegations—which included not only pervasive harassment but also criminal conduct—were plainly sufficient to state a claim for "hostile environment" sexual harassment.

The fact that sex-related conduct is "voluntary," in the sense that the alleged victim is not forced to participate against his or her will, is not a defense to a sexual harassment suit brought under Title VII. The high court stressed that:

> The gravamen of any sexual harassment claim is that the alleged sexual advances were unwelcome. The [trial court] erroneously focused

An employee's dress and behavior can be relevant

on the voluntariness of Vinson's participation in the claimed sexual episodes. The correct inquiry is whether Vinson by her conduct indicated that the alleged sexual advances were unwelcome, not whether her actual participation in sexual intercourse was voluntary.

However, it did allow that—while "voluntariness" in the sense of consent is not a defense to such a claim—an alleged victim's sexually provocative speech or dress might be relevant in determining whether he or she found particular sexual advances unwelcome.

> ...such evidence is obviously relevant. The EEOC Guidelines emphasize that the [court] must determine the existence of sexual harassment in light of "the record as a whole" and "the totality of circumstances, such as the nature of the sexual advances and the context in which the alleged incidents occurred."

On the issue of liability, the bank argued that Vinson's failure to use its established grievance procedure, or to otherwise put it on notice of the alleged misconduct, insulated it from liability for Taylor's wrongdoing. A contrary rule would be unfair, it argued, since in a hostile environment harassment case the employer often will have no reason to know about, or opportunity to cure, the alleged wrongdoing.

The Supreme Court rejected most of the bank's argument. The mere existence of a grievance procedure and a policy against discrimination didn't insulate the employer from liability. In fact, the bank's general nondiscrimination policy did not address sexual harassment in particular, and thus did not alert employees to their employer's interest in correcting that form of discrimination.

The bank's argument that Vinson's failure to lodge an official complaint insulated it from liability would have been "substantially stronger if its procedures were better calculated to encourage victims of harassment to come forward."

Justice William Rehnquist, writing for the court, boiled the conclusion down to six essential points:

1) hostile environment sexual harassment is a form of sex discrimination actionable under Title VII;

2) the employee's allegations of sexual conduct were sufficient to state a claim for hostile environment sexual harassment;

3) a sexual harassment claim doesn't require a direct economic effect on the employee;

4) the correct inquiry on the issue of sexual harassment is whether sexual advances were unwelcome, not whether employee's participation in them was voluntary;

5) evidence of an employee's sexually provocative speech and dress was not [relevant in this case], though it might be relevant in some contexts; and

6) mere existence of a grievance procedure and policy against discrimination, coupled with an employee's failure to invoke that procedure, did not necessarily insulate the employer from liability.

Those points remain the defining terms of sexual harassment.

In its most basic sense, sexual harassment means that an employee is treated differently because of how superiors or peers respond to his or her sexual identity. It entails a threat—either direct or indirect—some kind of negative impact to coerce complicity.

Ridiculing a co-worker's sexual orientation, forcing a subordinate to have sex and even engaging in a consensual sexual affair with a peer can all be considered sexual harassment, depending on circumstances.

These circumstances bedevil most employers. They often involve only the parties to the allegations—which means a he said/she said conflict without witnesses. They also sometimes involve subtle is-

Having a grievance procedure doesn't insulate you

sues of intent, when different people honestly believe totally different versions of a single episode.

How harassment manifests itself

The 1986 appeals court decision *Duchon v. Cajon Company* shows how harassment claims take the form of all kinds of particular issues. In this case, the alleged harassment manifested itself as a wage and hour dispute. In general, the case and its facts were a mess of contradictory allegations.

Roseann Duchon was hired by Ohio-based Cajon in June 1981 as a receptionist. In December, she attended a lengthy company Christmas party. At some point in the party, she and a male co-worker went to her car in the company parking lot so that Duchon could get a Christmas present she'd purchased for the co-worker. In the car, they "engaged in kissing and petting for an extended period of time." However, both participants agreed that they did not have sex—then or ever.

To Duchon, however, the Christmas party was the beginning of a "relationship." To her male co-worker it was an isolated "incident." In the months that followed, Duchon—a married woman with three children—developed what a court later called "an obsession" with the male co-worker.

In the summer of 1983, she wrote him several long and passionate letters pleading for his attention. She also began to show up uninvited—and unwelcomed, he said—at his condominium. The male co-worker would later testify that he believed Duchon occasionally carried a gun in her purse when she visited him.

In June 1983, the male co-worker—a top salesman for the company—informed his superiors at Cajon about his problems with Duchon. They told him to try to work it out on his own. Cajon management made no effort to confront Duchon or to ascertain the accuracy of the male co-worker's charges.

In September 1983, Duchon presented herself at

the male co-worker's condominium and refused to leave until he called the police. He reported this episode to company management and gave them copies of Duchon's letters. Within a week, Duchon's supervisor gave her the option of resigning or being fired. She resigned.

After her termination, Duchon received unemployment compensation, because Cajon management told the Ohio Bureau of Employment Services that she had been terminated for "lack of work."

However, she claimed that she was not paid properly for overtime she had accrued. She submitted the affidavit of an accountant who had compared Duchon's time cards with her paycheck stubs in accordance with Fair Labor Standards Act requirements and concluded Duchon had been undercompensated by $670.36.

Duchon subsequently filed sex discrimination charges with the EEOC. In August 1984, armed with a right-to-sue letter, she sued Cajon, her co-worker and her supervisor, alleging "sexual discrimination... defamation, interference with contractual employment relations, and failure to pay regular and overtime wages in violation of the Fair Labor Standards Act."

Cajon insisted that Duchon had never reported a single instance of harassment. With regard to overtime, the company claimed Duchon had been paid for all authorized overtime. Because office policy permitted employees to conduct personal business or socialize after quitting time, their time cards would often show that they left later than quitting time.

The trial court dismissed the claims against the individual defendants and the defamation and tortuous inference claims. It granted a summary judgment in favor of Cajon, dismissing Duchon's Title VII claim. It ruled that Duchon had established a prima facie case of gender discrimination but that Cajon had provided reasons for the discharge that were nondiscriminatory—namely, her pursuit of the co-worker.

Problems with overtime lead to harassment claims

A problem that had lingered for years

Duchon appealed. The appeals court ruled that Duchon's work performance had been satisfactory, but it agreed that her pursuit of the co-worker put Cajon at risk of losing a good salesman, and that this was a sufficient business reason to justify the company's request for Duchon's resignation. However, it did allow her overtime claim to proceed in lower court. Cajon settled that claim.

On-the-job feuds, office cliques and workplace love affairs further muddy the waters, making it tougher for employers to sort out the truth.

In February 1994, US West employee Robert Harlan was arrested on charges of kidnapping, raping and killing a waitress whose body later was found under a bridge in rural Colorado. The telephone company's problems began after the arrest. Current and former employees started coming forward to allege that they had complained for years that Harlan had touched female co-workers inappropriately, made lewd comments about their appearance, followed them through the office and even raped one woman.

US West knew of the allegations and investigated them according to strict internal policies and EEOC guidelines. "We have to walk a really fine line in dealing with sexual harassment, and we are comfortable with how we handled this case," said a spokeswoman. "Having said that, did we meet all the needs of all the employees involved in this case? Probably not."

Three days after his arrest, US West officials fired Harlan. Officials issued a terse press release announcing his dismissal, saying he violated "company anti-discrimination policy."

Another complication in the case: Co-workers complained that US West had adjusted Harlan's work schedule to accommodate probation and sex offender therapy meetings he was required to attend following his 1992 conviction for third-degree sexual assault.

One of the women who said Harlan had harassed her also claimed she and other coworkers were

uncomfortable when Harlan's wife, Sandra, was made an "in charge" operator. They felt she was a de facto supervisor and worried that their complaints would fall on deaf ears.

Even more troubling: Harlan had applied for and received "in charge" status, too. Female operators were outraged by this move because it gave him access to their home addresses and telephone numbers.

The US West spokeswoman said that employees could report harassment to their manager or their manager's manager—as well as to the company's equal employment opportunity representatives.

But even this prospect was problematic. One supervisor who had listened to complaints about Harlan allegedly failed to take action. One female operator told the supervisor in 1988 that Harlan had raped her. However, she had not reported the assault to police. "She told a supervisor Harlan raped her," the US West spokeswoman admitted weakly. "But she told us a few years after it happened and there was no police report filed, so it was difficult to react to."

Conclusion

You can't abdicate responsibility in these situations. Juries award damages on sketchy circumstances all the time. If you back away from a complicated problem, you increase the risk of being named in a subsequent lawsuit.

As is true of so many things in a litigious society, there's little you can do to avoid sexual harassment lawsuits altogether. To control the risk of being found liable in a harassment lawsuit, the best approach you can take is to eliminate any policy or practice that could be considered conducive to a "hostile environment." Court precedents have established this as the employer's most direct link to harassment liability.

The whole issue of hostile environment is problematic. For several years, federal courts were us-

The best you can do is control the risk

Seek simplicity and clarity in policies and procedures

ing an ill-defined "reasonable woman" standard to determine what constituted a hostile environment. This seemed to entail an assumption of guilt—that a borderline action was meant to be harassment.

In 1993, the Supreme Court ruled that the perspective of a "reasonable person" was more just. But the standard still shifts with the circumstances of given cases—and given courts.

As several commentators have noted, the legal system can give women broad protection against sexual harassment that is grounded specifically in an understanding of the female mind—or it can ignore gender differences and give women less protection. Neither prospect offers a reliable model to employers.

Nevertheless, the process for combating a hostile environment is fairly straightforward:

- have a written policy stipulating that sexual harassment and retaliation against anyone who claims sexual harassment "is prohibited and will not be tolerated";

- explain—precisely—the kinds of activities that constitute sexual harassment. Examples are useful in this process, but make sure that they aren't taken to be the only kinds of harassment you forbid;

- identify in advance particular individuals within the company who will investigate harassment complaints. Make sure these people have at least a basic understanding of the legal definitions of harassment and are credible to co-workers;

- start an in-house investigation as soon as a complaint is made. The investigator might ask the alleged victim what remedial action he or she wants you to take. The answer may indicate how serious the alleged victim considers the charge and may pave the way for a quick and easy solution;

- resolve all investigations with a finding of fact. People may not be satisfied with your conclusions. They may go on to complain—or already have complained—to government agencies. But the report helps you establish a good-faith effort to resolve the alleged problem;

- highlight your sexual harassment policies regularly, updating workers on recent cases that relate to your business or region.

If you're already facing a sexual harassment case, you can limit your liability by taking remedial action.

You can always clarify your company policy barring sexual harassment and encourage communication by holding anti-discrimination workshops for employees.

In most cases, you can perform an in-house investigation. If you find the complaint valid, you can take disciplinary action against the alleged harasser—but be very careful doing this.

Employers who react zealously when a worker accuses a colleague of sexual harassment can end up in court just as quickly as those who do nothing. You have to make sure to treat the accused harasser fairly—no matter how guilty you may believe he or she is.

CHAPTER 6:

AFFIRMATIVE ACTION

Introduction

Affirmative action is the aspect of workplace diversity that gets the most attention from the popular media. This is surprising, because affirmative action has less impact on most employers than specific laws like the ADA, Title VII or the Equal Pay Act.

Affirmative action isn't a particular law. It's a recruitment tool to bring formerly disadvantaged workers into the work force and to help them adapt to corporate cultures. The basic premise is a sound one: that people's potential comes wrapped in many different shapes and colors and, as an employer, you will have to take those differences into account in order to tap the potential.

In order to promote equal employment and avoid discrimination claims, conscientious employers establish voluntary internal audit procedures to evaluate their diversity efforts. But these efforts are voluntary—as long as you don't actively discriminate against people in protected classes, there's no law that says you have to implement an affirmative action program.

Unless you do a lot of business with government agencies.

The Labor Department's Office of Federal Contract Compliance Programs is responsible for seeing to it that companies with federal contracts do not

Most employers aren't subject to affirmative action

discriminate in employment decisions on the basis of race, sex, color, religion, national origin, disability, or veteran status.

The OFCCP does require that government contractors submit proof of affirmative action plans. The companies that have to meet with this requirement include most of the country's biggest employers—big computer companies, defense contractors, financial services giants and professional services firms.

Supporters of affirmative action programs see them as the means to dismantling illegal barriers to equal opportunity. Critics think of them as preferential treatment for special interests.

"Most [employers] are not subject to affirmative action laws. There's confusion about what affirmative action actually is. This is quite calculated on the part of [political] opponents" of affirmative action, says MALDEF employment law expert Kevin Baker. "No law requires quotas. Every law prohibits them."

The price of affirmative action programs in corporate American is significant—though somewhat unclear. *The Wall Street Journal* has claimed that direct and indirect affirmative action compliance costs equal about 1.5 percent of the gross national product of the United States. Other sources calculate the number as high as 2.5 percent. That would mean a total impact of over $150 billion.

More focused critics of the programs argue they have direct costs of between $16 billion and $20 billion a year. Supporters estimate the cost closer to $10 billion. Whichever is true, these are cost numbers that only a bureaucrat could love.

This gets to why the press focuses so intensely on affirmative action. The whole subject is a big one in Washington, D.C., where the little commerce that isn't part of the federal government does business with the federal government. The journalists, analysts and think-tank gurus in and around Capitol Hill are intimately familiar with government contract requirements.

They aren't usually so familiar with small or mid-sized companies outside of the Beltway that aren't affected by federal contracts.

It's unfortunate the people who administer affirmative action programs don't think more like small businesses. The biggest problem posed by these programs is that usually operate under numerous bureaucratic assumptions common to government agencies and huge corporations.

If affirmative action is a symptom of the bureaucratic administration of fat government contracts, why should growth-oriented companies in the private sector care at all about the programs? Because affirmative action is the focal point of the politics that defines workplace diversity law.

The people who draft laws like the ADA and Title VII make the same assumptions about affirmative action that big companies and big government make. They're usually from big companies and big government.

"Affirmative action is a fairly pure form of rent-seeking," University of Arizona economics professor Gordon Tullock has said, using the concept he developed for special interests' use of political power to extract subsidies for themselves from the economy. "There simply isn't any other economic rationale."

As an employer, you need to understand the sensibility behind diversity law. This helps you understand and comply with the spirit of the law. It also helps you follow—and maybe even predict—the direction of new developments in the law.

Perhaps the best question to ask about affirmative action: In today's highly competitive world, can we afford to discount the importance of merit in pursuit of fairness?

Legislative and political history

In many ways, this chapter provides political background to this entire book. The politics of affirmative action have colored the whole movement toward greater workplace diversity.

Color-blind laws versus dressed-up quotas

The main issue that defines debate over affirmative action plans is whether they are the logical application of color-blind laws like the 1964 Civil Rights Act or simply dressed-up quota systems.

The common notion of affirmative action stems from the 1964 Act and the generation of diversity laws which followed in the ten years that followed. The notion took shape in a series of so-called "set-aside" programs begun in the late 1960s and developed through the 1970s. These programs required that certain portions of government contracts—usually between three and 10 percent of total dollar value—be awarded to firms owned by people in protected classes.

According to University of Maryland at Baltimore Professor George La Noue, writing in the January 1993 issue of *Public Interest* magazine, over half of the Small Business Administration's set-asides go to groups that are composed largely of first- or second-generation immigrants. He suspected the same was likely to be true for all set-asides. In Washington, D.C.—where an amazing 90 percent of the city's road construction contracts were set aside—one of the largest beneficiaries was the Fort Myer Construction Corp., owned by a family of Portuguese origin who qualified as Hispanic because they emigrated from Argentina.

These programs created some legitimate access to capital and commerce for groups that had traditionally gone without. But they created an even greater backlash among politicians who have equated set-asides with the worst excesses of the welfare state.

As a result, many people confuse affirmative action with anti-discrimination law and even welfare programs. It's common for cheaper pundits to recite troubling statistics about poverty, illegitimate births and criminal convictions among racial minorities and then pontificate that "affirmative action has done nothing to reverse these dismal trends."

Of course affirmative action hasn't done anything

to reverse the dismal trends. It's a program for administering government contracts. It covers things like the hiring policies for engineers at defense contractors. It doesn't touch drug-dealing gangsters in urban slums.

Even cooler heads have problems applying affirmative action in a realistic way. Most admit that the constitutional concept of civil rights has given way to the political concept of group rights—but the analysis breaks down after that.

Evan Kemp, chairman of the EEOC under George Bush, tried to explore the progression of affirmative action. In a 1992 editorial in the *Washington Post*, Kemp wrote:

> We must examine the effects of policies—race-norming, quotas, goals, timetables—designed to facilitate affirmative action but resulting in insidious and pervasive racial, ethnic and gender preferences. We [need] take a hard look at what is producing tensions among groups and fostering division in our society....if "diversity" is used to mask a regime of quotas, we will tear the fabric of this nation along ethnic, racial and gender lines. Surely none of us wants that.

However, this same politician—who served in a supposedly pro-business administration—also wrote:

> As a leader of the disability rights movement, I fought for the guarantee of individual rights in the Americans with Disabilities Act. I knew group entitlement fails when applied to disability; employers do the minimum necessary under law to meet quotas, and never fill a quota with individuals with serious disabilities.

Employers are among the handful of groups left about whom public characters in Washington can make sweeping generalizations. Kemp's comment betrays the biases that government administrators, whatever their party affiliations, seem to share. To them, "employers" is an abstraction. A monolithic thing to be taxed, regulated and opportunistically vilified.

"Invidious and pervasive racial, ethnic and gender preferences"

Bill Clinton, an affirmative action fan, runs into trouble

But these bureaucratic administrators look at the beneficiaries of affirmative action in abstractions, too. And the problems cut against politicians from both ends of the ideological spectrum.

When Bill Clinton was elected President of the United States, he said that he would "have a diverse administration and...still be safe from quotas....[T]he achievement of diversity in an administration or student body or faculty or work force does not require a resort to quotas."

Clinton got into trouble with this claim almost immediately. Some constituents expected his administration to report its commitment to "diversity" in terms of the percentage of protected groups—by race, ethnicity, disability and gender—represented. Others saw this kind of accounting as a quota system.

According to widespread reports, some of his original Cabinet picks were bumped because they were the wrong sex or race. Key constituencies like urban Catholics and supporters of Israel were crowded out. His entire appointment process was slowed.

In a news conference that took place about a month before he took office, Clinton lashed out at feminist groups that protested what they perceived as too few women in the President's inner circle. Clinton was put in an awkward position of suggesting that diversity could conflict with merit.

Soon after, a senior Clinton appointee to the EEOC said, "I think the policy on affirmative action will be reviewed [by the administration]....There are a lot of new views here that may not have been heard before, and we will revisit the issue....We're looking at doing things in a more effective fashion."

The potential conflict between diversity and merit haunts most government efforts to encourage both. The Clinton administration found itself in another awkward position in a prominent reverse-discrimination case.

In 1994, the EEOC helped a white New Jersey high

school teacher win a court award because she had lost her job so that a black teacher could be retained.

In 1989, the Board of Education in Piscataway—in order to reduce the staff of its high school Business Education Department—had to decide which of two equally experienced and qualified teachers to let go. The board had previously drawn lots to resolve similar dilemmas.

However, citing a need to maintain racial diversity, the board laid off Sharon Taxman, a white teacher, and kept Debra Williams, who was the only racial minority teacher in the department.

The school board's diversity argument had already been rejected by the Supreme Court in a 1986 decision. In that case, a Michigan school board tried to lay off white teachers with greater seniority than black teachers who were retained in an effort to maintain the racial makeup.

Taxman took her case to the EEOC, which passed it on to the Justice Department's Civil Rights Division. In September 1991, the government filed suit as the principal plaintiff, joined by Taxman. By that time, she had been rehired to fill a vacancy—but was seeking lost pay and damages.

Government lawyers argued that staff diversity was not a valid reason without a record of discrimination under Title VII of the 1964 Civil Rights Act, which bars discrimination in public and private employment. Both sides agreed on the facts of the case, including that Williams had not been subject to past discrimination that might have required a remedy and that the school system's faculty was not racially imbalanced.

A federal district court judge concluded that race may be a consideration in voluntary affirmative action by an employer only if it is used to remedy past discrimination by the employer or to correct manifest underrepresentation by minorities in a traditionally segregated job category. She ruled in favor of the government and Taxman, awarding Taxman a year's back pay and interest.

The Justice Department confuses itself

Commitments you make in a voluntary affirmative action plan

Although courts have allowed hiring and promotion decisions to be made solely on the basis of race, they have generally not said the same about firings and lay-offs.

The school board appealed the district court's ruling. In July 1994, on the day it was scheduled to file a brief in support of the ruling, the Justice Department filed a motion stating that the government had changed its mind. It now disagreed with the ruling for Taxman.

"Upon further review," wrote Deval Patrick, chosen by Bill Clinton to head the Justice Department's Civil Rights Division after law professor Lani Guinier was withdrawn from consideration because of her views on quotas, "The United States believes that the District Court announced an unduly narrow interpretation of the permissible bases for affirmative action under Title VII."

Taxman would "not be unduly disadvantaged" by the government switching sides because she was already represented by her own lawyer and her layoff had been temporary, Patrick concluded with legalistic obfuscation.

Legal issues

The legality of affirmative action programs has been debated since the things first became prevalent in the 1960s. Essentially, there are two main legal issues. First, what commitments does an employer make when he or she enacts a voluntary affirmative action program? Second—and larger—are the programs constitutional?

If you put in place an affirmative action plan, it will be defined by the goals and timetables that it entails. This means you have to articulate the staffing problem to overcome and you have to commit to a schedule for accomplishing the task.

Government contractors and entities that receive public funds have to develop affirmative action plans. Why would anyone voluntarily set up standards against which they might fail, especially in so politically sensitive a context?

There aren't many compelling reasons. In fact, most of the voluntary affirmative action programs developed by corporate America aren't purely voluntary. They usually follow some kind of complaint or public trouble that—while falling short of legal action—creates a perception of discrimination or improper behavior.

One problem with voluntary affirmative action programs is that they invariably categorize people—which can lay the ground work for class action lawsuits if some group doesn't like an outcome.

The 1982 appeals court ruling *Paxton et al. v. Union National Bank* illustrates the most common problems that occur when class action lawsuits follow voluntary affirmative action programs.

The Union National Bank was a federally chartered bank with a main office and thirteen branches in Little Rock, Arkansas. Since the early 1970s, the bank had been owned by Herbert McAdams, an attorney and successful Arkansas banker.

The bank hired very few black people prior to 1973. In 1973, McAdams undertook an effort to develop business from black businesses and consumers. In support of this goal, he ordered his personnel officer to institute an affirmative action program designed to bring more black employees into the bank.

Black people were hired into the bank in numbers approximating their numbers in the work force in the Little Rock area. Most of the black employees were hired into entry-level positions.

The average educational level of black people employed by the bank during this period was 13.1 years; the average for white employees was 13.5 years. However, blacks received only a handful of promotions in the three highest salary ranges.

Between 1974 and 1979, 169 white employees received promotions in the three highest salary ranges and only 19 black employees received similar promotions.

Affirmative action plans categorize people

A bank commits to reversing a problematic past

By the early 1980s, all but one of the twenty-five vice presidents and assistant vice presidents were white. All division heads were white, as were fifty-four of the fifty-six persons having hiring or firing authority at the bank. Seventy-seven of the eighty bank officers were white, and twelve of the thirteen branch banks were managed by white employees.

Apart from a history of discrimination, there was evidence of on-going discrimination in salary increases awarded in connection with promotions. In over ninety percent of the cases, black employees received smaller increases than white employees when promoted within the same salary ranges.

Black employees made little or no progress in being appointed to professional, technical, managerial or administrative positions in the period 1974-1979. The bank employed one person in the technical category in 1974 and only one in 1979, and it employed one in the managerial category in 1974 and only two in 1979.

In 1980, a group of black Union National employees sued, seeking class-action certification and charging the bank with a pattern and practice of racial discrimination.

The federal District Court for eastern Arkansas denied the employees class certification during the trial and then held that Union National did not discriminate against black applicants or employees in any aspect of the employment relationship.

The trial court also ruled that Union National had sustained its burden of articulating a legitimate nondiscriminatory reason for its employment decisions with regard to six named plaintiffs and all other employees whose names had been suggested as possible victims.

On appeal, the employees argued that the trial court erred in failing to certify a class, and in denying relief to the class.

The first question the appeals court considered: Was the trial court right to delay the class certification until the trial was complete?

The appeals court ruled that the trial court had abused its discretion in reaching the result that it did. Specifically, the trial court should have certified a class consisting of the following two subclasses of blacks discriminated against by the bank:

1) Black employees who because of their race were denied a promotion or received lesser salary increases at the time of their promotion than did similarly situated white employees during the period January 1, 1974, to the completion of trial (the promotion class).

2) Black persons with less than two years of experience who were discharged because of their race during the period January 1, 1974, to the completion of trial (the discharge class).

The appeals court next considered the merits of the cases made by each of the two subclasses.

First, it considered the bank's promotion record. The bank's stated policy was to promote from within. This policy was followed in a large majority of cases. During the period 1974-1979, more than eighty promotions were made to supervisory or managerial positions. Black employees received only two of these promotions.

On a broader base, the appeals court found that the cumulative effect of smaller raises given to black persons each year was that the portion of black employees' wages resulting from promotion salary increases lagged almost $80 behind the same figure for their white counterparts.

The bank's defense was that black employees as a whole within the bank were not as qualified as white employees. However, the two groups' qualifications were substantially equal when measured by two key objective criteria: Black employees had as much experience as white employees; and their educational level averaged 13.1 years, compared to 13.5 years for the whites.

Those who were denied and those who never applied

Several compelling stories followed the filing

The bank didn't offer nondiscriminatory reasons for its failure to promote specific black employees. The few specific nondiscriminatory reasons it tried to offer were inconsistent and contradictory. The appeals court ruled:

> If a black person had more education than the white person receiving a promotion, the bank claimed that it made its selection on the basis of experience. Conversely, if a black employee had more experience than the white promoted, the bank claimed that education was the key to performing that job. And if the black employee had more experience and a better education, the bank often simply stated that the white employee was better qualified without giving a reason for the decision.

The appeals court cited one employee's testimony as an example:

> Mildred Hall, a black female, testified that when she went to work for the bank in 1978, her supervisor and the white employees working for her showed their resentment for her because she was a black woman taking the place of a white man. She stated that even though she has two years of college, seventeen years experience as a supervisor and an excellent work record, she has not been named an officer of the bank and has not been given an opportunity to get into the management training program. She has received raises of only four to five percent per year, considerably less than other supervisors, even though she has been told that her work is outstanding.

Indeed, Hall was not alone:

> Jerry Riley and Phyllis Mosley sought to represent the class of black persons who have been denied promotions or have been given lesser promotions on account of their race. Riley claims that he was denied a promotion to lead control clerk in the computer department, and that his promotion to computer operator trainee and computer operator were discriminatorily

delayed. Mosley alleges that she was not pro-
moted out of her telephone clerk job because
of her race.

Both Riley's and Mosley's claims rested on the
same legal theory as that of the class claims—
namely, that they had been subjected to "dispar-
ate treatment" in the area of promotions because
of their race.

The appeals court ruled that Mosely and Riley fairly
and adequately represented promotion class be-
cause:

- they alleged that they had been denied promo-
 tions within the bank on account of their race;

- they shared the class' interest in "procuring
 declaratory and injunctive relief to eradicate
 those aspects of the bank's promotion practices"
 that kept blacks in the lower-level positions;

- there was no indication that their interest in
 procuring their rightful place in the bank's hi-
 erarchy would be at the expense of other class
 members or would be otherwise antagonistic
 to the class' interests; and

- they demonstrated a willingness to prosecute
 the interests of the class through qualified
 counsel.

Several employees, in addition to Riley and Mosley,
testified that they had been denied timely promo-
tions because of their race and detailed the rea-
sons for their complaints. The testimony of these
employees demonstrated the typicality of the plain-
tiffs' grievances.

The appeals court concluded that black employ-
ees were not promoted to positions for which they
were qualified and when they were promoted, they
consistently received salary increases significantly
less than comparable white employees. It ruled
that the employees not only stated a prima facie
case but also carried the burden of proof against
the bank's attempt at an alternative explanation.

Second, the appeals court considered the claims

*A fair and
adequate
representation
of the class*

Statistical and anecdotal evidence supported the claims

of the class of black employees discriminatorily discharged from the bank.

Fifty-three blacks were discharged during the period from 1974 to 1980. They were discharged at a rate twice that of the white dischargees.

The appeals court asked: Were the black employees discharged because of their race? It answered its own question:

> Phyllis Mosley's allegation that she was discharged from her telephone clerk position on account of her race is typical of the claims of the discharge class. Mosley has also shown that she is not alone in her dissatisfaction with the bank's racially discriminatory practices. Two persons besides herself, Melvin Paxton and Harold Brown, testified that they had been actually or constructively discharged from their positions because of their race.

This was coupled with evidence that several of the blacks who were discharged for cause were granted unemployment compensation benefits after hearing.

And there was more than anecdotal evidence. The appeals court concluded that statistical evidence that blacks with less than two years of service were discharged at more than twice rate of similarly experienced white employees established a prima facie case of racial discrimination regarding the bank's discharge of black employees.

However, the appeals court admitted that the bank articulated nondiscriminatory reasons for each discharge, thus rebutting the prima facie case.

The appeals court held that Jerry Riley and Phyllis Mosley proved that they had been denied promotions on account of their race—and that Mosley was discriminatorily discharged. It further held that the district court erred in refusing to certify two subclasses of black discriminatees—those discriminated against with respect to promotions and those discriminatorily discharged.

The appeals court ruled that, though the bank had

instituted an affirmative action policy in early 1970s, it had not been implemented with respect to promotion process. Discrimination continued into the 1980s.

> Combinations of reasons account for this. White supervisors make most promotional decisions and the criteria for promotions are primarily subjective in nature. The affirmative action program was not effectively communicated to all supervisors and adherence to that policy was not required by top management. Vacancies were not posted. The system recently adopted to communicate vacancies to employees was incomplete and untimely. Acts of racism in the bank were not always dealt with firmly and fairly.

The court concluded that this behavior, in the wake of an affirmative action program, was worse than if no affirmative action effort had been made at all. It reversed the trial court's conclusions and ordered appropriate relief to several individuals and the promotion subclass.

In short, affirmative programs are like any other remedial compliance program—they're best avoided if they can be. If they can't be avoided, establish ground rules very carefully. When you set goals and timetables, stay away from sweeping or nonspecific language. Keep goals modest and related to real problems that exist in your workplace. Make timetables realistic, detailed and as flexible as possible.

Goals and timetables—and the internal systems for measuring each—are also the reasons that corporate diversity consultants can become a lingering expense. If you have to bring in an outside consultant to help develop the program, take particular care to define limits of subject matter and time. Don't resign yourself to the extortion-like tactics that some consultants use—threats of huge legal action and ponderous talk about how your corporate culture will have to change radically.

Bad behavior in the wake of a plan is worse than no plan

The Small Business Act

Most federal agency contracts must contain a sub-contractor compensation clause, which gives a prime contractor a financial incentive to hire sub-contractors certified as small businesses controlled by socially and economically disadvantaged individuals, and requires the contractor to presume that such individuals include minorities or any other individuals found to be disadvantaged by the Small Business Administration.

Indeed, the Small Business Act is one of the central tools in the federal government's support of affirmative action programs. The Act states that "the policy of the United States that small business concerns...owned and controlled by socially and economically disadvantaged individuals...shall have the maximum practicable opportunity to participate in the performance of contracts let by any Federal agency."

The Act defines "socially disadvantaged individuals" as "those who have been subjected to racial or ethnic prejudice or cultural bias because of their identity as a member of a group without regard to their individual qualities." It defines "economically disadvantaged individuals" as "those socially disadvantaged individuals whose ability to compete in the free enterprise system has been impaired due to diminished capital and credit opportunities as compared to others in the same business area who are not socially disadvantaged."

The Act establishes "[t]he Government-wide goal for participation by small business concerns owned and controlled by socially and economically disadvantaged individuals" at "not less than 5 percent of the total value of all prime contract and subcontract awards for each fiscal year."

It also requires the head of each Federal agency to set agency-specific goals for participation by businesses controlled by socially and economically disadvantaged individuals. The Small Business Administration implements these directives through a series of programs that set aside government

contracts for small businesses controlled by socially and economically disadvantaged individuals.

To participate in the 8(a) program, a business must be 51 percent owned by individuals who qualify as "socially and economically disadvantaged." The SBA presumes that Black, Hispanic, Asian Pacific, Subcontinent Asian, and Native Americans, as well as "members of other groups designated from time to time by SBA," are "socially disadvantaged."

Privacy and internal audits

Another commitment you make when undertaking an affirmative action program is that you will establish an internal auditing system for measuring your progress. These internal audit efforts can create significant risks.

When dealing with internal audits of workplace diversity, you have to be careful what you write. If internal memos honestly admit problems in employment diversity and candidly review slow progress, courts may force you to hand them over to litigious employees. Although such audits may be crucial resources for tracking compliance of equal employment efforts, they are also potential smoking guns in the wrong employee's hands.

But, if you edit memos so that they don't discuss diversity problems in detail, your program may not meet the measure of useful goals and timetables.

In discrimination lawsuits, employers generally try to keep internal diversity audits private based on three legal theories:

- the work product privilege,
- the attorney-client privilege, and
- the self-evaluative privilege.

The courts have interpreted these doctrines narrowly. They have allowed employees broad discovery rights, including access to sensitive personnel information concerning diversity efforts.

The work product privilege relies on the assump-

How courts interpret the work product privilege

tion that information prepared in order to make or defend against a lawsuit can't be handed over to the other side. The standard most often cited for protecting a document prepared in anticipation of litigation has been explained as the following:

> [T]he test should be whether, in light of the nature of the document and the factual situation in the particular case, the document can fairly be said to have been prepared or obtained because of the prospect of litigation.

Some courts have held that there must be a substantial probability of litigation to create this privilege—and that the privilege doesn't apply to a "remote prospect" of future litigation.

Other courts have adopted a less stringent standard, concluding "that litigation need not necessarily be imminent...as long as the primary motivating purpose behind the creation of the document was to aid in possible future litigation."

In the absence of a clear test to draw the line between a "substantial probability" and a "mere possibility" of litigation, a court may examine an employer's motivation for conducting the audit. Was it conducted in anticipation of litigation or for general business purposes? Was it conducted at the direction of an attorney, or at the direction of a human resources department? Was it conducted as part of a routine practice or in response to a particular circumstance?

The more common claim of attorney-client privilege relies on your request for legal—as opposed to business—advice. In its 1981 decision *Upjohn Co. v. United States*, the Supreme Court wrote that the purpose of this privilege:

> is to encourage full and frank communication between attorneys and their clients and thereby promote broader public interests in the observance of law and administration of justice. The privilege recognizes that sound legal advice or advocacy serves public ends and that such advice or advocacy depends upon the lawyer's being fully informed by the client.

Documents that are reports of general corporate business decisions as opposed to legal advice based upon confidential information are not privileged. Merely having a document prepared under an attorney's signature does not shield it from disclosure. Likewise, if you contact your lawyer on an ongoing basis in reviewing the results of an audit program, the activity may not be protected—unless it can be tied to potential or actual litigation.

In the event that you retain an outside consultant to audit equal employment efforts, the documents may be protected from disclosure by relying on the "ombudsman" privilege. (In fact, this is one of the few legitimate reasons to use a consultant.)

The "ombudsman" privilege has four general requirements:

1) the communication must be one made in the belief that it will not be disclosed;

2) confidentiality must be essential to the maintenance of the relationship between the parties;

3) the relationship should be one that society considers worthy of being fostered; and

4) the injury to the relationship incurred by disclosure must be greater than the benefit gained in the correct disposal of litigation.

The self-evaluative privilege—also called the "self-critical analysis" privilege—assumes that if you've undertaken a voluntary effort to insure diversity, you shouldn't be subject to forced disclosure. It is based on the concern that disclosure of documents reflecting candid self-examination will deter or suppress socially useful investigations and evaluations, or compliance with the law or with professional standards.

The self-evaluative privilege was first recognized in employment discrimination lawsuits in the 1971 federal district court decision *Banks v. Lockheed-Georgia Co.* Lockheed had appointed a "team of employees to study [its] problems in the area of

Employers often claim attorney-client privilege

Self-evaluative privilege is far-reaching but hard to prove

equal employment opportunities, and to determine the progress, if any, of [its] Affirmative Action Compliance Programs."

The team made certain findings, and from these findings it issued a formal report to the Office of Federal Contract Compliance Programs, pursuant to Executive Order 11246—which requires contractors to have affirmative action programs.

A group of employees suing Lockheed sought production of the "team's [findings] which include[d] a candid self-analysis and evaluation of the Company's actions in the area of equal employment opportunities."

The issue before the court was "whether the plaintiffs should have access to the candid reports of defendant company when such reports ha[d] been made in an attempt to affirmatively strengthen the Company's policy of compliance with Title VII and Executive Order 11246."

The court said no. It recognized a public policy of encouraging frank self-criticism and evaluation in the development of affirmative action programs. It concluded that "to allow the plaintiffs access to the written opinions and conclusions of the members of Lockheed's own research team would discourage companies such as Lockheed from making investigations that are calculated to have a positive effect on equalizing employment opportunities."

However, Lockheed was ordered to produce "any factual or statistical information that was available to the members of [its] research team at the time they conducted their study."

But audits of voluntary efforts have been subject to forced disclosure in discrimination lawsuits. The trend has been to apply the privilege only to materials prepared in response to EEOC settlement and affirmative action plans required by government contractors and subcontractors.

The 1978 Pennsylvania district court decision *Webb v. Westinghouse Electric Corp.* defined three

"potential guideposts" for application of the self-evaluative privilege:

> First, materials protected have generally been those prepared for mandatory governmental reports. (Examples of such mandatory reports are affirmative action plans (AAPs), and Equal Employment Opportunity Reports (Standard Form 100).)

> Second, only subjective, evaluative materials have been protected; objective data contained in those same reports in no case have been protected.

> Finally, courts have been sensitive to the need of the plaintiffs for such materials, and have denied discovery only where the policy favoring exclusion of the material clearly outweighed plaintiff need.

An argument that courts have given a lot of credence is that the audits in question have "marginal probative value"—in other words, they're irrelevant.

The 1980 Massachusetts district court decision *O'Connory v. Chrysler Corporation* admitted that few voluntary affirmative action plans are truly voluntary. Ironically, it used this conclusion to further limit the self-evaluative privilege:

> ...since the evaluations in these cases were not entirely voluntary, they will occur even if the threat of discovery is present....in some cases there may be significant deterrents to candid self-evaluation, even absent the possibility of discovery....An employee's interest in protecting himself and his fellow employees from discipline is likely to be at least as great as his interest in protecting his employer from suit.

In the 1987 New York district court decision *Hardy v. New York News, Inc.*, the company's equal employment manager had written several documents detailing her efforts to monitor and analyze the company's success in meeting certain minority employment goals. Subsequently, the company

Claiming that your own audits are of marginal value

An employer relied too much on a diversity consultant

hired a consulting firm that prepared work force analyses, comparative labor pool statistics, analyses of potential job opportunities for minorities, and draft affirmative action plans.

Some time later, in an employment discrimination lawsuit filed by several terminated employees, the documents evaluating the employer's equal employment efforts were requested in discovery.

The court rejected the self-evaluative defense to prevent disclosure, because it found that the documents were not governmentally mandated. Moreover, it found that the employees' interest in gathering information to prove discriminatory intent outweighed society's "interest in fostering candid self-analysis and voluntary compliance with equal employment laws."

The court said that the employer had an obligation to implement policies that would improve the utilization of minorities. It also said that failure to maintain affirmative action programs because documents pertaining to the effort might become available in the context of litigation ran contrary to what it called "basic principles of risk management."

Finally, the court concluded that the primary purpose of the work performed by the employer and the outside consultants was to develop an affirmative action plan, and not to prepare for litigation. Their work did not reveal litigation strategy or the mental impressions or thought processes of an attorney.

The 1992 Illinois district court case *Vanek v. NutraSweet, Inc.* involved claims of violations of Title VII and the Equal Pay Act because the employee was laid off while on maternity leave.

Prior to the lawsuit, NutraSweet had retained an outside consultant to perform a critical self-analysis of its affirmative action efforts. The audit involved interviewing employees, reviewing personnel documents, and analyzing work force statistics. The outside consultant's findings and recommendations were then submitted in a final report,

which was shown only to key members of management.

NutraSweet had also formed a task force on diversity to determine how it could best meet its work force diversity goals. The task force was charged with conducting critical self-analyses regarding the employer's effectiveness in meeting its affirmative action goals. The product of this task force was restricted to the members of the task force.

When the plaintiff in the termination suit requested the results of NutraSweet's various activities, the company refused, claiming critical self-evaluative privilege.

NutraSweet's argument was rejected by the federal court. It ruled the company had voluntarily decided to conduct a study of its hiring practices and to create the task force on diversity. Thus, the requested documents were discoverable.

Generally, courts have cautioned employers that "in light of the number of recent suits challenging specific affirmative action plans, an expectation of confidentiality is not prudent." That warning is worth heeding.

The constitutionality of affirmative action

Affirmative action programs are supposed to address specific problems of workplace diversity. And there's even doubt about their role in that regard. Beginning in the late 1980s, the Supreme Court raised questions about the constitutionality of government-sponsored affirmative action programs.

In the 1986 case *Wygant v. Jackson Board of Education*, the Court considered a challenge to a so-called "remedial" racial classification. The issue in *Wygant* was whether a school board could adopt race-based preferences in determining which teachers to lay off. It had made a policy of not laying off teachers who were members of racial minority groups.

The court asked a question in two parts: "whether

"An expectation of confidentiality is not prudent"

331

Many plans have questionable constitutional status

the layoff provision is supported by a compelling state purpose and whether the means chosen to accomplish that purpose are narrowly tailored." It concluded that "racial classifications of any sort must be subjected to strict scrutiny."

The term "strict scrutiny" crops up often in affirmative action issues. It means that courts—and government regulatory agencies—can't make broad assumptions about who has been discriminated against in a given situation. Critics of affirmative action programs generally like it; supporters generally don't.

The court went on to rule that the school board's interest in "providing minority role models for its minority students, as an attempt to alleviate the effects of societal discrimination," was not a compelling interest that could justify the use of a discriminatory racial classification.

It added that "[s]ocietal discrimination, without more, is too amorphous a basis for imposing a racially classified remedy." It insisted that "a public employer...must ensure that, before it embarks on an affirmative action program, it has convincing evidence that remedial action is warranted.... That is, it must have sufficient evidence to justify the conclusion that there has been prior discrimination."

The 1989 decision *City of Richmond v. J.A. Croson Co.* continuted this process. The Supreme Court ruled that state and local government set-aside programs were unconstitutional, unless specific pre-existing discrimination could be proved.

In *Croson*, as the case has become known, the Court concluded that strict scrutiny was the appropriate test for deciding the constitutionality of race-based affirmative action programs implemented by a state or local municipality. This legal test requires the Court to find a compelling reason to justify such programs.

It determined that the city of Richmond's minority set-aside plan violated the equal protection clause of the Fourteenth Amendment by guaranteeing subcontract business to minority businesses.

332

The Richmond plan required all prime contractors with the city to subcontract at least 30 percent of the contract's value with minority businesses anywhere in the United States. Waivers could be granted to prime contractors only if they were able to demonstrate exceptional circumstances that justified the hiring of non-minority businesses.

J.A. Croson Co. was the low bidder on a city jail construction project. Croson challenged the constitutionality of the city's affirmative action plan after the city denied its request for a waiver or a higher contract price following its inability to locate minority subcontractors willing to supply fixtures at the market price established in the project contract.

Although the Court expressed concern over "the sorry history of both private and public discrimination in this country [that] has contributed to a lack of opportunities for black entrepreneurs," it found that general history, without more specifics, could not validate what it called rigid racial quotas in the awarding of public contracts.

The Court also criticized the quota as unrelated to any past injury suffered by anyone:

> [W]here special qualifications are necessary, the relevant statistical pool for purposes of demonstrating discriminatory exclusion must be the number of minorities qualified to undertake the particular task....Without any information on minority participation in subcontracting, it is quite simply impossible to evaluate overall minority representation in the city's construction expenditures.

The Court also criticized the city's failure to consider race neutral programs as a means of increasing minority business participation and noted that, even in the absence of evidence of past discrimination, a city could properly increase accessibility to entrepreneurs of all races. Justice Sandra Day O'Connor observed the following:

> Many of the barriers to minority participation

The low bidder had to hire expensive minority subcontractors

in the construction industry relied upon by the city to justify a racial classification appear to be race neutral. If [minority businesses] disproportionately lack capital or cannot meet bonding requirements, a race neutral program of city financing for small firms would...lead to greater minority participation.

An important omission from the *Croson* decision: The justices could not agree on when and under what conditions affirmative action by the government is legally permissible.

But the conclusions it did reach carried a lot of legal weight. Governmental entities must produce specific and identifiable evidence of past discrimination against beneficiaries of affirmative action programs.

The Court agreed that "a state or local [government] has the authority to eradicate the effects of private discrimination within its own legislative jurisdiction," but it concluded that the city of Richmond had not acted with "a strong basis in evidence for its conclusion that remedial action was necessary." The Court also found it "obvious that [the] program is not narrowly tailored to remedy the effects of prior discrimination."

Probably the most important conclusion the Court made in *Croson* was that "the standard of review under the Equal Protection Clause is not dependent on the race of those burdened or benefited by a particular classification," and that the single standard of review for racial classifications should be strict scrutiny.

This standard implied three general propositions with respect to governmental racial classifications.

First, skepticism: "...[a]ny preference based on racial or ethnic criteria must necessarily receive a most searching examination...."

Second, consistency: "the standard of review under the Equal Protection Clause is not dependent on the race of those burdened or benefited by a particular classification...."

And third, congruence: "[e]qual protection analysis in the Fifth Amendment area is the same as that under the Fourteenth Amendment...."

Taken together, these propositions lead to the conclusion that any person, of whatever race, has the right to demand that any governmental agency justify racial classifications it uses. This was a dramatic change from earlier court rulings.

Local politicians, who had used some affirmative action programs as mechanism to handing out patronage to political allies, criticized the *Croson* decision. The most angry politicians engaged in so-called "disparity studies" to prove that discrimination against minorities was widespread.

Between 1990 and 1993, the federal government spent nearly $30 million on these studies. Almost half of that amount spent by one agency—the federal Urban Mass Transit Authority. On the local level, the numbers added up even more quickly. For example, the city of Atlanta spent more than $500,000 for a thousand-page report on how racism pervaded its contracting processes.

In another 1989 decision, the Supreme Court made it easier to challenge an affirmative action program. The case, *Martin v. Wilks*, involved expanding the concept of "collateral attack"—when a person who has not been a party in a case questions the result.

The *Martin* case began with a challenge to the hiring and promotion procedures used by the city of Birmingham, Alabama, and the surrounding county. In 1974, seven black firefighters sued the local governments, claiming illegal racial discrimination under Title VII of the 1964 Civil Rights Act. The lawsuits were settled when the city and county entered consent decrees that established hiring and promotion goals for black firefighters.

Several years later, white firefighters, who had not participated in the original lawsuits, challenged these hiring and promotion goals as violating Title VII because they discriminated on the basis of race.

Anyone can challenge government racial classifications

Reverse-discrimination claims plague affirmative action plans

Black firefighters objected to this new challenge and argued that the city and county were protected from charges of discrimination since they were complying with court-approved consent orders.

They also argued that the white firefighters were barred in their challenge, since they had not intervened in the original litigation.

The Supreme Court held that the white firefighters were not barred from challenging the legality of the hiring and promotion goals established in the consent decrees. It concluded:

> No one can seriously contend that an employer might successfully defend against a Title VII claim by one group of employees on the ground that its actions were required by an earlier decree entered in a suit brought against it by another, if the later group did not have adequate notice or knowledge of the earlier suit.

Martin v. Wilks means that charges of reverse discrimination cannot be defended by asserting compliance with previous court orders. If you're putting together an affirmative action program, you have to consider how its implementation will affect your entire work force. It's another reason to proceed carefully—and specifically—when you're enforcing diversity standards.

In one of its most famous reverse-discrimination cases, the Supreme Court confronted the question whether race-based governmental policies designed to benefit specific racial groups should also be subject to "the most rigid scrutiny."

The famous 1978 case *University of California v. Bakke* involved a constitutional challenge to a state-run medical school's practice of reserving a number of spaces in its entering class for minority students. A white male applicant challenged his rejection, arguing that less-qualified minority applicants had been accepted in his place.

The University argued that strict scrutiny should apply only to "classifications that disadvantage discrete and insular minorities." Justice Lewis

Powell's opinion announcing the Court's judgment in favor of Alan Bakke, the white male applicant, rejected that argument.

Powell wrote that "[t]he guarantee of equal protection cannot mean one thing when applied to one individual and something else when applied to a person of another color." He concluded that "[r]acial and ethnic distinctions of any sort are inherently suspect and thus call for the most exacting judicial examination."

On the other hand, four justices in Bakke would have applied a less stringent standard of review to racial classifications "designed to further remedial purposes."

Quotas

The phrase "enforcing diversity standards" gets uncomfortably close to the most difficult issue in this whole subject: Quotas.

Weary of vague terms like "goals" and "timetables," some employers are tempted to set simple quotas to assure workplace diversity. But quotas aren't a proper approach, either. Title VII clearly prohibits quotas—even as a means of correcting past discrimination.

A growing number of legal and economics experts agree with the weary employers, though. They say that affirmation action plans are simply quotas called something else. This argument is consistent with the term "rent-seeking" used by economist Gordon Tullock.

The legal argument for such government-imposed diversity quotas usually takes two parts. First, they are necessary to force employers to tap new pools of labor. Second, employers need a diverse work force to service an increasingly diverse population.

On a June 1993 appearance on the television news program *Nightline*, Lani Guinier said:

> I have advocated quotas...in a reference to exactly what President Clinton has talked about

<div style="text-align: right; font-style: italic; font-weight: bold;">

Does "enforcing diversity standards" mean quotas?

</div>

"Race-norming" is a controversial practice

in terms of making his Cabinet look like America—and that is a more diverse federal bench.

It was a response indeed to a series of appointments over the past several years in which there didn't seem to be any outreach to make the federal judiciary inclusive of all of the people of America, not just of minorities but also women.

Both parts of the argument make the same bureaucratic assumptions about employer biases that we've seen throughout this chapter. Of course, rent-seeking isn't meant to help employers make better decisions about the needs of a diverse population. If economists like Tullock are right, it's designed to redistribute society's wealth in a few selected directions.

Even its record as a means of wealth redistribution is mixed, though. Between 1970 and 1990 median family income among black Americans barely moved, from an inflation-adjusted $21,151 to $21,423.

Quotas in college admissions—probably the most systematic application in American society—haven't done much, either. In 1976, less than 23 percent of black 18-to-24-year-olds enrolled in college (compared with just over 27 percent of whites). In 1990, just over 25 percent of young black adults were enrolled (compared with over 32 percent of whites).

Sometimes quotas take the form of practices like so-called "race-norming." This refers to the practice of radically adjusting scores on entrance exams and aptitude tests to compensate for the systematically lower results of protected groups.

Race-norming had been going on in the federal government's hiring processes throughout the 1980s. It reportedly subjected at least 16 million test-takers to a quota system they knew nothing about.

After public outcry, race-norming was banned in the 1991 Civil Rights Act. But the process proved

difficult to eradicate. After the 1991 Act became law, some federal agencies adapted a technique called "banding"—concealing differences in performance by lumping ranges of scores together.

Most economists argue that diversity quotas—whether they're called goals, affirmative action, rent-seeking or anything else—don't work because they interfere with ordinary market trends in the cost of labor.

In his classic book *The Economics of Discrimination*, University of Chicago economist and Nobel Prize winner Gary Becker argued that, in a free market, you're likely to be paid something like what your work is worth. If you belong to a group that's discriminated against, employers may pay you less. But that means that they will make more money from hiring you. Thus, because you are a profitable hire, you will come into demand and your labor will be bid up. Quotas interfere with this process.

Another problem: Critics of affirmative action programs argue that advocates are suspect of any form of performance standard. "Many of these people believe there really is no such thing as job performance or productivity objectively defined, that it's really just a matter of one's cultural definition or cultural orientation," said University of Iowa industrial psychologist Frank Schmidt.

Compliance

The Labor Department requires federal contractors to report the race, ethnic and gender composition of its work force. Failure to reflect a so-called "correct" composition risks loss of federal contracts.

Employers also must grapple with "business necessity" and the Uniform Guidelines on Employee Selection Procedures—the government regulation that requires businesses to prove any selection procedure that has a "disparate impact" on racial, ethnic or gender groups is absolutely necessary.

Quotas interfere with market forces

Train managers in diversity issues

To avoid litigation, many business people who rely on big government contracts "hire by the numbers"—in other words, according to quotas—ensuring their work forces reflect the racial, ethnic and gender composition of their labor markets. This also satisfies the Office of Federal Contract Compliance (and for that matter, EEOC field investigators), even though the Supreme Court has held Title VII of the Civil Rights Act of 1964 protects individuals, not groups.

Unless you've run afoul of the Office of Federal Contract Compliance or otherwise agreed to a specific program, compliance isn't really an issue in affirmative action. "Avoidance" is probably the better way to describe what most employers think about in this context.

An essential part of avoiding the kinds of problems that lead to affirmative action programs is the ability to communicate well with colleagues and customers from diverse backgrounds.

Fostering good communication can take the form of buying packaged services from the ubiquitous diversity consultants, setting up special training programs for employees from protected groups and training managers to show sensitivity toward people with legitimate needs.

Of these options, the last is probably the most promising. It shouldn't take long for you to develop a basic package of information that informs managers about the basics of anti-discrimination laws and lets them know that you don't tolerate illegal behavior.

And a big part of complying with the spirit of affirmative action may be looking beyond the details of such programs. Committing to hiring the best people you can find isn't just a white-collar copout. It's a way to avoid the Balkanization that literal-minded affirmative action can create.

In an age of rapid information and increased diversity of all sorts, obsessing about the right boxes to check on an affirmative action checklist defeats the purpose of the plans. And it interferes with basic competitiveness.

Management by quota—even partly by quota—dumbs down your company. When less competent employees reach a critical mass, their lower performance standards become the standards of the organization. More senior employees who are equipped for the job abandon high standards and conform to the new, lower ones.

A major affirmative action test

One appeals court decision that's often cited as a standard for measuring the legality of affirmative action programs is the 1991 case *Peightal v. Metropolitan Dade County*. The case is long and complicated, but it does offer a thorough look at how affirmative action plans should work.

In October 1983, Alan Peightal, a white male, applied for a job as a firefighter with the Dade County Fire Department. Peightal took the firefighter examination along with 3,300 others. His score of 98.25 earned him a rank of 28 out of 2,188 persons who passed the test.

At the time Peightal applied, the Department was hiring pursuant to an minority preference program which sought to redress a statistical imbalance between the percentage of minorities it employed and the percentage of minorities in the general population. The plan called for the selection of female, black and Hispanic applicants in accordance with certain goals established for the purpose of increasing the representation of these groups.

The plan made a distinction between two kinds of employees for the purpose of determining hiring goals. For professional and administrative positions, the Department sought to achieve the same percentage of female and minority employees as existed in the available qualified labor force. For other categories—including firefighters, para-professionals, office clerical, skilled craftsmen and service maintenance—the plan called for utilization of a "70 percent rule."

This meant racial and gender percentages of hires made in each employee category had to be within

A "minority preference program" of dubious legality

70 percent of the respective percentages of the local population.

The local area had a history of gross disparity in employment of minorities going back to 1965. By 1975, with increase in the size of the Department the percentage of white employees was 89 percent. By 1983, when the plan was adopted, the Department numbered 921. Whites comprised 74 percent—with only 11.8 percent black and 13.8 percent Hispanic employees.

This was in contrast to the make-up of the general population (the available labor pool) which was 47 percent white, 17.3 percent black, 35.8 percent Hispanic and 50 percent female.

In 1983, the plan figured there were 754,443 white persons in Dade County, which represented 47 percent of the population. Accordingly, the Department aimed to have 33 percent (70 percent of 47 percent) of its recruit class made up of whites. For blacks, who comprised 17 percent of the population, the goal was 12.1 percent. Hispanics made up 36 percent of the population of Dade County, so the Fire Department wanted 25 percent of its recruits to be Hispanic.

Applicants were grouped and ranked by race and gender classification as defined by the Department pursuant to the plan. The following six categories were used:

 i) Black Males,

 ii) Black Females,

 iii) White Females,

 iv) Hispanic Males,

 v) Hispanic Females, and

 vi) White Males.

All applicants were scored and ranked only against those other members of the category. For example, a Black Male's test score would be ranked only against the score of another member of the class of Black Males taking the examination; the score of a White Male applicant such as Peightal would

not be ranked against the score of any non-"White Male" applicant.

Applying the 70 percent rule to local population statistics, the Department determined that its hiring goals for 1983 should include 44 whites, 23 blacks, 37 Hispanics, and 23 females. As a result of the Department's hiring from the 1983 examination, the following recruits were hired from 1983 to 1985: 23 White Males, 12 White Females, 18 Black Males, 5 Black Females, 24 Hispanic Males, and 4 Hispanic Females.

The total figure hired was 86 persons; and 51 of these scored lower than Peightal on the 1983 examination. Nevertheless, Peightal was not hired.

In March 1986, Peightal found out that he had been taken off the "stand-by" list of applicants and had not been hired due to the plan.

Peightal filed an EEOC Complaint alleging racial discrimination. In August 1986, the EEOC denied Peightal's charge and found that the Department's actions had been taken in accordance with an affirmative action plan. Still, the EEOC issued Peightal a right-to-sue letter.

In November 1986, Peightal filed a lawsuit against Dade County and the Fire Department, alleging violations of the federal labor code, the Equal Protection Clause of the Constitution and Title VII of the Civil Rights Act of 1964. He sought a court order banning Dade County's preferential hiring treatment of minorities and back wages from the time period which he should have been hired.

The County answered, defending its plan and offering the specific defense that the denial to Peightal of any position of employment was due to its "legitimate affirmative action program." It insisted that it should be exempt from liability on the ground that it adopted the EEOC regulations in implementing the plan.

The trial court upheld the plan against Peightal's claim that it violated Title VII and the Equal Protection Clause. Peightal appealed.

Limiting candidate competition leads to the lawsuit

Comparing a work force to the local population

The appeals court considered the two main issues—called "prongs"—which determine whether a plan like the Dade County Fire Department's could stand up to scrutiny.

First, the County had to show a compelling government purpose for the plan. In particular, this proof would have to include evidence that:

- the firefighter position at issue was unskilled;

- the general population was the proper labor pool to use for comparative purposes;

- Dade County was the appropriate geographic area; and

- the disparity between the percentages of minorities in the Fire Department and the general population was great enough to justify a finding of previous discrimination by the Department, and the need for the kind of remedial efforts sought by the plan.

To determine discriminatory exclusion, unskilled positions are compared to a different statistical pool than for jobs requiring special training. The Supreme Court has held:

> In determining whether an imbalance exists that would justify taking sex or race into account, a comparison of the percentage of minorities or women in the employer's work force with the percentage in the area labor market or general population is appropriate in analyzing jobs that require no special expertise...or training programs designed to provide expertise.

The position of firefighter was described as "specialized work in the protection of life and property"; the position was nevertheless an "entry-level" one, as "there are no specialized skills per se which must be possessed in order to obtain the position." The trial court ruled that "a comparison between the Fire Department's work force and the labor market is appropriate."

The use of Dade County's geographical boundaries went unchallenged by Peightal. The trial court let

the County stand as the geographic location. It considered the percentages of minorities in Dade County and compared that with the percentages of minorities employed as firefighters in the Department, to decide whether the disparities justified an affirmative action program.

It concluded:

> ...there is nothing in this record showing that the use of general population figures is improper, and no attack has in any way been leveled at its use, or assertion been made that a different labor pool should be employed than the general population to determine whether or not there was prior discrimination in the Fire Department....

Next, the statistical imbalance between minorities and non-minorities in the relevant work force and available labor pool had to be "approaching a prima facie case of a constitutional or statutory violation" before a public employer could adopt racial or gender preferences.

The "general rule" set by the Supreme Court was that the disparity must be "greater than two or three standard deviations" before it can be inferred that the employer has engaged in illegal discrimination under Title VII. The Court also called that sort of imbalance a "gross statistical disparit[y]."

The percentages of minorities in the Metropolitan Dade County Fire Department, as compared with the percentages of minorities in Dade County, revealed a statistical disparity far in excess of two or three standard deviations.

To determine whether there was evidence of discrimination against Hispanics in the Department, for example, the trial court compared the expected number of Hispanics in the Department (35.8 percent x 921 = 330), to the actual number of Hispanics on the firefighter force, which was 127. The difference between the actual number and the observed number is 203. The standard deviation in this case is equal to the square root of 921 x .358 x .642, or approximately 14.5.

Was the plan flexible and of limited duration?

To derive the number of standard deviations present in the case, the court divided 203 by 14.5— to obtain 14 standard deviations. Since 14 standard deviations markedly surpassed the rough limit of 2 or 3 standard deviations, the court held that evidence of prior discrimination existed.

The trial court had concluded that the second prong of the strict scrutiny standard was also satisfied by the Fire Department, because the plan was narrowly tailored to meet its remedial objectives. More specifically, the Plan:

- adequately considered and implemented alternative remedies to a minority-preference program;

- was flexible and of limited duration;

- was not unconstitutionally over- or under-inclusive; and

- did not unnecessarily trammel on the rights of non-minorities.

The appeals court support this conclusion generally, but it couldn't affirm it completely because the Supreme Court decision *Croson* required such strict scrutiny of affirmative action programs.

The trial court found evidence that the Fire Department tried other alternatives without success to increase representation of minorities. Chief Edward Donaldson testified at trial that the Fire Department had a recruitment program aimed at minorities. He stated that recruiters were sent to high schools and college campuses to inform and encourage minority students to sign up for the Fire Department's test.

The trial court also concluded that the plan did not continue indefinitely, but terminated upon the satisfaction of its affirmative action goals. Moreover, the plan's hiring provisions were appropriately sensitive to the Supreme Court's distinction between "goals" and "quotas."

Under a system of goals, the employer is never required to hire a person who does not have qualifications needed to perform the job successfully.

The plan did not require the Fire Department to hire an unqualified person in preference of another applicant who was qualified.

For example, although the Fire Department sought to hire 37 Hispanics in 1983, it was only able to hire 28. It was unwilling to hire unqualified minorities just to meet its goals. Had a strict quota been in place, on the other hand, the Department would have been required to fill these 37 positions with Hispanics.

Because the plan did not endure in perpetuity, and because it did not impose rigid quotas, the trial court had found that the Fire Department satisfied the second criterion. But, following guidelines set by *Croson*, the appeals court questioned whether the history of racial imbalance in the Department was specific enough to support an affirmative action solution.

Peightal argued that the Dade County minority preference program was over-inclusive because it favored white European Spaniards with no significant cultural or linguistic discernibility from non-Hispanic white persons.

At the same time, Peightal argued that the plan was under-inclusive because the class of persons qualifying for preferential treatment as "Hispanics" failed to include other national and ethnic groups that were susceptible to similar discrimination.

The court found no over-inclusiveness because Metro Dade was not offering hiring preferences to any groups that did not have history of discrimination in the local area.

"If Peightal had successfully revealed that a light-skinned Castillian, for example, with no discernible cultural or linguistic Hispanic characteristics, had been hired as a firefighter in his stead, then his claim of over-inclusiveness would have more force," it ruled. "The Equal Protection Clause does not require a state actor to grant preference to all ethnic groups solely because it grants preference to one or more groups. A state actor does not vio-

late the Fourteenth Amendment so long as it [is] rational...to conclude that the groups [the state actor] preferred had a greater claim to compensation than the groups it excluded."

Finally, the trial court had held that—though Peightal was harmed by hiring preferences—a state or local government may constitutionally require innocent non-minorities to share the burden of remedying the effects of past identified discrimination. It concluded that the plan did not have an unconstitutional effect on non-minorities. The appeals court hesitated to support this conclusion also, in light of the *Croson* decision.

So, the appeals court affirmed that the Fire Department's plan did not violate Title VII.

Enforcement

Under Clarence Thomas, the EEOC shifted its enforcement strategy from settling many cases under a rapid-processing policy to prosecuting all individual cases in which discrimination could be proved. Critics of this policy said the agency's focus on individual complaints meant that it had turned its back on affirmative action programs.

Under the Clinton administration, EEOC shifted its focus back and embraced affirmative action as a central measure for relief. This compelled employers to put stronger affirmative action plans in place.

Robert Reich, Clinton's Secretary of Labor, took a personal interest in EEOC claims (as well as OSHA complaints and other workplace regulation issues). In October 1994, Reich announced that three very different employers—Goodyear Tire and Rubber Company, the University of California at San Diego and American of Martinsville—had agreed to pay more than $1.25 million in back pay and salary adjustments to resolve alleged affirmative action problems.

"These settlements clearly demonstrate our strong commitment to ensure that our nation's workers

are protected and have access to equal employment opportunity in the workplace," Reich said. "Employers must understand that we take our mandate to enforce the law in a fair and responsible manner very seriously and will take necessary action to ensure compliance."

The agreements resolved charges of discrimination based on race and gender—as well as other problems identified in compliance reviews conducted by the OFCCP, which enforces Executive Order 11246.

- The University of California at San Diego agreed to pay $608,403 in back pay to 28 individuals—women and minorities denied jobs or promotions although they were fully qualified.

- Virginia-based furniture maker American of Martinsville agreed to pay $417,000 to resolve alleged discriminatory employment practices against nearly 200 minorities and women. The back pay, based on length of service, ranged from $100 to $2,700 per individual. The company also has agreed to pay about $200,000 in front pay. (Front pay is the difference between the new and old pay systems, usually paid retroactively.) In addition, the company agreed to design and implement a revised blue-collar pay system to be in place no later than January 1995.

- Goodyear Tire and Rubber Company's offices in Houston, Texas, agreed to pay $229,361 in back wages to 42 employees and applicants who were alleged victims of racial discrimination. The settlement resolved discriminatory hiring and personnel practices identified in a combined compliance review and a class-action complaint investigation. The OFCCP identified 33 victims of discrimination due to Goodyear's promotion policies and practices; seven minorities were paid unequal wages compared to non-minority workers, and two applicants were denied employment because of their ethnic identification.

A case focuses on affirmative action standards

In the wake of the settlements. Assistant Secretary for Employment Standards Bernard Anderson said: "Compliance with equal employment opportunity laws is in the best interests of workers and employers. By eliminating artificial barriers, workers have the opportunity to develop their work skills, improve their well-being, and participate in increasing our nation's productivity."

The 1977 Supreme Court case *Hazelwood School District v. United States* was the EEOC's main test of affirmative action plans. The case set the terms for how affirmative action efforts are measured.

The Hazelwood School District covered 78 square miles in the northern part of St. Louis County, Missouri. Hazelwood was formed from 13 rural school districts between 1949 and 1951. By the 1967-1968 school year, 17,550 students were enrolled in the district, of whom only 59 were black; the number of black students increased to 576 of 25,166 in 1972-1973—a total of just over 2 percent.

Initially, Hazelwood followed relatively unstructured procedures in hiring its teachers. Every person requesting an application for a teaching position was sent one. Completed applications were submitted to a central personnel office, where they were kept on file.

During the early 1960s, the personnel office notified all applicants whenever a teaching position became available. As the number of applications on file increased in the late 1960s and early 1970s, this practice was no longer considered feasible. So, the personnel office began the practice of selecting anywhere from 3 to 10 applicants for interviews at the school where the vacancy existed. It did not substantively screen the applicants in determining which of them to send for interviews. Generally, those who had most recently submitted applications were most likely to be chosen for interviews.

Applicants with student or substitute teaching experience at Hazelwood were given preference if their performance had been satisfactory.

School principals had virtually unlimited discretion in hiring teachers for their schools. The only general guidance given to the principals was to hire the "most competent" person available, and such intangibles as "personality, disposition, appearance, poise, voice, articulation, and ability to deal with people" counted heavily.

Hazelwood hired its first black teacher in 1969. The number of black faculty members gradually increased in successive years. In the 1972-1973 and 1973-1974 school years only 1.4 and 1.8 percent, respectively, of Hazelwood's teachers were black.

By comparison, according to 1970 census figures, of more than 19,000 teachers employed in that year in the St. Louis area, 15.4 percent were black. That percentage figure included the St. Louis City School District, which in recent years had followed a policy of attempting to maintain a 50 percent black teaching staff. Apart from that school district, 5.7 percent of the teachers in the county were black in 1970.

A prima facie case built on statistics

The statistical disparity between the Hazelwood School District and surrounding districts, particularly when viewed against the background of Hazelwood's teacher hiring procedures, was held by the EEOC to constitute a prima facie case of a pattern or practice of racial discrimination.

In 1973, acting on behalf of the EEOC, the Attorney General brought a lawsuit against Hazelwood and various of its officials. The lawsuit alleged that Hazelwood was engaged in a "pattern or practice" of employment discrimination in violation of Title VII of the Civil Rights Act of 1964.

The government mounted its "pattern or practice" attack on four different fronts. It provided evidence of:

- a history of alleged racially discriminatory practices,

- statistical disparities in hiring,

- standardless and largely subjective hiring pro-
cedures, and

- specific instances of alleged discrimination
against 55 unsuccessful black applicants for
teaching jobs.

Hazelwood focused its defense on perceived defi-
ciencies in the government's case and its own offi-
cial policy "to hire all teachers on the basis of train-
ing, preparation and recommendations, regardless
of race, color or creed."

The trial court ruled that the government had failed
to establish a pattern or practice of discrimina-
tion. The court found the statistics showing that
relatively small numbers of blacks were employed
as teachers irrelevant, because the percentage of
black students in Hazelwood was similarly small.

Finally, the court reviewed 55 cases of alleged in-
dividual discrimination. It found that this burden
had not been sustained in a single instance and
entered judgment for the defendants.

The Eight Circuit Court of Appeals reversed the
trial court's decision. It ruled that the trial court
had assigned inadequate weight to evidence of dis-
criminatory conduct on the part of Hazelwood be-
fore the effective date of Title VII.

The Court of Appeals rejected the trial court's
analysis of the statistical data as resting on an
irrelevant comparison of black teachers to black
pupils in Hazelwood. The proper comparison, it
argued, was between black teachers in Hazelwood
and black teachers in the relevant labor market
area.

Selecting St. Louis County as the relevant area,
the Court of Appeals compared the 1970 census
figures, showing that 15.4 percent of teachers in
that area were black, to the racial composition of
Hazelwood's teaching staff—of which 1.8 percent,
at most, was black.

In addition, the Court of Appeals reasoned that
the trial court had erred in failing to measure the

55 instances in which black applicants were denied jobs against the *McDonnell Douglas v. Green* standard. Applying that standard, the appeals court found 16 cases of individual discrimination, which "buttressed" the statistical proof.

Because Hazelwood had not rebutted the government's prima facie case of a pattern or practice of racial discrimination, the Court of Appeals directed judgment for the government.

The school district appealed to the Supreme Court. In its petition, it raised one important question:

> Whether a court may disregard evidence that an employer has treated actual job applicants in a nondiscriminatory manner and rely on undifferentiated work force statistics to find an unrebutted prima facie case of employment discrimination in violation of Title VII.

The Supreme Court ruled that the Court of Appeals erred in disregarding the possibility that the statistical evidence may have been rebutted at trial. It noted that "once a prima facie case has been established by statistical work force disparities, the employer must be given an opportunity to show that the claimed discriminatory pattern is a product of pre-Act hiring rather than unlawful post-Act discrimination."

Racial discrimination by public employers was not made illegal under Title VII until March 1972. After that date, a public employer that made all its employment decisions in a wholly nondiscriminatory way would not violate Title VII—even if it had formerly maintained an all-white work force by purposefully excluding racial minorities.

For the two-year period from 1972 to 1974, 3.7 percent of the new teachers hired in Hazelwood were black. The next important issue was to what control statistic that number should have been compared.

The lower courts had accepted the government's argument that the relevant labor market was St. Louis County and the city of St. Louis—where 15.4 percent of the teachers were black. They didn't

Once again, anecdotes buttress statistics

consider Hazelwood's contention that St. Louis County alone—where 5.7 percent of the teachers were black—should have been the comparison.

The Supreme Court ruled that the difference was significant because "the disparity between 3.7 and 5.7 percent may be sufficiently small to weaken the government's [case], while the disparity between 3.7 and 15.4 percent may be sufficiently large to reinforce it."

The Supreme Court hesitated to make any conclusions in favor of comparing Hazelwood to the higher city of St. Louis numbers. It concluded that a number of questions—including how long the city had been following its affirmative action plan and how successful it had been—would have to be resolved first by lower courts.

"Only the trial court is in a position to make the appropriate determination after further findings. And only after such a determination is made can a foundation be established for deciding whether or not Hazelwood engaged in a pattern or practice of racial discrimination in its employment practices in violation of the law," it concluded.

Finally, the high court noted that standard deviation analysis suggested, even if the lower St. Louis County numbers were the control, a prima facie case for discrimination against Hazelwood might still stand. Nevertheless, it ruled that the Court of Appeals had acted too hastily in disregarding Hazelwood's efforts to comply with Title VII after it took effect for public entities.

It sent the case back to trial court for further findings as to the relevant labor market area and for an ultimate determination of whether Hazelwood engaged in a pattern or practice of employment discrimination after March 1972.

The end of affirmative action?

Ironically, a year before Hazelwood, the Supreme Court decision *McDonald v. Santa Fe Trail Transportation Co.* began the questioning of certain af-

firmative action plans. It mandated that anti-discrimination laws be enforced equally in regards to all races—even racial majorities.

In September 1970, L.N. McDonald and co-workers Raymond Laird and Charles Jackson were jointly and severally charged with misappropriating 60 one-gallon cans of antifreeze which was part of a shipment Santa Fe was carrying for one of its customers.

A week later, McDonald and Laird—both white— were fired by Santa Fe. Jackson, who was black, was retained. The fired workers filed a grievance promptly with their union, pursuant to an existing collective-bargaining agreement. But grievance proceedings secured no relief.

About six months later, they filed complaints with the EEOC, charging that Santa Fe had discriminated against them on the basis of their race in firing them—and that their union local had discriminated against McDonald on the basis of his race in failing properly to represent his interests in the grievance proceedings. They alleged that all of these actions were in violation of Title VII and section 1981 of the federal labor code.

Title VII prohibits the discharge of "any individual" because of "such individual's race."

Section 1981 of the federal labor code provides:

> All persons within the jurisdiction of the United States shall have the same right in every State and Territory to make and enforce contracts, to sue, be parties, give evidence, and to the full and equal benefit of all laws and proceedings for the security of persons and property as is enjoyed by white citizens, and shall be subject to like punishment, pains, penalties, taxes, licenses, and exactions of every kind, and to no other.

The EEOC process proved ineffective for McDonald and Laird. The agency issued a right-to-sue letter in July 1971. They filed a civil lawsuit in federal district court within thirty days, as required. They

Two white employees are fired, a black one isn't

claimed that Santa Fe had discriminated against them on the basis of race and that their union had acquiesced in this discrimination by failing properly to represent one of them in grievance proceedings.

Santa Fe moved to dismiss the complaint—and, in June 1974, the trial court issued a final modified opinion and order dismissing the claims under both Title VII and section 1981.

Turning first to the section 1981 claim, the trial court determined that it was "wholly inapplicable to racial discrimination against white persons" and dismissed the claim.

Turning then to the claims under Title VII, the court concluded it had no jurisdiction over Laird's Title VII claim against the union local because Laird had not filed any charge against the local with the EEOC.

The court concluded that "the dismissal of white employees charged with misappropriating company property while not dismissing a similarly charged Negro employee does not raise a claim upon which Title VII relief may be granted."

McDonald and Laird appealed. The Court of Appeals affirmed their dismissals, noting in regard to the Title VII claim: "There is no allegation that the plaintiffs were falsely charged. Disciplinary action for offenses not constituting crimes is not involved in this case."

The employees appealed to the Supreme Court, which agreed to consider the case. Justice Thurgood Marshall, writing for the court, focused on two issues: first, whether a complaint alleging that white employees charged with misappropriating property from their employer were dismissed from employment, while a black employee similarly charged was not dismissed, stated a claim under Title VII; second, whether section 1981 afforded protection from racial discrimination in private employment to white persons as well as nonwhites.

Section 703 of the 1964 Act provided in pertinent part:

> (a) Employer practices. It shall be an unlawful employment practice for an employer...to fail or refuse to hire or to discharge any individual, or otherwise to discriminate against any individual with respect to his compensation, terms, conditions, or privileges of employment, because of such individual's race, color, religion, sex, or national origin.

> (b) Labor organization practices. It shall be an unlawful employment practice for a labor organization...to cause or attempt to cause an employer to discriminate against an individual in violation of this section.

The EEOC, whose interpretations are entitled to great deference, had consistently interpreted Title VII to proscribe racial discrimination in private employment against whites on the same terms as racial discrimination against nonwhites. The agency held that to proceed otherwise would "constitute a derogation of the Commission's congressional mandate to eliminate all practices which operate to disadvantage the employment opportunities of any group protected by Title VII, including Caucasians."

So, the Court ruled:

> Title VII...prohibits racial discrimination in private employment against white persons upon the same standards as racial discrimination against nonwhites.

> ...While [an] employer may decide that participation in a theft of cargo may warrant not retaining a person in its employment, this criterion must be "applied alike to members of all races," or Title VII is violated. Crime or other misconduct may be a legitimate basis for discharge, but it is not a basis for racial discrimination.

This conclusion remained consistent with uncontradicted legislative history to the effect that

The same rules apply to unions

Title VII was intended to "cover white men and white women and all Americans," and create an "obligation not to discriminate against whites."

The union local argued that it should not be subject to liability under Title VII in a situation where some but not all culpable employees were discharged on account of joint misconduct. It argued that, in representing all the affected employees in their relations with the employer, the union may necessarily have to compromise by securing retention of only some.

The Supreme Court rejected that argument. "The same reasons which prohibit an employer from discriminating on the basis of race among the culpable employees apply equally to the union; and whatever factors the mechanisms of compromise may legitimately take into account in mitigating discipline of some employees, under Title VII race may not be among them," it ruled.

Santa Fe suggested two lines of argument to support why section 1981 of the federal labor code should not prohibit racial discrimination against white persons. First, it argued that by the phrase "as is enjoyed by white citizens," section 1981 limited itself to the protection of nonwhite persons. Second, it argued that such a reading is consistent with the legislative history of the provision, which derives its operative language from the Civil Rights Act of 1866.

"We find neither argument persuasive," the court ruled. Instead:

> our examination of the language and history of section 1981 convinces us that [it] is applicable to racial discrimination in private employment against white persons....the statute explicitly applies to "All persons," including white persons. While a mechanical reading of the phrase "as is enjoyed by white citizens" would seem to lend support to respondents' reading of the statute, we have previously described this phrase simply as emphasizing "the racial character of the rights being protected."

And it made a detailed review of the legislative history of Civil Rights Act of 1866.

The bill ultimately enacted as the Civil Rights Act of 1866 was introduced by Senator Trumbull of Illinois as a "bill...to protect All persons in the United States in their civil rights" and was initially described by him as applying to "every race and color." In the course of Senate debate, Trumbull said:

> This bill applies to white men as well as black men. It declares that all persons in the United States shall be entitled to the same civil rights, the right to the fruit of their own labor, the right to make contracts, the right to buy and sell, and enjoy liberty and happiness....

The Supreme Court found it clear that the bill, as it passed the Senate, was not limited in scope to discrimination against nonwhites. Section 1 of the bill, as ultimately enacted, provided in relevant part:

> All persons born in the United States, and not subject to any foreign power, excluding Indians not taxed, are hereby declared to be citizens of the United States; and such citizens, of every race and color...shall have the same right, in every State and Territory in the United States, to make and enforce contracts...as is enjoyed by white citizens, and shall be subject to like punishment, pains, and penalties, and to none other, any law, statute, ordinance, regulation, or custom, to the contrary notwithstanding.

After the Senate's acquiescence to certain modifications proposed by the House of Representatives—and a subsequent veto by President Andrew Johnson—debate in both the Senate and the House again reflected the proponents' views that the bill did not favor nonwhites. Senator Trumbull once more rejected the view that the bill "discriminates in favor of colored persons."

In the House, Representative Lawrence observed that its "broad and comprehensive philanthropy which regards all men in their civil rights as equal

before the law, is not made for any...race or color...but...will, if it become(s) a law, protect every citizen...."

On these notes, Congress overrode Johnson's veto and passed the bill into law.

So, 110 years later, the Supreme Court concluded that:

> ...Section 1981 prohibits racial discrimination in private employment against white persons as well as nonwhites, and this conclusion is supported both by the statute's language, which explicitly applies to "All persons," and by its legislative history. While the phrase "as is enjoyed by white persons" would seem to lend some support to the argument that the statute is limited to the protection of nonwhite persons against racial discrimination, the legislative history is clear that the addition of the phrase to the statute as finally enacted was not intended to eliminate the prohibition of racial discrimination against whites.

As a result, the high court reversed the judgments of the trial court and appeals court. It ordered a ruling in favor of McDonald and Laird's claims.

A killing blow

The 1995 Supreme Court case *Adarand Constructors, Inc. v. Federico Pena* capped the move that *McDonald v. Santa Fe* began and *Croson* continued. The later decision changed the shape of programs like the SBA section 8(a) set-asides—and possibly affirmative action in general.

Adarand Constructors claimed that the federal government's practice of giving general contractors on government projects a financial incentive to hire subcontractors controlled by socially and economically disadvantaged individuals. In particular, it challenged the government's use of race-based presumptions in identifying such individuals as a violation of the equal protection component of the Constitution.

In 1989, the Central Federal Lands Highway Division (CFLHD), which is part of the United States Department of Transportation (DOT), awarded the prime contract for a highway construction project in Colorado to Mountain Gravel & Construction Company. Mountain Gravel then solicited bids from subcontractors for the guardrail portion of the contract. Adarand, a Colorado-based highway construction company specializing in guardrail work, submitted the low bid. Gonzales Construction Company also submitted a bid.

The prime contract's terms provided that Mountain Gravel would receive additional compensation if it hired subcontractors certified as small businesses controlled by "socially and economically disadvantaged individuals." Gonzales was certified as such a business; Adarand was not.

Mountain Gravel awarded the subcontract to Gonzales, despite Adarand's low bid. Mountain Gravel's chief estimator admitted that the company would have accepted Adarand's bid, had it not been for the additional payment it received by hiring Gonzales instead.

Mountain Gravel's contract came about as a result of the Surface Transportation and Uniform Relocation Assistance Act of 1987 (STURAA), a DOT appropriations measure. STURAA provided that "not less than 10 percent" of the appropriated funds "shall be expended with small business concerns owned and controlled by socially and economically disadvantaged individuals."

The operative clause in the contract in this case reads as follows:

> "Subcontracting. This subsection is supplemented to include a Disadvantaged Business Enterprise (DBE) Development and Subcontracting Provision as follows:

> "Monetary compensation is offered for awarding subcontracts to small business concerns owned and controlled by socially and economically disadvantaged individuals....

The major affirmative action case of the 1980s and 1990s

Shaky conditions favoring minority contractors

"A small business concern will be considered a DBE after it has been certified as such by the U.S. Small Business Administration or any State Highway Agency. Certification by other Government agencies, counties, or cities may be acceptable on an individual basis provided the Contracting Officer has determined the certifying agency has an acceptable and viable DBE certification program. If the Contractor requests payment under this provision, the Contractor shall furnish the engineer with acceptable evidence of the subcontractor(s) DBE certification and shall furnish one certified copy of the executed subcontract(s)....

"The Contractor will be paid an amount computed as follows:

"1. If a subcontract is awarded to one DBE, 10 percent of the final amount of the approved DBE subcontract, not to exceed 1.5 percent of the original contract amount.

"2. If subcontracts are awarded to two or more DBEs, 10 percent of the final amount of the approved DBE subcontracts, not to exceed 2 percent of the original contract amount."

After losing the guardrail subcontract to Gonzales, Adarand filed suit against various federal officials in the United States District Court for the District of Colorado, claiming that the race-based presumptions involved in the use of subcontracting compensation clauses violate Adarand's right to equal protection.

The District Court granted a summary judgment for the government rejecting Adarand's claims. The Court of Appeals supported that conclusion.

The Supreme Court took a different stand. It concluded that courts should analyze cases of this kind under a different standard of review than the one the Court of Appeals applied. It ruled that "all racial classifications, imposed by whatever federal, state, or local governmental actor, must be analyzed by a reviewing court under strict scrutiny."

The Adarand decision means that federal racial classifications—like those of a state—must serve a compelling governmental interest, and must be narrowly tailored to further that interest.

Setting a standard of "strict scrutiny"

"Requiring strict scrutiny is the best way to ensure that courts will consistently give racial classifications a detailed examination, as to both ends and means," Justice Sandra Day O'Conner wrote. "It is not true that strict scrutiny is strict in theory, but fatal in fact. Government is not disqualified from acting in response to the unhappy persistence of both the practice and the lingering effects of racial discrimination against minority groups in this country. When race-based action is necessary to further a compelling interest, such action is within constitutional constraints if it satisfies the narrow tailoring test...."

In dissent, Justices John Paul Stevens and Ruth Bader Ginsberg argued that the government should be able to make a distinction between "invidious" and "benign" discrimination. The first kind is discrimination that helps disadvantaged groups; the second hurts them.

If you think this sounds like a shaky concept, consider the explanation Stevens offered for making the distinction: "people [need to] understand the difference between good intentions and bad."

Justice Antonin Scalia, attacked this road-to-Hell theory: "To pursue the concept of racial entitlement—even for the most admirable and benign of purposes—is to reinforce and preserve for future mischief the way of thinking that produced race slavery, race privilege and race hatred. In the eyes of government, we are just one race here. It is American."

This was a mild reaction, compared to Justice Clarence Thomas's response:

> ...there is a "moral [and] constitutional equivalence" between laws designed to subjugate a race and those that distribute benefits on the basis of race in order to foster some current notion of equality....That these programs may

California turns the tide on 30 years of affirmative action

have been motivated, in part, by good intentions cannot provide refuge from the principle that under our Constitution, the government may not make distinctions on the basis of race."

In July 1995, the University of California's Board of Regents took a major step in ending race-based affirmative action programs in public institutions. The board, led by California governor Pete Wilson, voted to abolish a 30 year-old system of hiring teachers and admitting students according to racial categories.

Wilson, who had called affirmative action "the deadly virus of tribalism," set the terms for day-long debate that preceded the vote. He asked: "Are we going to treat all Californians equally and fairly? Or are we going to continue to divide Californians by race?" And, in case anyone missed his point, he answered his own questions: "We believe individual merit should be the rule."

Ward Connerly, a black businessman and regent who had proposed the resolutions to terminate the preference programs, argued that the affirmative action plan had outlived its usefulness and undermined achievement by blacks. "The goal of this nation and this state is to have its government institutions blind to the color of one skin or the national origin of one's ancestors in the transactions of government," he said before the vote. "We shouldn't make policy on how many blacks or Hispanics get admitted."

All day long, rhetoric was supercharged. More than a hundred speakers addressed the Board. Connerly bore the brunt of vitriol from affirmative action proponents—some of whom attacked him as a traitor to his race.

But not everyone objected. Nao Takasugi, a state senator and a survivor of Japanese-American internment camps during World War II, agreed with Connerly's proposals. Takasugi said "When we judge people on their gender, ethnicity, religion or race, we fundamentally dishonor the ideals upon which our great country was founded."

The measures submitted by Connerly, a Wilson appointee to the Board, dropped affirmative action hiring policies by January 1996 and removed race from student admission formulas by January 1997.

But the measures also required the regents to adopt "supplemental criteria for admission" or hiring that replaced membership in a racial or ethnic group with evidence of having "suffered disadvantage economically or in terms of...social environment (such as an abusive or otherwise dysfunctional home, or a neighborhood of unwholesome or antisocial influences)."

This approach—basing affirmative action benefits on social background rather than race or gender—has been cited by many policy makers as the most likely solution to problems caused by traditional plans.

In the California debate, some commentators predicted abandoning the university's race-based affirmative action program would reduce the number of black and Hispanic students and boost the number of Asians at the choice schools.

Recent history suggested this might be the case. In 1994, Asians admitted to UC Berkeley had a mean grade-point average of 3.95 (out of 4.0) in high school; whites had a 3.86; Hispanics had a 3.65 and blacks had a 3.43. One affirmative action administrator with the university president's office said, "...if you take out race in the admissions criteria and rely exclusively on socioeconomic factors, a great amount of ethnic diversity disappears. African-Americans are reduced by 40 to 50 percent, Chicano-Latinos by 5 to 15 percent, Asians make a gain and whites remain constant."

Wilson sought the regents' meeting as a follow-up to his June 1995 executive order rolling back affirmative action programs in California state agencies.

The same week Wilson was dismantling the University of California's affirmative action plan, President Bill Clinton Wednesday came out in defense of the minority programs, warning that racism and

Changing the focus to social background

sexism were still very much alive in the United States.

However, Clinton did acknowledge the federal programs for preferential treatment needed improvement and offered some reforms.

Conclusion

If you want to comply effectively with—or avoid—affirmative action issues, a number of critical guidelines emerge:

- maintain an open attitude toward new ways of management;

- talk to your employees and customers to determine how they want to be treated and managed;

- develop a set of policies that clearly prohibit illegal discrimination;

- be flexible with schedules;

- provide retraining and even remedial skills training;

- help employees handle work/family conflicts;

- allow grievances by members of protected groups;

- check lines of communication constantly;

- be extremely cautious of subjective comments or critiques placed in any internal report dealing with possible illegal discrimination or diversity problems;

- state clearly that internal reports are intended to investigate and resolve diversity issues;

- keep internal reports separate from other personnel files;

- if you involve attornerys in an internal report, emphasize in the report that they are being consulted as attorneys.

Although these steps will not guarantee that your diversity efforts will answer affirmative action questions, they address the basic terms of debate.

Chapter 7:
The Effect of State Diversity Laws

Introduction

While the majority of the laws that control workplace diversity issues are enforced at the federal level, most states have developed their own laws. In many cases, these state laws create new protected groups or extend protections that federal laws have already made.

Municipal ordinances can be even more aggressive.

In this chapter, we'll consider one state-specific workplace diversity law in detail to illustrate how the local rules interact with the national. We'll also look at a couple of other state-specific laws for comparison.

The majority of these state laws mirror the content and structure of the federal laws. So, if you have the practices in place to comply with the laws we've considered in the previous chapters, you'll probably be in decent shape to comply with laws we'll consider in this one.

In some cases, though, the state laws stand apart. The difference is usually that more groups are protected by state laws than by federal laws. A half-dozen states, including Massachusetts and New York, have laws banning job discrimination based on sexual preference.

Passage of the ADA has brought attention to the rights of the disabled, but some states—New Jer-

sey is one—already had laws against handicapped discrimination.

New Jersey's 1945 Law Against Discrimination protected certain handicaps and was amended several times to expand the definition of handicapped. Indiana also had an aggressive state law on workplace diversity.

But the state diversity law that we'll consider in greatest detail in this chapter is California's Unruh Civil Rights Act. This law—named after legendary California politician and local king maker Jesse Unruh—has been cited by a number of legal and human resources experts as the most progressive of all state laws. To most employers, that means it extends the greatest number of protections to the greatest number of groups in the greatest number of circumstances.

The Unruh Act secures equal access to public accommodations and prohibits discrimination by business establishments. It has been interpreted by California courts to apply to employment issues as well as access issues in regard to businesses.

Legislative and political history

The primary purpose of the Unruh Act is to compel recognition of the equality of all persons in the right to the particular service offered by an organization or entity covered by the Act.

Enacted in 1959, the Act provides that any person denied the rights it guarantees can sue for damages. Actions for triple damages may be brought for specific violations of the provisions of the Unruh Act which result in actual damages to any person denied the rights set forth in the Act.

In 1978, the California legislature amended the law to allow a district attorney or city attorney, in addition to the Attorney General, to bring an action under the Act.

The California Legislature expanded the scope of the Act by adding "sex" in 1974 and "blindness

and physical disability" in 1987 as additional pro-
hibited classifications.

So, the Unruh Act deals generally with discrimi-
nation in accommodations and services.

> All persons within...this state are free and equal,
> and no matter what their sex, race, color, reli-
> gion, ancestry, national origin, or blindness or
> other physical disability are entitled to the full
> and equal accommodations, advantages, facili-
> ties, privileges, or services in all business es-
> tablishments of every kind whatsoever....

In addition, the statute provides civil actions for
injunctive or other preventive relief.

> Whenever there is reasonable cause to believe
> that any person or group of persons is engaged
> in a pattern or practice of resistance to the full
> enjoyment of any of the rights hereby secured,
> and that the pattern or practice is of such a
> nature and is intended to deny the full exer-
> cise of the rights herein described, the Attor-
> ney General, any district attorney or city attor-
> ney, or any person aggrieved by the pattern or
> practice may bring a civil action in the appro-
> priate court....

The Unruh Act, by its history and language, is
applicable only to businesses and public accom-
modations. It is not applicable to private dwell-
ings.

The Act's language strongly suggests that it was
intended to provide recourse for those individuals
actually denied full and equal treatment by a busi-
ness establishment. The courts have acknowledged
that a cause of action under the Unruh Act is of
an "individual nature", and that "the rights pro-
tected by the Act are enjoyed by all persons, as
individuals."

This means an individual filing a civil suit under
the Act has to be the person who suffered the dis-
criminatory behavior. In the 1965 California ap-
peals court decision *Crowell v. Isaacs*, a white
couple listed their house for sale and later sued

**The law applies
to businesses
and public
accommodations**

369

their real estate agent for failing to advertise specifically that the property was available to buyers of all races. The court rejected all of the couple's claims based on the Unruh Act on grounds that they were not the persons to which the statutory remedy was extended.

"One who violates the Act is liable for damages 'suffered by any person denied the rights' granted by [the Act]," the court concluded. "That is the right to 'full and equal' facilities and privileges of defendant's business establishment, regardless of race, color or creed. The statute protects those so discriminated against."

The Unruh Act's immediate predecessor, California's first public accommodations statute, became law in 1897. It consisted of two primary sections. The first section declared that all citizens were entitled to the

> full and equal accommodations, advantages, facilities, and privileges of inns, restaurants, hotels, eating-houses, barber-shops, bath-houses, theaters, skating-rinks, and all other places of public accommodation or amusement, subject only to the conditions and limitations established by law and applicable alike to all citizens.

The second section prohibited "denying to any citizen, except for reasons applicable alike to every race or color," access to the places described in the first section or making "any discrimination, distinction, or restriction on account of color or race, or except for good cause, applicable alike to all citizens of every color or race whatever...."

The 1897 Act was patterned in part after the National Civil Rights Act of 1875 which guaranteed to all persons within United States jurisdiction "the full and equal enjoyment of the accommodations, advantages, facilities, and privileges of inns, public conveyances on land or water, theaters, and other places of public amusement...."

The two parts of the 1897 Act became sections 51 and 52 of the Civil Code in 1905. Sections 51 and

52 remained substantially unchanged from 1923 to 1959. Court decisions in the 1950s restricted the places of public accommodation covered by these sections, but they also confirmed their application to nonracial forms of discrimination.

In 1951, the California Supreme Court made a significant extension of the protections offered by the 1897 Act. In the decision *Stoumen v. Reilly*, the court held that the State Board of Equalization acted illegally in suspending the license of a bar and restaurant because it allowed patronage by homosexual persons.

Specifically, it stated that:

> ...something more must be shown than that many of [the bar's] patrons were homosexuals and that they used the restaurant and bar as a meeting place....

> Members of the public of lawful age have a right to patronize a public restaurant and bar so long as they are acting properly and are not committing illegal or immoral acts; the proprietor has no right to exclude or eject a patron "except for good cause," and if he does so without good cause he is liable in damages.

Observing there was no evidence of illegality on the premises, the court refused to find "good cause" for exclusion of homosexuals from the civil right protections offered by the Act.

Sections 51 and 52 were substantially revised in 1959 when they became the Unruh Act. In response to court decisions restricting the places covered by the statute, section 51's list of places was deleted and replaced by a reference to "all business establishments of any kind whatsoever."

In addition, the new section 51 declared that all citizens within the jurisdiction of this state were "free and equal, and no matter what their race, color, religion, ancestry, or national origin" were entitled to full and equal public accommodations.

Finally, the reference to "conditions and limitations established by law and applicable alike to all

One issue that extends beyond the limits of federal rules

citizens" was changed to read: "This section shall not be construed to confer any right or privilege on a person which is conditioned or limited by law or which is applicable alike to citizens of every color, race, religion, ancestry, or national origin."

Section 52 was amended to provide: "Whoever denies...or whoever makes any discrimination, distinction, or restriction on account of color, race, religion, ancestry, or national origin, contrary to the provisions of Section 51, is liable for the actual damages, and two hundred fifty dollars ($250) in addition thereto...."

The important aspect of Section 52 is that it holds individuals liable.

The "good cause" language was eliminated.

Extending the protections

The next significant extension of the Unruh Act came in the 1970 state supreme court decision In re Cox. In this case, the court interpreted the Act to protect a person who did not fit in any of the specific categories listed in the Act.

In Cox, a male customer challenged his arrest and conviction under a municipal trespass ordinance for refusing to leave a shopping center after being asked to do so by its owner. He argued that his presence in the shopping center was protected by the Unruh Act.

The court held that the shopping center did not have the right to exclude the customer—based only on his association with a young man "who wore long hair and dressed in an unconventional manner."

Despite the listing of specific types of discrimination in the statute, the court concluded that the Unruh Act prohibited all "arbitrary discrimination by a business enterprise" and that the listing was "illustrative rather than restrictive" of the kinds of discrimination prohibited by the Act.

Even though the court qualified its conclusion by stating that businesses subject to the Unruh Act

retained the right to "establish reasonable regulations that are rationally related to the services performed and facilities provided," the Cox ruling was a major development in the way in which the law was interpreted. It meant that courts—and angry employees—could define new protected groups under the law.

In the 1982 decision *Marina Point, Ltd. v. Wolfson*, the court applied its conclusions in *Cox* to hold that the owner of an apartment complex violated the Unruh Act by refusing to rent to families with young children. Again, it rejected the argument that the Unruh Act was limited to the categories of discrimination it specifically identified.

Reacting to the court's holding in *Marina Point*, the California Legislature affirmed that the Unruh Act prohibited age discrimination in the sale or rental of housing. But it enacted detailed provisions allowing an exception, under specified circumstances and within a specified time, for housing designed to meet the physical and social needs of senior citizens.

Later, it added "blindness and physical disability" as categories of prohibited discrimination under the Act, subject to provisions limiting a property owner's duty to modify existing property and structures.

In the 1992 decision *Sargoy v. Resolution Trust Corp.*, the state supreme court went on to say that the Act worked to protect groups from discrimination—but also from preferential treatment. The Sargoy case involved a dispute over savings-and-loan accounts that paid higher interest to older depositors. The court concluded "[the] Unruh Civil Rights Act does not prohibit all distinctions based on age, but rather, prohibits invidious or arbitrary distinctions that favor older citizens."

As a result of the various cases, section 51 of the Unruh Act has been changed to state:

> All persons within the jurisdiction of this state are free and equal, and no matter what their sex, race, color, religion, ancestry, national ori-

Outlawing promotions that favor specific groups

gin, or blindness or other physical disability are entitled to the full and equal accommodations, advantages, facilities, privileges, or services in all business establishments of every kind whatsoever. This section shall not be construed to confer any right or privilege on a person which is conditioned or limited by law or which is applicable alike to persons of every sex, color, race, religion, ancestry, national origin, or blindness or other physical disability.

Section 52, which is designed to provide an enforcement mechanism for section 51 and other provisions of law, provides in a manner parallel to section 51: "Whoever denies...or whoever makes any discrimination, distinction, or restriction on account of sex, color, race, religion, ancestry, national origin, or blindness or other physical disability contrary to the provisions of Section 51...is liable for each and every such offense...."

One of the difficulties posed by laws like the Unruh Act is that they're usually not limited to employment issues. This means that they are shaped by legal and political issues that have nothing to do with the employer/employee relationship.

The 1985 California Supreme Court decision *Dennis Koire v. Metro Car Wash et al.* illustrates this point. It has nothing to do with employment per se but a lot to do with how the Unruh Act affects businesses.

In the spring of 1979, Koire heard a series of radio advertisements for discounts targeted to women at several car washes and night clubs located in suburban Los Angeles. He visited the car washes on "Ladies' Day" and asked to be charged the same discount prices as were offered to females. The businesses refused his request.

Koire also claimed to have heard a radio ad for a nightclub called Jezebel's. The ad had publicized an event celebrating the first opportunity for young adults aged 18 to 21 to patronize the establishment. The ad stated that all "girls" aged 18 to 21 would be admitted free. Koire, an 18-year-old male,

went to Jezebel's and requested free admission. He was refused.

Koire sued seven car washes and the nightclub. He claimed that their gender-based price discounts violated the Unruh Act. He sought statutory damages and a court order forbidding the discounts.

The trial court granted judgment for the defendant businesses. It ruled that the gender-based price discounts did not violate the Unruh Act. Koire appealed.

To save the state further procedural costs, the state Supreme Court agreed to rule on the matter.

The defendant businesses—led by the owner of the nightclub Jezebel's—claimed that the Unruh Act only prohibited arbitrary discrimination, and that the gender-based price discounts at issue fell within recognized exceptions to the Act. They also argued that the gender-based discounts didn't violate the Act because they didn't injure anyone.

Finally, they argued that a prohibition on sex-based discounts will mean an end to all promotional discounts.

The state supreme court stressed that the Act guaranteed equal treatment for everyone by businesses. It cited the language of the Unruh Act as clear and unambiguous:

> "All persons within the jurisdiction of this state are free and equal, and no matter what their sex...are entitled to the full and equal accommodations, advantages, facilities, privileges, or services in all business establishments of every kind whatsoever...."

It noted that lower state courts had repeatedly held that the Unruh Act was applicable where unequal treatment is the result of a business practice. "The scope of the Unruh Act is not narrowly limited to practices which totally exclude classes or individuals from business establishments," the court ruled. "The Act's proscription is broad enough to include within its scope discrimination in the form of sex-based price discounts."

Emphasis should be on individual characteristics

The defendant businesses argued that gender-based price discounts did not constitute "arbitrary" discrimination. Although the Unruh Act proscribed "any form of arbitrary discrimination," it did not prevent a business from enforcing "reasonable deportment regulations....[A]n entrepreneur need not tolerate customers who damage property, injure others or otherwise disrupt his business."

However, the defendant businesses didn't claim that their gender-based admission discounts constituted reasonable deportment regulations. The court focused on this distinction:

> The prices charged are in no way dependent on the individual characteristics or conduct of the customers. They are based solely on the customer's sex.

> It would be no less a violation of the Act for an entrepreneur to charge all homosexuals, or all non-homosexuals, reduced rates in his or her restaurant or hotel in order to encourage one group's patronage and, thereby, increase profits.

In certain contexts, the Act had been found inapplicable to discrimination between patrons based on the "nature of the business enterprise and of the facilities provided." Jezebel's argued that it was entitled to this kind of exception. It claimed that gender-based price differences were not arbitrary because they were supported by "substantial business and social purposes."

Jezebel's argued that its "Ladies' Night" encouraged more women to attend the bar, thereby promoting more interaction between the sexes. It claimed this was a "socially desirable goal" of the state. The state supreme court pointedly rejected the claim:

> ...the "social" policy on which Jezebel's relies— encouraging men and women to socialize in a bar—is a far cry from the social policies which have justified other exceptions to the Unruh Act. For example, the compelling societal interest in ensuring adequate housing for the eld-

376

erly which justifies differential treatment based on age cannot be compared to the goal of attracting young women to a bar.

The businesses also argued that their gender-based price discounts didn't violate the Unruh Act because they did no injury to either men or women. The state court rejected this argument for several reasons:

> First, it does not recognize that by passing the Unruh Act, the Legislature established that arbitrary sex discrimination by businesses is per se injurious....

> Second....[Koire] was adversely affected by the price discounts. His female peers were admitted to the bar free, while he had to pay. On the days he visited the car washes, he had to pay more than any woman customer, based solely on his sex. In addition to the economic impact, the price differentials made him feel that he was being treated unfairly.

So the subjective standard that someone feels he or she was treated unfairly became a consideration in an Unruh Act lawsuit.

The trial court had supported the "no harm" argument because it suggested no ill intent on the part of the businesses. But the state supreme court noted that discriminatory intent was not required by the Unruh Act:

> [Koire] was entitled to equal treatment, "no matter what [his] sex," regardless of defendants' intent in denying him equal treatment....

> Moreover, differential pricing based on sex may be generally detrimental to both men and women, because it reinforces harmful stereotypes. Men and women alike suffer from the stereotypes perpetrated by sex-based differential treatment.

So, the state high court incorporated the highly political notions of gender stereotypes into interpretations of the law. For support, the court cited that, in striking down the New York Yankees' "La-

A court suggests how businesses should operate

dies' Day" promotion, the New York State Human Rights Appeal Board observed that "the stereotyped characterizations of a woman's role in society that prevailed at the inception of Ladies' Day in 1876" were outdated and no longer valid "in a modern technological society where women and men are to be on equal footing as a matter of public policy."

The defendants also protested that an end to Ladies' Days would mean an end to all types of promotional discounts. The court didn't agree with this claim, either:

> A multitude of promotional discounts come to mind which are clearly permissible under the Unruh Act. For example, a business establishment might offer reduced rates to all customers on one day each week. Or, a business might offer a discount to any customer who meets a condition which any patron could satisfy (presenting a coupon, or sporting a certain color shirt or a particular bumper sticker). In addition, nothing prevents a business from offering discounts for purchasing commodities in quantity, or for making advance reservations.

The key was that the discounts were "applicable alike to persons of every sex, color, race," instead of being contingent on some arbitrary, class-based generalization.

In a kind of apology near the end of its decision, the California Supreme Court further expanded the scope of the Unruh Act significantly:

> Courts are often hesitant to upset traditional practices such as the sex-based promotional discounts at issue here. Some may consider such practices to be of minimal importance or to be essentially harmless. Yet, many other individuals, men and women alike, are greatly offended by such discriminatory practices.

> The legality of sex-based price discounts cannot depend on the subjective value judgments about which types of sex-based distinctions are important or harmful....

The Legislature has clearly stated that business establishments must provide "equal... advantages...[and] privileges" to all customers "no matter what their sex."

This conclusion opened Unruh Act claims to tradition that offended some people.

The trial court's judgment was reversed—which may not have surprised anyone. But the Unruh Act became a lot more attractive to questionable interpretations and marginal attorneys because the court used such broad language in defining the law's limits.

Sexual orientation

In addition to managing a work force diverse in terms of race, disability and gender, employers in states with laws like the Unruh Act have to meet the needs of workers with diverse lifestyles. These lifestyles include single parents, unmarried employees with spousal equivalents, gay couples, job-sharers and two-income families.

While women, religious, and racial minorities have been protected by federal law from job discrimination for decades, gays and lesbians have not. Only a handful of states and localities have laws prohibiting discrimination on the basis of sexual orientation.

Probably the most controversial aspect of the Unruh Civil Rights Act is its extension of protected group status to homosexuals and bisexuals. Critics have focused on these protections (first explored in the 1951 *Stoumen v. Reilly* decision mentioned above) as an example of the Unruh Act's excessively broad terms.

In fact, other California laws reiterate the protections first cited in the *Stoumen* case. The "Political Affiliations" section of the state's Labor Code also specifically protects people of alternative sexual orientations.

The Labor Code states:

No employer shall coerce or influence or attempt to coerce or influence his employees through or by means of threat of discharge or loss of employment to adopt or follow or refrain from adopting or following any particular course or line of political action or political activity.

With that premise, it goes on to state:

Struggle of homosexual community for equal rights, particularly in view of employment, must be recognized as a political activity within this section...protecting fundamental right of employees in general to engage in political activity without interference by employers.

Going further, Labor Code provisions prohibiting discrimination on basis of sexual orientation also apply to discrimination based on perceived sexual orientation.

The standard used in the 1969 California Supreme Court decision *Morrison v. State Board of Education* and its 1977 decision *Board of Education v. Jack M.* in connection with the revocation of teaching credentials and dismissals is often applied to employment issues raised under Unruh.

Morrison involved a dispute over a termination that was based on private, noncriminal homosexual conduct. *Jack M.* involved a termination based on public, criminal homosexual conduct. Taken together, these cases held that a teacher engaging in homosexual conduct—even criminal conduct—should not be dismissed or lose his license unless unfitness to teach could be explicitly demonstrated.

In *Morrison*, the state supreme court specified that the factors which may be considered in making such a determination included:

- the likelihood that the conduct may have adversely affected students or fellow teachers;

- the degree of such adversity anticipated;

- the proximity or remoteness in time of the conduct;

- the type of teaching certificate held by the party involved;

- the extenuating or aggravating circumstances, if any, surrounding the conduct;

- the praiseworthiness or blameworthiness of the motives resulting in the conduct;

- the likelihood of the recurrence of the questioned conduct; and

- the extent to which disciplinary action may inflict an adverse impact or chilling effect upon the constitutional rights of the teacher involved or other teachers."

The Unruh Act and the state's Fair Employment and Housing Act of 1980 added marital status to the list of protected classes. Even before 1980, state courts had interpreted the Unruh statute to include categories such as sexual preference, children, students and the handicapped.

The 1979 decision *Gay Law Students Association v. Pacific Telephone & Telegraph* concluded that allegations that a state-protected public utility discriminated against people who identified themselves as homosexuals, who defended homosexuality, or who were identified with activist homosexual organizations was sufficient to state a claim for relief under the Unruh Act. The decision cited the law's language prohibiting employers from adopting policies to control or direct political activities or affiliations of employees.

Specifically, a state appeals court ruled that the Unruh Act "prohibit[s] a private employer from discriminating on basis of homosexual orientation or affiliation."

The *Gay Law Students* decision was full of dogmatic language directed at companies, public entities and other kinds of employers:

> Although some people's ideal of human adjustment is unconditional conformity, the genius of American pluralistic society has been its ability to accept diversity and differences. An appeal to this genius in the espousal of a cause and some degree of action to promote the acceptance thereof by other persons is "political activity."

One company changes its attitude towards gays

...Thus, the struggle of the homosexual community for equal rights is recognized as political activity.

...[O]ne important aspect of the struggle for equal rights is to induce homosexual individuals to 'come out of the closet,' and acknowledge their sexual preferences, and to associate with others in working for equal rights.

The effect of these laws have taken quite a while to filter down to private-sector employers—even large ones. In the late 1980s, when a group of gay and lesbian workers at Lockheed's Missile and Space Group asked for management recognition of their newly formed employee association, the reaction was less than encouraging.

Not only was the group denied membership in the company's large recreational association, but the vice president of human resources warned them to drop the word Lockheed from their name. "There was a veiled threat that if we didn't change our name, they would seek legal action," said one group member.

But years of lobbying—and consistent rulings from the state courts—brought about a gradual change in management attitudes. By the mid-1990s, the company was taking gay and lesbian issues into account when formulating diversity programs. In 1994, the president of the Missile and Space Group, invited members of the gay group into his office to tell them that the company would be adding sexual orientation to its nondiscriminatory policy.

Many of the legal advances made by homosexual groups have occurred at the local level. Municipal ordinances—rather than state or federal laws—will often extend civil rights protections on the basis of sexual orientation.

For example, Chapter IV, article 12, of the Los Angeles Municipal Code applies to discrimination between heterosexuals and homosexuals. It provides:

Sexual Orientation. As used in this ordinance, the term 'sexual orientation' shall mean an individual having or manifesting an emotional or physical attachment to another consenting adult person or persons, or having or manifesting a preference for such attachment, or having or projecting a self-image not associated with one's biological maleness or one's biological femaleness.

...It shall be an unlawful business practice for any person to deny any individual the full and equal enjoyment of the goods, services, facilities, privileges, advantages and accommodations of any business establishment on the basis (in whole and in part) of such individual's sexual orientation.

California courts have extended the enforcement powers of the Unruh Act to these protections.

AIDS affects legal rulings

Reflecting growing concern during the 1980s over the transmission of AIDS, California courts started to reconsider some of the sexual-preference protections created by the Unruh Act and the Fair Housing and Employment Act.

In the 1989 appeals court case *Paul Glen Jasperson v. Jessica's Nail Clinic*, an AIDS patient filed a suit against a pedicure salon for an alleged violation of a municipal ordinance prohibiting discrimination against persons with AIDS.

In July 1986, after being discharged from a hospital where he had been treated for pneumocystis carinii pneumonia—an opportunistic disease associated with AIDS—Jasperson went to Jessica's Nail Clinic for a pedicure. He was given an appointment for the following day.

While at the clinic, Jasperson, who was a hairdresser, ran into a client whom he told about his condition. His remarks were overheard by two employees of the clinic. The next day, he was called by the clinic and told his appointment had been

An HIV-positive man is refused service

canceled. He tried to reschedule his appointment but was told by an employee that the clinic was "not taking any new male clients."

Jasperson called Jessica Vartoughian, the clinic's owner, who repeated the explanation of why he wasn't given an appointment. She denied his accusation that the true reason he was being refused an appointment was because he had AIDS.

Vartoughian's version of the telephone conversation was that Jasperson was upset because he had been told that the clinic's pedicurist was "double-booked" and he would be unable to get an appointment for four or five weeks. He then expressed his belief that he had been denied an appointment because he had AIDS. She said that she apologized to him and asked whether he could wait for an appointment, but also told him that she could not force "the girls" at the clinic to give him a pedicure.

(Vartoughian later testified that the people at the salon were upset by Jasperson's revelation that he had AIDS and were unwilling to give him a pedicure.)

Jasperson filed a lawsuit under the Unruh Act and a city of West Hollywood ordinance prohibiting discrimination against people with AIDS. The ordinance prohibited discrimination in "employment, housing, business establishments, health care services, city facilities and services, and other public services and public services and accommodations."

The ordinance defined business establishment as "any entity, however organized, which furnishes goods or services to the general public." The ordinance makes it "an unlawful business practice for any person to deny any individual the full and equal enjoyment of the goods, services, facilities, privileges, advantages and accommodation of any business establishment...on the basis (in whole or in part) that such person has the medical condition AIDS or AIDS-related condition." Exempted from this section are any "service facility or estab-

lishment engaged in the exchange of products containing elements of blood or sperm."

Vartoughian answered the suit, offering the defense of "justification" in claiming that her company's treatment of Jasperson complied with the ordinance because providing services would have exposed the workers at the clinic to "a deadly risk to their health."

At trial, Vartoughian testified that pedicurists use another metal instrument, called a toenail nipper, for hang nails. She testified she was not aware of any statutory prohibition on the use of such an instrument. She characterized accidents during pedicures which result in bleeding as "occasional" or "common" occurrences.

Jasperson called expert witnesses experienced in AIDS research and education who testified that the Centers for Disease Control had developed guidelines for personal service workers which involve such things as not working with "open or exudative wounds on one's hands."

Additionally, state law proscribed working on feet with open cuts, sores, or abrasions, and barred the use of metal instruments in performing a pedicure minimizing the possibility of a cut resulting in bleeding. It also provided for sterilization procedures which would have inactivated HIV—the virus commonly linked to AIDS.

Pedicure instruments were required by law to be sterilized in a 70 percent alcohol solution at the beginning of each day and between customers. Additionally, if blood was drawn during a pedicure the same strength solution was used to disinfect both the cut and the contaminated instrument. Finally, all blood was wiped clean from a contaminated instrument using a 70 percent alcohol solution before the instrument was again used.

All witnesses agreed that a 70 percent alcohol solution would completely inactivate the HIV virus within a minute. The virus could also be inactivated by use of .3 percent hydrogen peroxide, household bleach, or other disinfectants.

Dispute over the business justification of choosing clients

Nevertheless, the Los Angeles County Superior Court entered a judgment for Vartoughian. It characterized the risk of the transmission of AIDS during a manicure as "marginal." But it concluded that any "risk of death, however minimal, cannot be acceptable or tolerated."

Jasperson appealed. (He died from AIDS-related complications during the appeal. Vartoughian tried to have the case dismissed as moot, but the court denied her argument.)

The Court of Appeal held that municipal ordinance prohibiting businesses from discriminating against persons with AIDS did not violate equal protection on its face or as applied to salon. It concluded:

> The question of the validity of AIDS anti-discrimination ordinances is a classic instance of a matter of continuing public controversy likely to recur as more jurisdictions adopt such ordinances. Additionally, the high rate of mortality among people with AIDS coupled with the sometimes glacial pace at which litigation moves through the courts make it appropriate for the court to review the merits of the case before us to determine the validity of the ordinance.

> ...even if we assumed that the [trial court] had the discretion to decline to enforce the ordinance on the basis of the risk of transmission posed, clearly the "any risk" standard would still be inappropriate.

Five years later, the political tide seemed to have changed the perspective of the courts. Another state appeals court seemed to agree with the sensibility of trial court in *Jasperson*.

In March 1994, the court ruled that the Boy Scouts of America was not covered by the Unruh Act and could bar homosexuals as Scout leaders. The case had originated when a San Francisco Bay Area man was rejected as a Scout leader because he admitted that he was gay.

The decision, *Timothy Curran v. Mount Diablo Council of the Boy Scouts of America*, became a test case for the application of the Unruh Act.

Curran had been a member in good standing of the Boy Scouts for more than five years. He'd attained the rank of Eagle Scout, the group's highest. In late 1980, he submitted an application to become a "Scouter"—a leadership position within a local Boy Scouts Council. Such an application by an Eagle Scout was almost always approved.

Curran's wasn't. In November 1980, an executive with the Mount Diablo Council informed him that he was no longer a member of the Boy Scouts of America and could not have Scouter status because he was a homosexual and hence not a good moral example for younger scouts.

Curran had recently taken a male date to his high school prom and had described himself as a gay-rights advocate in a local newspaper interview.

After his expulsion and rejection, Curran made a written request to the Western Region of the Boy Scouts of America for an administrative review of Mount Diablo's decision. The Boy Scouts told him that such a review would not be productive unless in fact he was not a homosexual. No other administrative remedy was available. As a consequence, all administrative remedies were exhausted.

Curran sued the Boy Scouts, alleging that his expulsion on the basis of his homosexuality constituted a violation of the Unruh Act.

The Boy Scouts argued that it was authorized under the charter granted it by Congress in 1916 to employ membership requirements based on sex, religious beliefs, political beliefs and other criteria the organization has historically applied. This argument rested on the premise that Congress, in granting the federal charter, intended to authorize the Boy Scouts to practice discrimination against homosexuals.

The trial court agreed with the Boy Scouts and dismissed Curran's lawsuit. Superior Court Judge Sally Disco ruled that the Scout council was a business but was entitled to exclude Curran in order to preserve its "belief system." In the ap-

Firing a homosexual is "capricious and offensive"

peals court decision, Justice Fred Woods said the Scouts were dedicated to "instilling values in young people" and were entitled to define those values.

"The imposition of a leader who is an improper role model is a severe intrusion upon the First Amendment activities of an expressive association" such as the Boy Scouts, the court concluded. It allowed that the disapproval of homosexuality was part of the Scouts' moral code.

Curran appealed. Reviewing the trial court's decision a state appeals court concluded:

> Expulsion from association on basis of person's status of homosexuality is both capricious and offensive to public policy, as mere status of homosexuality, without more, does not connote immorality.

> ...before homosexuality may lawfully be used as a basis to expel, a rational connection must be demonstrated between homosexual conduct and any significant danger of harm to the association resulting from the continued membership of the homosexual person.

> ...the allegations can reasonably be construed as charging that [the decision] to expel rests on [Curran's] political decision to "come out of the closet" and acknowledge his sexual preference of homosexuality. As so construed, the expulsion would be distinctly contrary to public policy.

Ultimately, the case was decided on much less political grounds. The key legal issue in the case was whether the term "business establishment"—which appears throughout the Unruh Act—applied to an organization like the Boy Scouts.

The California legislature intended term to be used in the broadest sense reasonably possible in enforcement matters. Previous court cases had determined that it included all commercial and non-commercial entities open to and serving general public.

The Boy Scouts argued that such a broad inter-

pretation infringed on its rights of privacy and free association.

The California Supreme Court agreed. It ruled that the Boy Scouts was a private membership organization, not a business, and was therefore exempt from the Unruh Act. This allowed the Scouts to exclude gays or any other group as members.

The ruling didn't mention a decision that had come a month earlier from a different appeals court that ruled the Boy Scouts was a business and could not bar atheists as members.

Jon Davidson, an American Civil Liberties Union lawyer who argued both cases, said that the conflict made it more likely that the state supreme court would review the issue.

In the meantime, Davidson said, the ruling gave the Boy Scouts and other charitable organizations "free rein...to exclude blacks and women and Jews."

He told one local newspaper that the court had adopted "some of the most homophobic and stereotypical views of gay people," such as a statement by the majority that the acceptance of a gay man as Scoutmaster would make boys "more likely to engage in homosexual conduct."

This language reflects the heated rhetoric that characterizes politically-charged issues like protection status for homosexuals.

Protection for the poor?

The heated rhetoric isn't limited to sexual-orientation issues. Another controversial interpretation of California's Unruh Act is whether it offers protected status to "economically-disadvantaged." This dispute tests the limits of what can be plausibly considered a group.

In March 1991, the California Supreme Court refused to extend the Unruh Act to bar discrimination against the poor. Its ruling meant that landlords could deny rentals to people who fail to meet minimum-income standards.

A higher court exempts the Boy Scouts from Unruh

Trying to extend Unruh to the economically disadvantaged

The case, *Tamela Harris v. Capital Growth Investors*, involved charges that a landlord's minimum income policy violated the Unruh because it constituted arbitrary economic discrimination and gender discrimination.

Harris and co-plaintiff Muriel Jordan were female heads of low income families whose income consisted solely of public assistance benefits.

Their case had begun in 1985 when Harris and Jordan sought apartments but were turned down because their monthly AFDC benefits of $698 were less than three times the monthly rent.

Capital Growth Investors followed an express written policy that prospective tenants had to have sufficient income—defined as "monthly income equal to or greater than three times the rent charged"—before they could be considered for an apartment. The apartments in question rented for between $275 and $360 a month, depending on size.

Harris and Jordan sued, arguing that they should have been allowed the chance to show that they could meet the monthly rent.

Harris also argued that the Unruh Act should allow a disparate impact claim. However, the language of the Act prohibited intentional discrimination. The state supreme court found nothing in the law that allowed use of "a disparate impact test, which has been developed and applied by the federal courts primarily in employment discrimination cases."

In fact, the Unruh Act explicitly exempts standards that are "applicable alike to persons of every sex, color, race, religion, ancestry, national origin, or blindness or other physical disability." By its nature, an disparate impact claim challenges a standard that is applicable alike to all persons based on the premise that, notwithstanding its universal applicability, its actual impact demands scrutiny.

In contrast to federal anti-bias statutes, the Unruh

Act requires proof of intent in any kind of discrimination. Someone suing under the Unruh Act has to prove intentional discrimination to win damages.

The California Supreme Court concluded:

> Economic and financial distinctions are not among the impermissible classifications listed in the [Unruh Act]. Although our decisions have occasionally recognized additional categories of prohibited discrimination (e.g., physical appearance and family status), those categories were based on personal characteristics of individuals that bore little or no relationship to their abilities to be responsible consumers of public accommodations. We find no support in the language or history of the Act for extending our past holdings to encompass economic criteria, which by their nature seek to further the legitimate interest of business establishments in controlling financial risk....

The court allowed the minimum-income policy because it did not make distinctions among persons based on the classifications listed in the Act or similar personal traits, beliefs, or characteristics that bear no relationship to the responsibilities of consumers of public accommodations. It was a financial criterion of customer selection that applied uniformly and neutrally to all persons regardless of personal characteristics.

The decision came in the first major review of the Act by the conservative high court and marked an abrupt departure from past decisions granting broad protections even against forms of bias not specifically covered by the law.

Harris v. Capital Growth Investors also raised some broader questions that apply to workplace diversity issues. In its conclusion, the state supreme court ruled that:

> Business establishments have an obvious and important interest in obtaining full and timely payment for the goods and services they provide. Indeed, in the absence of a subsidy,

Protection from "transaction costs of default"

prompt receipt of payment is generally vital to the continuation of a business enterprise and the public accommodation it provides. There is no serious question that a business may, without violating the Unruh Act, charge a stated price for goods or services and demand payment in advance.

It noted that a landlord bears the economic burden—what the court called the "transaction costs of default"—resulting from:

- loss of income from default to eviction;

- administrative time and the legal and other expenses incurred in the eviction process; and

- the delays and expense of collection of back rent from the tenant, as well as the risk of noncollection.

The court admitted that, in order to minimize the transaction costs of default, an economically rational landlord might adopt one or more of several approaches. These approaches reflect approaches employers often take in dealing with the costs of workplace diversity. According to the court, a business person:

...might simply charge higher rents to all tenants to absorb the additional expense. Such a policy, of course, contains its own element of arbitrariness because it penalizes the majority of tenants who pay their rent on a regular basis. Moreover, the charging of higher rents as a means of subsidizing defaults necessarily excludes even more low income persons from tenancy.

...might require larger amounts from all tenants as advance rent or security deposits. This policy, too, imposes additional burdens on the paying tenants. In apparent recognition of this fact, it is also subject to statutory limitations on the amount of advance payment a landlord may demand.

...might adopt one or more policies or practices designed to screen out prospective tenants who are likely to default.

Any of these approaches would comply with the anti-discrimination law.

In an angry dissent, Justice Allen Broussard, backed "in principle" by Justice Stanley Mosk, accused the court of making "a full retreat from the goal of equal access and opportunity" and said the decision meant that the poor "will no longer be able to challenge arbitrary and invidious discrimination."

Manuel Romero, a lawyer representing the women challenging the income-standard in the case, assailed the decision as "incredible and devastating....In its ruling, the court reflected an anti-poor, anti-women, anti-people-of-color sentiment."

"We are already facing a crisis in affordable housing in [California]," said another tenants-rights lawyer. "Those renters who are trying to survive will be at the mercy and whim of landlords....This is a frightening hindrance to the working poor."

While the ruling represented a setback to civil rights advocates, the court left intact previous rulings that extended protections beyond those listed in the Act—such as discrimination based on physical appearance and on sexual preference. In contrast to economic bias, those forms of bias represented discrimination based on personal characteristics the Act was intended to protect, the court said.

The Unruh Act and sexual harassment

In the fall of 1994, California governor Pete Wilson focused the Unruh Act in a new direction by adding "the right to be free of sexual harassment" to its protections.

Before Wilson's amendment, the Unruh Act allowed people to be free of violence or fear of violence based on their race, color, religion, ancestry, national origin, political affiliation, sex, sexual orientation, age or disability.

The changes also allowed sexual harassment vic-

> "A full retreat from the goal of equal access"

393

Sexual harassment involving professionals

tims to sue if the harassment occurred as part of a professional relationship. Up to that point, the state laws against sexual harassment related to the workplace in only a limited way. The Unruh Act broadened the application.

The changes meant that victims of sexual harassment could sue their therapists, doctors, landlords or lawyers more easily than under existing statutes. A professional would be liable for sexual harassment if he or she made sexual advances, solicitations, sexual requests or demands for sexual compliance that were unwelcome and persistent or severe.

"Often, the victim of harassment cannot easily get out of a professional relationship, fearing further hardship, economic or otherwise," Wilson said after signing the changes. "This bill will make harassers accountable for their actions."

Enforcement

Since the Unruh Act is remedial in nature—which means it tries to make up for societal wrongs in the past—California courts have ruled that it should be given a liberal construction "with a view to effect its object and to promote justice."

The California Supreme Court has determined that the use of the words "all" and "of every kind whatsoever" in referring to the business establishments mentioned in the Unruh Act indicates that the Legislature intended "that the term *business establishments* was used in the broadest sense reasonably possible."

While emphasizing personal characteristics in finding arbitrary discrimination, California court decisions have also recognized that legitimate business interests may justify limitations on consumer access to public accommodations.

- In *Cox*: "A business establishment may, of course, promulgate reasonable deportment regulations that are rationally related to the services performed and the facilities provided."

- In *Frantz v. Blackwell* (1987): the refusal to sell a house to speculator in potential competition with the seller did not violate the Act.

- In *Reilly v. Stroh* (1984): segregation of persons under 21 in a restaurant was not arbitrary in view of legal requirements imposed on the proprietor relating to consumption of alcoholic beverages by minors.

- In *Ross v. Forest Lawn Memorial Park* (1984): a cemetery's policy of private funerals that excluded "punk rockers" did not violate the Act.

- In *Wynn v. Monterey Club* (1980): an agreement to bar a pathological gambler who had written bad checks from a card club was "good business and social practice" that did not violate the Act.

In each case, the particular business interests of the company or entity in maintaining order, complying with legal requirements, and protecting a business reputation or investment were recognized as sufficient to justify distinctions among its customers.

To enforce the terms of the Unruh Act and the analogous Fair Housing Act, the California Department of Fair Employment and Housing uses various tools. The most aggressive of these—and the most controversial—are undercover "checkers."

The use of checkers is controversial because the Department of Fair Employment and Housing has a policy that prohibits the use of checkers. As a result, it counts on local fair housing agencies or other groups to perform the undercover investigations. Then, it decides whether or not to proceed with enforcement action.

A checker assumes an identity similar to that of a job seeker who's complained that he or she has been discriminated against—because he or she is a single mother, a disabled man or a lesbian. The checker visits the employer in question, collects information about such things as the application process, job availability and management prac-

The use of "checkers" to enforce the law

tices. He or she also makes a subjective analysis of the workplace—observing the attitudes and styles of management.

When they receive assignments, checkers are not told what type of complaint they are investigating—whether it is a potential case of racial, religious, marital status or sexual orientation discrimination.

Sometimes, state agencies will test patterns of discrimination by sending checkers from various protected groups. If the original complainant was a black woman, three checkers might be sent to apply for the same job—a white woman, a black woman and a black man—all with similar economic and life-style profiles.

The checkers file standard reports with the local housing agency or employee-rights group. Once a report has been filed, agency personnel compare it to other checker reports to determine whether all checkers were given equal treatment and opportunity to apply for the job.

If the local agency determines that there's evidence of discrimination, the original complainant has several alternatives. The agency can try to structure a settlement with the employer, the case can be referred to the state Department of Fair Employment and Housing or a private attorney can take the case.

Once the Department of Fair Employment and Housing gets involved, everything escalates. The Department doesn't use undercover checkers, but it does have authority to subpoena records such as employment contracts, accounting books and job applications. The Department can also levy punitive and compensatory damages if it determines that discrimination has occurred.

"Once a complaint has been filed, we can't do any checking," one Department spokeswoman told a local newspaper. "If we feel checking evidence is important to the case, we usually ask the person to go to a community fair-housing group or even get the information themselves by having friends do a check."

And the Department can use information gathered by checkers as part of its investigation.

Courts have almost unanimously accepted the use of checkers in housing discrimination cases. In a series of decisions, the U.S. Supreme Court has validated the use of checkers by giving them the right to sue for damages on their own if they were discriminated against during their work.

The reasons people volunteer to be checkers are varied. For some, checking is a way to contribute to the community. For others it is a type of revenge for an incident in which they were victims of racial discrimination. For others still, it's the chance to help a friend or family member who has been treated badly.

These are all strong motives, but none of them suggests an objective approach.

Even sources at the local fair housing and employment agencies that use checkers sound like interested parties. The words that some of the California agencies use in their own press information and promotional material gives away their biases. They talk about "challenges" being "more difficult" because discrimination has become "more clever and subtle."

The relationship between state and federal laws

In its 1987 decision *Rotary International v. Rotary Club of Duarte*[1], the U.S. Supreme Court generally upheld the broader and more aggressive language of the Unruh Act. Specifically, it held that:

- the Unruh Act did not violate the First Amendment by requiring California Rotary Clubs to admit women;

- application of the Act to local Rotary Clubs did not interfere unduly with club members' freedom of private association; and

- application of the Act to California Rotary Clubs did not violate First Amendment right of expressive association.

[1] For a more detailed discussion of this case, see Chapter 5, page 276.

The U.S. Supreme Court agreed with a broad reading

The Rotary International argued—as others have—that the Unruh Act was unconstitutionally vague and overbroad. The U.S. Supreme Court declined to consider the argument.

> ...these contentions were not properly presented to the state courts. It is well settled that this Court will not review a final judgment of a state court unless "the record as a whole shows either expressly or by clear implication that the federal claim was adequately presented in the state system."

> ...When "the highest state court has failed to pass upon a federal question, it will be assumed that the omission was due to want of proper presentation in the state courts, unless the aggrieved party in this Court can affirmatively show the contrary."

> [The Rotary International has] made no such showing in this case.

It affirmed the ruling of a California Court of Appeals that applied the Unruh Act broadly.

However, conflicts between state workplace diversity laws and federal laws are often the basis for defenses that employers make to discrimination charges. In legal terms, employers can sometimes argue that contradictory federal laws "preempt" the state laws.

The late 1980s California decision *Jonathan Club v. City of Los Angeles* considered exactly this kind of conflict. In January 1988, the private nonprofit and tax-exempt Jonathan Club, knowing that the city would file suit the next day, filed a complaint in federal court.

The federal lawsuit argued that a city ordinance which would force it to admit women and members of racial minorities as members was unconstitutional.

The Club also made two other arguments: that it was private and therefore exempt from the city ordinance, and that the ordinance was preempted by the Unruh Act and existing federal law.

Finally, the Club argued that the city couldn't enforce the ordinance pending the outcome of a United States Supreme Court case[2] which involved a similar anti-discrimination ordinance in New York.

The California court rejected the Jonathan Club's last argument. "Although the New York case appears to involve similar issues, we have no reason to believe that the resolution of that case will be of any assistance in resolving the present [case]," it wrote. "Notwithstanding the policy in favor of federal courts exercising jurisdiction, it has been recognized that there are circumstances wherein it may be appropriate for a federal court to defer to a pending state court proceeding."

As an example of such circumstances, the California court cited the U.S. Supreme Court decision *Younger v. Harris*, which held that deference to a state court "is appropriate where, absent bad faith, harassment, or a patently invalid state statute, federal jurisdiction has been invoked for the purpose of restraining state criminal proceedings."

The concept didn't mean blind deference to states' rights any more than it meant centralization of control over every important issue at the federal level. It meant a balance between the two, which would entail a "sensitivity to the legitimate interests of both state and national governments."

It also meant that "the national government, anxious though it may be to vindicate and protect federal rights and federal interests, always endeavors to do so in ways that will not unduly interfere with the legitimate activities of states."

More directly, a state lawsuit could take preference over a federal lawsuit under the following conditions:

1) there are pending state judicial proceedings;

2) the state proceedings implicate important state interests; and

3) the state proceedings provide an adequate opportunity to raise federal questions.

[2] That case was *New York State Club Association, Inc. v. The City of New York.*

When these criteria are met, "a district court must dismiss the federal action...[and] there is no discretion to grant injunctive relief."

The city of Los Angeles characterized the Jonathan Club situation in exactly that way. But the California court didn't agree with that characterization. The Club was not seeking to interfere with the state proceedings (in other words, the city's lawsuit). It sought to stop the city from enforcing an ordinance that it claimed was unconstitutional.

The court allowed the Jonathan Club's request. The city of Los Angeles couldn't enforce its ordinance until the lawsuits had been settled. And, in all likelihood, the state lawsuit would precede the federal lawsuit.

Three years later, in early 1991, the Indiana Civil Rights Commission issued a proposed order barring a Fort Wayne employer from capping AIDS benefits under a self-insured health plan. Lincoln Foodservice Products had imposed a $25,000 annual cap and $50,000 lifetime cap on AIDS benefits under a self-insured health plan it had instituted in January 1988.

The company also capped lifetime benefits for mental illness, alcoholism, drug abuse, nervous disorders and psychotic and psycho-analytic illness at $25,000.

However, major medical benefits provided in other parts of the plan had a lifetime cap of $1 million. That difference, according to the Indiana Civil Rights Commission, was discriminatory. A Lincoln Foodservice employee who'd contracted AIDS brought the initial action that led to the Civil Rights Commission investigation.

The Civil Rights Commission ruled that the employee with AIDS was a handicapped individual as defined by Indiana law. The Commission concluded that "Lincoln is prohibited from classifying handicapped employees in any way which adversely affects their opportunities or status as to compensation and changes in compensation and fringe benefits."

Lincoln argued that the decision hurt the company—and that third party administrators and excess insurance carriers refused to provide insurance quotes for expanded health care for people with AIDS. "This is direct and overwhelming evidence that if employers are not allowed to cap certain catastrophic illnesses, the new result is that insurance coverage for all employees will be either totally unavailable or must necessarily be severely restricted in the scope of its coverage," the company said in a public statement.

Between 1988 and 1991, Lincoln's health care costs had increased from 49 percent to as high as 107 percent over the base year of 1987. "As a result, Lincoln has constantly struggled with providing maximum benefits to as many employees as is financially possible, while at the same time being fiscally responsible," the company statement explained.

The Civil Rights Commission insisted that the "dire picture" presented by Lincoln was an exaggeration. "Lincoln added to the plan the AIDS limitation at the same time it greatly increased other benefits....Often there are equitable balancing factors to consider; this is not one of those instances," its hearing officer ruled.

Beyond the issues of fact, Lincoln questioned the Indianapolis-based Civil Rights Commission's jurisdiction over the matter. Using a common legal theory, it argued that the Employment Retirement Income Security Act of 1974 (ERISA) preempted disability laws.

Self-insured plans are exempt from state benefit mandates and ERISA imposes no such mandates on health and welfare plans. While legal experts debate the details of ERISA's application in situations like the Lincoln Foodservice case, the general consensus holds that there's nothing necessarily discriminatory about capping benefits for an illness that may create a claim.

The Indiana regulators held firm to their charges against Lincoln Foodservice, though. "No federal

law concerning employment discrimination has been found which would permit Lincoln to maintain the plan in its present form which segregates and limits benefits on the basis of the handicap or disability of AIDS," the state Civil Rights Commission ruled.

Conclusion

Because state and local laws can be even more severe than federal laws, you need to pay attention to them. In general, though, these laws will follow the mechanics and sometimes even the definitions set up by the federal laws.

If you're looking for conflicts between local laws and federal laws as a way of negating the local law's effect, your best prospect will usually be to compare federal benefits law like ERISA than federal diversity law.

But, as is true with the federal laws, you're probably better off complying in good faith with the spirit of the local laws. That remains the employer's best defense in a diversity dispute.

Conclusion:

Diversity as a Business

Now that you've traced the issues and read examples of how diversity works, you have a good working background for understanding a complex subject. You know the concepts and the jargon. You know the traps to avoid and the information to share.

You know that an employer who intends to discriminate can't hide from the law. And you know that the employer who doesn't intend to discriminate sometimes trips over it.

That's where you have to be the most careful—saying and showing that you don't intend to discriminate. Many employers throw up their hands at this proposition. They hire outside consultants to help them articulate diversity goals and programs. And, more than anything, they hire these consultants as a kind of tribute to forces they feel they can't control.

That's no better than any other kind of superstition. It's operating from fear—always a bad idea. Business people who make decisions based on resignation and fear invite problems.

Those problems take the form of a booming industry in diversity consulting. We've looked at specific, useful applications of outside consultants through the course of this book. But, like consultants of all stripes, diversity specialists sometimes look out for their own self-interest instead of yours.

The jargon of the profession hints at its biases

These consultants invariably use recurring jargon. They talk about "system-wide approaches" to teaching "members of the white ruling class" that they need to "learn to recognize the sexism and racism in themselves." Once this has been accomplished, "the healing process" can begin to help people "understand how racism and sexism operate in their lives."

Of course, what you really want to know is how to avoid getting sued under Title VII or ADA. The consultants hint at solving this problem...but many of them sound like an extortionist hinting at providing "protection."

In a fawning 1992 *Los Angeles Times* profile, consultant Elsie Cross—a "63-year-old, soft-spoken black woman from Philadelphia"—repeated the conventional wisdom that keeps diversity consultants employed.

Like most consultants, Cross would run focus groups and workshops intended to define racism, sexism and other discrimination in very broad strokes. Cross would tell potential clients that "successfully redefining the corporate culture and managing diversity requires a major commitment of time and money." Most had to sign multi-year contracts.

Few had a choice. Like most diversity consultants, Cross sold her services to companies under court order to create diversity programs. Her firm got its start after AT&T Corp. lost a $30-million lawsuit for discrimination against women—in its time, the largest EEOC suit ever filed.

Not surprisingly, Cross's comments reflected a mix of pop psychology and a vested interest in perpetuating notions of intolerance:

> ...the problem of racism and sexism is bigger than individual bias and prejudice. And besides, I've never met anyone yet who told me upfront they were racist or sexist—and yet all these terrible behaviors persist.
>
> Most people in this society...are not willing to

look at the systemic issues. We almost always put the burden on the victim rather than on the perpetuation of a system that helped create the victim.

...Our work is based on the fundamental belief that racism and sexism are deeply rooted in our culture. We have never resolved these problems because people are not given an opportunity to talk about these issues in a safe environment.

...I've seen white men in organizations be the ones to take this work on, and they take it on knowing full well they're not going to be liked by other white men, but ultimately, they prevail and become very powerful leaders.

And, later in the profile, the woman blurted out stereotypes that no one but a credentialed diversity consultant could get away with saying in public:

...Women of color, oppressed by race and gender, remain the most vulnerable and disenfranchised people within an organization....

...As a means of survival, white women internalize oppression...and become listless or isolate themselves from other women with their silence.

...Men of color are patronized...instead of trained; they are passed over for promotion because they don't look the part of a leader.

...White men are oppressed by having to become clones, pressured to fit a mold—in appearance, management style, speech and behavior. "As victims of oppression, they become agents of oppression for new entrants into an organization, and each successive generation of newcomers is oppressed by the group above them."

...Social networking around golf was identified as an enabler for white men.

Of course. Workplace diversity is a problem because white men are scheming on the golf course.

Assumptions and generalizations have an ironic effect

An infamous FAA "sensitivity" seminar

Some diversity consultants use perception games that exaggerate problems. In one common exercise, managers are asked to list negative racial, gender and other stereotypes. The list is distributed and the managers are then asked to put red stickers next to the stereotypes they think others believe in. Then they are asked to put black stickers next to stereotypes they believe in.

The inevitable result: many red stickers and only a few black stickers. Aggressive consultants will claim that this proves both bigotry and denial. A equally compelling interpretation—that managers basically mean well but have been conditioned to suspect bigotry in others—is seldom suggested.

Elsie Cross is not alone in the diversity consulting business. Perhaps the best-known example of diversity training gone awry was a 1992 program put on by the Chicago office of the Federal Aviation Administration.

The male participants at the FAA seminar on "cultural diversity" were left in a hallway outside a closed meeting room. They weren't told what was going on inside the meeting room.

One by one, the men were asked to enter the room. As each man walked in, he was swarmed by female participants, some of them colleagues from work. Several men claimed the women fondled their legs, buttocks and genitals in an exercise that the seminar's organizer described as "the gauntlet."

In addition to the gauntlet, men were brought to a room where pictures of penises were displayed in various sizes and states of arousal. They were also rated by women on a scale of one to 10 as to their perceived sexual attributes—in an apparent attempt to show men how women feel when men comment on such things as breast size.

Douglas Hartman, an air-traffic controller who went through this cracked version of diversity training, sued the U.S. Department of Transportation. In a rich irony, he sought $300,000 in damages and alleged that the FAA violated Title VII by allowing a hostile environment of sexual harassment against males.

Hartman's suit followed an unsuccessful attempt by the National Air Traffic Controllers Association to stop the seminars under an unfair labor practices complaint it filed in 1991—shortly after the workshops started.

In an official statement, the FAA said it did not condone training involving physical harassment or offensive behavior. Richard Mintz, a spokesman for the Department of Transportation, elaborated in fitting bureaucratese: "If these allegations are true...these are the kinds of things we need to be concerned about."

He said the Transportation Department was conducting an internal review of diversity-training procedures.

Louise Eberhardt, whose consulting firm organized the disputed "training seminar," claimed the thing was designed to make male employees more sensitive to gender and race bias by demonstrating how demeaning such attitudes are.

Eberhardt, president of the Maryland-based Hart Performance Group, confirmed that the activities Hartman objected to had been included in seminars designed by her company.

"The gauntlet is a one-minute thing," she told one Chicago newspaper. "Most men say they've gotten some understanding of what women go through after the gauntlet....What's so ironic is all the publicity is going to a white male when women and people of color experience this kind of harassment every day."

Though she insisted groping or contact of a sexual nature was forbidden, Eberhardt said she was not present at the Chicago FAA session. Her explanation allowed an inference that the session might have gotten out of hand.

That was certainly the inference suggested by the FAA's $75,000 settlement with the National Air Traffic Controllers Association that followed several weeks after Douglas Hartman filed suit.

R. Roosevelt Thomas, Jr., founder of The Ameri-

"Awareness" breeds sexual harassment charges from men

A better approach to diversity training

can Institute for Managing Diversity at Georgia's Morehouse College, says that most training programs mirror the general strategy of affirmative action. Thomas has written that these programs

> seek to bring diverse employees into the organization, but then homogenizes them once they've been hired....This approach principally attempts to eliminate or minimize all the "isms," like sexism, anti-Semitism and racism, that may exist in a workplace.

Thomas suggests a better approach—one that uses equal employment laws and affirmative action as a framework for creating a work environment that allows a diverse work force to achieve greater productivity. "This doesn't mean anything goes," he says, "some people will be too diverse for an organization. But those who are excluded will be because of true requirements, not preferences, tradition, or convenience."

Mastering diversity in your workplace won't always be easy. Like any other bottom-line factor, it demands attention, time and effort. As you proceed, you'll probably need to come back to key practices. Here's a recap:

- *Articulate policies clearly and forcefully.* Every employee you hire should know that you won't tolerate illegal discrimination. Demand knowledge of and compliance with employment law basics from your managers.

- *Enforce policies fairly and consistently.* If someone makes complaints about discrimination, you want to squelch the charges quickly. The best tool for that is a paper trail of compliance. When you've proved consistency, regulators and courts have to allow you leeway for individual decisions as business judgment.

- *Emphasize the practical reasons that support workplace diversity.* In a world of instant communication, growing sophistication and global markets, you're going to do business with all kinds of people. You have to be ready and able to hire all kinds of people.

- *Commit to goals; avoid quotas or programs.* Make it clear to all employees, vendors and business associates that you support equal opportunity for all people. Set goals for work place diversity. But don't commit slavishly to specific quotas or programs. In most cases, you don't have to.

- *Assess your company's situation on an on-going basis.* Like many issues, diversity can become a problem unexpectedly. The fact that you didn't know discrimination was going on may mitigate problems in court—but you don't want to get that far. Diversity audits performed by outside consultants aren't usually necessary. But listening to employees usually is. Take the time to do this.

- *Give employees options.* Many diversity disputes turn critical because employees feel trapped in a hierarchy. Identify uninvolved managers or employees informed about diversity issues who can act as impartial channels. If it's feasible, identify yourself as one of these.

- *Allow as much flexibility as you can* in schedules and work loads. These efforts can occasionally backfire. But, if you're careful about how they are implemented, they can add a great deal of perceived value.

- *Budget time for encouraging communication.* This doesn't have to be a big expense—and it can take many forms: regular company-wide meetings, off-site or recreation events, cross-training or employee rotation and education opportunities are a few that have worked for some employers.

- *Give recognition.* Some employers have a hard time keeping employees from minority groups because they offer few signs of access to success in their companies. A good way to instill commitment in a diverse work force is to recognize a mix of employees with attention and, when appropriate, promotion.

Basic practices that help you master diversity

Take the initiative to define your own terms

- *Stress merit.* A good way to cut through the static and confusion that workplace diversity sometimes causes is to reward clearly-defined performance. This not only encourages productivity, but it also builds the belief in employees that they'll be judged by merit and not by appearance.

- *Resist stereotypes.* Even if your experience as an employer and an individual bears out some generalizations, you can't apply them in employment situations. For example, no matter how many women choose to raise families instead of pursuing careers, you still can't assume the next woman you interview for a job will make that same decision.

- *Expect some friction.* People gravitate toward groups; groups sometimes collide. A diverse workplace will experience clashes along familiar lines from time to time. Don't deny this. And don't let it discourage diversity efforts. Set up policies for resolving intramural conflicts as quickly and peacefully as possible.

- *Take the first step.* It's a natural tendency to associate with people like yourself. And business—or work—isn't a context in which everyone feels comfortable taking chances. As the employer or manager, you'll profit from making the effort to get to know as many employees as you can.

That last point may be the most important one to remember. Even though the laws related to workplace diversity are many and complex, you can't let them make you shy away from dealing with a diverse work force made up of different individuals on your terms.

A lingering worry that some of the employers who have spoken for this book shared: They weren't assertive enough in the early stages of what became a diversity dispute. They hesitated to follow their instincts and judgment because they thought that the law would work against them. And they usually didn't like the result of their hesitation.

"I should have just used common sense," says one employer who waited to fire a problem clerical employee—and then faced a more complicated lawsuit because of it. "I knew [the employee] was trouble. And I even had enough paperwork to support the firing. But I waited because I was afraid the EEOC would line up against me. Of course, the person just got worse. And the EEOC lined up against me anyway—though they weren't as much of a problem as I feared they might be."

Wiser for the $50,000 experience, this employer now swears he'll follow laws but also his own business judgment. Diversity laws allow this mix—some even encourage it.

As well they should. You're the employer. You set the tone for the entire employment relationship. Any employee, like any person, can sue you if they want to. If you manage the employment relationship badly, you may lose that lawsuit. If you do it well, you may win.

Or, if you manage the employment relationship really well, you may not get sued at all.

The point is that the terms are yours to define. You can—you must—take control.

FORMS, LETTERS AND CHECKLISTS

The following appendices give you primary source material, forms and checklists for managing workplace diversity issues. All the forms support various strategies discussed in the course of this book.

A caveat: While most workplace diversity laws are enforced at the federal level, others vary from state to state. While these materials will help you analyze exposures and manage risks, they're not a substitute for specific legal or management advice. If you think a particular situation will be troublesome, talk to a lawyer.

With that understood, you should find these forms helpful in keeping on top of your employment situation. Feel free to use them verbatim or modify them as you see fit.

414

GUIDELINES FOR MASTERING DIVERSITY

Mastering diversity in your workplace won't always be easy. Like any other bottom-line factor, it demands attention, time and effort. As you proceed, you'll probably need to come back to key practices. Here's a recap:

☐ Articulate policies clearly and forcefully. Every employee you hire should know that you won't tolerate illegal discrimination. Demand knowledge of and compliance with employment law basics from your managers.

☐ Enforce policies fairly and consistently. If someone makes complaints about discrimination, you want to squelch the charges quickly. The best tool for that is a paper trail of compliance. When you've proved consistency, regulators and courts have to allow you leeway for individual decisions as business judgment.

☐ Emphasize the practical reasons that support workplace diversity. In a world of instant communication, growing sophistication and global markets, you're going to do business with all kinds of people. You have to be ready and able to hire all kinds of people.

☐ Commit to goals; avoid quotas or programs. Make it clear to all employees, vendors and business associates that you support equal opportunity for all people. Set goals for workplace diversity. But don't commit slavishly to specific quotas or programs. In most cases, you don't have to.

☐ Assess your company's situation on an on-going basis. Like many issues, diversity can become a problem unexpectedly. The fact that you didn't know discrimination was going on may mitigate problems in court—but you don't want to get that far. Diversity audits performed by outside consultants aren't usually necessary. But listening to employees usually is. Take the time to do this.

☐ Give employees options. Many diversity disputes turn critical because employees feel trapped in a hierarchy. Identify uninvolved managers or employees informed about diversity issues who can act as impartial channels. If it's feasible, identify yourself as one of these.

☐ Allow as much flexibility as you can in schedules and work loads. These efforts can occasionally backfire. But, if you're careful about how they are implemented, they can add a great deal of perceived value.

☐ Budget time for encouraging communication. This doesn't have to be a big expense—and it can take many forms: regular company-wide meetings, off-site or recreation events, cross-training or employee rotation and education opportunities are a few that have worked for some employers.

☐ Give recognition. Some employers have a hard time keeping employees from minority groups because they offer few signs of access to success in their companies. A good way to instill commitment in a diverse work force is to recognize a mix of employees with attention and, when appropriate, promotion.

☐ Stress merit. A good way to cut through the static and confusion that workplace diversity sometimes causes is to reward clearly-defined performance. This not only encourages productivity, but it also builds the belief in employees that they'll be judged by merit and not by appearance.

☐ Resist stereotypes. Even if your experience as an employer and an individual bears out some generalizations, you can't apply them in employment situations. For example, no matter how many women choose to raise families instead of pursuing careers, you still can't assume the next woman you interview for a job will make that same decision.

☐ Expect some friction. People gravitate toward groups; groups sometimes collide. A diverse workplace will experience clashes along familiar lines from time to time. Don't deny this. And don't let it discourage diversity efforts. Set up policies for resolving intramural conflicts as quickly and peacefully as possible.

☐ Take the first step. It's a natural tendency to associate with people like yourself. And business—or work—isn't a context in which everyone feels comfortable taking chances. As the employer or manager, you'll profit from making the effort to get to know as many employees as you can.

SAMPLE EMPLOYMENT APPLICATION FORM

Employment Application

It is the policy of this company to comply with all federal, state and local equal employment opportunity laws and guidelines.

Please complete all items.

Date:_____
Position desired: _____
Date available:_____
Days/hours preferred: _____
Salary desired:_____
Referred by:

☐ advertisement
☐ friend
☐ relative
☐ walk-in
☐ employment agency
☐ other

Personal Information

Name: _____
 (last) (first) (MI)

Social Security number:_____
Address _____
City, State, ZIP_____
Home telephone: (_____) _____
Business telephone: (_____) _____
Are you over the age of 18?_____
If not, please state your date of birth:_____
Are you eligible for employment in the United States? ☐ Yes ☐ No

Has any restriction been placed on your eligibility for employment in the United States?
 ☐ Yes ☐ No
 If yes, please explain. _____

NOTE: If hired, you will be required to provide proof of employment eligibility.

Have you been employed by this company before? ☐ Yes ☐ No
 If yes, please give previous dates of hire and departure. _____

Do you have any personal friends or relatives employed at this company?
 ☐ Yes ☐ No

If yes, please list them and their relationship to you and their positions. _____

Are you capable of performing — with reasonable accommodation — the essential functions of the position which you seek? ☐ Yes ☐ No

If no, please explain. _____

Have you even been convicted of a felony? ☐ Yes ☐ No

If yes, please explain date and nature of conviction. _____

NOTE: Disclosure of a criminal record will not necessarily disqualify you from employment. The nature and date of the conviction and the position desired will be taken into consideration.

Military Service Information

Have you ever served in the United States armed forces? _____

If yes, please give the dates of service. _____

If yes, please list skills, abilities and other relevant training you received. _____

Educational Information

	name of school attended	date of graduation	type of degree, diploma or training received	major fields of study
High school	_____	_____	_____	_____
College/ undergraduate university	_____	_____	_____	_____
Graduate school	_____	_____	_____	_____
Technical school	_____	_____	_____	_____
Other	_____	_____	_____	_____

List honors, awards, or scholarships received: _____

List relevant activities, memberships or positions held: _____

Employment Record

Please list all employment, starting with most recent position and working back. Please attach a separate sheet if necessary.

Company: _____

Address: _____

Phone: (_____) _____

Position, with brief outline of duties: _____

Supervisor's name and title: _____

Dates of employment: from _____ to _____

Reason for leaving: _____

References

Please list — with address and phone number — three people familiar with your education, training, or professional experience. Please do not include family members or relatives.

1) _____
2) _____
3) _____

Notice of physical testing

This company is commited to maintaining a drug-free workplace. All candidates for employment are required to complete a physical examination and/or test for drug and alcohol use. These tests will be administered by a physician or clinic of the company's choice.

I agree to undergo pre-employment drug and/or alcohol testing. I understand that results of any such test will be disclosed only to the human resources department of this company and relevant management employees. I understand that if I refuse to undergo testing, fail to provide physical specimens when requested, provide false or tampered specimens or otherwise fail to complete the testing process, I will not be hired.

Applicant Acknowledgement

I grant permission for this company to conduct an investigation and solicit information related to my educational, employment, military service and criminal histories. I release this company and any of its employees or representatives from any liabilities arising from such investigations.

I grant permission for this company to test, as allowed by applicable laws and regulatory guidelines, my ability to meet the bona fide occupational qualifications of any poistion for which I may be considered.

I grant permission for this company to conduct an investigation and solicit information related to my personal credit and financial histories as well as my professional character and reputation. I release this company and any of its employees or representatives from any liabilities arising from such investigations.

I understand that this employment application and any other company documents do not constitute or in any way imply a contract of employment. I understand that no employee or representative of the company has authority to make or imply any contract of employment with me. I understand that any individual hired by this company may voluntarily leave or be terminated at any time, with or without cause being given.

If terminated, I authorize this company to deduct — to the extent permitted by law — any monies which I might legitimately owe the company from any monies the company might owe me.

All statements made and information given by me on this application are true and correct to the best of my knowledge. I understand that any false, inaccurate, omitted or misleading statements or information can be grounds for rejection of my application or termination of my employment.

I have read, understand and by my signature consent to these statements.

Signed _____ Date _____

GUIDELINES FOR JOB APPLICANT INTERVIEW

Keep notes of interviews or complete report forms. While you do not have to be slavish in the matter, try to keep interviews as consistent as reasonably possible from applicant to applicant.

Ask questions that allow the applicant to elaborate on his or her background, skills and working style. The questions should concentrate on issues relevant to the job at hand.

Ask candidates how they react to typical situations and how they would react to hypothetical ones.

Example: Give an example of a time when you encountered someone with whom it was difficult to work.

What did you do about it?

What happened?

Don't crowd the conversation. Try to have the applicant do most of the talking. Look for initiative, self-confidence, thoughtful decision making, and constructive problem-solving.

If you suspect the applicant might have trouble meeting the requirements of the job without special accommodation, ask whether he or she thinks that he or she can. If the applicant thinks he or she would need some kind of accommodation, ask for some specific idea of what that accommodation might be. Let the applicant talk specifics. It's not a good idea to ask pointed or leading questions.

Ascertain the basic skills the applicants used in previous jobs. Have them describe their normal work load in previous positions. Sometimes, a person will take key skills for granted or neglect to mention them.

Focus your questions and comments on the challenges of the position. Let the applicant be the one to focus on specific characteristics of himself or herself. Sometimes, in recounting a former job, an applicant will give you a better image of his or her work habits than he or she intends.

Focus on goal-orientation. As for specific answers and examples of assignments a candidate has accomplished.

Ask applicants to assess their performance at previous jobs. Look for consistency in tone and work history. Lots of job-hopping paired with nothing but glowing memories might suggest a problem worker.

If you think that legitimate issues of corporate culture are relevant, you can mention how your company operates and what its culture is. Let the applicant compare himself or herself to this model. Don't lead the conversation by suggesting your thoughts.

Look for stability, both in work history and career goals.

When possible, interview candidates more than once. Have different people handle each interview.

Never promise permanent employment or guaranteed job security.

SAMPLE JOB APPLICANT INTERVIEW REPORT FORM

To be filled out by interviewer. As we've mentioned, consistency is vital in diversity issues related to hiring and firing. If your hiring process is challenged, you will need to show that you treat all applicants for a single job as evenly as possible. Most employers use standard application forms; where many get in trouble is in documenting evaluative interviews. A standard interview report form can help solve this problem.

Applicant: _____

Interviewer: _____

Date: _____

Examples of tasks the applicant performed that used important skills and abilities.

What did he or she do?_____

How? _____

Why? _____

What were the results? _____

How did these skills and abilities suit the previous employer's needs? _____

Examples of important decisions the applicant has made on the job.

In each case, describe the situation, the process and the end result. _____

Examples of how, in previous jobs, the applicant solved a specific problem.

How did the applicant adapt to changes during a previous job?_____

Applicant's description of his or her work habits. _____

Description of himself or herself as worker. _____

Description of timeliness or tardiness. _____

Examples of how this has worked for or against the applicant in previous positions.

Examples of how the applicant took direction from former supervisors.

How does the applicant prefer to work: independently or on a team? _____

Examples of how the applicant has worked each way.

How would the applicant's past experience contribute to the company? _____

In what aspect of work does the applicant take the most pride? _____

How important is it for the applicant to feel that he or she:

receives specific instruction? _____

has clearly-defined responsibilities? _____

solves problems? _____

has secure job and income? _____

Overall impression of the applicant on the following standards:

	excellent	good	average	fair	poor	unacceptable
Qualification	☐	☐	☐	☐	☐	☐
Organization	☐	☐	☐	☐	☐	☐
Experience	☐	☐	☐	☐	☐	☐
Education/training	☐	☐	☐	☐	☐	☐
Cooperation	☐	☐	☐	☐	☐	☐
Flexibility	☐	☐	☐	☐	☐	☐
Problem-solving skills	☐	☐	☐	☐	☐	☐
Communication	☐	☐	☐	☐	☐	☐
Discipline	☐	☐	☐	☐	☐	☐
Enthusiasm	☐	☐	☐	☐	☐	☐
Match for corporate culture	☐	☐	☐	☐	☐	☐

GUIDELINES FOR EMPLOYEE HANDBOOKS AND MANUALS

Employee manuals can cover a range of subject matter, depending on the state and industry in which you're doing business. Check with your local trade association or state labor department for the specifics you need to include.

Here are some generally applicable guidelines to follow.

The manual should:

☐ outline company policies on tardiness, absence, vacation time and sick pay

☐ outline available benefits — workers' comp and any others — and emphasize the employee's self-interest in controlling related costs

☐ outline usual disciplinary procedures — while preserving your right to step outside them if you wish or circumstances merit

☐ explicitly state the company's commitment to a workplace free of illegal race, gender, age or disability discrimination

☐ describe the means and mechanisms of making complaints related to illegal discrimination, harassment or other improper behavior

☐ state that the company will investigate all charges of discriminatory behavior and respond in a timely manner (but avoid describing specific disciplinary measures)

☐ avoid any discussion of preferential hiring or promotions, goals or timetables unless specifically required by a regulatory or law enforcement agency

☐ make no promises to dismiss only for "just cause"

☐ reflect all relevant collective-bargaining arrangements

☐ outline available complaint or appeal mechanisms

☐ avoid such subjective terms as "fair," "timely," "reasonable" and "equitable," which stimulate litigation

☐ state, clearly, that it is not a contract and that you reserve the right to modify or amend any personnel policy at any time, with or without notice

☐ state that only specifically designated company officials can enter into oral or written contracts with employees

☐ state that, if there is any inconsistency between a statement in the handbook and actual practice, the handbook governs

☐ not imply that the employee can expect promotions regularly or as a matter of course

If your handbook specifies a probationary period for new employees, it should also state that such employees can be fired before probation ends and that successfully completing probation does not guarantee continued employment.

The handbook should change as policies change; when you alter policy regarding conduct (to comply with laws barring sexual harassment, for example), change your manual accordingly.

SAMPLE EQUAL EMPLOYMENT AND
SEXUAL HARASSMENT POLICIES

Company name:_____

Address:_____

Date: _____

It is the policy of this company to provide equal employment opportunity for all people. All qualified applicants for employment will be recruited, reviewed, hired and assigned on the basis of merit and the best economic interests of this company.

This company does not consider race, color, gender, disability, sexual orientation, creed or ethnic origin in its employment and staffing decisions. It demands that all qualified applicants and employees are treated fairly and equally, without discrimination, in matters of compensation, training, advancement and discipline.

This company will not tolerate unlawful discriminatory behavior in any employee or representative. Such behavior is grounds for disciplinary action.

It is policy of this company to maintain a work environment free from sexual harassment or misconduct.

While recognizing appropriate rights to privacy and free expression, this company will not tolerate unlawful sexual harassment or misconduct in any employee or representative. Included in this company's definition of sexual harassment are:

- requesting or demanding sexual relations as a condition of employment;
- unwarranted or uninvited touching, fondling, or physical contact;
- intentional, specific and disparaging sexual remarks;
- specific remarks or actions related to a person's gender, sexuality or sexual orientation that create a hostile work environment;
- in certain circumstances, as defined by applicable statute and legal precedents, consentual sexual relationships.

Such behavior is grounds for disciplinary action.

Any employee subjected to sexual harassment or discrimination is expected to contact his or her supervisor in a timely manner. If that employee feels uncomfortable discussing the misconduct with his or her supervisor, he or she may speak with any other management-level employee. Any manager informed of sexual misconduct is expected to take immediate corrective action.

Because it takes issues of employment discrimination and sexual harassment seriously, this company will not tolerate dishonest, manipulative or untrue accusations of such behavior.

By signing this document, you—as an employee—attest that you have reviewed and understand these policies.

Signed _____ Date _____

SAMPLE EMPLOYEE PERFORMANCE REVIEW

Consistency is important in how you administer job performance reviews. After hiring and firing issues, performance reviews are the most common grounds for discrimination complaints. Whenever possible, use standard review forms for all employees in the same or equivalent positions.

Employee name: _____

Employee ID number:_____

Date:_____

Position: _____

Reviewer name and position: _____

To the reviewer: Each evaluation and each rating category must be accompanied by written explanations. Space is provided in this form, but feel free to use more space, if needed.

Ratings

Excellent:	Performance always exceeds expectation and requirements
Good:	Performance exceeds requirements of position most of the time
Average:	Consistently meets requirements of position
Fair:	Performance usually meets requirements, needs improvement
Poor:	Performance does not meet requirements of position
Unacceptable:	Abject failure to meet requirements of position

Knowledge of position

Employee knows the job to be performed and the most efficient ways to do it. Employee has needed skills and abilities; pays attention to keeping these skills and abilities up-to-date. Employee knows relevant company policies and procedures.

- ☐ Excellent
- ☐ Good
- ☐ Average
- ☐ Fair
- ☐ Poor
- ☐ Unacceptable

Comments: _____

Quality of work

Employee does job efficiently and well, on time and without disruption to other employees. Employee works without unwarranted supervision or mistakes.

- ☐ Excellent
- ☐ Good
- ☐ Average
- ☐ Fair
- ☐ Poor
- ☐ Unacceptable

Comments: _____

Reliability

Attendance is good. Employee can be trusted to meet all demands of position, will work as needed to complete assignments and jobs.

- ☐ Excellent
- ☐ Good
- ☐ Average
- ☐ Fair
- ☐ Poor
- ☐ Unacceptable

Comments: _____

Responsibility

Employee is a self-starter and self-manager, helps others when necessary, takes pride in work and shows desire to improve self and skills.

- ☐ Excellent
- ☐ Good
- ☐ Average
- ☐ Fair
- ☐ Poor
- ☐ Unacceptable

Comments: _____

Cooperation

Employee works well with peers and supervisors, shows maturity and stability.

- ☐ Excellent
- ☐ Good
- ☐ Average
- ☐ Fair
- ☐ Poor
- ☐ Unacceptable

Comments: _____

Judgment

Employee exercises sound judgment and discretion in focusing on job goals, establishing priorities and reacting to the unexpected.

- ☐ Excellent
- ☐ Good
- ☐ Average
- ☐ Fair
- ☐ Poor
- ☐ Unacceptable

Comments: _____

Communication:

Employee can express basic necessary information related to job in clear, efficient manner.

- ☐ Excellent
- ☐ Good
- ☐ Average
- ☐ Fair
- ☐ Poor
- ☐ Unacceptable

Overall rating among peers

- ☐ Top fifth
- ☐ Second fifth
- ☐ Middle fifth
- ☐ Fourth fifth
- ☐ Bottom fifth

Employee's strongest assets: _____

Employee's primary weaknesses: _____

Reviewer's signature: _____

Date: _____

Employee acknowledgement

A copy of this report has been discussed with me. I understand its contents and conclusions.

Employee's signature: _____

Date: _____

Employee's comments, if any: _____

RESPONSE TO ALLEGATIONS OF DISCRIMINATORY BEHAVIOR

As soon as an employee raises a discrimination concern or complaint, ask him or her to complete a written questionnaire, which you should keep on file. If the employee will not complete the form, his or her manager should.

Company name: _____

Division: _____

Date: _____

Complainant: _____

Form filled out by: _____

What — exactly — happened? _____

Was this a subtle act, or a blatant one? Explain. _____

Was this an isolated incident, or part of a pattern? _____

When — exactly — did the alleged incident occur? _____

How many people were involved? List names. _____

How many witnesses saw or heard the incident? List names. _____

Do the people who did this act as though they have protection? _____

Does the alleged victim know the company's policies on discriminatory behavior? _____

What does the alleged victim expect the company to do about the complaint? _____

WORKERS' COMPENSATION CLEARANCE LETTER

Workers' compensation claims are sometimes the starting point for legal disputes that include discrimination, sexual harassment and other diversity claims. One way to control this exposure is to have an employee sign a comp clearance letter when he or she leaves your company. A caveat: These clearance letters are not always enforceable.

Company name:_____

Department or division: _____

Date: _____

I testify that I have reported — through standard written channels — all work-related accidents, injuries or illnesses suffered while employed by this company.

I have informed the following supervisory personnel of any relevant injuries or illnesses:

1) _____

2) _____

3) _____

At this time, I know of no work-related accident, injury or illness for which I could seek workers' compensation—other than those I have already reported and/or for which I have sought compensation.

Signed: _____

Date: _____

RELEASE UPON TERMINATION

Specific states may require specific language in an enforceable release. Check with your local labor and/or industry regulatory authorities.

Company name:_____

Employee name: _____

Date: _____

In consideration of the payment to you of $_____, less necessary withholdings and deductions, you hereby release this company and its directors, officers and employees from any claim you may have in connection with your employment at this company.

You also agree not to use or reveal to any other persons any confidential information which you may have acquired while an employee at this company.

In exchange for the benefits extended in this memorandum to you, you agree to release this company from any and all causes of action, known or unknown, arising out of, in any way connected with or relating to your employment (or its termination) with this company. Such causes of action include but are not limited to: breach of contract, impairment of economic opportunity, intentional infliction of emotional harm or other tort, the Age Discrimination in Employment Act of 1967, Title VII of the Civil Rights Act of 1964, the Americans with Disabilities Act, or any state or municipal statute or ordinance relating to discrimination in employment. However, you expressly reserve your rights under this company's pension plan or other post-employment benefits, as well as the right to institute legal action for the purpose of enforcing the provisions of this memorandum.

Company representative: _____

Date: _____

Employee's signature : _____

Date: _____

QUESTIONS YOU CANNOT ASK JOB APPLICANTS

Some things you simply cannot say when you interview an applicant for a job or a current employee for a promotion. The general rule that applies: You cannot ask an applicant anything that would force him or her to offer information about membership in a group protected by anti-discrimination law. You have some more flexibility in dealing with current employees seeking promotion or transfer; but it is still a good idea to keep these guidelines in mind. In certain instances, you can ask some of these questions if they relate to specific bona fide occupational requirements. But, even in those instances, you should proceed carefully.

- Are you disabled?

- How old are you? What year did you graduate high school? College?

- Are you Black? Hispanic? What race are you?

- What country do you come from? What kind of accent do you have?

- What religion do you practice?

- Are you mentally retarded? Do you have any other kind of mental illness?

- Are you currently under the treatment of a psychiatrist, psychologist or other mental health professional? Have you even be under such treatment?

- Are you an alcoholic? Are you a drug addict? Have you ever suffered injuries caused by alcohol or drug use?

- Are you currently in treatment for alcoholism or drug addiction? Have you ever recieved treatment for alcoholism or drug addiction?

- Do you have a history of substance abuse in your family? Of mental illness? Of any other disease?

- Are you currently using any prescription drugs? What prescription drugs have you used in the past?

- Has your use of medical benefits in the past been high? How many days of work have you missed in the last year because of illness or disability?

- Where else have you lived?

- Are you married? Are you divorced?

- Are you pregnant now or do you plan to be pregnant in the future? How many children do you have?

- How does your spouse feel about your working?

- Have you ever filed a workers' compensation claim?

- Have you ever been arrested?

QUESTIONS YOU CAN ASK JOB APPLICANTS

One of the problems posed by all the prohibitions that workplace diversity laws put on what an employer can say is that many employers become gun shy. They assume they cannot ask questions that, in reality, they can. Questions you can ask include:

- Do you drink alcohol?

- Do you currently use illegal drugs?

- Have you used any of the following controlled subtsances in the last 30 days:
 marijuana
 cocaine
 LSD
 barbituates
 amphetamines

- Are you able to perform the specific responsibilities outlined in this job description without special accommodation?

- Have you ever been convicted of driving under the influence or driving while intoxicated?

- Have you ever had your drivers license suspended or revoked?

- Have you ever been convicted of a drug- or alcohol-related felony?

- Why did you leave your last job? Did you have any performance problems at your last job?

- How many days were you absent from work last year? Over the last two years?

- Can you meet the normal requirements of our company's work hours and schedule?

- Would you require any special work hours or time off from the job?

- Have you ever injured another person in a work-related accident that you caused?

- Do you understand our business and our corporate culture? How would you describe each? Do you foresee any difficulty working in this environment?

If a disability is apparent or if the applicant voluntarily informs you of a disability, you can ask the following questions:

- Are you capable of performing the responsibilities outlined in the job description without accommodation?

- If you need an accommodation, what do you think that would entail?

- Can you describe or demonstrate how you would perform these responsibilities?

After you've offered an applicant a job, but before the employment has begun, you can ask a few other more detailed questions. These include:

- Are you currently taking any prescription drugs?

- Do you have any medical condition or limitation which would pose a significant health or safety risk on the job to yourself or others?

- What is your workers' compensation history?

COMPLYING WITH THE ADA

The Americans with Disabilities Act sets a number of specific terms under which employers can communicate with and manage their workers. Among the guidelines that the Act establishes:

☐ Understand the broad scope of the definition of "disability." Disabilities can include mental impairments—such as Attention Deficit Disorder—and ailments such as migraine headaches, AIDS, alcoholism and drug addiction, even unusual sensitivity to tobacco smoke.

☐ The law prohibits you from asking job applicants about the existence, nature or severity of disabilities they might have. But you can ask about an applicant's ability to perform specific job functions.

☐ Document the basic functions of every job at your company. You can go through a job description and make sure an applicant can perform each function in it. If you turn down a disabled job applicant for a particular position because he or she can't perform the work required, you can better defend yourself against discrimination charges if you already have the basic functions of the job documented.

☐ So-called "prophylactic measures," such as alerting middle managers to the perils of the interview process and the termination process, stressing diversity in the workplace, updating job descriptions, and appointing a company ADA officer, can serve to reduce your risk of ADA liability.

☐ Check your application, interviewing, hiring and medical examination processes. Make sure prospective employees are not asked questions regarding impairments or disabilities which are unlawful. The key to ADA compliance is documentation.

☐ Pre-employment physicals are only allowed after a conditional offer of employment is made, and the results may not be used to discriminate unless the person cannot perform the essential functions of the job or poses a direct threat to safety or health.

☐ Medical exams of current employees can only be performed if they are job-related and consistent with business necessity.

☐ The law requires "reasonable accommodation" for a disabled employee's needs—such as restructured job duties, modified work schedules, special equipment or alterations to physical facilities. Before you face an issue, establish a procedure for handling accommodation.

☐ Adopt a liberal view of what is a reasonable accommodation.

☐ Employees who want accommodation should first make an oral request, then repeat the request in writing. The request must be specific—for a tape recorder or a move to another desk.

☐ Your accommodation policy should include limits at which the time and money you spend accommodating people become an undue hardship. These limits will be different for different companies and different kinds of jobs. The larger your company and the more senior the position, the more you should be prepared to spend.

☐ Whenever you're considering or making an accommodation, communicate with the employee or applicant. Avoid any kind of antagonistic response. Many times the employee has a good idea about providing accommodations that are reasonable.

☐ If you're not going to make the accommodation, you should state the reasons in a note and file it.

☐ If a disabled employee at a profitable company needs a device to accommodate his or her needs, declining to purchase the device can be risky. Juries evaluating whether an accommodation poses an "undue burden" on an employer often look straight at the bottom line.

☐ Supervisors should take care not to raise issues of disability—especially questions of alcoholism or drug abuse, mental problems, emotional problems or politically-charged diseases like AIDS. Refer employees who show signs of these problems to an employee assistance program.

☐ If feasible, refer problem employees to an employee assistance program in which they can talk about trouble they're having on the job. This serves as an official forum for them to address shortcomings or discuss problems. It works especially well in the case of suspected alcohol or drug abusers—they'll have a harder time claiming perceived disability.

COMPLYING WITH THE ADEA

Like other workplace diversity laws, the Age Discrimination in Employment Act involves hundreds of pages of statute and analysis which can be distilled into a few basic observations. As is true of the ADA and laws like the Equal Pay Act, the ADEA follows the enforcement model set by Title VII of the Civil Rights Act of 1964. This model essentially implies that an employer should:

☐ Educate your managers about the Age Discrimination in Employment Act. Make it clear that all company policies and practices—as well as informal communications—comply with the law.

☐ Consider making policies to slow work-induced stress and encourage effective stress management. These issues are important to everyone, but are especially common in age discrimination claims.

☐ Offer benefits. General efforts to make the workplace comfortable for older workers—including retraining programs and flexible work schedules—can do more to mitigate claims than case-specific damage control.

☐ Consider management alternatives like horizontal transfers that open positions for younger workers while refocusing older workers through new training and challenges. Also, consider rotating employees through top positions, giving younger workers experience without shutting down older people.

☐ When interviewing older job applicants, avoid questions like: "How would you feel working with so many younger individuals?" or "Would you really be interested in starting all over again?" or "Do you have up-to-date job skills?"

☐ Avoid jargon like "You're overqualified" or "We need high-energy individuals" or "You have so much experience...."

☐ Do not assume that an older worker will stay with your company a shorter time than a younger worker. It might seem counter-intuitive, but some evidence suggests older workers actually stay longer in particular jobs than younger workers.

☐ Make sure your hiring, management and firing processes are perceived as fair by all employees. Companies that give little thought to managing their communications are more likely to be involved in litigation.

☐ Permit employees to appeal. Appeals are generally informal and handled by the human resources department.

☐ Document early-retirement plans carefully. You need to establish clearly that your plans are voluntary and that employees have at least seven days to consider them. Avoid any sense of coercion.

☐ Make sure anything you call "layoffs" are made only for legitimate business purposes and aren't a pretext for getting rid of someone.

☐ Consider how you structure layoffs. Legitimate business purpose may be easier to prove when an entire department is being eliminated, rather than a percentage of the overall work force.

☐ Know the health-related cost benefits issues of older workers. Fringe benefits—especially health care—become more important to older workers.

AVOIDING GENDER BIAS AND SEXUAL HARASSMENT

It's hard to eliminate the risk of an employee making charges that involve gender biases or sexual harassment. These issues are complicated ones, even when the people involved are honorable and well-intentioned. However, a number of procedures can help you control these risks.

☐ Don't tolerate managerial or supervisory comments that include unfounded generalizations about what men or women "tend to be" or "should be like." Even said in jest, these kinds of comments create misperceptions—and not just among people who'll sue. People who hear salty comments in a closed meeting are more likely to let something stupid slip in the hallway.

☐ Don't personalize reviews or evaluations. Keep the focus on the job. If you have to criticize improper or unprofessional behavior, do it on neutral terms. Taken to the extreme, this can turn into awkward political correctness. However, having a paper trail of gender neutral policies makes discrimination more difficult to prove.

☐ Train managers and supervisors to avoid stereotyping language in recruitment, performance evaluations, promotions, memos and public documents. These guidelines should apply in all business contexts—whether in the office or outside. Supervisors should carefully consider what they say, even in private conversations with subordinates or peers.

☐ Establish objectivity whenever you can. Even seemingly non-quantifiable areas such as interpersonal skills can be objectified with behavioral rating scales. Where objectivity is impossible, try to establish consistency. Consistency may be the hobgoblin of little minds, but it lessens the chance of discrimination lawsuits.

☐ Review the composition of your work force on a regular basis. Diversity laws can't tell you whom to hire or promote, but they can indicate where problems lie. Knowing that angry employees can use statistical trends to establish prima facie discrimination, you can look for potential problems. Segregation of women into lower-level jobs may indicate a pattern of behavior based on improper gender stereotypes.

☐ Be aware that isolated individuals in otherwise homogeneous environments make many discrimination and harassment claims. Promoting a single woman to a senior position doesn't solve your gender mix problems. It may actually increase them. This doesn't mean you should adapt broad quotas—in fact, it means the opposite. Promote people who deserve to be promoted. That strengthens their position.

☐ Keep policies clear and update them regularly. When information and criteria are ambiguous, stereotypes can provide structure and meaning to confused employees. Stereotypes shape subjective perceptions most when data are open to multiple interpretations.

The process for combating a hostile environment—which is a common way of establishing sexual harassment—is fairly straightforward:

☐ Have a written policy stipulating that sexual harassment and retaliation against anyone who claims sexual harassment "is prohibited and will not be tolerated."

☐ Explain—precisely—the kinds of activities that constitute sexual harassment. Examples are useful in this process, but make sure that they aren't taken to be the only kinds of harassment you forbid.

☐ Identify in advance particular individuals within the company who will investigate harassment complaints. Make sure these people have at least a basic understanding of the legal definitions of harassment and are credible to co-workers.

☐ Start an in-house investigation as soon as a complaint is made. The investigator might ask the alleged victim what remedial action he or she wants you to take. The answer may indicate how serious the alleged victim considers the charge and may pave the way for a quick and easy solution.

☐ Resolve all investigations with a finding of fact. People may not be satisfied with your conclusions. They may go on to complain—or already have complained—to government agencies. But the report helps you establish a good-faith effort to resolve the alleged problem.

☐ Highlight your sexual harassment policies regularly, updating workers on recent cases that relate to your business or region.

☐ If you're already facing a sexual harassment case, you can limit your liability by taking remedial action. You can always clarify your company policy barring sexual harassment and encourage communication by holding anti-discrimination workshops for employees.

☐ In most cases, you can perform an in-house investigation. If you find the complaint valid, you can take disciplinary action against the alleged harasser—but be very careful doing this.

☐ A caveat: Employers who react zealously when a worker accuses a colleague of sexual harassment can end up in court just as quickly as those who do nothing. You have to make sure to treat the accused harasser fairly—no matter how guilty you may believe he or she is.

AVOIDING AFFIRMATIVE ACTION COMPLAINTS

If you want to comply effectively with affirmative action guidelines, a number of critical guidelines emerge. Although these steps will not guarantee that your diversity efforts will answer the demands of a federally-sponsored affirmative action plan, they address the basic terms of debate.

☐ Maintain an open attitude toward new ways of management.

☐ Talk to your employees and customers to determine how they want to be treated and managed.

☐ Develop a set of policies that clearly prohibit illegal discrimination.

☐ Develop hiring and promotion practices that treat applicants and employees as consistantly as possible.

☐ Be reasonably flexible with schedules.

☐ Provide retraining and even remedial skills training.

☐ Help employees handle work/family conflicts.

☐ Allow grievances by members of protected groups to proceed, if necessary, through alternative channels.

☐ Check lines of communication constantly.

☐ Be extremely cautious of subjective comments or critiques placed in any internal report dealing with possible illegal discrimination or diversity problems.

☐ State clearly that internal reports are intended to investigate and resolve diversity issues.

☐ Keep internal reports separate from other personnel files.

☐ If you involve attorneys in an internal report, emphasize in the report that they are being consulted in their capacity as attorneys.

☐ Be cautious of changing any hiring or management policy in a way that might be perceived as reducing benefits provided to protected groups.

ADA JOB ACCOMMODATION IDEAS

(Excerpted from a report issued by the President's Committee on the Employment of People with Disabilities.)

Job accommodation for people with disabilities requires a partnership between the employee with a disability and company representatives. If there is a labor union, their personnel can assist. All parties must work together as equals to come up with the best way for the person to do the job.

The President's Committee sees the job accommodation process as similar to many other workplace problems which are resolved through research and common sense. Each individual accommodation is an example of "working together for change." This teamwork generally results in cost-effective solutions. The President's Committee's Job Accommodation Network (JAN) offers assistance in resolving these situations. JAN has developed a large national data base of solutions to accommodation problems and has offered a few examples to introduce the concept to people who are first learning about hiring people with disabilities.

These sample accommodations are not necessarily the "only" or "ideal" solutions. Accommodations are made on an individual basis, one at a time, so there could be several other possibilities if an employer faces a similar situation. Accommodations alone do not necessarily bring a company in total compliance with the ADA, but they can solve many problems.

We present these "problems" and "solutions" to start the creative process. They can be used to give a person who is inexperienced in hiring people with disabilities an idea of some accommodations that have actually been achieved. They maker it easier to begin the process of working together for change.

After you read a few, you may want to read the problem, cover the solution section, and try to think of alternatives yourself. Then you can see the one that was actually used.

Problem: A person had an eye disorder. Glare on the computer screen caused fatigue.
Solution: An antiglare screen was purchased. ($39.00)

Problem: A person with a learning disability worked in the mail room and had difficulty remembering which streets belonged to which zip codes.
Solution: A rolodex card system was filed by street name alphabetically with the zip code. This helped him to increase his output. ($150.11)

Problem: A plant worker had difficulty using the telephone due to a hearing impairment that required use of hearing aids. It was suggested that he take a lower paying job that does not require telephone use.
Solution: A telephone amplifier that worked in conjunction with his hearing aids was purchased. He kept the same job. ($48.00)

Problem: A clerk developed limited use of her hands and became unable to reach across the desk to her files.
Solution: A lazy Susan file holder was provided so she could access the files and keep her current job. ($85.00)

Problem: An individual lost the use of a hand and could no longer use a camera. The company provided a tripod, but that was too cumbersome.
Solution: A waist pod, such as is used in carrying flags, enabled him to manipulate the camera and keep his job. ($50.00)

Problem: A seamstress could not use ordinary scissors due to pain in her wrist.
Solution: The business purchased a pair of spring-loaded ergonomically designed scissors. ($18.00)

Problem: A receptionist, who was blind; could not see the lights on her telephone which indicated whether the telephone lines were ringing, on hold, or in use at her company.
Solution: The company bought a light-probe, a penlike product that detected a lighted button. ($45.00)

Problem: An insurance salesperson with cerebral palsy had difficulty taking notes while talking on the telephone.
Solution: Her employer purchased a headset for a phone. ($49.95)

Problem: A person applied for a job as a cook and was able to do everything required except opening cans, due to the loss of a hand.
Solution: The employer called the President's Committee's Job Accommodation Network, was given a list of one-handed can openers, and bought one. ($35.00)

Problem: A medical technician who was deaf could not hear the buzz of a timer which was necessary for specific laboratory tests
Solution: An indicator light was attached. ($26.95)

Problem: An individual with dyslexia who worked as a police officer spent hours filling out forms at the end of each day.
Solution: He was provided with a tape recorder. A secretary typed out his reports from dictation, while she typed the others from handwritten copy. This accommodation allowed him to keep his job. ($69.00)

Problem: A person who used a wheelchair could not use a desk because it was too low and his knees would not go under it.
Solution: The desk was raised with wood blocks, allowing a proper amount of space for the wheelchair to fit under it. ($0)

Problem: An employee who used a wheelchair could not use the restroom.
Solution: The toilet facilities were enlarged, and a handrail was installed. ($70.00)

Problem: A person who worked outdoors had a medical condition which caused his hands to be unable to tolerate cold.
Solution: The individual used gloves with pocket hand warmers such as those used by hunters. ($50.00)

Problem: A person with an unusually soft voice was required to do extensive public speaking.
Solution: A hand-held voice amplifier did the trick. ($150.00)

Problem: An employer wanted to make the elevator accessible to a new employee who was blind and read braille.
Solution: Raised dot elevator symbols that were self-adhesive made the elevator accessible. The cost was six dollars apiece.

Problem: A company wanted to hire a clerk who could not access the vertical filing cabinets from her wheelchair.
Solution: They moved the files into a lateral file and hired her ($450.00)

Problem: A person had a condition which required two-hour rest periods during the day.
Solution: The company changed her schedule and allowed her longer breaks, although she worked the same number of hours. ($0)

Problem: An employer wanted an individual who was short statured to drive a heavy loading machine. His legs did not reach the brake pedals.
Solution: The machine was fitted with special seating. ($1200.00)

Problem: A mail carrier with a back injury could no longer carry his mailbag.
Solution: A cart that could be pushed allowed him to keep his route. ($150.00)

Problem: A long-time employee in a factory developed allergic reactions to dust and aerosol sprays.
Solution: He was fitted with a portable air purifying respirator. ($200.00)

Problem: A sales agent was paralyzed from the neck down and could not access his tape recorder.
Solution: A drafting table, page turner, and pressure sensitive tape recorder were purchased, enabling him to keep his job. ($800.00)

These ideas are offered to assist employers and people with disabilities in solving the problems presented by an inaccessible environment. They are also offered to address a myth that has been widely circulated about job accommodation for people with disabilities-that the process is costly. To clarify the facts, the President's Committee's Job Accommodation Network presents the following information regarding accommodations in its data base:

Thirty-one percent of accommodations cost nothing.
Fifty percent cost less than $50.00.
Sixty-nine percent cost less than $500.00.
Eighty-eight percent cost less than $1,000.00.

NOTICE OF EMPLOYEE RIGHTS UNDER FMLA

This information is taken from a poster recommended by the President's Committee for the Employment of People with Disabilities.

YOUR RIGHTS
under the
FAMILY AND MEDICAL LEAVE ACT OF 1993

FMLA requires covered employers to provide up to 12 weeks of unpaid, job-protected leave to "eligible" employees for certain family and medical reasons. Employees are eligible if they have worked for a covered employer for at least one year, and for 1,250 hours over the previous 12 months, and if there are at least 50 employees within 75 miles.

REASONS FOR TAKING LEAVE: Unpaid leave must be granted for any of the following reasons:

- to care for the employee's child after birth, or placement for adoption or foster care;

- to care for the employee's spouse, son or daughter, or parent, who has a serious health condition; or

- for a serious health condition that makes the employee unable to perform the employee's job.

At the employee's or employer's option, certain kinds of pay leave may be substituted for unpaid leave.

ADVANCE NOTICE AND MEDICAL CERTIFICATION: The employee may be required to provide advance leave notice and medical certification. Taking of leave may be denied if requirements are not met.

- The employee ordinarily must provide 30 days advance notice when the leave is "foreseeable."

- An employer may require medical certification to support a request for leave because of a serious health condition, and may require second or third opinions (at the employer's expense) and a fitness for duty report to return to work.

JOB BENEFITS AND PROTECTION:

- For the duration of FMLA leave, the employer must maintain the employee's health coverage under any 'group health plan.'

- Upon return from FMLA leave, most employees must be restored to their original or equivalent positions with equivalent pay, benefits, and other employment terms.

- The use of FMLA leave cannot result in the loss of any employment benefit that accrued prior to the start of an employee's leave.

UNLAWFUL ACTS BY EMPLOYERS: FMLA makes it unlawful for any employer to:

- interfere with, restrain, or deny the exercise of any right provided under FMLA;

- discharge or discriminate against any person for opposing any practice made unlawful by FMLA or for involvement in any proceeding under or relating to FMLA.

ENFORCEMENT:

- The U.S. Department of Labor is authorized to investigate and resolve complaints of violations.

- An eligible employee may bring a civil action against an employer for violations.

FMLA does not affect any Federal or State law prohibiting discrimination, or supersede any State or local law or collective bargaining agreement which provides greater family or medical leave rights.

FOR ADDITIONAL INFORMATION: Contact the nearest office of the Wage and Hour Division, listed in most telephone directories under U.S. Government, Department of Labor.

U.S. Department of Labor, Employment Standards Administration
Wage and Hour Divsion, Washington, D.C. 20210

WH Publication 1420
June 1993

REQUEST FOR FMLA LEAVE OF ABSENCE

Employees who have worked for at least 1,250 hours during the 12-month period immediately prior to the request for leave are eligible for unpaid leave under the FMLA. You should keep a standard form for this kind of leave request. Here is one sample.

Name: _____

Department:_____

Employee Number:_____

Hire Date:_____

TYPE OF LEAVE REQUESTED

Employee Medical Leave of Absence

> Extension of Employee Medical Leave of Absence Dates of prior approved Medical Leave are:
> _____ to _____

Family Medical Leave of Absence

> Extension of Family Medical Leave of Absence Dates of prior approved Family Medical Leave are:
> _____ to _____

Leave to care for newborn or adopted child or a child placed (via state procedures) foster care

> The Leave (or extension) requested will begin on _____ and end on _____.

> If the request is for multiple days off for recurring medical treatments of a child, parent, or spouse, or for your own medical treatments, specify dates requested:
> _____

REASON FOR LEAVE

I request a family leave of absence for the following reason:

> ☐ My personal serious health condition

> ☐ Birth of my child

> ☐ Adoption of a child by me

> ☐ Placement (by the state) of a child with me for foster care

> ☐ Serious health condition of my child

> ☐ Serious health condition of another family member

APPLICATION FOR AMERICANS WITH
DISABILITY ACT LIABILITY INSURANCE

☐ The Home Insurance Company of Wisconsin

☐ The Home Insurance Company of Illinois

☐

APPLICATION FOR AMERICANS WITH DISABILITY ACT LIABILITY INSURANCE (Claims-Made-and-Reported Basis)

1. Name of Applicant: _____

 ☐ a) Corporation ☐ b) Partnership ☐ c) Sole Proprietor

 ☐ d) Other _____

2. Mailing Address: _____

3. City: _____ State: _____ Zip: _____

 Phone #: (_____) _____ Fax #: (_____) _____

4. List all locations owned or occupied by the insured with the following information on each one: Name of insured entity applicable at this location, nature of operations, square foot area of buildings, square foot area of owned parking lots and walkways, number of full time equivalent employees, date acquired or occupied. (Use the separate schedule attached.)

5. A. Limits Desired:

 ☐ $500,000 per claim/$1,000,000 aggregate

 ☐ $1,000,000 per claim/$1,000,000 aggregate

 B. Deductible Desired:

 ☐ $1,000 ☐ $2,500 ☐ $5,000⁻ ☐ $10,000

 ☐ Other $ _____

 C. Retroactive Date Desired (if different than policy effective date): _____

6. Describe all claims or suits alleging discrimination against a disabled person during the last five years (if none, please state).

7. At the time of the signing of this application, are you aware of any circumstances which may reasonably be expected to give rise to a claim under this policy? ☐ Yes ☐ No

 If so, give details: _____

8. How have you reviewed policies, practices and procedures to determine compliance with the ADA?

9. Have you developed an action plan to implement changes in your firm required to comply with the ADA? ☐ Yes ☐ No If yes, please explain. _____

10. Is any person or persons in your organization responsible for ADA compliance, including public accommodations issues and employment-related functions? ☐ Yes ☐ No If so, provide names, titles and duties and to whom they report:_____

11. Do you expect any closings or layoffs within the next year? ☐ Yes ☐ No If so, please advise details. (Use a separate sheet.)

12. Have the following been reviewed to see if alterations, modifications or alternatives are necessary to accommodate the disabled?

Doors/Entrance Ways	☐ Yes ☐ No		
Parking Area(s)	☐ Yes ☐ No		
Bathroom(s)	☐ Yes ☐ No		
Workstations	☐ Yes ☐ No		
Steps/Stairs	☐ Yes ☐ No	☐ N/A	
Elevator(s)	☐ Yes ☐ No	☐ N/A	
Drinking Fountain(s)	☐ Yes ☐ No	☐ N/A	
Locations Where Goods or Services are Provided	☐ Yes ☐ No	☐ N/A	

13. Is an ADA poster conspicuously displayed in your workplace(s)? ☐ Yes ☐ No If not, have you ordered the poster from the EEOC or other source? ☐ Yes ☐ No

14. Have those employees responsible for hiring received instructions, including interview training, on ADA concerns? ☐ Yes ☐ No

15. Do you have written job descriptions which define the "essential functions" of each position? ☐ Yes ☐ No

16. Do your job descriptions include quantified minimum production/performance standards (e.g. type 60 words per minute)? ☐ Yes ☐ No ☐ N/A If not, please explain:_____

17. If you require physical examinations of job applicants, do you do so only after a conditional offer of employment has been made? ☐ Yes ☐ No ☐ N/A

18. Are medical records kept separate from other personnel records and secured in locked file cabinets? ☐ Yes ☐ No If not, how do you plan to maintain confidentiality of medical histories?_____

19. Are there written guidelines that specify how and under what circumstances employee medical files can be inspected? ☐ Yes ☐ No If not included in employee handbook, please attach a copy.

20. If qualification/skill tests are required of job applicants, are arrangements made to accommodate the disabled? ☐ Yes ☐ No ☐ N/A

21. If you are a party to any collective bargaining agreements, do they describe the duties of various jobs? ☐ Yes ☐ No ☐ N/A

22. Have written emergency and/or evacuation procedures been reviewed to ensure that the needs of the disabled have been considered? ☐ Yes ☐ No

23. If you use private employment agencies to recruit job applicants, have you explained to them in writing and documented that they must comply with the ADA? ☐ Yes ☐ No ☐ N/A

APPLICATION FOR EMPLOYMENT
PRACTICES LIABILITY INSURANCE

Application for

Employment Related Practices
Liability Insurance

Please have your licensed insurance representative send this completed application to:

The New Hampshire Insurance Company

401 City Avenue/Suite 210
Bala Cynwyd, PA 19004-1122

THIS APPLICATION IS FOR A CLAIMS-MADE POLICY WHICH INCLUDES DEFENSE EXPENSE WITHIN THE LIMITS OF COVERAGE.
IF ISSUED, READ YOUR POLICY CAREFULLY.

I. GENERAL INFORMATION

1. Named Insured: _____

2. Address: _____

3. Person to contact: _____

 Telephone: _____ Fax: _____

4. Business is: ☐ Corporation ☐ Individual Proprietor ☐ Partnership ☐ Other(Specify)

5. Nature of Business: _____

 Years in Business _____

6. Number of locations by state (including #2 above): _____

7. Desired Limits: Each Insured Event Limit/Total Limit (000's omitted)

 ☐ 500/500 ☐ 500/1000 ☐ 1000/1000 ☐ 1000/2000

8. Desired Effective Date: _____

9. Describe prior coverage for the past five years (if any):

Policy Period	Insurer	Premium	Limit	SIR/Deductible
_____	_____	$ _____	$ _____	$ _____
_____	_____	$ _____	$ _____	$ _____
_____	_____	$ _____	$ _____	$ _____
_____	_____	$ _____	$ _____	$ _____
_____	_____	$ _____	$ _____	$ _____

II. EMPLOYEES

1. Total Number of Employees, including Directors and Officers, (all locations):

 | Non-union: | Full Time | Part Time | Seasonal | Temporary |
 | Union: | Full Time | Part Time | Seasonal | Temporary |

 For seasonal and temporary employees, indicate total annual hours worked:

 Non-union _____ Union _____

2. Total number of employees for each of the last 3 years (all locations):

 Latest Year _____ Second Year _____ Third Year _____

3. Annual employee turnover rate for each of the last 3 years (all locations):

 Latest Year _____ % Second Year _____ % Third Year _____ %

4. How many employees have you terminated in the past three years (all locations):

 Latest Year _____ Second Year _____ Third Year _____

5. Percentage of employees with salaries greater than: $100,000 _____ % $250,000 _____ %

6. Number of employees by length of service: Less than 5 years _____ More than 5 years _____

III. LOSS HISTORY

1. List all EEOC or NLRB charges and demand letters from current or former employees or their attorney for the past five years. Include for each the applicable dates, damages incurred, legal expenses, current status and brief description of circumstances. Also indicate the valuation date and source of this data. _____

2. List all lawsuits and any negotiated settlements entered into with any current or former employee for the past five years. Include for each, the applicable dates, jurisdictions, Civil Action or Index Number, legal expenses incurred, current status, and brief description of circumstances. Also the valuation date and source of this data. _____

3. Are you aware of any circumstances which might give rise to a claim under this policy?

 ☐ Yes ☐ No **If yes, please provide details on a separate sheet of paper.**

IV. HUMAN RESOURCES

1. Do you have a Human Resource or Personnel position or department?

 ☐ Yes ☐ No **If no, how is this function handled?** _____

 If yes, how many employees are there in this department? _____

2. Do you have a written manual of all your personnel policies and procedures?

 ☐ Yes ☐ No

 If yes, do all your management and supervisory employees maintain a copy?

 ☐ Yes ☐ No

 Do these staff members receive training in the proper implementation of your personnel policies and procedures?

 ☐ Yes ☐ No

 Indicate the date your manual was last updated. _____

3. Do you anticipate any plant, facility, branch or office closings or layoffs within the next 24 months?

 ☐ Yes ☐ No **If yes, please provide details on a separate sheet of paper.**

4. Do you use an employment application for all your applicants for hire?

 ☐ Yes ☐ No **If yes, please attach a copy.**

5. Do you conduct an orientation for all new employees?

 ☐ Yes ☐ No

 Is an orientation checklist maintained for each employee?

 ☐ Yes ☐ No **If yes, please attach a copy of the checklist.**

6. Do you publish an employee handbook?

 ☐ Yes ☐ No **If yes, please attach a copy.**

 Do you distribute it to all employees?

 ☐ Yes ☐ No

Does the employee handbook contain written company policies pertaining to Equal Employment Opportunity and Sexual Harassment ? ☐ Yes ☐ No

If no, please attach a copy of your Equal Employment Opportunity and Sexual Harassment statement.

7. Do you provide written performance evaluations for all your employees?

 ☐ Yes ☐ No **If yes, how often?**_____ **Please attach a copy.**

Do your supervisory employees receive training in the proper method of conducting performance appraisals?

 ☐ Yes ☐ No

8. Do you have a written progressive disciplinary program?

 ☐ Yes ☐ No **If yes, please attach a copy.**

9. Do you have a written grievance program?

 ☐ Yes ☐ No **If yes, please attach a copy.**

10. Do you use any tests for screening employment applicants or for continued employment?

 ☐ Yes ☐ No **If yes, please describe.**_____

11. Do you have a formal out-placement program which assists terminated or laid off employees in searching for other jobs?

 ☐ Yes ☐ No **If yes, please describe on a separate sheet.**

12. Do you have an Employment Assistance Program (EAP)?

 ☐ Yes ☐ No **If yes, please describe on a separate sheet.**

13. Do you seek counsel from a human resource person or attorney prior to terminating an employee?

 ☐ Yes ☐ No

14. Do you conduct exit interviews when an employee relationship is ended?

 ☐ Yes ☐ No

15. Are you currently subject to any collective bargaining agreements?

 ☐ Yes ☐ No **If yes, please describe.**_____

Provide a brief history (on a separate sheet of paper) of any other collective bargaining in which you have participated.

16. Do you post, in places conspicuous to all employees and applicants for employment, all required notices relating to equal employment opportunity laws?

 ☐ Yes ☐ No

17. Do you have an inforce Directors and Officers Liability policy which includes coverage for employment related practices?

 ☐ Yes ☐ No **If yes, list the name of the carrier, policy period,**

deductible or SIR and limits of liability._____

Does this Directors and Officers Liability policy exclude "Discrimination", "Sexual Harassment" or "Wrongful Termination"?

 ☐ Yes ☐ No

V. CLAIMS HANDLING

1. List the name of the individual you have designated to handle claims:

 Name Title Phone Number

2. Do you have a written procedure for the prompt reporting of incident and claim information?

 ☐ Yes ☐ No

 Have these procedures been communicated to all your management and supervisory personnel?

 ☐ Yes ☐ No

VI. ATTACHMENTS

The following information must accompany the application if applicable:

- ■ Employment Application
- ■ Employee Disciplinary Procedures
- ■ Employee Grievance Procedures
- ■ Employee Handbook/Manual

- ■ New Employee Orientation Checklist
- ■ Employee Performance Evaluation Forms
- ■ Collective Bargaining Agreements
- ■ EEO and Sexual Harassment Policy

IF A POLICY IS ISSUED, A COPY OF THIS APPLICATION WILL BE ATTACHED TO THE POLICY AND SHALL BE THE BASIS FOR ISSUANCE OF THE CONTRACT. SIGNATURE BY APPLICANT CONSTITUTES A REPRESENTATION THAT ALL INFORMATION PROVIDED HEREIN IS ACCURATE AND COMPLETE. SIGNATURE ON THIS FORM DOES NOT CONSTITUTE BOUND COVERAGE.

> **Notice To New York and Ohio Applicants:** Any person who knowingly and with intent to defraud any insurance company or other person files an application for insurance or statement of claim containing any materially false information or conceals for the purpose of misleading, information concerning any fact material thereto, commits a fraudulent insurance act, which is a crime.

Applicant's Authorized Signature Title Date Signed
(of a Principal, Partner or Officer)

Name of Producer _____

Address _____

City _____ State _____ Zip Code _____

Telephone _____ Fax _____

INDEX